Time in the History of Art

"This sophisticated collection is essential reading for anyone in the humanities attending to the 'temporal turn' in the making and understanding of images."

Mark A. Cheetham, *University of Toronto*

Addressed to students of the image—both art historians and students of visual studies—this book investigates the history and nature of time in a variety of different environments and media as well as the temporal potential of objects. Essays will analyze such topics as the disparities of power that privilege certain forms of temporality above others, the nature of temporal duration in different cultures, the time of materials, the creation of pictorial narrative, and the recognition of anachrony as a form of historical interpretation.

Dan Karlholm is Professor of Art history at Södertörn University in Stockholm.

Keith Moxey is Professor Emeritus at Barnard College/Columbia University.

Studies in Art Historiography
Series Editor: Richard Woodfield
University of Birmingham

The aim of this series is to support and promote the study of the history and prac-tice of art historical writing focusing on its institutional and conceptual foundations, from the past to the present day in all areas and all periods. Besides addressing the major innovators of the past it also encourages re-thinking ways in which the sub-ject may be written in the future. It ignores the disciplinary boundaries imposed by the Anglophone expression 'art history' and allows and encourages the full range of enquiry that encompasses the visual arts in its broadest sense as well as topics falling within archaeology, anthropology, ethnography and other specialist disciplines and approaches.

The Academy of San Carlos and Mexican Art History
Politics, History, and Art in Nineteenth-Century Mexico
Ray Hernandez-Duran

Sculptural Materiality in the Age of Conceptualism
International Experiments in Italy
Marin R. Sullivan

Comparativism in Art History
Edited by Jaś Elsner

Constructing the Viennese Modern Body
Art, Hysteria and the Puppet
Nathan J. Timpano

Messerschmidt's Character Heads
Maddening Sculpture and the Writing of Art History
Michael Yonan

Time in the History of Art
Temporality, Chronology, and Anachrony
Edited by Dan Karlholm and Keith Moxey

For more information about this series, please visit: https://www.routledge.com/Studies-in-Art-Historiography/book-series/ASHSER2250

Time in the History of Art
Temporality, Chronology, and Anachrony

Edited by Dan Karlholm and Keith Moxey

Routledge
Taylor & Francis Group

LONDON AND NEW YORK

First published 2018
by Routledge

2 Park Square, Milton Park, Abingdon, Oxfordshire OX14 4RN
52 Vanderbilt Avenue, New York, NY 10017

Routledge is an imprint of the Taylor & Francis Group, an informa business

First issued in paperback 2020

Library of Congress Cataloging-in-Publication Data
A catalog record for this book has been requested

ISBN: 978-0-415-34744-0 (hbk)
ISBN: 978-0-367-51617-8 (pbk)

Typeset in Sabon
by Apex CoVantage, LLC

Contents

Figures

Introduction

Telling Art's Time

Dan Karlholm and Keith Moxey

Art history as we know it is regarded by many actors in the art world as obsolete. Today, it seems contemporaneity rules in a "post-historical" situation, where art history seems deprived of a future. Some two decades or more after the heyday of postmodernism, it is time to reconsider what kinds of historical claims can still be made for the field of art history and visual studies. If the very word "history" is laden with antiquated expectations of "objectivity" as the discipline goes about its customary business of putting objects back into their chronological place, then the concept of temporality opens up fresh approaches to the temporal organization of the discipline. What if visual art is in a position to explain and expand history rather than vice versa? What if the artwork *grounds* history? What if the work does not necessarily belong to its own time, but was born prematurely or belatedly, disjointed with respect to a chronological axis? Art historical approaches are still possible, indeed needed, but they do look a little different from those to which we have become accustomed.

The unquestioned assumption of the discipline of the history of art since its creation in the late nineteenth century is that time unfolds chronologically, in an orderly manner leading somewhere. The chronological shape of historical writing has its ancient roots in natural metaphors of birth, maturity, and decay, as much as in the purposive direction ascribed to the passage of time by Christianity. In the late eighteenth century, intellectual and social events, epitomized by the Enlightenment and the French Revolution, encouraged philosophers to develop concepts of history that depended on notions of progress. Hegel, writing in the 1820s, argues that time is self-motivated and that its passage coincides with the workings of the "Spirit" as it wends its way through the ages.[1] The founders of art history similarly sketched a developmental history of art, where each period contained the seeds of that which was to come.

The Italian Renaissance, called into being by early art historians as the first "period" of the nascent discipline, proved a popular place to demonstrate these ideas. Ever since Jacob Burckhardt's masterful *Civilization of the Renaissance in Italy* (1860) provided a synchronic account of a stunning culture, the magnificence of its achievements was held up as an inspiration to a nineteenth-century audience.[2] Poets, patrons, philosophers, and painters who inhabit this colorful tapestry represent, by implication rather than argumentation, the culmination of a civilizing process. Heinrich Wölfflin, Burckhardt's successor in Basle and one of the first scholars to occupy a chair of art history, explicitly borrowed Hegel's ideas of temporal development to account for the art of the Renaissance, regarding artistic creation as embodying the passage of the spiritual "feeling for form" as it coursed through time.[3]

The use of Hegelian ideas by the first generations of art historians therefore served to consolidate a developmental form of chronology as the model of temporality on which the discipline unfolded. Aby Warburg's "afterlife" of images and Alois Riegl's idea of "age value," according to which works of art had an autonomous achronological temporality of their own, became the exception that proved the rule.[4] The constructed nature of this historicist system was rarely acknowledged. It was, for example, alive and well in the criticism of Clement Greenberg in the mid-twentieth-century writing about modern art.[5] While Greenberg's account of the progressive accomplishments of the avant-garde decisively shaped the art-writing of his time and beyond, critical examinations of the model, such as that undertaken by George Kubler in the 1960s, were almost ignored.[6]

Only recently have art historians around the world called the authority of chronology into question. Theoretical initiatives in anthropology, sociology, and philosophy as well as art history—such as new materialism, the agency of objects, actor-network theory, object-oriented ontology, and a renewed interest in phenomenology and the latent life of images—all insist on the active role of objects in shaping their histories. Instead of focusing on the time of the work's creation, they draw attention to the "work" of the work in the moments of its changing historical reception. A number of art historians have rebelled against the discipline's continuing dedication to historicism. Hubert Damisch, for example, was among the first to argue that works of art have the capacity to "think" for themselves and that their "thought" initiates a critical response spanning the ages.[7] Mieke Bal, Michael Ann Holly, Ernst van Alphen, Victor Stoichita, and Hanneke Grootenboer have all since created their own achronological, or anachronic (as distinct from anachronistic) approaches to telling art's time.[8] Works of art, for these writers, do not belong in any one time, but to many. In Germany, Gottfried Boehm, Horst Bredekamp, and Hans Belting, among others, have explored the temporal potential of images.[9] While Boehm discusses the power of the image to initiate the process of its interpretation, Belting and Bredekamp characterize it as an actor on the stage of human affairs. Following the phenomenological footsteps of Maurice Merleau-Ponty,[10] and inspired by Aby Warburg's "afterlife" of images, the French art historian Georges Didi-Huberman foregrounds the capacity of the work of art to make its own time as it rolls through the ages.[11] In the United States, W. J. T. Mitchell and James Elkins have explored the capacity of images to shape behavior and influence thought.[12] Art historians Alexander Nagel and Christopher Wood, on the other hand, suggest that the Renaissance was characterized by two overlapping but radically different forms of time.[13] It is in the Renaissance, these scholars argue, that artistic production, depending on the principle of substitution, a process in which images laden with particularly powerful religious presence were repeatedly duplicated, was gradually replaced by artistic production that emphasized performativity and the identity of the creative artist. Nagel and Amy Powell have also challenged the traditional chronology of the history of art by relating works from different "periods" to one another based on perceived formal correspondences.[14] The positions of these writers collectively pose a radical challenge to the entire chronological organization of the discipline by inverting its traditional preoccupation with the significance of the image at the moment of its production to that of its reception.

Here lies the greatest problem for the temporal structure of the history of art. If the presentness of the visual object might be more significant than its historical location, is chronology still relevant at all? What happens to the "history" of art history? If the

pastness of images or works of art continues to fascinate historians, on what architectonic of chronology can they rely? Can history be saved from the embrace of historicism? Can we have chronology without teleology? Since responses to visual artefacts vary over the course of time, how is that difference to be recognized? The anachronic conflation of temporalities that results from the phenomenological engagement with art relies, perhaps, on the structure of chronology. Or could the one exist without the other?

Just as important as the notion of chronology is the issue of *whose* chronology we are talking about. Is chronology a universal phenomenon; does the passage of time flow at the same speed in all places? If chronology is, as we suggest, a necessary social construct (since the late nineteenth century identified with Greenwich Mean Time), then how is time's passing conceived in non-western cultures, and, most importantly, how can we relate one form of time to another? The problem of the coeval or non-coeval nature of time in different cultures is clearly related to their power relations. In the West, the tendency to deny contemporaneity to colonized peoples can be traced back to the Renaissance. As Johannes Fabian points out, anthropology was built, from its inception in the nineteenth century, on the "denial of co-evalness" to non-western cultures.[15] Colonialism and its handmaiden, globalized capital, claimed that subjugated cultures belonged to an earlier time in human development. The industrial/non-industrial distinction, with its inequalities of military and economic strength, ensures that time is equated with power, and thus politics. Economic and social modernity was accompanied by modernism in the arts. Artists rebelled against the conventions of past art under the banner of a motivated chronology. If the "new" was culturally desirable and the "old" was to be discarded, every truly innovative artistic movement was clothed in the prestige with which time had been invested by modernity. The effect of this temporal valorization of modernity meant that any artistic creation produced in a non-western location, the places where time was not supposed to register, was automatically dismissed as primitive or *retardataire*.

Important challenges to the singular chronology of colonialism mark the historiographic landscape of the present. Dipesh Chakrabarty's book *Provincializing Europe* offers an important example of the limitations of western temporal schemes to account for the Indian past.[16] Recognizing that the idea of chronology is itself Western, Chakrabarty seeks to find ways of divorcing this principle from its claim to universality and necessity. The idea of heterochrony resulting from any attempt to escape the universal claims of chronology raises the issue of commensurability. Can the different scales of qualities of time that have marked the world's cultures be reconciled with one another? If times are to be made commensurable, by what standard are they to be translated? Here is one of the most pressing historiographic problems of the moment.

Closely related to both the question of anachrony versus chronology and heterochrony versus monochrony (or homochrony) is that posed by the question of contemporaneity. The end of modernism as the dominant ideology of artistic production for over a century and until the 1960s at least has led scholars to ponder the nature of artistic time today. In other words, the issue of chronology's necessity continues to play a role in current discussions of art history and contemporary art. The failure of postmodernism to signify anything but belatedness has led to a debate as to whether art since the 1960s is even periodizable. Modernist nostalgia for a past when progressive value was attached to the passage of time, together with a growing awareness of the heterochronicity of contemporary artistic production have combined to define the current situation as strangely timeless—as either the end of time or the beginning of a featureless

eternity. This state has been famously phrased by Francois Hartog as presentism, "the sense that only the present exists, a present characterized at once by the tyranny of the instant and by the treadmill of the unending now."[17] Debated by almost every important writer on contemporary art, the issue of the "now" absorbs the attention of artists, critics, the art market, as well as anyone interested in the art of our own time.[18] In the wake of any dominant theory as to where time's passage is leading, artistic production is the place where artists and thinkers address the existential questions of the day. Art's philosophical potential (so presciently recognized by Hegel) offers a "public sphere" in which the most urgent philosophical and political issues of the moment can be posed. It may be that art's relation to time has never been so crucial, so complex, and so full of creative potential.[19] The temporal complexity of the Anthropocene is underlined by Chakrabarty's insistence that "the imbrication of human institutions in the geological and biological processes of the planet calls on us to think in terms of *both* the history of capitalism and its inequities, and to place humans on the much larger canvas of geological and evolutionary times at *the same time.*"[20]

This collection of essays brings together contributions from leading art historical scholars from many places in the world to reflect on these issues. The volume is divided into chapters devoted to one or another dimension of the idea of time and art. We have been particularly fortunate in being able to include essays that reflect deeply on non-western temporalities and how they might intersect with the hegemonic time propagated by colonialism and perpetuated by capitalism. We also include reflections on specific works and historical moments for the insights they bring to broader philosophical and political questions.

Historical Time

As the editors, we have contributed essays that reflect upon the nature and scope of the temporal problem facing art history today. We try to articulate the nature of the "time problem" in all of its ramifications. *Dan Karlholm* points out that declarations that the present is post-historical effectively perpetuate the historicism they purport to reject. "Post-history," like "post-modernism," is just another link in the periodic chain. Taking his cue from Heidegger, he is more interested in the "unveiling" of truth brought about by the work of art than in so-called "truths" about the work based on the circumstances of its creation. He calls for an "efficient" art history, one more concerned with the way in which the work reveals itself in the shifting present than with attempts to locate it within a chronologically determined past. *Keith Moxey* argues that works of art seethe with the confusion of multiple forms of time in their very materials, and that these materials bear traces of the temporal systems of the cultures for which they were made. He further claims that the human encounter with the heterochronic times of objects must inevitably alter and transform their temporalities. He illustrates his argument with works produced in the context of distinct time systems, intimating that their contemporary presence is betrayed by consigning them to a chronological table of western origin.

Post-colonial Time

Is the chronological system on which art history depends universal? How does it relate to the temporal system of other cultures and can these systems be reconciled?

John Clark boldly insists that Asian modernism is incommensurable with what he calls "Euramerican" modernism. He argues that there can be no "genuine World Art History" before the radical alterity of the world's temporal systems is recognized. To evaluate Asian modernism in terms of the modernist trajectory in Europe and the United States makes no sense because the temporalities to which they belong cannot be synchronized. On the vexed subject of intercultural periodization, he concludes: "In short, the structure of periodizations could be relatively similar across cultures, but the actual historical duration may be very different. When we have truly established the set of those changes in their different Asian contexts, we will have established a paradigm for Asian modernities, and it is this whose comparison with Euramerica will allow redefinition of 'modernity in art' and all its myriad temporalities." Like Clark, *Partha Mitter* emphasizes the incommensurability between chronological time and the traditional time systems of India. He traces art history's teleological narrative from Vasari to modernity with particular attention to the ways in which Indian art has been misunderstood and belittled for its "failure" to live up to the chronological expectations of English colonial power and the international art market. Offering a sweeping review of the temporal systems of ancient India and their encounter with British time, he also describes the dilemmas facing Indian nationalists seeking to construct an "Indian" identity from the temporal chaos of the communities inhabiting the subcontinent. *Mary Roberts* argues that at a moment that saw the growth of "Orientalism," the definition of the cultures of Turkey and the Middle East as distinct from and inferior to a more developed and civilized Europe, the collection formed by the British vice-consul William Henry Wrench offers insight into the complexity of the attitudes brought to bear on the subject of "Islamic Art." Her argument hinges on the contrast of Wrench's painting by the Turkish artist Osman Hamdi Bey and one by his French counterpart Léon Gérôme. Whereas the former displays a respectful interest in the Ottoman past, the latter renders it as backward and decadent. Hamdi's work indicates that understanding Wrench's collection was built on assumptions quite different from characteristic European attitudes of his time. Istanbul is also the setting for *Esra Akcan*'s chapter, but translation is its theme. Fully appreciative of the complexity of moving ideas from one language to another, she nevertheless offers an optimistic vision of its function as both necessary and inevitable. Musing on the temporal implications of Victor Burgin's video of the digital modeling of a destroyed coffee house by the twentieth-century Turkish architect Sedad Eldem, she discerns a form of translation at work that transcends the binary logic that would consign such buildings to either "progressive" or "belated" categories in the history of modernism.

Artist's Time

Hanneke Grootenboer chooses an apparently unremarkable Dutch painting of everyday life (by Jacob Vrel, *Woman by a Hearth*, Hermitage Museum, St. Petersburg, ca. 1655), one of thousands of examples produced in Holland during the seventeenth century, in order to listen to what it has to "say." A working woman sits in a rocking chair with her head turned away from the viewer so that her face remains invisible. Nothing at all is happening; the painting represents an "interval" in time. Looking at the painting pulls us into an eddy in time's flow; its mood infectiously determines our own reception. She concludes: "Although the painting asks us to pause, it does so without promising us anything in return—it wants us to come to a standstill, but is

unwilling to reveal itself fully to us." The work asks us, she says, to reflect upon "the rhetoric of temporality that it has helped establish." *Miguel Ángel Hernández Navarro* writes about the Peruvian artist Fernando Bryce who appropriates documents such as newspaper headlines and film publicity as his raw material, which he then photo-copies before copying them yet again in India ink and brush on paper. Laborious and time-consuming, Bryce's method parodies the frenzied rush of the daily news by trans-forming it by artisanal means into works that demand careful appreciation. Some of his works borrow newspapers and film publicity from the time of World War II, the Spanish Civil War, and other twentieth-century conflicts that took place far from his native Lima. Chronology is denied by calling attention to earlier and geographically removed forms of time. The lack of synchrony between the temporal systems in ques-tion serves to illustrate this deeply melancholic reflection on time. The time of ink on paper, for example, alludes to the Peruvian context in which news of so-called First World warfare was received.

Narrative Time

Giovanni Careri's thoughtful analysis of Caravaggio's *Calling* and *Martyrdom of Saint Matthew* in the Contarelli Chapel of San Luigi dei Francesi in Rome reveals the variety of painted temporalities that animate the experience of the viewer. Careri argues that in the *Calling*, Caravaggio indicates that the figures of Christ and St. Peter, dressed in antique garb, belong to a time that is distinct from that of St. Matthew and those around him who are clad in sixteenth-century clothing. In theological terms, the message of the Gospels is an eternal one, so Christ's appeal to humans to follow his lead reverberates through the ages and is as relevant to what Careri, following Walter Benjamin, calls the *Now-time* of the viewer. Careri dwells on the reception of these works because he wants to liberate them from the architecture of a history of art that tends to enfold such paintings in contextual information drawn from its historical horizon—an effort that prevents us from responding to them with the intensity they demand.

Ontological Time

Zainab Bahrani draws attention to ancient works that were deliberately filled with the kind of presence now attributed to the modern notion of "art" and associated with aesthetic response. She argues that *melammu*, an Akkadian word used to describe the power attributed to images of gods and kings in ancient Mesopotamia, contains within it a pre-Kantian concept of the sublime. Texts incised on these images, dating from the third millennium B.C., not only identify the historical figures, but they also claim a transcendental power for them that is valid for all time. Such monuments seem to combine an interest in chronology, the date of an event or reign with a desire to invest individuals with an eternal power activated whenever they happen to be seen. *Avinoam Shalem* meditates on the role of materials in shaping the temporality of works of medieval art. Islamic authors of the twelfth and thirteenth centuries waxed eloquent on the powers of stone, gold, silver, rubies, diamonds, and rock crystal to withstand the ravages of time. Both Islamic and Christian writers suggested that the transparency of rock crystal indicated that it was water that had been petrified by God's gaze. It may have been such ideas that allowed Islamic crystals produced for the

Fatimid court in Cairo to be transformed into Christian reliquaries in the later Middle Ages. Shalem also cites examples of Byzantine churches whose floors were covered with marble because their striated formations recall the waves of the sea. *Christine Ross* provides a thorough analysis of an installation by Sarah Sze at the 2015 Venice biennale. Drawing upon the theoretical territory of new materialism and object-oriented ontology, Graham Harman and Catherine Malabou in particular, her chapter centers around the "bio-affective" concept of wonder, which, she argues, is a temporal phenomenon, gradually revealed by the visitor to the work. In their withdrawal, the garden objects "turn the volume up on the unperceived, the barely perceivable, the under-perceived," thereby "sustaining the subject's capacity to be touched and not to be indifferent."

Photographic Time

Emmanuel Alloa muses on the current circumstances in which contemporary art is exhibited, arguing that the medium-specific "exposure time" of works of art is sacrificed in the interests of "time showed" or the "time of showing." The ubiquity and universality of the "white cube" circumstances in which contemporary art is currently exhibited results in what he calls an "immunization of the gaze." It is difficult to distinguish one work from another in situations that treat them all exactly alike. He uses the photographs of the nineteenth-century Danish-American photographer Jacob Riis to claim that what is lost is the time of the medium itself as it is recorded on the surface of the objects it creates. The cumbersome flash equipment necessary to make the nighttime images he wanted left traces on the negatives and affected the attitudes of those photographed. This has necessitated the cropping and framing of his images, even though his photographic plates still reveal the "exposure time" blemishes that must be lost to the exhibitionary regime with which we have become familiar. *Amelia Groom* also turns her attention to the photographic unseen in her chapter on the photographic "blur." Like Alloa, she argues that there is a temporality to the medium that exceeds its uncanny capacity to record what it is meant to capture. She claims that the blur serves as an allegory of the impossibility of capturing moments in time, thus challenging the utopian dream of measuring and controlling it: "We can think of the blur as an irrational temporal density, where time refuses to be flattened out and instrumentalized into a series of discrete units."

The multiple forms of time inherent in works of art offer the historical imagination inexhaustible motivated chronology. The importance of exploring these avenues becomes clearer, as well as more urgent, as the heterochronicity of world times, together with their incommensurability, becomes increasingly evident.

Notes

1. G. W. F. Hegel, *Aesthetics. Lectures on Fine Art*, trans. T. M. Knox (Oxford: Clarendon Press, 1998).
2. Jacob Burckhardt, *The Civilization of the Renaissance in Italy* (1860), trans, S. G. C. Middlemore (1878) (London: Penguin, 1990).
3. Heinrich Wölfflin, *Principles of Art History: The Problem of the Development of Style in Early Modern Art*, trans. Jonathan Blower (Los Angeles: Getty Research Institute, 2015).
4. Aby Warburg, *The Renewal of Pagan Antiquity: Contributions to the Cultural History of the Italian Renaissance*, trans. David Britt (Los Angeles: Getty Research Institute, 1999);

Alois Riegl, "The Modern Cult of Monuments: Its Character and Origin," *Oppositions* 25 (1982), 21–51.

5. Clement Greenberg, *Art and Culture: Critical Essays* (Boston: Beacon Press, 1961).
6. George Kubler, *The Shape of Time: Remarks on the History of Things* (New Haven: Yale University Press, 1962).
7. Hubert Damisch, *A Theory of the Cloud: Towards a History of Painting*, trans. Janet Lloyd (Stanford: Stanford University Press, 2002); *The Origin of Perspective*, trans. John Goodman (Cambridge, MA: MIT Press, 1994).
8. Mieke Bal, *Reading "Rembrandt": Beyond the Word-Image Opposition* (New York: Cambridge University Press, 1991); Mieke Bal, *Quoting Caravagio: Contemporary Art, Preposterous History* (Chicago: University of Chicago Press, 1999); Michael Ann Holly, *Past Looking: Historical Imagination and the Rhetoric of the Image* (Ithaca: Cornell University Press, 1996); Ernst van Alphen, *Caught by History: Holocaust Effects in Contemporary Art, Literature and Theory* (Stanford: Stanford University Press, 1998); Ernst van Alphen, *Art in Mind: How Contemporary Art Shapes Thought* (Chicago: University of Chicago Press, 2005); Victor Stoichita, *The Self-Aware Image: An Insight into Early Modern Metapainting* (Cambridge: Cambridge University Press, 1996); Stoichita, *A Short History of the Shadow* (London: Reaktion Books, 1997); Hanneke Grootenboer, *The Rhetoric of Perspective: Realism and Ilusionism in Seventeenth-Century Dutch Still Life Painting* (Chicago: University of Chicago Press, 2005) and *Treasuring the Gaze: Intimacy and Extremity in Eye Miniature Portraits* (Chicago: University of Chicago Press, 2012).
9. Gottfried Boehm (ed.), *Was ist ein Bild?* (Munich: Fink, 1995); Gottfried Boehm (ed.), *Movens Bild: Zwischen Evidenz und Affekt* (Munich: Fink, 2008); Gottfried Boehm, *Wie Bilder Sinn Erzeugen: Die Macht des Zeigens* (Berlin: Berlin University Press, 2008); Horst Bredekamp, *Theorie des Bildakts* (Berlin: Suhrkamp, 2010); Hans Belting, *An Anthropology of Images: Picture, Medium, Body*, trans. Thomas Dunlap (Princeton: Princeton University Press, 2014)
10. Galen Johnson (ed.), *The Merleau-Ponty Aesthetics Reader:Philosophy and Painting* (Evanston: Northwestern University Press, 1993).
11. Georges Didi-Huberman, *Confronting Images: Questioning the Ends of a Certain History of Art*, trans. John Goodman (University Park, PA: Pennsylvania State University Press, 2005; 1st ed. Paris, 1990); Didi-Huberman, *The Surviving Image: Phantoms of Time and Time of Phantoms: Aby Warburg's History of Art* (College Park, PA: Pennsylvania State University Press, 2016; 1st ed. Paris, 2000); Didi-Huberman, "Before the Image, Before Time," *Compelling Visuality: The Work of Art in and out of History*, ed. Claire Farago and Robert Zwijnenberg (Minneapolis: University of Minnesota Press, 2003), 31–44; Didi-Huberman, "The Surviving Image: Aby Warburg and Tylorian Anthropology," *Oxford Art Journal* 25, no.1 (2002), 61–70; Didi-Huberman, "Panofsky vs. Warburg and the Exorcism of Impure Time," trans. Vivian Rehberg and Boris Belay, *Common Knowledge* 9, no. 2 (2003), 273–85.
12. W. J. T. Mitchell, "What is an Image?", *New Literary History* 15 (1984), 503–37; W. J. T. Mitchell, *Picture Theory: Essays in Verbal and Visual Representation* (Chicago: University of Chicago Press, 1995); W. J. T. Mitchell, *What Do Pictures Want? The Lives and Loves of Images* (Chicago: University of Chicago Press, 2005); James Elkins, *The Object Stares Back* (New York: Houghton, Mifflin Harcourt, 1996); James Elkins and Maja Naef (eds.), *What is an Image?* (University Park, PA: Pennsylvania State University Press, 2011).
13. Alexander Nagel and Christopher Wood, *Anachronic Renaissance* (New York: Zone Books, 2010).
14. Alexander Nagel, *Medieval Modern* (New York: Thames & Hudson, 2012); Amy Powell, *Depositions: Scenes from the Late Medieval Church and the Modern Museum* (New York: Zone Books, 2012).
15. Johannes Fabian, *Of Time and the Other: How Anthropology Makes its Object* (New York: Columbia University Press, 1983); Nancy Munn, "The Cultural Anthropology of Time," *Annual Review of Anthropology* 21 (1992), 92–123.
16. Dipesh Chakrabarty, *Provincializing Europe: Postcolonial Thought and Historical Difference* (Princeton: Princeton University Press, 2000).

17. Francois Hartog, *Regimes of Historicity: Presentism and Experiences of Time* [2003], trans. Saskia Brown (New York: Columbia University Press, 2015), xv.
18. An excellent overview and discussion is provided by Christine Ross, *The Past is the Present; It's The Future Too: The Temporal Turn in Contemporary Art* (New York: Bloomsbury, 2012), 1–52. She argues that "although presentism certainly defines a predominant realignment of the past present, and future of the contemporary world, it coexists with other regimes of historicity made of less absorbing but still highly significant realignments" (49).
19. See Bruno Latour (ed.), *Reset Modernity!* (Karlsruhe: ZKM/Center for Art and Media, distributed by Cambridge, MA: MIT Press, 2016).
20. Dipesh Chakrabarty, "The Human Significance of the Anthropocene," in Latour (ed.), *Reset Modernity!*, 189–99, esp. 197 (italics in original). See also his "The Climate of History: Four Theses," *Critical Inquiry* 35, no. 2 (Winter 2009), 197–222.

Bibliography

Alphen, Ernst van. *Caught by History: Holocaust Effects inContemporary Art, Literature and Theory*. Stanford: Stanford University Press, 1998.

Alphen, Ernst van. *Art in Mind: How Contemporary Art Shapes Thought*. Chicago: University of Chicago Press, 2005.

Bal, Mieke. *Reading "Rembrandt": Beyond the Word-Image Opposition*. New York: Cambridge University Press, 1991.

Bal, Mieke. *Quoting Caravagio: Contemporary Art, Preposterous History*. Chicago: University of Chicago Press, 1999.

Belting, Hans. *An Anthropology of Images: Picture, Medium, Body*. Trans. Thomas Dunlap. Princeton: Princeton University Press, 2014.

Boehm Gottfried, ed. *Was ist ein Bild?* Munich: Fink, 1995.

Boehm, Gottfried, ed. *Movens Bild: Zwischen Evidenz und Affekt*. Munich: Fink, 2008.

Boehm, Gottfried. *Wie Bilder Sinn Erzeugen: Die Macht des Zeigens*. Berlin: Belin University Press, 2008.

Bredekamp, Horst. *Theorie des Bildakts*. Berlin: Suhrkamp, 2010.

Burckhardt, Jacob. *The Civilization of the Renaissance in Italy* [1860]. Trans. S. G. C. Middlemore (1878). London: Penguin, 1990.

Chakrabarty, Dipesh. *Provincializing Europe: Postcolonial Thought and Historical Difference*. Princeton: Princeton University Press, 2000.

Chakrabarty, Dipesh. "The Climate of History: Four Theses." *Critical Inquiry* 35, no. 2 (Winter 2009), 197–222.

Chakrabarty, Dipesh. "The Human Significance of the Anthropocene" In Latour, ed. *Reset Modernity!*, 189–99.

Damisch, Hubert. *A Theory of the Cloud: Towards a History of Painting*. Trans. Janet Lloyd. Stanford: Stanford University Press, 2002.

Damisch, Hubert. *The Origin of Perspective*. Trans. John Goodman. Cambridge, MA: MIT Press, 1994.

Didi-Huberman, Georges. *Confronting Images: Questioning the Ends of a Certain History of Art*. Trans. John Goodman. University Park, PA: Pennsylvania State University Press, 2005.

Didi-Huberman, Georges. *The Surviving Image: Phantoms of Time and Time of Phantoms: Aby Warburg's History of Art*. College Park, PA: Pennsylvania State University Press, 2016.

Didi-Huberman, Georges. "Before the Image, Before Time." In *Compelling Visuality: The Work of Art In and Out of History*, ed. Claire Farago and Robert Zwijnenberg. Minneapolis: University of Minnesota Press, 2003, 31–44.

Didi-Huberman, Georges. "The Surviving Image: Aby Warburg and Tylorian Anthropology." *Oxford Art Journal* 25, no. 1 (2002), 61–70.

Didi-Huberman, Georges. "Panofsky vs. Warburg and the Exorcism of Impure Time." Trans. Vivian Rehberg and Boris Belay, *Common Knowledge* 9, no. 2 (2003), 273–85.

Elkins, James. *The Object Stares Back*. New York: Houghton Mifflin Harcourt, 1996.

Elkins, James and Maja Naef, eds., *What is an Image?* University Park: Pennsylvania State University Press, 2011.

Fabian, Johannes. *Of Time and the Other: How Anthropology Makes its Object*. New York: Columbia University Press, 1983.

Greenberg, Clement. *Art and Culture: Critical Essays*. Boston: Beacon Press, 1961.

Grootenboer, Hanneke. *The Rhetoric of Perspective: Realism and Ilusionism in Seventeenth-Century Dutch Still Life Painting*. Chicago: University of Chicago Press, 2005.

Grootenboer, Hanneke. *Treasuring the Gaze: Intimacy and Extremity in Eye Miniature Portraits*. Chicago: University of Chicago Press, 2012.

Hartog, Francois. *Regimes of Historicity: Presentism and Experiences of Time* [2003]. Trans. Saskia Brown. New York: Columbia University Press, 2015.

Hegel, G. W. F. *Aesthetics. Lectures on Fine Art*. Trans. T. M. Knox. Oxford: Clarendon Press, 1998.

Holly, Michael Ann. *Past Looking: Historical Imagination and the Rhetoric of the Image*. Ithaca: Cornell University Press, 1996.

Johnson, Galen, ed. *The Merleau-Ponty Aesthetics Reader:Philosophy and Painting*. Evanston: Northwestern University Press, 1993.

Kubler, George. *The Shape of Time: Remarks on the History of Things*. New Haven: Yale University Press, 1962.

Latour, Bruno, ed. *Reset Modernity!*, Karlsruhe: ZKM/Center for Art and Media distributed by Cambridge, MA: MIT Press, 2016.

Mitchell, W. J. T. "What is an Image?" *New Literary History* 15 (1984), 503–37.

Mitchell, W. J. T. *Picture Theory: Essays in Verbal and Visual Representation*. Chicago: University of Chicago Press, 1995.

Mitchell, W. J. T. *What Do Pictures Want? The Lives and Loves of Images*. Chicago: University of Chicago Press, 2005.

Munn, Nancy. "The Cultural Anthropology of Time," *Annual Review of Anthropology* 21 (1992), 92–123.

Nagel Alexander and Christopher Wood. *Anachronic Renaissance*. New York: Zone Books, 2010.

Nagel, Alexander. *Medieval Modern*. New York: Thames & Hudson, 2012.

Powell, Amy. *Depositions: Scenes from the Late Medieval Churchand the Modern Museum*. New York: Zone Books, 2012.

Riegl, Alois. "The Modern Cult of Monuments: Its Character and Origin." *Oppositions* 25 (1982), 21–51.

Ross, Christine. *The Past is the Present; It's The Future Too: The Temporal Turn in Contemporary Art*. New York: Bloomsbury, 2012.

Stoichita, Victor. *The Self-Aware Image: An Insight into Early Modern Meta-Painting*. Cambridge: Cambridge University Press, 1996.

Stoichita, Victor. *A Short History of the Shadow*. London: Reaktion Books, 1997.

Warburg, Aby. *The Renewal of Pagan Antiquity: Contributions to the Cultural History of the Italian Renaissance*. Trans. David Britt. Los Angeles: Getty Research Institute, 1999.

Wölfflin, Heinrich. *Principles of Art History: The Problem of the Development of Stylein Early Modern Art*. Trans. Jonathan Blower. Los Angeles: Getty Research Institute, 2015.

Part I
Historical Time

1 Is History to Be Closed, Saved, or Restarted? Considering Efficient Art History

Dan Karlholm

Why do we get so much pleasure out of being so different not only from others but from our own past? What psychologist will be subtle enough to explain our morose delight in being in perpetual crisis and in putting an end to history?

Bruno Latour[1]

The symptoms of crisis within the discipline of art history, this time around, seem more profound than usual. While history as such can be understood as in permanent crisis, this word can also point to "a singular, accelerating process in which many conflicts, bursting the system apart, accumulate so as to bring about a new situation after the crisis has passed." Can we envision a new situation after the current crisis has passed? Can it pass or are we heading for the third meaning of crisis: "purely and simply the final crisis of all history that precedes it, where proclamations of the Last Judgement are everywhere employed?"[2]

"Whither art history?," asks a leading academic art journal,[3] implying that it is going somewhere (else), while others just note that "art history as we know it is over."[4] In the field of contemporary art, where the signs of crisis are perhaps most evident, new ways to conceptualize the contemporary condition are delivered that account for multiple co-existing times while also drawing a firmer wedge than ever before between an expanding present and the receding past.[5] It is on the latter field, and in the aftermath of the 1989 events in particular, that the most drastic diagnoses appear, expressed through a number of post-phenomena from post-modern, post-colonial, post-socialist, and post-historical to post-critical and post-human, to name a few. One of the most troubling categories is post-future, which signals an end to even hoping for solutions, let alone a fresh start. While none of these posts is exclusively relevant to the academic discipline of art history, the latter will be my point of entry here. My interest is in viewing our situation from a slightly shifted perspective than what these inherently historicist post-terms can offer. The very vocabulary is part of the problem; we seem collectively unable to think outside of the box, as it were, of Western modernity with its progressive concept of history and its teleological philosophies of history. Refusing to position myself as either a conservative, hanging on to an art history gone stale, or as a radical, coining ever harsher diagnoses and critical lamentations of this state of affairs, I think it is time to shelve both of these options and contribute a different model. Many of us feel a need to start over, without either closing art history or saving it as some kind of heritage. Restarting art history would of course require some extra memory space and perhaps an external hard drive to house a reconfiguration

of its dominant model of history. My excuse for choosing such a big topic for a short essay is pragmatic and political; it is urgent to part from the negative modern route of wholesale critique or postmodern despair (including a certain delight in this despair) and to try to fashion, instead, a non-modern model, for want of a better word, which could do justice to all kinds of art, no matter where or when it was made, to continue mapping and measuring its multiple interconnections, its patterns of change and duration, without locking it up in canonical hierarchies symbiotically linked to national-ethnic origin, monetary value, or temporal recentness.[6]

Post-history, Post-future, and the Present

"What is new," according to Jonathan Crary in 2013, "is the sweeping abandonment of the pretense that time is coupled to any long-term undertakings, even to fantasies of 'progress' or development. An illuminated 24/7 world without shadows is the final capitalist mirage of post-history, of an exorcism of the otherness that is the motor of historical change."[7] The concept of post-history (*posthistoire*) performs a peculiar paradox. While claiming to have nothing more to do with history, post-history in itself constitutes a historical sequence; after history, history is no more. Pronouncing this, however, as post- or literally after history betrays the modern historical mindset strung up between then and now, before and after. Being after history is to remain in the space carved out by history, in its trajectory, legacy or "afterness."[8]

 Referencing post history, or the end of history, is one of the first ways to summarize what contemporaneity in art might mean:

> . . . once art had ended . . . everything was permitted, since nothing any longer was historically mandated. I call this the Post-Historical Period of Art, and there is no reason for it ever to come to an end. Art can be externally dictated to, in terms either of fashion or of politics, but internal dictation by the pulse of its own history is now a thing of the past.[9]

Just like Francis Fukuyama, who professed the end of history (and the universal victory of liberal democracy) in 1989, Arthur Danto takes Hegel literally and posits a possibly endless end to the history of art at a certain point in time.[10] That is, Hegel's thesis on the unique resolution of history in history (with the battle of Jena in 1806) is cut and pasted onto a different temporal moment. For Danto this occurred with Andy Warhol's exhibition at the Stable Gallery in New York in 1964, and for Fukuyama in connection to the events that led to the demolition of the Berlin Wall in 1989. What follows from these respective Hegelianisms is a definition of history where the object of history is pushed forward by some internal force of development or "motor of change" (Crary) dictating its course toward a predetermined goal or end point, wherefrom there can be no more history as such, to no one's regret, apparently. Getting rid of history even inspires rejoicing: "We sing to the infinity of the present and abandon the illusion of a future," as Franco "Bifo" Berardi ends his manifesto in *After the Future*.[11] Abandoning the future sounds like a futurist hallucination itself, a sci-fi dream of eternal life for some cyborg species without either of the phenomenological fundamentals of the historical human: experience or expectation. From this short quote alone, a paraphrase of the Futurist Manifesto from 1909, it is clear that what has ended is not the future itself, whatever that would mean exactly, but the

"illusion" that the future could be calculated or programmed, foreseeable as a proper *effect* directly related to *causes* from within the preceding historical present. This is apparently no longer the case to most observers, perhaps because what lies ahead is too complex, too volatile, too fast and chaotic to be calculable let alone monitored or planned. We can all agree, I suppose, that illusions deserve to be unveiled and abandoned. Believing, however, that this temporal dimension of our human existence can just be abandoned, as an act of will, risks creating another illusion: that the present is infinite. This clearly evades a future-oriented perspective of a more reliable and real kind: not just the "possibility of death" in Martin Heidegger's phrase, among us mortals, but for the planet itself.[12] Are we not facing a future that dare not speak its name, so open and indefinite, so threateningly vacuous and potentially devastating that we simply must rename it? We call it *the present*.

"The era of post-future has begun."[13] Bifo's chilling proclamation is essentially, if paradoxically, a modern one by preserving the modernist idea of future as the ideal realization or actualization of being, while simultaneously declaring—in a more postmodern vein—its impossibility. The future is cherished to the point where its loss is not only quietly bemoaned but also commemorated by the new term's eternal determination of being *without* future, which is of course a way of being *with* it. By pulling the overcoming of future—the being without which is a being with—into the future, we seem destined to have to live with after-future for the foreseeable future.

Post-history and post-future are conceptual siblings. When history emerged as a collective singular around 1800, as a new conceptual formation—"history itself"—corresponding to a "new time" (*Neuzeit*) a.k.a. modernity, the past was artificially separated from the progressing present, with which Western modernity identified, not least to distance itself from nature and the cultures of the world.[14] The gap between past and future widened ever more speedily during the high modern era in the nineteenth and twentieth centuries, which, after this era was declared over, eventually led to the perception of a singular "broad present" (Gumbrecht), the idea of a "boundless" or "perennial present" (Harootunian), corresponding to a whole presentist regime of historicity (Hartog).[15] Another word for the present, especially on the field of art, is "*the* contemporary" which "is now widely claimed as a period, composed of loosely related aesthetic tendencies, following and displacing modernism."[16]

Danto and Bifo also speak of a "period" or an "era" starting up. The use of such classical periodizations, along with concepts like epistemes or regimes, highlighting cultural dominants and temporal ruptures, surely indicates that we have not left the building of modern history. While the hypothesis of a not only expanding but eternal present or "forever now" is vintage post-history, it adheres to the logic of history as well, with its pre- and post-terms.[17] With the past long gone, presumably, if also available as digitalized traces on our screens, and the future evacuated of all the good things moderns projected on it—further progress, emancipation, justice, profit, power, peace, etc.—we seem stuck with a rather monstrous *post-future-present-future*. The dark undertones of "post-future" are revealing of just how modern this discourse is. Future is still associated, as such, with positive values only, disavowing threats and dangers and the certainty of death. Furthermore, the notion of post-future offensively circumvents the imminent prospects of climate change and environmental disaster, which can afford neither some non-committing or punkish "no future" response, nor a conservative reassuring that nothing will ever change.

When Siegfried Gidieon addressed "the eternal present" sixty years ago, this was to capture the pre-modern world; pre-history's remarkable constancy before change was introduced and everything started to move, differ, and disintegrate.[18] When the eternal present returns in our day, it is in the form of a paradoxical prognosis. When the illusion of future retires, it is immediately replaced by the illusion—the *prognosis*—of eternity. If this is indeed the "final crisis of all history," in Koselleck's words, we hear no Last Judgement proclamations, which would presuppose that we were alarmed, or at least bothered, by such a crisis.

Pre-history and After- or Efficient History

History, in ordinary parlance and since its modern inception in the late eighteenth century in Europe, has been a kind of pre-history, if not at all in the conventional sense of this word, exemplified by Gidieon above, which alludes to a not-yet history or a time without written sources. According to the "normal" definition of history, contemporaneous with but not identical to teleological philosophies of history, history conjures up accounts of what has happened (needless to add: of importance) in history. History shows only what has actually (*eigentlich*) happened, in Leopold von Ranke's famous utterance,[19] by establishing past happenings in as secure and truthful a way as possible. Notwithstanding the problems involved in this kind of history, which are many but also massively researched for decades, its mode of operation involved two elements that could be fruitfully brought to bear on the present discussion: an *open scope* and an analogously *open end*. An open scope means that anything, any content in principle (what?), from anywhere and any point in historical time, could be subjected to historicizing, by means of any plot structure or narrative (how?). An open end, which follows from the open scope, signals a successively deferred future, an open—meaning radically undetermined, unforeseeable—future. While the market for histories on a certain topic could well be saturated, there are no internal limits to the number of historical texts that can be turned out, and no conceivable point in time when this practice will come to an end. The writing of histories will certainly go on, with no definite end point in sight. This practice—this venerable tradition—would respond to the calls for an end to history and the concomitant inauguration of post-history and post-future with the determination to write this history too.

What is uncontested within this practice, however, is that what historians do is reserved, by and large, to past happening, previous occurrences, to a kind of pre-history—to a history directed to *the before*, in two ways, the first of which is self-evident. While histories are written in the present, a continuously *shifting* viewpoint, they regard the past. This is true even of so-called contemporary history today. Moreover, the object of study selected by this kind of history—an event or a person, for example—is typically also studied from the point of view of its past. When the historian took to study Napoleon or the British working class, the thrust was on what determined them, what led to their actions and formations, and what caused certain happenings to emerge as effects. The goal was to explain them historically, which meant to account for how and why they came about.[20]

I am interested in supplementing this established practice of history with one focusing on what has happened to the object of study after it emerged, a history which instead of establishing determinative causes followed by more or less predictable effects—or instead of aiming for a goal in order to resolve itself philosophically—seeks

to establish the after-history of a historical phenomenon, which is constantly on the move in the present. Such a project, indebted to Michel Foucault's genealogy, "grey, meticulous and patiently documentary,"[21] would trace works in their state of non-permanent, non-chronic, becoming. History writing in the after-historical sense envisioned here will always also be indefinitely deferred and put on hold—its last word is yet to come. The main point of maintaining a temporal space of and for history, however, is to pave the way for a more nuanced understanding of those anachronic "quasi-objects" we call works of art.[22]

What the after-historian sets herself to investigate are the causes that lie embedded in and ahead of the work, or *the effects that the work as effect effect, the causes that the work as cause cause.* Turning a key causal factor of conventional history—influence—around, we could benefit from thinking along the lines of *outfluence* instead. There is no predetermined end to this web of relations, of connections and associations, which could of course be discontinued, theoretically speaking, but is more likely to keep unfolding. The specific nature of this unfolding, this sequence of links and happenings is what needs to be historicized by adequately accounting for the process as well and as detailed as possible.

Like all forms of history, after-history is situated in the present and turned backwards, but instead of focusing on the determinants of its objects of study, it would be attentive to the projected histories or veritable "lives" of these quasi-objects in and through time, even up to the slowly deferred now of the historian. This way to historicize a work of art, for example, would entail focusing not on what it once was and how come, but on what it has *become*. The model for this procedure is neither causal history nor "effective history" in Hans-Georg Gadamer's sense, which assembles the work's interpretations (its highbrow reception history).[23] What could be called *efficient* history, instead, pitches the work as "[p]roductive of effects, effective, adequately operative."[24] Besides comprising regular interpretations, this form of history would include all sorts of material and coincidental actions that have in practice—*in effect*—shaped the "life experiences" of the work. This is where a point of contact presents itself with actor-network theory (ANT), where a network is seen as "the trace left behind by some moving agent," such as an artwork.[25] According to the partly unacknowledged precursor to this theory, moreover, "art is history in the essential sense that it grounds history," not the other way around. History does not predetermine but springs forth from the work of art, and to state that "the happening of truth is at work" in the work, as Heidegger does, is to accredit the work as an agent or actor.[26]

"The working of the work," Heidegger further cautions, "does not consist in the taking effect of a cause. It lies in change, happening from out of the work, of the unconcealedness of what is, and this means, of Being,"[27] which establishes yet another point of connection with ANT's considerable disinterest in causality. The binary cluster cause-and-effect belongs to what is commonly only described as causality or the realm of causal explanations, which is a clear enough hint on what is privileged here: the pre-, before, or origin of a phenomenon. In Bruno Latour's terminology, we could say that *causes* set off "intermediaries" that faithfully deliver or transport some essence or explanatory factor to the corresponding *effect*. Putting the thrust on efficient history, however, is to deprive causes of any predictive or determinative power. The term "intermediary" carries the connotation of prediction, since taken to more or less unmediatedly or without intrusion carry something over to something else. Instead, from my suggested perspective, so-called effects would behave or appear

as causes—as something which act, produce, and mediate, and are not only the mere outcome or consequence of a previous, typically hidden, action.

The interesting etymology of the word "cause," which Heidegger explains in his essay on things, is retrieved in the Italian *cosa* or French *chose*, meaning thing (a gathering as well) which constitutes not a matter of fact, but a "matter of concern," according to Latour.[28] The conclusion is that things are not simple entities but *assembled*, and they are assembled in time, I would add. Networks are constantly worked and reworked, and so the work of art is not the mere result of a laborious process that required material and intellectual resources, but the *source* of a new process, a future, a history, a "life." The work of art—conventionally described as an effect explained by a chain of causes in the history of art—is, in this vision of after-history that I just renamed "efficient history," seen and treated as a cause or an actor, the unforeseeable "effects" of which are traceable as an idiosyncratic network and as such immune to periodizing. The work of art marks a new beginning, a "leap" (Heidegger) into a new entity or practiced thing, the practice or process of which is traceable through "mediators" (as opposed to intermediaries), i.e. as channels with transformative powers or, as Latour puts it, with powers of "translation" instead of transmission, which pinpoints the tangle of historical factors, connections, events, etc. that make up the "life" of the artwork. Relevant mediators would include, for example, frames and labels, experience of collection and display, including loans and foreign trips, grants, awards and refusals, restorations and renovations, acquisitions and depositions, art fair presence, chemical analysis, auction estimations, criticism, vandalism or theft, literary references, donations, insurance evaluations, repercussions within popular culture, interpretations and misinterpretations, historicizations, attributions and misattributions, paraphrasing, online representation (downloadability), cataloguing and inventory, copying, and more. A work of art becomes an actor-network in the history of art if we are able to trace its connections and associations with other actants, which as such constitutes its "social" life.[29]

The Present Past

According to Heidegger, again, "[t]he history of being is never past but stands ever before us."[30] If his claim that history is truly *futural* (*zukunftig*, literally (able) to come) is a reasonable one, history in general (historicist history) is not what we ordinary historians of art and culture always thought it was, in which case the past and the future are also not what we thought it was; namely something radically absent or different from the present (in existence now). Already Augustine knew the latter to be too simplified,[31] but his insight was eventually lost in modernity, with western colonialism and capitalism, where progress and acceleration were structurally overvalued and whatever was regarded as regressing or remaining was correspondingly under-valued, to put it mildly. The very idea, however, that we are able to *leave the past behind* is a modern delusion—truly wishful thinking since the past is always with us, always changing, always alive, reshaping itself and eventually succeeding in consuming us all. We do not move away from the past, toward a glorious or disastrous future; *we move toward it*. Heidegger's concept "being-towards-death" captures a variant of this. In my reformulation, picking up a distinction from Henri Bergson via Gilles Deleuze, we advance into a generalized past, where our individual past is already secured a place.[32] This booking, so to speak, was effectuated the moment

we were born, wherefore we could say that we were born into the past, unknown to us at first and only gradually, only partially revealed. The past is a place we grow accustomed to, a place we live with, which means that our acts and deeds contribute to its formation. The past is a place we at some point enter—not fall back into—after which no more direct contribution is possible. This place is shared with everyone and everything that lives and exists, that has lived or enjoyed existence, the long gone and the yet unborn along with the world of inanimate being, which is why it must not be confused with history. The past "which has not ceased to be" is "identical with being in itself." In death we enter a state of non-being that is certain to prevail, to be. Following Bergson, "[w]e really leap into being, into being-in-itself, into the being in itself of the past."[33] We are entitled, in other words, to think the present as passing, and the past as enduring. If the present marks a limit—an utmost contraction of duration—which has existence but no essence whatsoever, this present resembles the notion of the horizon or the contour line which comes to exist as a pure illusion or temporary hallucination, as a pure difference between bodies. Such a division cannot *be*, enjoy any durable existence, or have essence; it can only be imagined or thought.[34]

The other, more enduring if also loose definition of the present is as a temporal space and spatial temporality of a much longer extension, duration and stability: the extended present, the so-called now, our contemporaneity. This present actually concerns the most recent past, including still prevailing notions of the future as part of this timespan. Rhetorically, however, the present is presented as abiding, around, here, available, in place. The limit toward the conventional understanding of what constitutes this present could be anything from a few years to a generation or two. To this well-established figure of thought, which cuts us all a space of action and what Aby Warburg called thought-space (*Denkraum*), another version has, as we saw, recently emerged. This model takes the present, which is literally nothing but which has typically been treated as something, i.e. a short and limited duration, to be everything; ever spreading, broadening, perpetually. Such a clinging to the now, assumed to forever remain or forever keep changing (without losing its character of being present), makes the very idea of a gradual transformation toward the unknown, or in plain speech: of having something to historicize, unthinkable. Granted that the ephemeral category of the present represents our space of action, by occupying territories of the progressing past, which is also our temporary life condition, a presumed perpetual present is tantamount to a dominion of death, where repetition and difference, progress and regress, are equally forestalled.

Anachronism vs. Anachrony

All this talk of history may seem peripheral in view of the fact that art history is not based on history, but on aesthetics and a hit list we call the canon, based, that is, on judgments of greatness, followed by historicization. The *Wissenschaft* of art history, however, has long operated as if the deal was ultimately to situate every artwork into its correct timeplace. To this model, anachronism presents a challenge. Nowadays it is talked about in two ways, typically, the first negative and the second positive. It is classically a fault or mistake, as when one "refer[s] to a wrong time" as the Greeks had it. The *Oxford English Dictionary*'s (*OED*) first two aspects both hinge on the mismatch between some temporal entity or phenomenon and its later reference; a disregard of chronology, a failed synchronicity between something and the way this is

talked about, categorized, or understood, resulting in "error."[35] This use of the term has been matched by a more modern reversal of the term's inherent negativity. For the historian to be "out of date" with the historical phenomenon studied could be seen as an inescapable condition of any historicizing operation, which is one ground for its acceptance. Rather than declaring anachronism to be "necessary" to the historical operation, however, it could be viewed as an option to embrace. To describe it as a necessity or what Latour would call a "matter of fact" paradoxically weakens the normative claim that anachronism proves a most "fertile" way to temporally express the "exuberance, complexity and overdetermination of images," in Georges Didi-Huberman's words.[36] What for me justifies dropping the suffix and using anachrony instead is, first of all, not to avoid the negativity of anachronism, but, on the contrary, to (p)reserve it as a still valid term for a historical mistake. To follow up on Didi-Huberman's example: for a historian of art to characterize the non-figurative fresco fragment by Fra Angelico as a poor understanding of abstract expressionism would be to commit an anachronism that is by no means inevitable.

All historical and etymological references to the term "anachrony," however, are just as ingrained with a rhetoric of mistakes and wrongdoing as is anachronism. But while the open acknowledgment and practice of anachronism(s) for historical inquiry is sometimes just a way to use new ideas or interpretations on old material without apologizing for the friction, mismatch, or violence thus inflicted, the use-value of anachrony is different. It pertains not to the time-gap problem in the writing of history as much as to the heterocronicity of the quasi-objects of such histories. Concerning ontology rather than epistemology, it describes a new level of historical complexity. Where actively seized anachronisms might maintain that the old wrong is the new right, defenders of anachrony would emphasize that there can be no temporal wrong or right when it comes to an artwork, since the "proper" date is only one of its many "chronic" aspects. Seen as anachronic, works of art "disturb and disrupt chronology rather than organize it."[37] They are neither ever "too early" or "too late" (*Oxford English Dictionary*), terms implying a correct date, but rather early *and* late, in *and* out of time—a phenomenon of its immediate environment, on the one hand, and a phenomenon of its successive "history" of events and eventualities, on the other: "The work of art when it is late, when it repeats, when it hesitates, when it remembers, but also when it projects a future or an ideal, is anachronic," according to the authors of *Anachronic Renaissance*.[38] After-history (not to be confused with post-history) in the sense of efficient history is a way to describe the historical trajectories of anachronic artworks, whereby clear demarcations between past and present become impossible to draw.

Warburg's concept of *Nachleben* associated with anachronism is variously translated as after-life or, more often, survival.[39] After-life would seem to presume a life after life, i.e. after death, but after-life as *Nachleben* actually means continued life, despite everything, including the normal anticipation of death as a fact of life. It means still life, not *nature morte* but life still. Something prevails or *survives* in some subsequent phenomenon, either as itself (against all odds) or transformed.

My concept of after- or efficient history, as a kind of after-life, contains the potentiality of eternal life for artworks, an endless life postponing death perpetually. Unlike finite humans for Heidegger, such non-humans as artworks are not beings-toward-death. They are already "dead," or permanently undead, which prevents them from suddenly dying in the sense of interrupted existence. The only way for them to go out of existence

would be through physical annihilation, in which case they may only be remembered. The fact, however, that a work is "forgotten" or missing, hidden, deemed obsolete, boring, or no longer comprehensible by no means precludes their life potentials. The default mode of artworks is *sleep mode*. Age-old or brand new, they all await the wake-up call of actualization (*Aktualisierung, actualisation*), based on the motivated interest we bestow upon them, to disrupt their inherent sleepiness and realize their being through our encounter with them.[40] The Danish painter Asger Jorn pinpointed something similar: "Any new idea will in its development be linked to the milieu it has grown out of, but will belong to the milieu where it meets with a response."[41]

Survival means beating death, if only just, while after-life presupposes the timing of death *and* the overcoming of it, magic fashion. Both of the terms slightly obscure my point of infinite life expectancy, in principle, for such a phenomenon as an artwork. That works of art, again, are born "dead" makes them immune to dying. Their successive metaphorical lives are indistinguishable from their deaths, akin to humans and the entire bio-sphere: our living is (the same as) dying. While our lives are definitively interrupted, however, artworks remain, in principle, although their living/dying transforms in time. They hang in there, continue, persist, endure, but they also age and morph, which is where they resemble us most. They differ from us by surviving us, but they too, like us, demand historicizing, internally (as aging objects) and externally (in their interconnectedness to other phenomena in their web of "life").

Viewing artworks as anachronic takes account of the fact that they do not survive as remnants or leftovers, as a skull "survives" a living body, but as themselves. As survivors, they are still around, still of the present, if also with increasingly aged and heterochronic identities. Their primary value is what Alois Riegl termed their "age value," which is only possible to account for in belated contemporaneity. In fact, their increasingly complex age value is impossible to distinguish from their contemporary identity.[42] Artworks—old and new—demand to be actualized or realized anew with each attentive encounter. All old art (unless hidden, missing, or "forgotten") is contemporary too, in this respect, as all new art is "historical" or at least *of* the past. Artworks undermine the division between history and practice, past and present, being old (of age) and being contemporary.

The model for efficient art history cannot obviously be the historical narrative of art history centered on a historical reconstruction of the subject's art historical past. A model for efficient history is, rather, the *catalogue raisonné*, which ignores the prehistory or pedigree of the piece, its traditional history of art, heavily reliant upon its author/artist, and starts off from the material emergence of the finished or "definitely unfinished" work.[43] Its reasoned goal is to trace, map, and comment upon the work's further developments, in principle up to the open, thus postponed, end of its journey, in a manner similar to this consideration of an anachronic efficient art history, based on Heidegger's futural thinking, aspects of Warburg's after-life, Riegl's contemporary age value, and Latour's non-modern ANT.

Notes

1. Bruno Latour, *We Have Never Been Modern*, trans. Catherine Porter (Cambridge, MA: Harvard University Press, 1993), 114.
2. Reinhart Koselleck, "Some Questions Regarding the Conceptual History of 'Crisis'," trans. Todd Samuel Presner, in *The Practice of Conceptual History: Timing History, Spacing Concepts* (Stanford: Stanford University Press, 2002), 236–47.

22 *Dan Karlholm*

3. A series introduced by the editor Kirk Ambrose, in *Art Bulletin* XCVI, No. 1 (March 2014), 7.
4. Robert Baldwin, "A Sea Change in Art History: The Decline of the Past and the Rise of Contemporary Art," available at www.socialhistoryofart.com (accessed April 25, 2017).
5. A recent shortcut to many of these debates can be found in Geoff Cox and Jacob Lund, *The Contemporary Condition: Introductory Thoughts on Contemporaneity & Contemporary Art* (Berlin: Sternberg Press, 2016).
6 For an inspiring essay on the modern project of critique, see Rita Felski, *The Limits of Critique* (Chicago: University of Chicago Press, 2015). "Nonmodern" is indebted to Latour, *We Have Never Been Modern*.
7. Jonathan Crary, *24/7: Late Capitalism and the Ends of Sleep* (New York: Verso, 2013), 9.
8. Jacques Derrida, "Some Statements and Truisms about Neologisms, Newisms, Postisms, Parasitisms, and Other Small Seismis," in David Caroll (ed.), *The States of "Theory": History, Art, and Critical Discourse* (Stanford: Stanford University Press, 1994), 63–94; Gerhard Richter, *Afterness: Figures of Following in Modern Thought and Aesthetics* (New York: Columbia University Press, 2011).
9. Arthur C. Danto, *Beyond the Brillo Box: The Visual Arts in Post-historical Perspective* (New York: Noonday Press, 1992), 9.
10. Francis Fukuyama, "The End of History?", *The National Interest* 16 (Summer 1989), 3–18.
11. Franco "Bifo" Berardi, *After the Future*, trans. Ariana Bove et al. (Edinburgh: AK Press, 2011), 166.
12. Martin Heidegger, *Being and Time*, trans. Joan Stambaugh (Albany: SUNY Press, 1996), 219–46.
13. Berardi, *After the Future*, 164.
14. E.g. Reinhart Koselleck, "'Neuzeit': Remarks on the Semantics of the Modern Concepts of Movement," in *Futures Past: On the Semantics of Historical Time*, trans. Keith Tribe (Cambridge, MA: MIT Press, 1985), 231–66.
15. Hans Ulrich Gumbrecht, *Our Broad Present: Time and Contemporary Culture* (New York: Columbia University Press 2014); Harry Harootunian, "Remembering the Historical Present," *Critical Inquiry* 33 (Spring 2007), 471–94; Francois Hartog, *Regimes of Historicity: Presentism and Experiences of Time*, trans. Saskia Brown (New York: Columbia University Press, 2015). For Hartog, however, presentism emerges from within the modern regime of historicity. What is new is its increasing dominance in our time.
16. David Joselit, "On Aggregators," *October* 146 (Fall 2013), 3–18, italics in original.
17. Cf. *The Forever Now: Contemporary Painting in an Atemporal World*, cat. (New York: MoMA, 2014); Mieke Bal, *Quoting Caravaggio: Contemporary Art, Preposterous History* (Chicago: University of Chicago Press, 1999).
18. Siegfried Gidieon, *The Eternal Present: A Contribution on Constancy and Change* [The A. W. Mellon Lectures in the Fine Arts, 1957] (New York: Pantheon Books, 1962).
19. Leopold von Ranke, "Preface: Histories of the Latin and Germanic Nations from 1494–1514," in *The Varieties of History: From Voltaire to the Present*, ed. Fritz Stern, 2nd ed. (New York: Vintage Books, 1973), 57.
20. "The study of history is a study of causes," according to the authoritative account of E. H. Carr, *What is History?* (London: Penguin, 1990), 87. On art history's "fundamental hypothesis: the accepting as natural, given, or in other words beyond discussion, of a certain concordance between what are distinguished as cause and effect," see Donald Preziosi and Claire Farago, *Art is Not What You Think It Is* (Oxford: Wiley-Blackwell, 2012), 8.
21. Michel Foucault, "Nietzsche, Genealogy, History," in *Language, Counter-Memory, Practice*. Trans. Donald F. Bouchard and Sherry Simon (Ithaca: Cornell University Press, 1992), 139–64.
22. Michel Serres, *The Parasite*, trans. Lawrence R. Shehr (Minneapolis: University of Minnesota Press, 2007), 224–34. Cf. also Latour, *We Have Never Been Modern*, 151–55.
23. Hans-Georg Gadamer, *Truth and Method*, trans. unmentioned (London: Sheed & Ward, 1979), 267–74.
24. "Efficient," second sense, *OED*, 2nd ed. (Oxford: Clarendon Press, 1989), 84. Furthermore: "The fact of being an operative agent or efficient cause. Now only in philosophical use" is the

first definition of "efficiency" (83). The second definition, allegedly obsolete, is equally interesting: "The action of an operative agent or efficient cause; production, causation, creation."

25. Bruno Latour, *Reassembling the Social: An Introduction to Actor-Network Theory* (Oxford: Oxford University Press, 2005), 132.
26. Martin Heidegger, "The Origin of the Work of Art," in *Poetry, Language, Thought*. Trans. Albert Hofstadter (New York: Harper, 2001), 17–86, esp. 56, 75.
27. Heidegger, "The Origin of the Work of Art," 70.
28. Martin Heidegger, "The Thing," in *Poetry, Language, Thought*, 163–80, esp. 172; Latour, *Reassembling the Social*, 87ff.; Bruno Latour, "Why Has Critique Run out of Steam?," *Critical Inquiry* 30, No. 2 (Winter 2004), 225–48.
29. This establishes a radically different approach to art than what the so-called social history of art contributed, hinging on historical materialism—on Marx reading Hegel—foregrounding hidden material (economic) factors as causes or at least as the work's formative or determining context.
30. Martin Heidegger, "Letter on "Humanism" [1946], trans. Frank A. Capuzzi, in *Pathmarks*, ed. William McNeill (Cambridge: Cambridge University Press, 1998), 239–76, esp. 240.
31. Augustine's "three times" could superficially be seen to affirm the omnipresence of the present, but while current presentists claim to have done away with past and future, Augustine keeps this triadic structure within the present: *The Confessions of St. Augustine*, trans. Albert Cook Outler (Mineola, New York: Dover, 2002), 229.
32. Gilles Deleuze, *Bergsonism*, trans. Hugh Tomilson and Barbara Habberjam (New York: Zone Books, 2011).
33. Deleuze, *Bergsonism*, 57.
34. Today, however, in our digitally saturated life-worlds, the present can no longer be seen as punctual, but as dynamic and what could be described as always "delayed." See Wolfgang Ernst, *The Delayed Present: Media-Induced Tempor(e)alities & Techno-traumatic Irritations of "the Contemporary"* (Berlin: Sternberg Press, 2017).
35. "Anachronism," *OED*, 426.
36. Georges Didi-Huberman, "Before the Image, Before Time: The Sovereignty of Anachronism," trans. Peter Mason, in Claire Farago and Robert Zwijnenberg (eds.), *Compelling Visuality: The Work of Art In and Out of History* (Minneapolis: University of Minnesota Press, 2003), 31–44.
37. Keith Moxey, *Visual Time: The Image in History* (Durham, NC: Duke University Press, 2013), 174.
38. Alexander Nagel and Christopher S. Wood, *Anachronic Renaissance* (New York: Zone Books, 2010), 13.
39. Cf. Didi-Huberman, "Artistic Survival: Panofsky vs. Warburg and the Exorcism of Impure Time," *Common Knowledge* 9, No. 2 (Spring 2003), 273–85.
40. For a presentation of this thesis as a redefinition of contemporary art, see my "After Contemporary Art: Actualization and Anachrony," *Nordic Journal of Aesthetics* 51 (2016), 35–54.
41. Erik Steffensen, *Asger Jorn: Animator of Oil Painting*, trans. Reginald Spink (Hellerup: Format, 1995), 114.
42. Alois Riegl, "On the Modern Cult of Monuments: Its Character and its Origin" [1903] . trans. Kurt Forster and Diane Ghirardo, *Oppositions* 25 (1982), 21–51. Cf. also Thordis Arrhenius, *The Fragile Monument: On Conservation and Modernity* (London: Artifice, 2012), 92–111.
43. Cf. Thierry de Duve (ed.), *The Definitely Unfinished Marcel Duchamp* (Cambridge, MA: MIT Press, 1991).

Bibliography

Arrhenius, Thordis. *The Fragile Monument: On Conservation and Modernity*. London: Artifice, 2012.
Bal, Mieke. *Quoting Caravaggio: Contemporary Art, Preposterous History*. Chicago: University of Chicago Press, 1999.

Baldwin, Robert. "A Sea Change in Art History: The Decline of the Past and the Rise of Contemporary Art," available at www.socialhistoryofart.com (accessed April 25, 2017).

Berardi, Franco "Bifo". *After the Future.* Trans. Ariana Bove et al. Edinburgh and Oakland: AK Press, 2011.

Carr, E. H. *What is History?* [1961], 2nd ed. London: Penguin, 1990.

The Confessions of St. Augustine. Trans. Albert Cook Outler. Mineola, New York: Dover, 2002.

Cox, Geoff and Jacob Lund. *The Contemporary Condition: Introductory Thoughts on Contemporaneity & Contemporary Art.* Berlin: Sternberg Press, 2016.

Crary, Jonathan. *24/7: Late Capitalism and the Ends of Sleep.* New York: Verso, 2013.

Danto, Arthur C. *Beyond the Brillo Box: The Visual Arts in Post-historical Perspective.* New York: Noonday Press, 1992.

Deleuze, Gilles. *Bergsonism.* Trans. Hugh Tomilson and Barbara Habberjam. New York: Zone Books, 2011.

Derrida, Jacques. "Some Statements and Truisms about Neologisms, Newisms, Postisms, Parasitisms, and Other Small Seismis," in *The States of "Theory": History, Art, and Critical Discourse,* ed. David Caroll. Stanford: Stanford University Press, 1994, 63–94.

Didi-Huberman, Georges. "Artistic Survival: Panofsky vs. Warburg and the Exorcism of Impure Time," *Common Knowledge* 9, no. 2 (Spring 2003), 273–85.

Didi-Huberman, Georges. "Before the Image, Before Time: The Sovereignty of Anachronism." Trans. Peter Mason, in *Compelling Visuality: The Work of Art In and Out of History,* eds. Claire Farago and Robert Zwijnenberg. Minneapolis: University of Minnesota Press, 2003, 31–44.

Duve, Thierry de, ed. *The Definitely Unfinished Marcel Duchamp.* Cambridge, MA: MIT Press, 1991.

Ernst, Wolfgang. *The Delayed Present: Media-Induced Tempor(e)alities & Techno-traumatic Irritations of "the Contemporary".* Berlin: Sternberg Press, 2017.

Felski, Rita. *The Limits of Critique.* Chicago: University of Chicago Press, 2015.

The Forever Now: Contemporary Painting in an Atemporal World, cat. New York: MoMA, 2014.

Foucault, Michel. "Nietzsche, Genealogy, History," in *Language, Counter-Memory, Practice.* Trans. Donald F. Bouchard and Sherry Simon. Ithaca: Cornell University Press, 1992, 139–64.

Fukuyama, Francis. "The End of History?," *The National Interest* 16 (Summer 1989), 3–18.

Gadamer, Hans-Georg. *Truth and Method.* Trans. Unmentioned. London: Sheed & Ward, 1979.

Gidieon, Siegfried. *The Eternal Present: A Contribution on Constancy and Change* [The A. W. Mellon Lectures in The Fine Arts, 1957], New York: Pantheon Books, 1962.

Gumbrecht, Hans Ulrich. *Our Broad Present: Time and Contemporary Culture.* New York: Columbia University Press 2014.

Harootunian, Harry. "Remembering the Historical Present," *Critical Inquiry* 33 (Spring 2007), 471–94.

Hartog, Francois. *Regimes of Historicity: Presentism and Experiences of Time.* Trans. Saskia Brown. New York: Columbia University Press, 2015.

Heidegger, Martin. *Being and Time.* Trans. Joan Stambaugh. Albany, NY: SUNY Press, 1996.

Heidegger, Martin. "Letter on 'Humanism' " [1946]. Trans. Frank A. Capuzzi, in *Pathmarks,* ed. William McNeill. Cambridge: Cambridge University Press, 1998, 239–76.

Heidegger, Martin. "The Origin of the Work of Art," in *Poetry, Language, Thought.* Trans. Albert Hofstadter. New York: Harper, 2001.

Heidegger, Martin. "The Thing," in *Poetry, Language, Thought.* Trans. Albert Hofstadter. New York: Harper, 2001.

Joselit, David. "On Aggregators," *October* 146 (Fall 2013), 3–18.

Karlholm, Dan. "After Contemporary Art: Actualization and Anachrony," *Nordic Journal of Aesthetics* 51 (2016), 35–54.

Koselleck, Reinhart. " 'Neuzeit': Remarks on the Semantics of the Modern Concepts of Movement," in *Futures Past: On the Semantics of Historical Time.* Trans. Keith Tribe. Cambridge, MA: MIT Press, 1985, 231–66.

Koselleck, Reinhart. "Some Questions Regarding the Conceptual History of 'Crisis,'" in *The Practice of Conceptual History: Timing History, Spacing Concepts*. Trans. Todd Samuel Presner. Stanford: Stanford University Press, 2002, 236–47.

Latour, Bruno. *We Have Never Been Modern*. Trans. Catherine Porter. Cambridge, MA: Harvard University Press, 1993.

Latour, Bruno. "Why Has Critique Run out of Steam?," *Critical Inquiry* 30, no. 2 (Winter 2004), 225–48.

Latour, Bruno. *Reassembling the Social: An Introduction to Actor-Network Theory*. Oxford: Oxford University Press, 2005.

Moxey, Keith. *Visual Time: The Image in History*. Durham, NC: Duke University Press, 2013.

Nagel Alexander and Christopher S. Wood. *Anachronic Renaissance*. New York: Zone Books, 2010.

Preziosi Donald and Claire Farago. *Art is Not What You Think It Is*. Malden: Wiley-Blackwell, 2012.

Ranke, Leopold von. "Preface: Histories of the Latin and Germanic Nations from 1494–1514," in *The Varieties of History: From Voltaire to the Present*, ed. Fritz Stern, 2nd ed. New York: Vintage Books, 1973.

Richter, Gerhard. *Afterness: Figures of Following in Modern Thought and Aesthetics*. New York: Columbia University Press, 2011.

Riegl, Alois. "On the Modern Cult of Monuments: Its Character and its Origin" [1903]. Trans. Kurt Forster and Diane Ghirardo, *Oppositions* 25 (1982), 21–51.

Serres, Michel. *The Parasite*. Trans. Lawrence R. Shehr. Minneapolis: University of Minnesota Press, 2007.

Steffensen, Erik. *Asger Jorn: Animator of Oil Painting*. Trans. Reginald Spink. Hellerup: Format, 1995.

2 What Time is it in the History of Art?[1]

Keith Moxey

What is the time of art history, what time does it tell, and to which time does it belong? Art history purports to render a visual account of the passage of time, but how does the temporality of this traditional narrative relate to the temporality of the work of art? Can the temporalities of images or objects actually be synchronized with the radically different temporalities of texts? Images, pictures, sculptures, photographs, and prints tend to be perceived by rapid eye movements that flit restlessly across their surfaces. They fill our attention instantly. Texts, on the other hand, have a linear structure that unfolds in time, an inherent movement that must be obeyed. The most common form of narration is one that has a beginning, a middle, and an end. Do historical narratives offer a foundation on which art can be charted, or does "art" inevitably escape the entanglements of language? "Art" may provoke "history," but the time of one is incommensurable with the time of the other. "Art" turns on its companion "history" so as to destabilize assumptions about their mutual commensurability. Its intransigent "otherness" places it beyond the reach of narrative. The time of the visual cannot be folded into linguistic time without being impoverished.

This chapter addresses an issue not often brought to art historical light. *What time is it in art history?* The linear and teleological temporal system on which the discipline was founded in the late nineteenth century continues to inform its disciplinary organization today. Most academic departments in Europe and the United States, as well as those in countries whose educational institutions have been modeled upon them, are dedicated to the study of the Western canon in an orderly progression: Ancient, Medieval, Renaissance, Baroque, and Modern.[2] While the study of non-European traditions took place soon after art history's intellectual origins, such fields have often been rendered marginal to its disciplinary concerns. It is only lately, at the end of modernism with the advent of post-colonial theory, that scholars look at the world anew.

Established art historical narratives are facing both internal and external pressures. Within art history itself, there has been a revival of the heritage of Aby Warburg's "survival" or "afterlife" of images. From W. J .T. Mitchell to Gottfried Boehm, to Georges Didi-Huberman, there are imaginative approaches that accord images an active status within the context of historical writing.[3] According to these authors, works of art provoke and in part determine the critical and historical responses of their interpreters.[4] Scholars in neighboring disciplines such as anthropology, literature, and the history of science have also turned to objects in order to address them as if they possess agencies of their own. There is now a considerable literature on what is called "thing theory" in literature and anthropology, while in science studies it assumes the allied rubric of "actor-network theory."[5]

I want to distinguish between two forms of time that seem most relevant to the temporal politics of art history in its current situation: *heterochrony* and *anachrony*. On the one hand, *heterochrony*, or multiple forms of time, declares that time flows at different speeds in different directions in different locations and cultures. George Kubler, for example, writes that time is filled with the particles of other times, those belonging to the past as well as those anticipating the future.[6] Time, that inscrutable force that passes through all things but that only appears to register in its reception by human beings, is multiple in its manifestations and belongs to no single moment. In other words, there is no single "now." *Anachronic* (*not* anachronistic) time, on the other hand, refers to the power inherent in objects to exceed the parameters of their chronological circumstances. Rather than misplaced time, known as anachronistic time, anachronic time depends but does not belong to chronology. It falls out of it and seems to pertain to no particular time. It is the time of "enchantment,"[7] most often partnered with the aesthetic reception of works of art—their capacity to entrance viewers beyond their own temporal horizon. The juxtaposition of multiple and particular time, the heterochronic and the anachronic will appear to constitute an antinomy. How can a temporality that has no shape be reconciled with one that has a shape only in order to break it? Rather than an antinomy, the temporalities of works of art present us with an engaging paradox. While constituted by the temporal shards of different materials and subject to varying time-based operations in their facture (heterochrony), they have been assigned places within a chronological framework that they then proceed to challenge (anachrony). The innate life of objects cannot be contained within the parameters of a chronological sequence for it is neither fixed nor stable. The continuing responses they solicit from those who encounter them through the ages ensure that the accounts they provoke will define their temporal complexities in multiple and ever-changing ways.

Can notions about the animation of images, ubiquitous in art historical circles today, help us understand the tension between the time of the object and the time of historical texts that lies at the heart of the enterprise? My argument depends on what has become something of a commonplace among those who think about human interactions with objects: it relies on a critique of the subject/object distinction, while nevertheless maintaining it for heuristic reasons. In order better to understand how both objects and images intrude on our consciousness and initiate an exchange, we need to blur the distinction between "us" and "them." What happens if we approach things as if they were neither subjects nor objects, but belong somewhere in a continuum in between? What if the distinction "human/non-human" is an analytical tool and that objects have many of the characteristics of subjects and vice versa?[8] My own argument? Visual images, like objects, do not merely occur *within* time, they *possess* and *actively create* time as they cross our paths and enliven our days.

To what extent are our perceptual responses to works of art affected by the materials of which they are composed? What forms of temporalities do they reveal and how do they relate to historical study? Of course there are many, many other kinds of time that works of art might embody, such as the temporal attention played out in the compositional choices that constitute a work's facture. Some artists are more clearly invested in the potential of formal displays as markers of artistic intervention than others. Others are more determined to convey a religious or cultural ideology, to subject formal experimentation to the conventional sign systems or iconographies through which meaning is manipulated. For some examples of time's materiality, I

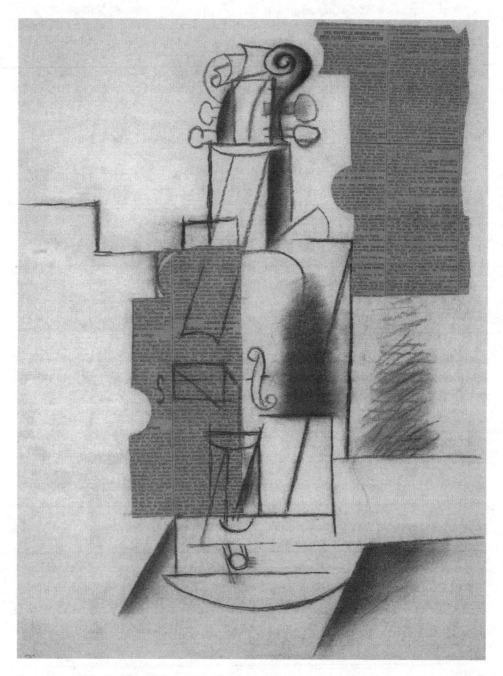

Figure 2.1 Pablo Picasso, Violin, 1912. Charcoal and newspaper pasted on paper. Musee d'Art Moderne, Paris via Art Resource. © 2017 Estate of Pablo Picasso/Artists Rights Society (ARS), New York. Photo credit: CNAC/MNAM/Dist. RMN-Grand Palais/ Art Resource, NY

will discuss a few objects, which in the process of making their own artistry visible attract the attention of the viewer in such a way as to draw out and prolong their appreciation.

One of the most dramatic manipulations of material temporality occurs in early twentieth-century Cubist collages. In Pablo Picasso's *Collage with Violin*, the musical instrument is cleverly suggested by two pieces cut from a single sheet of newsprint. The cutouts are flipped, so that the opposite side of a convex outline in the center of the image appears as a concavity in its upper register, the whole arrangement is over-drawn with charcoal, and then stuck to a paper background. Collages such as this sever the umbilical cord of mimesis with which artistic representation in Europe had been attached to the world around it for centuries. If Picasso and Braque's cubist paintings had already called into question the methods and techniques of naturalistic art, these collages, with their use of different materials, deny painting's traditional identification as a vehicle of representation. Art's subordination to the process of perception, its role in translating the real, is transformed. The world's primacy, embodied in the idea of "re-presentation," is displaced as the work defines itself as a "presentation"—as a material presence in the world itself rather than a mere copy or shadow.[9]

An important dimension of this revolution is the ephemeral quality of the sub-stances employed in the adventure. Charcoal and newspaper glued to a paper background—nothing could be more makeshift and impermanent. Newspapers carry not only a reference to daily routine, the speed of time's passage, the motley assort-ment of events with which it is accompanied, but also carry whiffs of popular culture and references to the time of social classes far removed from the lofty ambitions and intellectual pretensions of the moneyed art world.[10] Newsprint itself is notoriously impermanent, discoloring quickly in sunlight and subject to disintegration. Picasso's collage no longer appears as it did at the moment of its creation, for the paper openly bears the scars of the passage of time.

Charcoal, or carbonized wood, is a friable substance. Charcoal sticks, introduced in the nineteenth century, are easily reduced to dust and thus quickly erased so that artists often use them in preliminary sketches. Far from being covered with other materials, charcoal occupies the surface and determines the appearance of the work. Charcoal drawing serves not just as a dynamic sign of the artist's presence, but its light and shade modeling indicates the fall of light. Re-presentation may be gone but it is not forgotten.[11]

The manipulation of these transient materials calls attention to another dimension of their temporality. Cutting the newspaper, arranging it on the page, and gluing it to a support constitutes one set of maneuvers, while the charcoal drawing of the violin's bridge and neck speaks of another. Is it a violin or a cello? Do the echoes of the instru-ment's sounds haunt our experience?[12] How does the temporality of music, that most abstract of media, intersect with the more haptic experience of vision? The effect of this temporal layering resembles the process of montage used in films to indicate the pas-sage of time.[13] One form of time is superimposed upon another to generate yet a third.

How can we explain this change in artistic temporalities at the beginning of the twentieth century? Some suggest that Picasso's use of newsprint, with its accounts of the fighting in the Balkans that preceded the First World War, reflects his own anar-chist politics. The revolutionary nature of the images is thus more than a formal devel-opment aimed at the destruction of the conventions of an earlier time—they manifest the artist's own stake in the political conflicts of the age.[14] Others insist that Picasso's

forms are akin to linguistic signs, theorized by Ferdinand de Saussure in 1908 as a system in which the signifying potential of words depends on their arbitrary relation to one another rather than on their referential capacity.[15] We either understand Picasso's collage as a demonstration of his anarchism, his desire for political and cultural change, *or* we interpret it as an attempt to emancipate representational forms from their bondage to perceptual experience.

Picasso's experiments and their temporal implication take on a particular resonance in an age that witnessed both the establishment of a global system of universal time as well as a growing recognition of its relativity. European industrialization during the nineteenth century, especially the need to coordinate railway schedules, led to creation of a universal system of keeping time to which we still subscribe. Solar time, on which localities had hitherto depended, was replaced by telegraphed time signals. These economic and technological developments led, in 1884, to a momentous conference in Washington that established the originary longitude (according to which time at all other locations was either ahead or behind), passed through Greenwich, a suburb of London, at the heart of the British Empire. Time itself was thus disciplined and organized according to a capitalist and colonial criterion.

At approximately the same moment, however, Albert Einstein was formulating a theory that established the relativity of all measurements of time by arguing for what he called a space-time continuum.[16] Time, that is, is claimed to be relative to the location in which it was measured because all the factors involved in its calculation are themselves in motion. While capitalist and colonial interests were in the process of taming time by rendering it uniform, theoretical physics argued that it was inextricably related to the place in which it was registered. To what shape does Picasso's visual time belong? Is it part and parcel of a world in the throes of economic globalization, a manifestation of the so-called "spirit" of the age? Or is it to be identified with the theoretical speculations of advanced physics?

The relentless forward march of nineteenth-century industrialization with its concomitant transformation of traditional concepts of time may have found unanticipated philosophical confirmation in theoretical speculations that undermined faith in locally established time systems. Einstein's relativization of all temporal systems may have added urgency to the desire to create a single unified form of time to be observed by all people in all places. As the first art form to posit itself as an avant-garde movement, a form of artistic production claiming to be the arrow of time's unfolding, Cubism's claim to the universal significance of its temporality clearly fit the demands of a developing capitalist culture.

How do the materials used by artists afford us access to the ideological commitments, the world views to which their cultures subscribed? Here is a striking piece of Aztec feather work in the Museum of Anthropology in Mexico City, one of the few surviving examples of what was once a major form of Mexica cultural production.[17] The use of feathers for the creation of works of precious objects such as headdresses, cloaks, and ceremonial shields dates from well before the conquest, though the medium's adoption by the Aztec court took place shortly before the reign of Moctezuma II. The disk, about eleven inches in diameter, may once have decorated the exterior of a ceremonial shield. If it was produced in an imperial workshop, then the feathers may have been harvested from an aviary beside the royal palace in which a variety of species were caged.

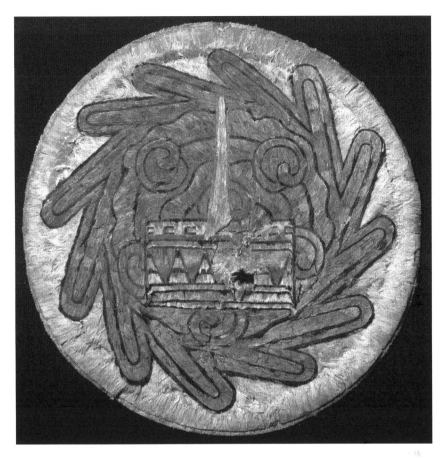

Figure 2.2 Feather Disk, Mexico, ca. 1540. Museo Nacional de Antropologia, Mexico City via Art Resource. Werner Forman Archive/National Museum of Anthropology, Mexico City. Photo credit: HIP/Art Resource, NY

The materials of the mosaic are as varied and remarkable as the skills that crafted it. The backing on which the feathers are glued is composed of non-woven cotton fibers that would have been brought to Tenochticlan, the Aztec capital and site of present-day Mexico City, from the tropical provinces of the empire as tribute. It is composed of feathers of both common and exotic birds: from the ducks and grackles that provided the browns and blacks to the macaws and the aptly named "lovely contingas," responsible for the scarlet, yellows, and turquoise blues. Some of these birds are indigenous to the valley of Mexico, but the exotic ones belong to the tropical forests of the Gulf coast and as far away as Guatemala. The creation of this object displays a remarkable sensitivity to the natural environment with its own rhythmical cycle of seasons and of life and death. Distanced forever by technology from the intimacy with which this culture once lived cheek by jowl with animal life, our own culture currently seeks to rescue nature's remnants from the dustbin of history, so that we

can only wonder at the intimate relations that enabled such artisanship. Consciously or unconsciously, the object echoes the pre-Columbian cyclical view of time, one in which an event that takes place in the present is just as likely to have happened in the past, just as it is likely to happen again in the future. The disk itself, with its revolving representation of the Nahuatl pictograph *atl*, meaning water,[18] suggests a form of time that knows no dramatic and irreversible change, no French Revolution, no internal combustion engine, no microchips, no future that is not part and parcel of yesterday and today. A form of time that allowed Moctezuma to mistake the arrival of Cortez for Quetzalcoatl, lord of the heavens and god of water, and the Hawaiians to mistake Captain Cook for Lono the god of fertility who ushers in the new year.[19]

To what time does this object belong? If we set aside the interpretation that proposes that the image depicts the toponym of a particular place identified with a whirlpool, a cultivated field and an agave thorn, the image constitutes something of an iconographic puzzle in which two temporal master narratives confront each other. According to some, the blue pictograph of water on the yellow background refers to the Aztec rain goddess Chalchiuhlicue. Others, however, prefer a Christian narrative. Found hidden in the lining of a case meant for the transport of a Eucharistic chalice in 1915, the blue swirl is said to represent the living water of the divine word from which emerges the blood of Christ that washes away the sins of the world. The object thus either belongs to a culture organized around a cyclical or spiraling form of time, or one that depends on a purposive movement of time from Christ's birth to the Last Judgement. Both these interpretations are projective responses to the striking shape and design of the object. They tell us as much about the historians as they do about the thing itself. The image itself is a vivid example of visual excess: an object whose nature outruns the capacity of language to translate or otherwise fix with meaning. It slips out of language's net to suggest that it belongs to another order of reality, to another time. Must it be ascribed a place in a chronological narrative or can it be understood as an event that appears on different occasions? Can it be part of a story, suspended like a pearl on a necklace, so that its significance lies in its relation to what came before and what comes after, or can it also be appreciated as an object that stands outside time, and whose historical value must ever be renewed in the act of perception and translation? The world to which it once belonged is long gone, yet its seductive magic remains, reminding us of the existence of the uncontrollable and indiscernible powers that inform the material world around us.

An object whose cross-cultural fate similarly complicates its insertion into a historical narrative is the little sixth-century bronze Buddha from Kashmir on the Afghanistan-Pakistan border found in a cache of Viking plunder on an island in Lake Mälaren in eastern Sweden, a work of art now in the Swedish History Museum in Stockholm.[20] Helgo island seems to have been an important Viking trading center for it was found along with the bronze top of a bishop's crozier (probably Irish) and a Coptic christening bronze ladle from North Africa. To what time does this object belong? How does it tell its story? Should we characterize it as a Buddhist devotional object dating from a moment when the historical Buddha was being invested with divine qualities? Should we dwell on the silver *urna* on its forehead representing enlightenment, the hand position or *mudra* of protection, the double lotus of purity on which it sits, and the holes at the back that indicate it was once fixed against a decorated support, or shall we consider that it was found with a leather strap around its neck and wrist?

Was the religious identity of the Buddha relevant to its abduction from its place of creation, or was it invested with magical properties that had nothing to do with this

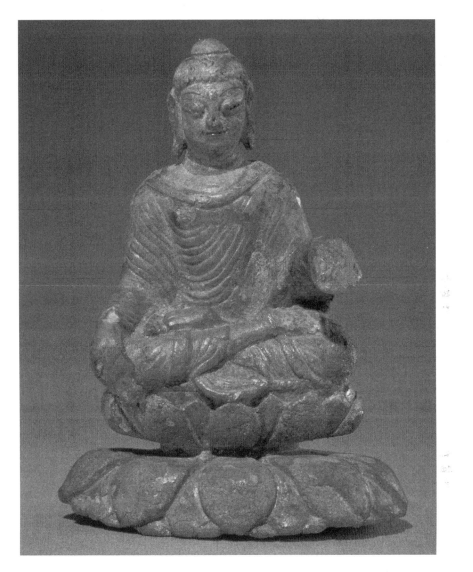

Figure 2.3 Bronze Buddha, ca. sixth century AD, found in Viking burial on Helgo Island, Lake
Mälaren, Sweden in 1954. The Swedish History Museum, Stockholm

particular religion? Does it belong in Buddhist time, the recipient of prayers by those
seeking enlightenment, or does it belong to the time of the Viking who carried it back
to Sweden and wore it as an amulet? If the latter, then to what extent was the Viking
cognizant of the significance of the figure, or was it simply an apotropaic object
meant to keep him from harm? Since perceptual experience cannot afford us entry
into these enigmas, what is it about the little figure that entrances us now? Surely
time is as important here as the visual attraction of the object itself. Time, or what
we fantasize regarding the Buddha's cross-cultural travels through time, arouses our
curiosity and excites our imaginations. How and why did the Viking, or the merchant
who sold it to him, arrive in central Asia and what was he doing there? What made

the object valuable to someone who may not have shared Buddhist values? Perhaps it is the difficulty in discerning the time to which the object belongs that renders it so fascinating.

The monstrance reliquary of Al-Zahir in the Germanisches Nationalmuseum in Nuremberg was probably crafted in Venice in about 1350 using a rock ring crystal (two identical carved pieces fastened together) carved in Egypt in the tenth or eleventh

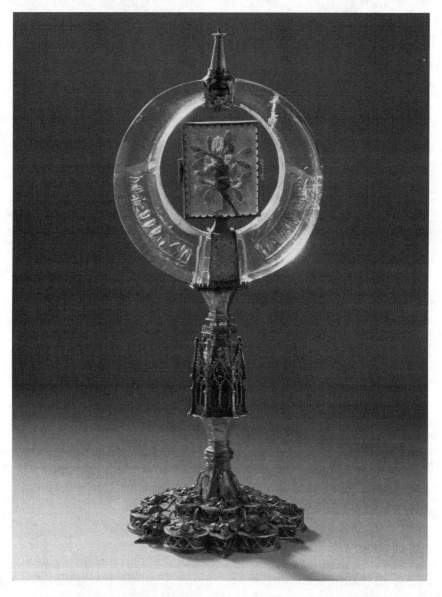

Figure 2.4 Reliquary of Caliph al-Zahir, ca. 1021–36, rock crystal with Kufic inscription. Silver gilt mounting, Venice, ca. 1350. Now in Nuremberg, Germanisches Nationalmuseum. Nuremberg, Germanisches Nationalmuseum. Germanisches Nationalmuseum, Nuremberg, photo by Monika Runge

century. The crystal bears an Arabic inscription in Kufic letters blessing the Fatimid caliph Ali al-Zahir, stating that Allah will prolong his life.[21] When and how it came to Venice is unknown. What is the time of this object? To dwell only on the moment of its production is to reduce it to the poverty of traditional art historical explanations in which the only date that matters is the moment of creation. What about the rest of its rich and complex life?

How and why was this crystal incorporated into an important object of Christian devotion? Since antiquity, rock crystal was often regarded as petrified water. In the Christian tradition, such stony water was rendered all the more valuable because it invoked the presence of the divine. According to the Apocalypse, God's presence is made responsible for the frozen transparency of the waters surrounding his throne.[22] If the divine nature of this material made it suitable for the display of relics, then its transparency made it even more attractive. Beginning in the late Middle Ages, institutional Christianity witnessed an ever-increasing desire to make not only the Eucharistic host, Christ's body, but also relics, visible to the faithful. Changes in the liturgy allowed those partaking in the Eucharist to see the host when it was held aloft by priests who faced them, while consecrated wafers were prominently displayed in ecclesiastical monstrances for all to see.

The original purpose of the crystal object made for al-Zahir remains unknown. While it is possible that its resemblance to the crescent moon from which Islamic months are still calculated rendered it auspicious, it acquired fresh significance when incorporated into the gilded silver reliquary. A precious object inscribed with a Muslim blessing and associated with an aniconic tradition is thus transformed by a faith deeply involved in the worship of images and other objects. Even if the relics once mounted within the crystal ring have disappeared, the monstrance was once the object of intense devotion. To what extent was its Christian use inspired by the crystal's material and its workmanship, or, as seems less likely, did its inscription render it a religious object worthy of respect? In view of the antagonisms that might have informed Christian views of Islam in a Mediterranean context, the twin temporalities of this object continue to puzzle. Whatever factors allowed an object precious in one religion to become valuable to another, the artifact itself proves provocative and suggestive. Its heterochronous nature, laden with forgotten narratives and infused with lost promises of salvation, invites a recognition of its affective presence.[23]

These transcultural examples fascinate not just because of their extraordinary travels but also because of the temporalities embedded within them, as well as those they have provoked in their passage through time. They are visual examples of heterochronicity, objects whose facture incorporates many distinct forms of time just as they themselves are saturated with the accumulated times of their existence. Picasso's newspaper brings with it the time of European wars, of the news media of early industrialization, while his charcoal both echoes and transforms the nature of post-Renaissance academic drawing. Together they challenge the mimetic and naturalistic time of nineteenth-century painting. The Aztec disk contains the feathers that contain the time of birds, of an age when humans lived life closer to other living things; feathers used to indicate the time of ceremonies, of courtly practices, and of deities (either new or old) that required human attention. The bronze Buddha invokes the momentous transition of an enlightened human into a god possessed of saving grace—an object recognized by a pagan Norseman in the mountains of Central Asia to be as just

as, if not more, powerful than his own foresty deities of thunder and lightning. Finally, the reliquary of al-Zahir, possessed of precious material of mystic value, breathes the culture of the Mediterranean with its interlocking yet contestatory faiths.

The same works of art also illustrate the necessarily contingent nature of all art historical accounts. The inherent temporality of works of art ensures that no generation is ever entirely satisfied with what its predecessors made of the past. In doing so, Picasso's collage, the Aztec feather disk, the bronze Buddha, and the reliquary of al-Zahir demonstrate the power of anachrony, the ways in which an object steps out of chronology to keep attracting attention to itself at different moments in time. Not only are the artifacts themselves bearers of more times than we can account for, but they also intersect with viewers who see them from multiple temporal perspectives. The heterochronic potential of these objects meets the chronological times of those who encounter them at eccentric angles so that they are endowed with atemporal or anachronic power. Such convergences constitute events. Events breaks through the apparently smooth surface of time to remind us that discontinuity and change are more common than stability and repetition. An event, however, only becomes such when it is interpreted. In calling works of art "prime objects" after prime numbers, numbers that cannot be divided, Kubler characterizes them as unique, a distinction that stems from their role as cultural agents.[24]

The assertion that the particular time of the work of art matters, that it is a discrete event in the temporal flow at a moment seeking to overcome an obsession with forms of identity involving race, religion, nationality, gender, class, and age, may seem counterintuitive. In the recent past, such assertions of difference have been regarded as relativistic and there is a tendency to return to theories that emphasize human universals rather than those that insist on particular differences. This is particularly true in the context of "global" or "world" art history—attempts to account for the production of the planet's artistic production on the basis of concepts developed for the study of Euroamerican cultures.[25] The affirmation that the time of the image outruns the time of its explanatory texts draws attention to the inadequacies that must inevitably result from efforts to write histories of art based on space rather than time as the more important vector of interpretation. The impulse to survey the world according to the dominant temporality eliminates serious consideration of its alternatives. The economic concept of "globalization," meant to put a positive spin on the cultural chaos and social misery that often accompanies the integration of the world's economic activity, cannot be invoked in the humanities without recognizing its limitations. While work that places different cultures in dialogue with one another, that attempts to relate civilizations without privileging one over the other has already produced striking results,[26] universalizing attempts to fit art's geographic and cultural complexity within the compass of a particular methodological perspective (let alone the covers of a single book!) seem fated to be reductive.[27]

In calling attention to the mixed temporalities of works of art, this argument means to enrich rather than impoverish the complexity of art history's temporal landscape. Accepting a constellation of different forms of time encourages the discipline to acknowledge the time-bound nature of its narratives and to recognize the provisional and transient nature of its explanatory structures. Forms of modernism taking place outside Euroamerica need not be regarded as belated or tardy. Their relevance for historical understanding cannot be judged solely on the alleged universality of the global

time system, but on the organization of time in the cultures where they take place. Characterizing the particularity of the temporal conditions in which a work was created, as well as something of the texture of the times through which it has passed historically, is one way to add depth and resonance to their potential to create their own forms of temporality. The history of art is emphatically a history of its objects. It is time to recognize their active participation in the creation of the narratives we spin about them. The time of the history of art is therefore a heterochronic and anachronic event created at their intersection with the equally complex temporalities of those who encounter them.

Notes

1. This chapter was first presented as a lecture at the Getty Research Institute in Los Angeles in March 2017. I am grateful to Thomas Gaehtgens and Alexa Sekyra for the invitation to take part in a scholarly year dedicated to Art and Anthropology, and to Tracy Bonfitto for her research assistance. Howard Morphy and Carlo Severi proved inspiring colleagues. Special thanks are also due to my co-editor Dan Karlholm for his comments.
2. The Eurocentricity of this periodization is remarked upon by Enrique Dussel, *The Invention of the Americas: Eclipse of the "Other" and the Myth of Modernity*, trans. Michael Barber (New York: Continuum, 1995), 10: "The pseudo-scientific periodization of history into Antiquity, the Middle (preparatory) Ages, and finally the Modern (European) Age is an ideological construct which deforms world history."
3. Aby Warburg, *The Renewal of Pagan Antiquity: Contributions to the Cultural History of the Renaissance (Texts and Documents)*, trans. David Britt (Los Angeles: Getty Research Institute, 1999); Dieter Wuttke, *Aby Warburgs Methode als Anregung und Aufgabe* (Gottingen: Gratia, 1979); Horst Bredekamp, Michael Diers, and Charlotte Schoell-Glass (eds.), *Aby Warburg: Akten des internationalen Symposiums* (Weinheim, VCH, 1991); Martin Warnke and Claudia Brink, *Der Bilderatlas Mnemosyne, Aby Warburgs Gesammelte Schriften* II, 1 (Berlin: Akademische Verlag, 2000); Georges Didi-Huberman, *Atlas: How to Carry the World on One's Back?* (Madrid: Museo Reina Sofia and TF Editores, 2010); Philippe-Alain Michaud, *Aby Warburg and the Image in Motion*, trans. Sophie Hawkes (New York: Zone Books, 2004); Georges Didi-Huberman, *The Surviving Image: Phantoms of Time and Time of Phantoms: Aby Warburg's History of Art* (College Park, PA: Pennsylvania State University Press, 2016).
4. W. J. T. Mitchell, "What is an Image?" *New Literary History* 15 (1984), 503–37; W. J. T. Mitchell, *Picture Theory: Essays in Verbal and Visual Representation* (Chicago: University of Chicago Press, 1995); W. J. T. Mitchell, *What Do Pictures Want? The Lives and Loves of Images* (Chicago: University of Chicago Press, 2005); Michael Ann Holly, *Past Looking: Historical Imagination and the Rhetoric of the Image* (Ithaca: Cornell University Press, 1996); James Elkins, *The Object Stares Back* (New York: Houghton Mifflin Harcourt, 1996); Elkins, *Pictures and Tears: A History of People Who Have Cried in Front of Paintings* (London: Routledge, 2001); Elkins and Maja Naef (eds.), *What is an Image?* (University Park, PA: Pennsylvania State University Press, 2011); Gottfried Boehm (ed.), *Was ist ein Bild?* (Munich: Fink, 1995); Gottfried Boehm (ed.), *Movens Bild: Zwischen Evidenz und Affekt* (Munich: Fink, 2008); Gottfried Boehm, *Wie Bilder Sinn erzeugen: Die Macht des Zeigens* (Berlin: Belin University Press, 2008); Horst Bredekamp, *Theorie des Bildakts* (Berlin: Suhrkamp, 2010); Hans Belting, *An Anthropology of Images: Picture, Medium, Body*, trans. Thomas Dunlap (Princeton: Princeton University Press, 2014).
5. See Igor Kopytoff, "The Cultural Biography of Things: Commoditization as Process," in *The Social Life of Things: Commodities in Cultural Perspective*, ed. Arjun Appadurai (Cambridge: Cambridge University Press, 1986), 64–91; Alfred Gell, *Art and Agency* (Oxford: Oxford University Press, 1998); Bruno Latour, *Pandora's Hope: Essays on the Reality of Science Studies* (Cambridge, MA: Harvard University Press, 1999); Bruno Latour, *Politics of Nature: How to Bring the Sciences into Democracy* (Cambridge, MA: Harvard

University Press, 2004); Lorraine Daston (ed.), *Things that Talk: Object Lessons from Art and Science* (New York: Zone Books, 2004); Hans Ulrich Gumbrecht, *Production of Presence: What Meaning Cannot Convey* (Stanford: Stanford University Press, 2004); Bill Brown, "Thing Theory," in *Things*, ed. Bill Brown (Chicago: University of Chicago Press, 2004), 1–22; Christopher Pinney, "Things Happen: Or, From Which Moment Does That Object Come?", in *Materiality*, ed. Daniel Miller (Durham, NC: Duke University Press, 2005), 256–72; Carlo Severi, *The Chimera Principle: An Anthropology of Memory and Imagination*, trans. Janet Lloyd (Chicago: University of Chicago Press, 2015); Carlo Severi, *L'objet personne: Une anthropologie de la croyance visuelle* (Paris: Éditions Rue d'Ulm/ Presses de l'École normale superieure and musée du quai Branly, 2017).

6. George Kubler, *The Shape of Time: Remarks on the History of Things* (New Haven: Yale University Press, 1962), 17–18.
7. Alfred Gell, "The Technology of Enchantment and the Enchantment of Technology," in *Anthropology, Art and Aesthetics*, eds. Jeremy Coote and A. Shelton (Oxford: Clarendon, 1994), 40–67.
8. Latour, *We Have Never Been Modern*, trans. Catherine Porter (Cambridge, MA: Harvard University Press, 1993).
9. For an imaginative reflection on the significance of this transformation in light of Picasso's encounter with "primitive" art, see Carlo Severi, "L'empathie primitiviste: Intensification de l'image et déchiffrenent de l'espace," in *L'objet personne*, 23–60.
10. For temporal differences between social classes, see Ernst Bloch, "Non-contemporaneity and Contemporaneity, Philosophically (1935)," in *Heritage of Our Times*, trans. Neville Plaice and Stephen Plaice (Cambridge: Polity Press, 1991), 104–16. For the avant garde's use of popular culture, see Thomas Crow, "Modernism and Mass Culture in the Visual Arts," in *Modernism and Modernity: The Vancouver Conference Papers*, eds. Benjamin Buchloh, Serge Guilbaut, and David Solkin (Halifax: Nova Scotia College of Art and Design, 1983), 215–64; Patricia Leighten, *The Liberation of Painting: Modernism and Anarchism in Avant-Guerre Paris* (Chicago: University of Chicago Press, 2013), 137.
11. Thanks to Dan Karlholm for drawing my attention to this point.
12. Here I am indebted to Martin Schenk.
13. Georges Didi-Huberman, *Images in Spite of All: Four Photographs from Auschwitz*, trans. Shane Ellis (Chicago: University of Chicago Press, 2008). See also Chari Larsson, "Didi-Huberman's Ghosts," PhD. Dissertation, University of Queensland, 2015, 163–67. His notion of montage is taken from Gilles Deleuze, *Cinema 2: The Time Image*, trans. Hugh Tomlinson and Robert Galeta (Minneapolis: University of Minnesota Press, 1989): "Simple succession affects the presents which pass, but each present coexists with a past and a future without which it would not itself pass on. It is a characteristic of cinema to seize this past and this future that coexist in the present image" (37).
14. Patricia Leighten, *Re-ordering the Universe: Picasso and Anarchism, 1897–1914* (Princeton: Princeton University Press, 1989).
15. Rosalind Krauss, *The Picasso Papers* (New York: Farrar, Straus & Giroux, 1998), 28. See also Christine Poggi, *In Defiance of Painting: Cubism, Futurism and the Invention of Collage* (New Haven: Yale University Press, 1992).
16. Peter Galison, *Einstein's Clocks, Poincare's Maps: Empires of Time* (New York: Norton, 2003).
17. Felipe Solis and Roberto Velasco Alonso, "Chalice Cover," cat. no. 328, p. 482, *Aztecs*, eds. Eduardo Matos Moctezuma and Felipe Solis Olguin, exh. cat. (London: Royal Academy of Arts, 2002); Alessandra Russo, "Image-plume, temps reliquaire? Tangibilités d'une historire esthétique," in *Traditions et temporalités des images*, eds. Giovani Careri, Francois Lisarrague, Jean-Claude Schmitt, and Carlo Severi (Paris: Éditions de l'École des Hautes Études en Sciences Sociales , 2009), 153–64; Alessandra Russo, *The Untranslatable Image: A Mestizo History of the Arts in New Spain, 1500–1600* (Austin: University of Texas Press, 2014), 33–34; Laura Filloy Nadal and Maria de Lourdes Navarijo Ornelas, "Currents of Water and Fertile Land: The Feather Disk in the Museo Nacional de Antropologia," in *Images Take Flight: Feather Art in Mexico and Europe, 1400–1700*, eds. Alessandra Russo, Gerhard Wolf, and Diana Fane (Florence and Munich: Kunsthistorisches Institut and Hirmer Verlag, 2015), 253–58.

18. I am grateful to Carolyn Dean for this identification and for other information relating to this pictograph.

19. Nancy Farriss, "Remembering the Future, Anticipating the Past: History, Time, and Cosmology among the Maya of Yucatan," in *Time: Histories and Ethnologies*, eds. Diane Owen Hughes and Thomas Trautmann (Ann Arbor: University of Michigan Press, 1995), 107–38; David Stuart, *The Order of Days: The Maya World and the Truth about 2012* (New York: Three Rivers Press, 2011); Serge Gruzinski, *Man-Gods of the Mexican Highlands: Indian Power and Colonial Society, 1520–1800*, trans. Eileen Corrigan (Stanford: Stanford University Press, 1989); Marshall Sahlins, *Islands of History* (Chicago: University of Chicago Press, 1985).

20. Colm, "The Helgo Treasure: A Viking Age Buddha" *Irish Archaeology Blogs*, December 28, 2013 at http://irisharchaeology.ie/2013/12/the-helgo-treasure-a-viking-age-buddha/ (accessed: January 1, 2018); Yoshitaka Takaki, "A Dozen Articles on Asian Arts," Online Academic Community University of Victoria.

21. For a valuable discussion of this reliquary, see Avinoam Shalem, "Histories of Belonging and George Kubler's Prime Object," *Getty Research Journal* 3 (2011), 1–14. See also Anna Contadini, "Facets of Light: The Case of Rock Crystals," in *God is the Light of the Heavens and the Earth: Light in Islamic Art and Culture*, eds. Jonathan Bloom and Sheila Blair (New Haven: Yale University Press, 2015), 123–55.

22. For the notion that materials and scale were often used to represent an escape from time, I am indebted to Avinoam Shalem, "Resisting Time: On How Temporality Shaped Medieval Choice of Materials," in this volume.

23. Shalem, "Histories of Belonging," 2.

24. Kubler, *The Shape of Time*, 39–40. For the philosophical idea of the "event," see Gilles Deleuze and Felix Guattari, *What is Philosophy?* trans. Hugh Tomlinson and Graham Burchell (New York: Columbia University Press, 1994).

25. For a judicious review of the debates about whether art history's basic premises and protocols can be used to study the world's art, see Paul Wood, *Western Art and the Wider World* (Chichester: Wiley Blackwell, 2014), 257–89. The position that believes that art history must necessarily depend on Euroamerican tradition if it is to be recognized as a discipline has been argued by James Elkins, "Art History as a Global Discipline," in *Is Art History Global?*, ed. Elkins (New York: Routledge, 2007), 3–23; James Elkins, "Can We Invent a World Art Studies?", in *World Art Studies: Exploring Concepts and Approaches*, eds. Kitty Zijlmans and Wilfried van Damme (Amsterdam: Valiz, 2008), 107–17; Elkins, "Writing about Modernist Painting Outside Western Europe and North America," *Transcultural Studies* 1 (2010), 1–19. For criticisms of this view, see Shigemi Inaga's "Is Art History Globalizable? A Critical Commentary from a Far Eastern Point of View," 249–79 and Atreyee Gupta and Sugata Ray, "Responding from the Margins," in *Is Art History Global?*, 348–57. See also Gerard Mermoz, "Art History: Contemporary Issues (2007)" *Oxford Art Online/Grove Art Online*; Huw Hallam, "Globalized Art History: The New Universality and the Question of Cosmopolitanism," *Australian and New Zealand Journal of Art* 9 (2008/9), 75–89; Monica Juneja, "Kunstgeschichte und kulturelle Differenz: eine Einleitung," *Kritische Berichte* (Universalität der Kunstgeschichte?) 40 (2012), 6–12 and other essays in this volume.

26. See "Connecting Art Histories," a special issue of *Art in Translation* 9 (2017), esp. Deborah Marrow and Joan Weinstein, "Introduction," 3–6; Hannah Baader, Avinoam Shalem, and Gerhard Wolf, "'Art, Space, Mobility in Early Stages of Globalization,' A Project, Multiple Dialogue, and Research Program," 7–33; and Kavita Singh, "Colonial, International, Global: Connecting and Disconnecting Art Histories," 34–47.

27. For recent literature exploring the possibility of a global or universal history of art, see David Summers, *Real Spaces: World Art History and the Rise of Modernism* (New York: Phaidon, 2003); Thomas DaCosta Kaufmann, *Towards a Geography of Art* (Chicago: University of Chicago Press, 2004); Kaufmann and Elizabeth Pilliod (eds.), *Time and Place: The Geohistory of Art* (Burlington, VT: Ashgate, 2005); Kaufmann, Catherine Dossin, and Beatrice Joyeux-Prunel (eds.), *Circulations in the Global History of Art* (Burlington, VT: Ashgate, 2015); Kitty Zijlmans and Wilfried van Damme (eds.), *World Art Studies: Exploring Concepts and Approaches* (Amsterdam: Valiz, 2008); Elkins, *Is Art History Global?*;

Elkins, Zhivka Valiavicharska, and Alice Kim (eds.), *Art and Globalization* (University Park, PA: Pennsylvania State University Press, 2010); David Carrier, *A World Art History and its Objects* (University Park, PA: Pennsylvania State University Press, 2008); John Onians, *Neuroarthistory: From Aristotle and Pliny to Baxandall and Zeki* (New Haven: Yale University Press, 2008); John Onians, *European Art. A Neuroarthistory* (New Haven: Yale University Press, 2016). Attempts to formulate a universal history of art also characterize the early history of the discipline. See Ulrich Pfisterer, "Origins and Principles of World Art History 1900–2000," 69–89 and Marlite Halbertsma, "The Many Beginnings and the One End of World Art History in Germany 1900–1933," in *World Art Studies*, 91–105.

Bibliography

Baader, Hannah, Avinoam Shalem, and Gerhard Wolf. "Art, Space, Mobility in Early Stages of Globalization: A Project, Multiple Dialogue, and Research Program,"*Art in Translation* 9 (2017), 7–33.

Belting, Hans. *An Anthropology of Images: Picture, Medium, Body*. Trans. Thomas Dunlap. Princeton: Princeton University Press, 2014.

Bloch, Ernst. *Heritage of Our Times*. Trans. Neville Plaice and Stephen Plaice. Cambridge: Polity Press, 1991.

Boehm, Gottfried. ed. *Was ist ein Bild?* Munich: Fink, 1995.

Boehm, Gottfried. *Movens Bild: Zwischen Evidenz und Affekt*. Munich: Fink, 2008.

Boehm, Gottfried. *Wie Bilder Sinn erzeugen: Die Macht des Zeigens*. Berlin: Berlin University Press, 2008.

Bredekamp, Horst, Michael Diers, and Charlotte Schoell-Glass, eds. *Aby Warburg: Akten des internationalen Symposiums*. Weinheim: VCH, 1991.

Bredekamp, Horst. *Theorie des Bildakts*. Berlin: Suhrkamp, 2010.

Brown, Bill. "Thing Theory," in *Things*, ed. Bill Brown. Chicago: University of Chicago Press, 2004.

Carrier, David. *A World Art History and its Objects*. University Park, PA: Pennsylvania State University Press, 2008.

Colm, "The Helgo Treasure: A Viking Age Buddha," *Irish Archaeology Blogs*, December 28, 2013.

Crow, Thomas. "Modernism and Mass Culture in the Visual Arts," in *Modernism and Modernity: The Vancouver Conference Papers*, eds. Benjamin Buchloh, Serge Guilbaut, and David Solkin. Halifax: Nova Scotia College of Art and Design, 1983, 215–64.

Daston, Lorraine. *Things that Talk: Object Lessons from Art and Science*. New York: Zone Books, 2004.

Deleuze, Gilles. *Cinema II: The Time-Image*. Trans. Hugh Tomlinson and Robert Galeta. Minneapolis: University of Minnesota Press, 1989.

Deleuze, Gilles and Felix Guattari. *What is Philosophy?* Trans. Hugh Tomlinson and Graham Burchell. New York: Columbia University Press, 1994.

Didi-Huberman, Georges. *Images in Spite of All: Four Photographs from Auschwitz*. Trans. Shane Ellis. Chicago: University of Chicago Press, 2008.

Didi-Huberman, Georges. *Atlas: How to Carry the World on One's Back?* Madrid: Reina Sofia Museum and TF Editores, 2010.

Didi-Huberman, Georges. *The Surviving Image: Phantoms of Time and the Time of Phantoms: Aby Warburg's History of Art*. Trans. Harvey L. Mendelsohn, College Park, PA: Pennsylvania State University Press, 2016.

Dussel, Enrique. *The Invention of the Americas: The Eclipse of the "Other" and the Myth of Modernity*. Trans. Michael Barber. New York: Continuum, 1995.

Elkins, James. *The Object Stares Back*. New York: Houghton Mifflin Harcourt, 1996.

Elkins, James. *Pictures and Tears: A History of People Who Have Cried in Front of Paintings*. London: Routledge, 2001.

Elkins, James, ed. *Is Art History Global?* New York: Routledge, 2007.

Elkins, James. "Can We Invent a World Art Studies?", in *World Art Studies: Exploring Concepts and Approaches*, eds. Kitty Zijlmans and Wilfied van Damme. Amsterdam: Valiz, 2008, 107–17.

Elkins, James. "Writing about Modernist Painting Outside Western Europe and North America," *Transcultural Studies* 1 (2010), 1–19.

Elkins, James, Zhivka Valiavicharska, and Alice Kim, eds. *Art and Globalization*. University Park, PA: Pennsylvania State University Press, 2010.

Farris, Nancy. "Remembering the Future, Anticipating the Past: History, Time and Cosmology among the Maya of the Yucatan," in *Time: Histories and Ethnologies*, eds. Diane Owen Hughes and Thomas Trautmann. Ann Arbor: University of Michigan Press, 1995, 107–38.

Gell, Alfred. "The Technology of Enchantment and the Enchantment of Technology," in *Anthropology, Art and Aesthetics*, eds. Jeremy Coote and A. Shelton. Oxford: Clarendon Press, 1994, 40–67.

Gell, Alfred. *Art and Agency*. Oxford: Oxford University Press, 1998.

Gruzinski, Serge. *Man-Gods of the Mexican Highlands: Indian Power and Colonial Society, 1520–1800*. Trans. Eileen Corrigan. Stanford: Stanford University Press, 1989.

Gumbrecht, Hans Ulrich. *Production of Presence: What Meaning Cannot Convey*. Stanford: Stanford University Press, 2004.

Gupta, Atreyee and Sugate Ray. "Responding from the Margins," in *Is Art History Global?*, ed. James Elkins. New York. Routledge, 2007, 348–57.

Halbertsma, Marlite. "The Many Beginnings and One End of World Art History in Germany 1900–1933," in *World Art Studies: Exploring Concepts and Approaches*, eds. Kitty Zijlmans and Wilfied van Damme. Amsterdam: Valiz, 2008, 91–105.

Hallam, Huw. "Globalized Art History: The New Universality and the Question of Cosmopolitanism," *Australian and New Zealand Journal of Art* 9 (2008/9), 75–89.

Holly, Michael Ann. *Past Looking: Historical Imagination and the Rhetoric of the Image*. Ithaca: Cornell University Press, 1996.

Inaga, Shigemi. "Is Art History Globalizable? A Critical Commentary from a Far Eastern Point of View," in *Is Art History Global?*, ed. James Elkins. New York: Routledge, 2007, 249–79.

Juneja, Monica. "Kunstgeschichte und kulturelle Differenz: eine Einleitung," *Kritische Berichte* (Universität der Kunstgeschichte?) 40 (2012), 6–12.

Kaufmann, Thomas DaCosta. *Towards a Geography of Art*. Chicago: University of Chicago Press, 2004.

Kaufmann, Thomas DaCosta and Elizabeth Pilliod, eds. *Time and Space: The Geohistory of Art*. Burlington: Ashgate, 2005.

Kaufmann, Thomas DaCosta, Catherine Dossin, and Beatrice Joyeux-Prunel, eds. *Circulations in the Global History of Art*. Burlington, VT: Ashgate, 2015.

Kopytoff, Igor. "The Cultural Biography of Things: Commoditization as Process," in *The Social Life of Things: Commodities in Cultural Perspective*, ed. Arjun Appadurai. Cambridge: Cambridge University Press, 1986, 64–91.

Krauss, Rosalind. *The Picasso Papers*. New York: Farrar, Straus & Giroux, 1998.

Kubler, George. *The Shape of Time: Remarks on the History of Things*. New Haven: Yale University Press, 1962.

Larsson, Chari. "Didi-Huberman's Ghosts," PhD dissertation, University of Queensland, 2015.

Latour, Bruno. *We Have Never Been Modern*. Trans. Catherine Porter. Cambridge, MA: Harvard University Press, 1993.

Latour, Bruno. *Pandora's Hope: Essays on the Reality of Science Studies*. Cambridge MA: Harvard University Press, 1999.

Latour, Bruno. *Politics of Nature: How to Bring the Sciences into Democracy*. Cambridge: Cambridge University Press, 2004.

Leighten, Patricia. *Re-ordering the Universe: Picasso and Anarchism, 1897–1914*. Princeton: Princeton University Press, 1989.

Leighten, Patricia. *The Liberation of Painting: Modernism and Anarchism in Avant-Guerre Paris*. Chicago: University of Chicago Press, 2013.

Marrow, Deborah and Joan Weinstein. "Introduction," *Art in Translation* 9 (2017), 3–6.

Mermoz, Gerard. "Art History: Contemporary Issues," *Oxford Art Online/Grove Art Online* (2007).

Michaud, Philippe-Alain. *Aby Warburg and the Image in Motion*. Trans. Sophie Hawkes. New York: Zone Books, 2004.

Mitchell, W. J. T. "What is an Image?" *New Literary History* 15 (1984), 503–37.

Mitchell, W. J. T. *Picture Theory: Essays in Verbal and Visual Representation*. Chicago: University of Chicago Press, 1995.

Mitchell, W. J. T. *What Do Pictures Want? The Lives and Loves of Images*. Chicago: University of Chicago Press, 2005.

Nadal, Laura Filloy and Maria de Lourdes Navarijo Ornelas. "Currents of Water and Fertile Land: The Feather Disk in the Museo Nacional de Antropologia," in *Images Take Flight: Feather Art in Mexico and Europe, 1400–1700*, eds. Alessandra Russo, Gerhard Wolf, and Diana Fane. Florence and Munich: Kunsthistorisches Institute and Hirmer Verlag, 2015, 253–58.

Onians, John. *Neuroarthistory: From Aristotle and Pliny to Baxandall and Zeki*. New Haven; Yale University Press, 2008.

Onians, John. *European Art: A Neuroarthistory*. New Haven: Yale University Press, 2016.

Pfisterer, Ulrich. "Origins and Principles of World Art History 1900–2000," in *World Art Studies: Exploring Concepts and Approaches*, eds. Kitty Zijlmans and Wilfied van Damme. Amsterdam: Valiz, 2008, 69–89.

Pinney, Christopher. "Things Happen: Or. From Which Moment Does that Object Come?", in *Materiality*, ed. Daniel Miller. Durham, NC: Duke University Press, 2005.

Poggi, Christine. *In Defiance of Painting: Cubism, Futurism and the Invention of Collage*. New Haven: Yale University Press, 1992.

Russo, Alessandra. *The Untranslatable Image: A Mestizo History of the Arts in New Spain, 1500–1600*. Austin: University of Texas Press, 2014.

Sahlins, Marshall. *Islands of History*. Chicago: University of Chicago Press, 1985.

Severi, Carlo. *The Chimera Principle: An Anthropology of Memory and Imagination*. Trans. Janet Lloyd. Chicago: University of Chicago Press, 2015.

Severi, Carlo. *L'Objet personne: Une anthropologie de la croyance visuelle*. Paris: Éditions Rue d'Ulm/Presses de l'École normale supérieure et musée du quai Branly, 2017.

Shalem, Avinoam. "Histories of Belonging and George Kubler's Prime Object," *Getty Research Journal* 3 (2011), 1–14.

Singh, Kavita. "Colonial, International, Global: Connecting and Disconnecting Art Histories," *Art in Translation* 9 (2017), 34–47.

Summers, David. *Real Spaces: World Art History and the Rise of Modernism*. New York: Phaidon, 2003.

Takaki, Yoshitaka. "A Dozen Articles on Asian Arts," *Online Academic Community*, University of Victoria.

Warburg, Aby. *The Renewal of Pagan Antiquity: Contributions to the Cultural History of the Renaissance*. Trans. David Britt. Los Angeles: Getty Research Institute, 1999.

Warnke, Martin and Claudia Brink, *Der Bilderatlas Mnemosyne*, *Aby Warburgs Gesammelte Schriften* II, 1. Berlin: Akademische Verlag, 2000.

Wood, Paul. *Western Art and the Wider World*. Chichester: Wiley Blackwell, 2014.

Wuttke, Dieter. *Aby Warburgs Methode als Anregung und Ausgabe*. Göttingen: Gratia, 1979.

Part II
Post-colonial Time

3 Time Processes in the History of the Asian Modern[1]

John Clark

The Asian Modern conceives of modern art in various Asian countries and cultural continuities as articulating similar sets of developments which have analogies, common procedures, and sometimes interlinked causalities which are not always those found in Europe and North America, but which are still identifiably "modern."[2] They form a separate Asian paradigm set for constructing and comparing "modernisms," and in many cases are not due to the transfer of these from Euramerica even if there were liminal causal processes which Euramerican and chiefly colonial interactions have set off.[3] The nomenclature "Euramerica" and "Euramerican" helps us to avoid attributing origination or subsequent ownership of modern art to the "West." "The Asian Modern" is a tremendously enabling frame which permits us to see where Asia has its own modernities, and allows artists the authority to follow their own culturally specific or culturally hybrid paths to modernity.[4] It stands outside and invalidates simplistic or even brute Eurocentricity from the outset. It sets aside Euramerican critiques that think looking at the Asian "Modern" now is to misapply frames already outmoded in their space of origin, or which are rendered invalid because globalization has now both allowed and forced artists to go beyond the limitations of those spaces when the Euramerican modern was founded in the 1850s–1860s.

Clearly with such complexities in play, ones which are often unacknowledged in a simplistic transfer of Euramerican concepts, "modern', "modernity," and "modernism" are being applied to a culturally and historically different space than Euramerica. The Asian space is every bit as complex to construct and historically analyze as the Euramerican one,[5] not to mention the geographic extension of the Asian space and its historical longevity. But the Asian Modern has not yet achieved the recognized status of equivalent importance in Euramerica, surely a basic requirement for the founding of any genuine World Art History. Nor are the problematics of using Asian material to identify temporality and then work toward its understanding at all worked out. This chapter is by means of a preliminary sketch.

Art history deals with art works and their makers, followed by their receivers and other mediators: it treats these whether or not the art works are physical or virtual, or the art makers authorial, or whether those receiving the art constitute an audience loop through which an author position is established, one which is sometimes taken as a putative author by a curator.

I am going to discuss three different works from three different cultures and times which may allow an evidential focus and see what this analysis tells us about how concepts of time apply, or allow art history to generate new kinds of meaning. To begin

with, we cannot assume the methodological neutrality of temporal concepts, nor can the cultural domain of their application remain beyond question. The comprehension and representation of time in space has occupied several minds, a literature which is too large to review here. The Euramerican debates are indebted greatly to St. Augustine, who forms the basis for Peter Osborne's recent excursions in this field:

> Ever since Augustine first conceived the "time of the soul" as that of a "three-fold-present" in which the temporal dimensions of present/past/future are contracted to the subjective orientations of attention/memory/expectation, the subjective meaning of history has been thought in terms of the relations between memory and expectation. Indeed, the abstract temporal formalism of the time of modernity—of which avant-garde and the contemporary are specific, transformative articulations—is itself a projection onto history of just such a fundamentally subjective temporality.[6]

Among the more systematic but, for some, provocative non-Euramerican analyses are those of C. K. Raju, who notes the intervention of Christian theology into the structuring of time as scientific concepts for causation to impose a linear notion:

> unlike earlier rejections of quasi-cyclic time, the curse on cyclic time benefited the state, by strengthening hierarchy . . . As propagated by Western theologians, "linear" time symbolizes the Christian view, "cyclic" time the primitive pagan view; "linear" time represents progress, human freedom, and so on, while "cyclic" time represents stagnant societies, fatalism, etc.[7]

Raju's view is very close to that of Johannes Fabian:

> Enlightenment thought marks a break with an essentially medieval, Christian (or Judaeo-Christian) vision of time. That break was from a conception of time/space in terms of a history of salvation to one that ultimately resulted in the secularization of Time as natural history.[8]

Included in pictures of time C. K. Raju distinguishes, in no apparent particular sequence, super-linear time, irreversible time, mundane time, apocalyptic time, epistemically broken time, ontically broken time (the material grounds of being as opposed to its general and philosophically grounded ontological ground)[9] and super-cyclic time.[10] The processes in which temporal concepts are used to denote or describe Euramerican art, particularly modernism and its avatars, are usually presented in interpretive explorations of temporal concepts and of their causal implications, or sometimes shown by diachronic chronologies rather than synchronic occurrence. Raju presents us with the likelihood that many of these concepts remain culturally bound to Euramerican systems of thought and are not further generalizable without considerable reservations. The exception might be, perhaps, as partial frames to interpret the Euramerican side of movement of art to spaces outside Euramerica, and to assess the relative fit with the art of discourses into which Euramerican art moved, e.g. how long did it take for "them" to learn how to paint realist academy nudes?[11] Or was there an instantaneous grasp of Surrealism, and did it take a *long period* of uninterrupted contact for them to

understand? Was their Asian Cubism really cubism?[12] The shock of such facetious but by no means uncommon questioning is that the technical efficacy of transfer is only conceived as a disturbance to the Euramerican systems, not the making of a new kind of art with multiple discursive sources and conditions. The recurrent trope is of having a necessary precursor modernity in Euramerica under conditions not met outside it. An exemplar of this view is that of Terry Eagleton:

> The colonial processes which helped for both good and ill, to deprive third-world societies of a developed modernity have now largely yielded to the neo-colonial processes where those still partly pre-modern formations are sucked into the vortex of the West's post-modernity. Post-modernity without an evolved modernity to be consequent to is thus increasingly their destiny, as belatedness gives birth to a form of prematurity. An added contradiction is that this painful tension between the archaic and the avant-garde then, at the cultural level, reproduces something of the classic conditions of a modernist art.[13]

In any case, the Euramerican sets of temporal concepts remain part of a paradigmatic set of possible concepts which is not itself Euramerican, or exposes and challenges what are its essentialist underpinnings.[14]

If we look at modern Asian art, three examples spring to mind among the many possible pictures of time: the epistemically broken, the mundane, and the super-cyclic. I have deliberately selected works which are interpretable via these concepts from different art cultures in ways which indicate a cross-Asian periodization but no rigid, mono-cultural or bi-cultural chronology. They will allow us to apply several of C. K. Raju's temporal "pictures" and then see what else they involve about non-temporal and controlling features of the Asian modern.

In the picture of time as epistemically broken, a connection between two instants of time may well exist, but one (the observer) does not know, and orderly time-evolution is broken by a sudden transition between two states.[15] This is characteristically a picture of time where an existing discourse is radically transformed by the interposition, or imposition, of a change in subject matter which implies a choice in interpretation about an existing body of representations and their underlying belief systems. In Siam/Thailand one sees this in the 1850s—1860s in the mural paintings of Khrua In Khong, where under the royal instruction of King Mongkut, Rama IV, the subjects of mural schemes in several temples were changed away from either serried hierarchies of divine beings, or from the iterated narratives of Buddha's lifetimes before his historic one, to a depiction of moral tales from this present world linked to monuments or teachings in the life of the historical Buddha.

Here then is the first kind of temporal concept found in modern Asia: a rupture, and a shift toward the quotidian. This borrows heavily for its visual representations on contemporary American prints of city views and illustrations of paintings brought by US missionaries in the 1840s or given in the exchange of diplomatic gifts in the 1850s and 1860s. These may have visually facilitated a switch in Khrua In Khong's murals away from *Jataka* stories which iterate scenes from Buddha's lives in previous incarnations to that of his present enlightenment. They move distinctly toward narration of Dhamma teachings via illustration of proverbs and other moral anecdotes drawn from Traiphum (Tripitaka) called *pritsanatham*, or moral riddles. These often

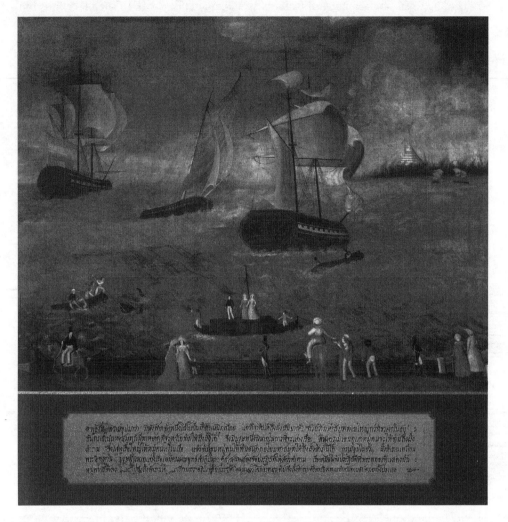

Figure 3.1 Khrua In Khong, mural painting to right of principal Buddha in which a *virtuous man leads people to a ship* in order to cross to the happy land pagoda at right, *ubosot* (ordination hall), Wat Baromniwat, 1860s

pointed to the road to moral happiness. A big ship became an allegorical device for a moral story about taking the believer and right-acting Buddhist to the blessed destination. For example, I translate the content of the inscription by Window II in a scheme from about the 1860s by Khrua In Khong at Wat Baromniwat in Bangkok as follows:

> This relates the comparison that heaven is shown as the opposite and safe bank of the river. It is hard to attain because of The Great Ocean in between. The Lord Buddha is like the builder of the boats which transport passengers to the other side. Boats are like the Precepts of Practice, all the people having gone across are like monks and those who attain [spiritual] achievement.

The texts which accompany the murals are also new in pointing to a direct, real-world link to moral choices, not to acts by supernatural beings or their magical powers. In other words, it is the result of a choice by a patron, but is an appropriation needed for local purposes. In the Siam of the 1850s and 1860s this choice is neither forced from outside, nor are the visual representations selected evidence for misprision or poor learning by a dominated or colonial subject, since these are adopted without external constraint.[16]

In the picture of time as mundane,[17] the branching of straight-line arrows of causation indicates a choice in which unique but real pasts are described by lines and branch away from other pasts which might have been but were not chosen. The future branches away from the now, the presence here of the actual art work.

Sudjojono's art in the 1950s was produced under the historical conditions of leaving behind colonial domination, war, civil war, and entering a new, utopic, post-colonial republic.

He deploys a visual idiom which looks away or has chosen to avoid the formalist and expressionist modern experiments of the late 1930s and 1940s. It is not yet clear how indebted these were to Euramerican precursors. However, the owner of the Regnault Paint Company toured modernist European works from his collection through Jakarta, Bandung, and Surabaya during the late 1930s. There are clear resemblances between Marc Chagall's portrait of his wife shown in the Regnault Collection

Figure 3.2 S. Sudjojono, *Perusing a Poster*, ca. 1956, oil on canvas, 109 × 140 cm, Oei Hong Djien Collection, Magelang

and Sudjojono's portrait of his woman friend, apparently a prostitute, and between a painting by Ensor from Regnault and Sudjojono's work *Kap ko me*.[18]

Unfortunately, these possible connections were never admitted by Sudjojono, nor have they been investigated to date by Indonesian art critics or historians. Neither have the abstractionist tendencies favored in Bandung in the 1950s been investigated, save as an antithesis to the figuration at Yogyakarta, whose stylistics owed much directly or indirectly to European modernist painting, but which were appropriated with an Indonesian, anti-colonial spirit.

Sudjojono cleaves to the everyday subject of the *orang kecil* (ordinary little people) in the street looking at a poster in the now. Here arises another kind of Asian modern, the deployment of the everyday as an occlusion of the past and a wall against the future. It is a kind of progressivism without the future envisaged utopia: here one should recall that at the time Sudjojono was a communist member of parliament, but was soon to have to resign both party and parliament for the sake of an affair with the person who became his second wife. Representation of the mundane thus carries with it a closure of both past and the morally ordained future: here perhaps lies the appeal of realism or fantasy which one may without difficulty find across several modern Asian art cultures, an escape into the now.

In the picture of super-cyclic time, "nothing prevents the distant future from 'wrapping around' to the remote past."[19] This is possible because of counterfactual geometry where one direction can go around to the future clockwise, but can also go back to the future in the anti-clockwise direction.[20]

Figure 3.3 Zhang Peili, *Water—The Cihai Dictionary Standard Edition*, 1991, a single channel video, 9'35"

In the case of the earlier iterative works of Zhang Peili, the future is a repetition of a past which traps out, or excludes, the living in the present. In this 1991 work, *Water—The Cihai Dictionary Standard Edition*, a single channel video:

> Xing Zhibin, the female television announcer who once represented the image of the official state media in China, reads aloud from the standard *Cihai* dictionary the terms beginning with the character *shui*, or water, with impeccably standard speed and diction. The video itself is shot according to the standard style of television news in China with the production facilities of the Beijing Media Center, making this an exercise in absurdity and suggesting something of the actual content or rigor of typical news broadcasts.[21]
>
> Her formal reading clashes with the seemingly nonsensical content of the text as if her orthodoxy were unfit for the irrelevance of what she reads. Zhang appropriates a highly iconic image used to validate a specific political discourse and deconstructs that same discourse by juxtaposing the "right" image with the "wrong" set of words.[22]

In Zhang Peili's mesmerizing iteration of this news reader, one cannot separate the repetition from the mundane content of her framing in a standard TV news-reading format, and indeed in the image of the newsreader being so well-known as to constitute a kind of static frame in itself. *Water* provides the viewer with an alarmingly still view of a future which it turns out by association with the regularity of her visage and framing to have been a kind of Mao-speak statism from the near past. In other words, the viewer feels trapped between the past and the future in a present which is a mere absurdist repetition, one which indeed seems not to change. *Water* presents a particularly clear use of a framing device and a procedure which could be seen from a Euramerican standpoint as similar to, say, Andy Warhol, or borrowed from other non-Chinese video art works shown two years earlier in 1990 in Hangzhou. In 1990 at Zhejiang Academy of Fine Arts, visiting professor Ernst Mitkza from Hamburg showed eight hours of video which had been made for German TV in commemoration of the 900th anniversary of City of Cologne.[23]

To see such borrowing as a simple transfer and assimilation would ignore the whole Chinese history of repetition, of blocked or enclosed language in Mao-speak and its subsequent deployment in propaganda, and the cold irony which has quite Chinese bases. Zhang Peili is useful in reminding Euramerican viewers of the originality and localism of temporal discourses which can appear to be seated in imported technologies or borrowed art discourse, but quite clearly have their own local causes and uses.

Here the potential of "moving image" practice in video and its theorizations is to rearticulate relationships between the past, present, and future in order to close them off from each other. Much writing on video, for example, attempts to discover a history for an art practice which has only existed for fifty or so years, or, in China, only twenty-eight years (1988–2016). Zhang Peili is more interested in the advent of technology bringing new possible concepts of time than the impact of historical understanding on development of video art. He relates:

> New technology is now a kind of continuation, deepening, and opening up of the expression of time. But present digital technology also makes us have different concepts about time. In the past we gave more importance to "true" time; time now and

time then are not the same, at least conceptually, but they are all true and have taken place. For example, as they involve this time, yesterday, the day before yesterday or half a month ago, are at least already the past, but they are not illusory. Yet present media, digital technology, can produce another kind of time which is illusory. This illusory time or we may call it space and time, is one never ever experienced. It is not something you experienced in the past. You don't know if it is in the end true. This kind of illusory time can create a false impression [misconception] about true time. It can be a kind of composite. It is very difficult for you to ascertain what is true time what is illusory time. Present media technology compared with the past has brought different understandings and concepts about time.[24]

There has long been a view that Asian modernities were set off by close cultural contact under colonial conditions in the nineteenth century and are in many senses a late transfer of a discourse already anachronistic at the time of its Asian adoption. In this event, this view runs, very many different—and for some—alien temporalities as well as temporal concepts were brought together and forced to co-exist, if not also co-align. I doubt if this sense of heterochrony is valid for contact between art cultures and art discourses which are already highly advanced and, in their institutional patterns at least, highly similar. This is hardly the case even for contact *in extremis* between advanced technological mass civilizations linked by "imagined" commonalities with much less technologically elaborate small-scale, tribal cultures. If this heterochrony was so radical, why would tribal peoples be able to operate technologically advanced devices such as radios, televisions and computers so quickly? The irony is that aboriginal art's entry to the transnational flow of art works becomes a further caesura defining the advent of a notion of the contemporary among those flows.[25] The notion that such contacts are between different kinds of time is undermined by the fact that many of these senses of time are intercommunicable even if they are not evaluated alike due to metaphysical or mythological grounding in different cultures.

For Johannes Fabian, there are four related conceptual categories of time: Physical Time, Mundane Time, Typological Time, and Intersubjective Time.[26] His major argument is that the denial of coevalness in Time between anthropologizing and anthropologized cultures is to privilege the former over the latter, frequently in parallel to an imposed hegemony. For Fabian, "*Somehow we must be able to share each other's past in order to be knowingly in each other's present.*"[27] The idea that somehow one culture's chronos produces or defines another culture's anachronos sets aside the issue of hegemony over each culture's rules in which that hegemony is in part embodied. What is different is that spatial distance and separation may enable some cultures to tell stories of their own which stand outside the hegemonic culture's chronos.[28] All cultures may be non-chronological to each other, if their relative structures of hegemony are separate, and of course the technological control which permits this distance is structured to allow it.

This is a matter of art works existing in the "correct" time, that is, the culturally ordained time for any particular concept of it. Correctness is also given by the domination of formal rules. Cultural transfer often involves in one culture a different, out-of-temporal sequence to that expected in the other, and this difference can be found in formal emphases between story events and plot elements. Anachronistic juxtaposition can have political consequences, such as the view of Ernst Bloch that an earlier element is carried within those who belong to a more modern culture, but with different demands which can fracture or be perverted by the new, as in the transition from Weimar to Nazi Germany:

Not all people exist in the same Now. They do so only externally, through the fact that they can be seen today. But they are thereby not yet living at the same time as the others . . . There is little more unexpected and nothing more dangerous than this power of being at once fiery and meagre, contradictory and non-contemporaneous. The workers are no longer alone with themselves and the employers. Much earlier powers, from a very different bottom, begin between them.[29]

So, for example, in narrative representation the event of the death of a king may not function in the same temporal sequence as the motif of revenge for loss of inheritance between cohorts of potential inheritors.

Outside Euramerica, time has frequently been used to map causal series seen at the intersection of internal and external dynamics enforced by encounters with Euramerican imperialism and later forms of domination. This is frequently the case in cultures where there is a local temporal division used to mark historical periods, such as the modern imperial reign names of Meiji, Taishô, Shôwa, and Heisei in Japan, names which may mean little to non-Japanese but have very specific period connotations for breaking down fine historical periodizations inside Japan.[30] The same may be said for Republican-era dates in China, or the bracketing of rule by the name of a particular King in Siam/Thailand, say Rama IV Mongkut or Rama V Chulalongkorn. These named datings are actually implicated in quite different series of associations even though they may be expressible in "Western" or "Common Era" dates. What is internal to one series, the Euramerican "universal" or BCE dates, is seen as external to the other, say the Japanese, or to be found at its side of the juncture. Cultural contact is not merely the site of Euramerican projections, but also the site of counterprojections from non-Euramerican frameworks, and for the other frameworks their self-definition is not "non-Euramerican" or "not Western," but quite definitely "Japanese," "Siamese/Thai," or "Chinese." In other words, the direction of flow in historical causation is asymmetric and "our"-culture centered, above all with temporal markers.

At such interstices there is synthetic convergence of hybrid cultural formations, and explicit temporal schemes further serialize phenomena. Summing up recent discussions of these issues, Terry Smith posed these questions: is modernism belated outside its originating zones or is it an element within contemporary art? Or is modernism both at the same time? This sounds to me like a definition of post-modernism. How do multiple modernities construct contemporary art? What is the link between World Art and Global Art?[31]

From what frame and what picture of time are we to define or articulate "post-ness"? Are we to do so from a perspective tied to medium and its passed-on quality as a periodizing indicator? Some scholars like Rosalind Krauss, and the artist she instances Marcel Broodthaers, think there is a direct link between the contemporary and some separation from the notion of medium as central to periodization. We have to be careful to again remember there is no cultural universality about medium, however technically neutral or distributionally transnational it may appear, nor can any deployment of medium be easily separated from the cultural and historical context of the deployment. Indeed, to do so would be to turn a quality of time, the freedom from medium constraints, away from what is a culture-dependent quality, one of space, that is, away from medium as it functions in any particular art or cultural discourse. Rosalind Krauss notes that:

it could be argued that in the '60s, "opticality" was also serving as more than just a feature of art; it had become a medium of art. As such it was also aggregative, an affront to what was officially understood as the reductivist logic of modernism.[32]

She later continues:

1 . . . the specificity of mediums, even modernist ones, must be understood as differential, self-differing, and thus as a layering of conventions never simply collapsed into the physicality of their support. "Singleness," as Broodthaers says, "condemns the mind to monomania."
2. It is precisely the onset of higher orders of technology—"robot, computer," which allows us, by rendering older techniques outmoded to grasp the inner complexity of the mediums those techniques support. In Broodthaer's hands, fiction itself becomes such a medium, such a form of differential specificity.[33]

Perhaps this imperviousness to the other-cultural context is due to the conceptualization of time in relation to art works having largely been carried out with reference to Euramerican objects which were sited in a Euramerican cultural space. And this is perhaps the reason why the debates on the advent of what is the contemporary are in general so fixated on the Euramerican 1960s. Then a shift in discourse propagated by artists and propagandized by commercial galleries toward minimalism and conceptualism wanted to cut itself off from modernist teleologies and at the same time from ties with the twin heritages of Euramerican modernism and the art of the European salon.

How temporally are we to define the contemporary in Asia and what are the consequences of this caesura? These definitions are in fact no longer of art discourse, or art work, but are based on political events and art institutional changes, at least in the cases of China and the Philippines. The onset of the contemporary in China is seen by Wu Hung as due to the art events of 1989, the China Modern Art exhibition in February, and the non-art event of the Beijing Massacre of students in June. This was followed by a radical economic development begun in 1992 that was qualitatively unlike the modest but controlled "opening up" which had taken place in the decade since 1979:

Chinese art after 1990 had a very different appearance: the energy of a mass movement was completely gone. In its place emerged numerous individual and smaller-scale experiments. Issues of common concern included art medium and language, identity, the public function of art, and globalization. Working with independent curators, artists also tried to create new exhibition venues and commercial infrastructure for their works. It was around this time, starting from the early 90s, that the term *dangdai yishu* or "contemporary art" replaced "modern art," appearing on many book covers and in exhibition titles.[34]

In the Philippines and elsewhere in parts of Southeast Asia, the onset of the contemporary is marked by the shift from artist to curator, where in many cases artists actually become the curator, at least of short term thematic exhibitions.[35] There is an impetus for this "post"-ness:

the turn against idealization and the drift towards the liberation of everyday life from exoticism through the reengagement with "reality," and the break from the institutionalization of modern art that it be effected by an independent curator in the biennales.[36]

One turning point was the collaboration between Malaysian artists Redza Piyadasa and Suleiman Esa in the joint curation and manifesto of *Towards a Mystic Reality* in 1974. This was followed by a post-independence critique of nationalist essentialism as found through Redza Piyadasa's work in the 1980s. Another turn was the activities of the artist Raymundo Albano as director of the Cultural Centre of the Philippines from around 1972 to 1985. And a further example is the curation of the 1975 *Seni Rupa Baru Indonesia* exhibition which was part of a new movement in Indonesian art by the installation sculptor Jim Supangkat. There were also activities in Thailand by Apinan Poshyananda that culminated in his curation of the Thai entry for the 2003 Venice Biennale. He persuaded artists to institute a version of a Thai street market whose intention was to force a move beyond the exotic as grounds for attention to non-Euramerican modern art. These movements taken together may collectively over the years 1970–2003 have produced the contemporary. As Patrick Flores notes:

> The disruption of the modernist continuum that buttresses modern art history in the West frees up a space for an alternative schema of the "contemporary."[37]

If there is a transnational tendency to which these trends in artist-curation might be assimilated, it is the rise of conceptualism which allows a freedom to critique existing art historical conceptions, including those found in modernism. Flores further notes:

> The curatorial gesture could have emerged from the self-reflective instinct of conceptualism. It gave rise to a discursive disposition: the desire to interpret, to craft a tale, name a phenomenon, and muster examples to sustain arguments . . .[38]

Curation in temporary venues by "independent curators" changes the nature of long-term appraisal in the absence of secure or authoritative institutions like national galleries of art, and may be in contradiction with these where they exist as "national institutions." These tend to have vague atmospheric definitions based on an unclear or politically motivated notion of national art history, and to these conceptualism presents many challenges in the short term, at least when the definition of the "national" may be sharply contested between the "institutional" and the "independent" curatorial processes. Indeed, the very temporality of the curation means that new media which are in the curator's special province to interpret may arise, such as installation and video.

Installation art in China, for example, began to be exhibited around 1985, but made a larger discursive entrance in the *China Avant-Garde* exhibition in 1989, one year after Zhang Peili had made the first Chinese video art work *30 × 30* in 1988. It was shown at Huangshan Meeting for artists and critics, one of the preparations for the *China Avant-Garde* exhibition of the following year. It deliberately mobilizes the aesthetics of boredom to challenge mass-media viewing conventions and mock the social consequences of popular televisual codes. Zhang Peili wished to test the tolerance of the assembled critical art curators and critics. Significantly, both installation and performance art were in effect banned from exhibition at the China Art Gallery from 1990 to 2000, now the National Art Museum of China.[39]

If this selection relativizes and de-legitimates as past/passed those previously established media, then time and its concepts serve as markers of presence in new discursive spaces, and as the indicator of the periodicity of sequence. Time also serves

as a marker index of causality in the generation of art objects: time privileges the directionality, and given that teleological models of the modern have lost their status by reference to the past, marker indexes have also worked in a quasi-modernist way by the enjoining re-valuation of new and old monuments as reference points for current practice. Salon history painting serves as references for 1840s portraits of Raden Saleh, and these with 1860s photographic portraits of him later serve as the models for Heri Dono's *Raden Saleh with the Winged Angel Doll* (2010).

Marcel Duchamp's ready-mades of around 1913 serve as a conceptual reference for Huang Yongping's *One Thousand-Armed Avalokitesvara* at the Shanghai Biennale in 2012. Duchamp's wine drying rack is expanded to the height of the former turbine hall with significant objects of contemporary life placed at the extremities of the arms, like the different karmic objects of attachment shown by a Buddhist Avalokitesvara.

We could choose to avoid relating distinct temporal narratives to one another. The problem is that the time of the local discourses, or even the artist's localized appropriation of a transnational discourse in time, requires such a broad range of references that for historical interpretation, a grasp of both endogenous and exogenous discourses is required. Underlying patterns characterize the temporal experience of different cultures, but for Euramerican discourses projected in this way, they are those of the *other* culture. Here *anachronic* is close to *alien*.

Indeed, the history of acceptance of Australian aboriginal art as contemporary art is such that in around 1982–84, the former admiration of aboriginal art as a kind of primitive, autochthonous, non-chronical, non-synchronous achievement by at least three generations of Australian artists only became widely accepted art because the categories under which it was received were changed to contemporary.[40]

We are looking at an interface of cultures or at the very least the co-articulation of the art discourses they bear. The causal implication of such an interface is either the formation of a new, autonomous and hybrid tertiary space between them—which also has its own temporal rates of change—or a kind of slow or fast melding or interpenetration on both sides at the surface of contact.

Obviously for Asian modernities, Euramerican history, which was mainly, but not wholly, the history of the colonial powers until the 1940s, cannot be the sole or even the major criterion of comparison between the arts of different cultures. Is it possible to translate and mistranslate the cultural experience of temporality, or translate partially according to local needs and rules, but this has to be in both directions, not just one. The problem for art history is that periodization depends on diachronic chronologies, however much these are qualified as in any given present by the synchronic occurrence or co-occurrence of singular possibilities. Misconceptions of cultural siting, the application of codes of interpretation which may be local or non-local, endogenous or exogenous, can be obviated by the clarity of formulation and the commonality or intercommunicability of any set of codes for the audience in any given conceptual address. The criterion of comparison is the paradigm set of all the possibilities, all the ways of defining modernity, into which both the Asian and the Euramerican modernities fit, or which serve as particular sub-sets. It is not that of the Euramerican structures by themselves with their attendant but nonetheless culturally specific temporalities.

The issue of the intersection of internal and external dynamics and what temporal consequences these have for the construction of art histories will not go away. I have thought that the solution for many difficulties is to conceive of internal and external

causation, the endogenous and the exogenous, but the question outside Euramerica is one of the use of temporal sequences to map endogenous causal series. These are not cognate in interpretation, however much their external forms may be mappable or identifiable by exogenous series. The illusion of co-temporality is as miasmic as that of anachrony.

In understanding the temporal intersections of internal and external dynamics, there seems to be no way out from the enforcement in practice of discursive coherence by a hegemon which is usually external—except, of course, for individual artistic creativity and origination functioning in relative autonomy from other social forces. Often in recent history from the 1830s to the 1990s, this intersection has been identified by encounters with, and often subjection to, Euramerican domination. It is under these subjections, or out of the unfilled gaps between discourses, as well as in the endogenous forces constructed against the exogenous that the Asian Modern comes into sight.

To sum up, cultural contact is not unidirectional and it is not a site for mere Euramerican projections; there are also counterprojections from non-Euramerican frameworks, each with their own temporality. Saying one or the other is non-chronic only means "their" time is not "our" time, however constructed. For the purposes of establishing an Asian modernity which is at least, and should be more than, the sum of all the Asian interactions and constructions, the Asian side is more important. Time and its concepts serve as markers of presence in discursive spaces, temporality serves as the indicator of the periodicity of sequence of adjustments and as a relative index of causality in the generation of art objects: they have no absolute or generalized descriptive power.

Adjustment and innovation between different Asian sites is subject to the simultaneity and differential periodicity of these causations. No temporal unity can be presumed without demonstration of periodicity in different cultural contexts. Analogous phenomena such as the rise of modern art schools and exhibition structures are subject between cultures to different onsets and terminations, but there are, for example, some astonishingly near-synchronicities between colonial India and uncolonized Japan between the 1880s and 1910s which are unlike those between Thailand and China after World War II. In short, the structure of periodizations could be relatively similar across cultures, but the actual historical duration may be very different. When we have truly established the set of those changes in their different Asian contexts, we will have established a paradigm set for Asian modernities, and it is this whose comparison with Euramerica will allow a redefinition of "modernity in art" and all its myriad temporalities.

Notes

1. A version of this chapter was presented at the ANU conference in Canberra, *Moving Image Cultures in Asian Art*, organized by Chaitanya Sambrani and Olivier Krischer in August 2016, and at the conference *Archival Turn: East Asian Contemporary Art and Taiwan* in April 2017 at the Taipei Fine Arts Museum with the addition of more East Asian examples.
2. See my *Modern Asian Art* (Sydney: Craftsman House & Honolulu: University of Hawaii Press, 1998), 29. My two-volume book *The Asian Modern* is in production at the National Gallery of Singapore and is scheduled for publication in 2019.
3. See my *Asian Modernities: Chinese and Thai Art Compared, 1980 to 1999* (Sydney: Power Publications, 2010), 25–36.

4. A comment later made to me by the Asian-Australian artist John Young, who participated in the conference *Modernism and Post-Modernism in Asian Art* (ANU, Canberra, 1991).
5. A second edition has appeared of Hal Foster, Rosalind Krauss, Yves-Alain Bois, and Benjamin H. D. Buchloh, *Art since 1900, Modernism, Anti-Modernism, Postmodernism* (London: Thames & Hudson, 2012), with a supplementary chapter on contemporary art by David Joselit. For a critical response to the earlier 2004 edition, see my "A Short Review of a Very, Very Long Book," *Yishu: Journal of Contemporary Chinese Art* 4, no. 4 (Winter 2005), 107.
6. Peter Osborne, *Anywhere or Not at All: Philosophy of Contemporary Art* (London: Verso, 2013), 175.
7. C. K. Raju, *The Eleven Pictures of Time: The Physics, Philosophy, and Politics of Time Beliefs* (New Delhi: Sage Publications, 2003), 45–46, reviewed by Don Miller in *Time and Society* 13, no. 2 (2004). Raju's work in the history of mathematics has also been the subject of controversy, particularly in relation to his view of the prior invention of calculus in India and its transmission to Europe. See C. K. Raju, *Cultural Foundations of Mathematics: The Nature of Mathematical Proof and the Transmission of the Calculus from India to Europe in the 16th c. CE* (Delhi: Pearson Education, 2007), reviewed by José Ferreirós in *Philosophia Mathematica* 17, no. 3 (2009). Another critical chain is found at https://analyze thedatanotthedrivel.org/2010/08/12/c-k-raju-genius-or-crank-part-1 (accessed November 25, 2017).
8. Johannes Fabian, *Time and the Other: How Anthropology Makes its Object* (New York: Columbia University Press, 2014 [1983]), 26.
9. Later C. K. Raju marks this as typical of quantum systems which evolve continuously until the moment they are observed and the temporal series of causations jumps: Raju, *The Eleven Pictures of Time*, 291–92. The terms 'ontic' and 'ontological' figure in some recent Heideggerian philosophical discussions and may need clarification for general readers as a preparatory reference to Chapter 7, "Art Time," in Osborne, Main title, which largely presents a Heideggerian view. Osborne does not incorporate understanding of Reinhard May, *Heidegger's Hidden Sources: East Asian Influence on His Work* [German original 1986, trans. with a complementary essay on Heidegger's links with, and reception in Japan, by Graham Parkes] (London: Routledge, 1996).
10. See Raju, *The Eleven Pictures of Time*, Chapter 8 for a full description of these different ways of picturing time. My use here is metaphorical for a range of possible conceptions of time, and distant from Raju's intended metonymic precision.
11. See Joyce Fan and Kim Inhye, *Realism in Asian Art* (Singapore: National Art Gallery & Seoul, National Museum of Contemporary Art, 2010).
12. See Tatehata Akira et al., *Cubism in Asia: Unbounded Dialogues* (Tokyo: National Museum of Modern Art & Seoul: National Museum of Contemporary Art & Singapore: Singapore Art Museum, 2005–06).
13. See Terry Eagleton, *The Illusions of Postmodernism* (Oxford: Blackwell, 1996), Note 10, 139.
14. See my *Asian Modernities: Chinese and Thai Art Compared, 1980 to 1999* (Sydney: Power Publications, 2010), 204–07.
15. Raju, *The Eleven Pictures of Time*, 290–91.
16. See Khronggan burana patthisankhon Wat Baromniwat, eds., *Baromniwat Ratcha Anusorn* [The Royal Memorial Baromniwat], Khrungtheep: Samnak Khian Saphsin Suan Phramahakasat [The Crown Property Bureau] BE 2558 (2015), 50.
17. Raju, *The Eleven Pictures of Time*, 289–90.
18. Much of the Regnault Collection was bought by or given to the Stedelijk Museum in Amsterdam. There is a good catalog which gives the dates of exhibition of particular works in the Dutch Indies: Caroline Roodenburg-Schadd, *Goed Modern Werk: De Collectie Regnault in Het Stedelijk* (Zwolle: Waanders Uitgevers, 1995). Dutch-language newspaper reports of exhibitions of modern art in Java are the subject of current studies of exhibition histories in late colonial Dutch Indies and independent Indonesia by Adrian Vickers, Siobhan Campbell, and myself, which are funded by the Australian Research Council. Some details will be found under 'Sudjojono' in Volume Two of my *The Asian Modern*, as mentioned above, forthcoming in 2019.
19. The ancient base is the distinction between Origen's picture of quasi-cyclic time and the Stoic picture of super-cyclic time. See, inter alia, Raju, *The Eleven Pictures of Time*, 42.

20. Raju, *The Eleven Pictures of Time*, 281.
21. Robin Peckham and Venus Lau (eds.), *Certain Pleasures / Qieque de kuaigan* [Retrospective Catalogue of Zhang Peili] (Shanghai: Minsheng Art Museum & Hong Kong: Blue Kingfisher Ltd., 2011), 114.
22. Dal Lago in Peckham and Lau, *Certain Pleasures / Qieque de* kuaigan, 10–11. The work was shot in a TV studio without the presence of the artist.
23. Katharine Grube of New York University, as part of her PhD research, has established a list of videos left behind by Mitkza in Hangzhou for future reference of artists.
24. Or in China only twenty-eight years (1988–2016). Zhang Peili is more interested in the advent of technology bringing new possible concepts of time than the impact of historical understanding on the development of video art. I translate below from my interview with Zhang Peili in 2010.
25. See Ian McLean (ed.), *How Aborigines Invented the Idea of Contemporary Art* (Brisbane: Institute of Modern Art & Sydney: Power Publications, 2011), 17–75. This is by no means an issue restricted to Australian aboriginal art and can be found, for example, in the strategies for the survival of folk art in Mexico. See Néstor García Canclini, *Hybrid Cultures: Strategies for Entering and Leaving Modernity* (Minneapolis: University of Minnesota Press, 1995), Chapter 5, "The Staging of the Popular."
26. See Fabian, *Time and the Other*, 22–24.
27. See Fabian, *Time and the Other*, 92 (his italics).
28. On the story which takes over the story-teller, so that the tribe can keep *its* story, see Mario Vargas Llosa, *The Storyteller* (London: Faber & Faber, 1989). On the interpellation of local myth with a modern novel narrative, see "Gaspar Ilóm," in Miguel Angel Asturias, *Men of Maize* [original 1949, trans. Gerald Martin, 1975] (London: Verso, 1988). This book is thought to be the first Latin American novel in the manner of "magical realism."
29. See "Summary Transition: Non-contemporaneity and the Obligation to its Dialectic (May 1932)," in Ernst Bloch, *Heritage of Our Times* [original of 1935, trans. Neville and Stephen Plaice] (Cambridge: Polity Press, 1991), 75.
30. See Karatani Kôjin, 'The Discursive Space of Modern Japan," in *Japan in the World*, eds. Masao Miyoshi and H. D. Harootunian (Durham, NC: Duke University Press, 1993), 288–315.
31. Questions posed by Terry Smith in his lecture, "Seeing Art Historically Today: Where We Are and Ways to Go," at the Art Gallery of New South Wales, July 20, 2016. See also among his many writings on the contemporary, *What is Contemporary Art?* (Chicago: University of Chicago Press, 2009); "The State of Art History: Contemporary Art," *Art Bulletin* XCII, no. 4 (December 2010), 366–83; *Contemporary Art: World Currents* (London: Lawrence King Publishing, 2011); "Contemporaneity in the History of Art, A Clark Workshop 2009, Summaries of Papers and Notes on Discussions," *Contemporaneity* 1 (2011) (at http://contemporaneity.pitt.edu (accessed November 5, 2017)).
32. Rosalind Krauss, *"A Voyage on the North Sea": Art in the Age of the Post-medium Condition* (London: Thames & Hudson, 1999), 30.
33. Krauss, *"A Voyage on the North Sea,"* 53.
34. Wu Hung, "From 'Modern' to 'Contemporary': A Case in Post-Cultural Revolutionary Art," *Contemporaneity* 1 (2011), 37 (at http://contemporaneity.pitt.edu (accessed November 5, 2017)).
35. Patrick Flores, "Position Papers: Turns in Tropics, Artist-Curator," in *The 7th Gwangju Biennale: Annual Report: A Year in Exhibitions*, ed. Okwui Enwezor (Gwangju: Gwangju Biennale Foundation, 2008), 262–85, for a copy of which I am grateful to Patrick Flores.
36. Patrick Flores, "The Curatorial Turn in Southeast Asia and the Afterlife of the Modern," in *Contemporary Art in Asia: A Critical Reader*, Melissa Chiu and Ben Genocchio (Cambridge, MA: MIT Press, 2011), 198.
37. Flores, "Position Papers," 277.
38. Flores, "Position Papers," 281.
39. For further details on Zhang Peili, see Volume Two of my *The Asian Modern*, in forthcoming in 2019.
40. See in particular, Ian McClean, *How aborigines invented the idea of contemporary art* (Sydney: Power Publications), 41–43.

Bibliography

Asturias, Miguel. Angel *Men of Maize*. London: Verso 1988.

Bloch, Ernst. *Heritage of Our Times*. Cambridge: Polity Press, 1991.

Canclini, Néstor García. *Hybrid Cultures: Strategies for Entering and Leaving Modernity*. Minneapolis: University of Minnesota Press, 1995.

Clark, John. *Modern Asian Art*. Sydney: Craftsman House; Honolulu: University of Hawaii Press, 1998.

Clark, John. "A Short Review of a Very, Very Long Book," *Yishu: Journal of Contemporary Chinese Art* 4, no. 4 (Winter 2005), 105.

Clark, John. *Asian Modernities: Chinese and Thai Art Compared, 1980 to 1999*. Sydney: Power Publications, 2010.

Clark, John. *The Asian Modern*, 2 vols. Singapore: National Gallery of Singapore, forthcoming 2019.

Eagleton, Terry. *The Illusions of Postmodernism*. Oxford: Blackwell, 1996.

Fabian, Johannes. *Time and the Other: How Anthropology Makes its Object*. New York: Columbia University Press, 2014 [1983].

Fan, Joyce and Kim Inhye. *Realism in Asian Art*. Singapore: National Art Gallery; Seoul, National Museum of Contemporary Art, 2010.

Flores, Patrick. "Position Papers: Turns in Tropics, Artist-Curator," in *The 7th Gwangju Biennale: Annual Report: A Year in Exhibitions*, ed. Okwui Enwezor. Gwangju: Gwangju Biennale Foundation, 2008.

Flores, Patrick. "The Curatorial Turn in Southeast Asia and the Afterlife of the Modern," in *Contemporary Art in Asia: A Critical Reader*, eds. Melissa Chiu and Ben Genocchio. Cambridge, MA: MIT Press, 2011.

Foster, Hal, David Joselit, Rosalind Krauss, Yves-Alain Bois, and Benjamin H. D. Buchloh. *Art since 1900, Modernism, Anti-Modernism, Postmodernism*. London, Thames & Hudson, 2012.

Karatani, Kôjin, 'The Discursive Space of Modern Japan," in *Japan in the World*, eds. Masao Miyoshi and H. D. Harootunian. Durham, NC: Duke University Press, 1993.

Khronggan burana patthisankhon Wat Baromniwat [editors], *Baromniwat Ratcha Anusorn* [The Royal Memorial Baromniwat], Khrungtheep: Samnak Khian Saphsin Suan Phramahakasat [The Crown Property Bureau] BE 2558 [2015]

Krauss, Rosalind. *"A Voyage on the North Sea": Art in the Age of the Post-medium Condition*. London: Thames & Hudson, 1999.

Llosa, Mario Vargas. *The Storyteller*. London: Faber & Faber, 1989.

May, Reinhard. *Heidegger's Hidden Sources: East Asian Influence on His Work*. London: Routledge, 1996.

McLean, Ian, ed. *How Aborigines Invented the Idea of Contemporary Art*. Brisbane: Institute of Modern Art; Sydney: Power Publications, 2011.

Osborne, Peter. *Anywhere or Not at All: Philosophy of Contemporary Art*. London: Verso, 2013.

Peckham, Robin and Venus Lau, eds. *Certain Pleasures/Qieque de kuaigan* (Retrospective Catalogue of Zhang Peili). Shanghai: Minsheng Art Museum; Hong Kong: Blue Kingfisher Limited, 2011.

Raju, C. K. *The Eleven Pictures of Time: The Physics, Philosophy, and Politics of Time Beliefs*. New Delhi: Sage Publications, 2003.

Raju, C. K. *Cultural Foundations of Mathematics: The Nature of Mathematical Proof and the Transmission of the Calculus from India to Europe in the 16th c. CE*. Delhi: Pearson Education, 2007.

Roodenburg-Schadd, Caroline. *Goed Modern Werk: De Collectie Regnault in Het Stedelijk*. Zwolle: Waanders Uitgevers, 1995.

Smith, Terry, *What is Contemporary Art?* Chicago: University of Chicago Press, 2009.

Smith, Terry. "The State of Art History: Contemporary Art," *Art Bulletin* XCII, no. 4 (December 2010), 366–83.

Smith, Terry. *Contemporary Art: World Currents*. London: Lawrence King Publishing, 2011.

Smith, Terry. "Contemporaneity in the History of Art, A Clark Workshop 2009, Summaries of Papers and Notes on Discussions," *Contemporaneity* 1 (2011), 3.

Tatehata Akira et al. *Cubism in Asia: Unbounded Dialogues*. Tokyo: National Museum of Modern Art; Seoul: National Museum of Contemporary Art; Singapore: Singapore Art Museum, 2005–06.

Wu, Hung. "From 'Modern' to 'Contemporary': A Case in Post-Cultural Revolutionary Art," *Contemporaneity* 1 (2011), 37.

4 Colonial Modern

A Clash of Colonial and Indigenous Chronologies: The Case of India

Partha Mitter

> Why does art have to go anywhere? Art hasn't ended and neither has the history of pictures.
>
> David Hockney[1]

This volume has set itself the urgent task of revising the universalist western chronology that dominates modernism and its putative heir, the more recent global Contemporary Art. While totally in sympathy with this view, this chapter will not explore the anomalous global situation, but will offer both a critique of the prevalent art historical chronology in India and a micro-study of an equally important and larger question: the historical imagination of colonial India, which itself is riddled with the contradictions of incommensurate temporalities—between the prevailing dominant chronology, a colonial legacy, and the plethora of competing regional temporalities.[2] To put it baldly, this problem of incommensurate temporalities has a long history going back to the beginning of the colonial era. But before we turn to our main desideratum, let me offer a brief review of the anomalous situation that plagues the present generation of Indian artists as part of the emerging global network.

Non-western Modernism: A Case of Delayed Growth?

Following decolonization and more recent globalization of art, contemporary Indian artists, caught in the predicament of derivativeness, seek to erase the stigma by denying history and the dominant chronology of modern art with its universalist ambitions. Contemporary Indian artists are convinced that they were born fully armed in the manner of goddess Athena, owing almost nothing to history, or to the cultural context of their art production. Many artists tend to invoke history merely to repudiate its claims. Rejecting the lens of history, the Group 1890 in India, founded in 1962, made a plea for a return to an innocent eye that will let artists transcend any desire for heroism or martyrdom with a view to renewing their contact with an "authentic" self.[3] More recently, the brilliantly witty Raqs Media Collective meets headlong the whole concept of time in its installation, *The Untimely Calendar*. The Collective has enjoyed playing a plurality of roles, often appearing as artists, but occasionally as curators, and philosopher *agents provocateurs*. *Asamayavali/Untimely Calendar* is a proposition put forward by the Collective on the question of how to be with the untimely, and yet survive encounters with time and remain unscathed. An *asamayavali*, an un-chronology, is by definition un-retrospective. What *Untimely Calendar*

offers is an unorthodox way of reading contemporaneity. In short, *Asamayavali* is an anachronistic account of a time that is out of kilter with history.[4]

Time lag and delayed growth are the two complaints frequently leveled by western art historians and critics against modernisms from outside the West. Among those who felt compelled to challenge this common prejudice, Geeta Kapur, the leading Indian critic of modernism, does not directly address the temporal question. However, the thrust of her complex arguments is to counter the charge of derivativeness as attempts to catch up with mainstream modernism.[5] Kapur accepts the essential linearity of history, endorsing the Marxist idea of the logical stages of social development toward global capitalism. In sympathy with the Marxist interpretation of history, modernization in India, she avers, has been an incomplete historical process, as it battles the forces of superstition and communalism. It thus gives rise to contradictions between progressive art movements—both formalist and radical socially committed ones—and archaic aesthetics that valorize primitive techniques and artisanal skills. Again, as a historical materialist, she cannot imagine Indian modernism outside universal capitalism, even though advocating "the parallel aesthetics" of the former colonized regions.[6] Her admonition springs from the need to forestall the "hostile takeover" by western art history and its particular timeframe. She contends: "we should reperiodize the modern in terms of our own historical experience of modernization . . . [which] would enable us to enter the postmodern at least potentially on our own terms."[7]

Geeta Kapur is in fact echoing the anxieties of many of the recent critics from the periphery, who have argued alternative ways of entering and exiting modernity. A most persuasive tool for unsettling the hegemonic canon and the attendant monolithic notion of culture has been the concept of hybridity. Among Latin American scholars, Néstor García Canclini uses the concept to formulate "multi-temporal heterogeneities," while Gerardo Mosquera champions a de-centralized international culture to argue that the peripheries are ceasing to be defined entirely by the notion of tradition. They are emerging as multiple centers of international culture, strengthening local developments in a constant process of cultural hybridization.[8] The "wound" that artists beyond the "modern West" bear makes them long for modernity with ever greater poignancy. I can do no better than paraphrase the Nobel lecture of the Mexican poet Octavio Paz, who agonizes over the incommensurate times of the center and the periphery and of belonging to the margins that automatically suffer from a case of delayed time. Starting by saying that Mexicans "have been expelled from the present," he continues:

> In spite of what my senses told me, the time from over there, belonging to the others, was the real one, the time of the real present. For us, as Spanish Americans, the real present was not in our own countries: it was the time lived by others, by the English, the French and the Germans. It was the time of New York, Paris, London. I wanted to belong to my time and to my century . . . I wanted to be a modern poet . . . The idea of modernity is a by-product of our conception of history as a unique and linear process of succession . . . Modernity is the spearhead of historical movement, the incarnation of evolution or revolution, the two faces of progress.[9]

These are persuasive interventions. But whether modernism or global contemporary, these movements outside the West remain the prisoner of art historiography and its

"progressivist" chronological schema. The benchmark for this was set by Giorgio Vasari, the seventeenth-century Italian artist and biographer. He had raised the issue of temporality when he defined the relationship between center and periphery as dependent not only on spatial *but also* on temporal factors. Vasari had presented the conquest of representation as a continuous story that started with Cimabue and continued through Leonardo to Michelangelo and Raphael. He further asserted that Florence, and to a lesser extent, Rome and Venice were the sole centers of innovation, while other schools such as Parma—the site for instance of Correggio's work— suffered from a delayed growth. Thus, Correggio's work has generally been assessed in terms of "catching up" with the styles of Michelangelo and Raphael rather than being a unique achievement. This severely linear framework deployed in the history of the Italian Renaissance was extended in the nineteenth century to the art of the rest of the world, in order to construct a universal history of art, ranking different countries within an evolutionary framework.[10] Modernism, as well as more recent global Contemporary Art, carry this legacy so that art from the periphery is always viewed as trying to "catch up" with the innovations of the metropolitan center.

The problem of the incommensurability of different time structures in global Contemporary Art, as underscored by Néstor García Canclini, for instance, remains.[11] This problem however is not confined to art history. To take the case of anthropology, accepted as one of the most outward-looking disciplines, Johannes Fabian, the Dutch anthropologist, lays bare the colonial underpinnings of anthropological self-confidence in its claimed objective methodology, based on a functional non-judgmental relativism. During fieldwork, the anthropologists and their interlocutors as partners exist in contemporary time. Yet the anthropological discourse no longer presents the same interlocutors as partners, but as the other, temporally different (primitive, less developed, unchanging). Such a "schizogenic" discourse that represents the other as existing in another time helps to justify colonial domination by universalizing western progress. The striking fact is that Fabian's view of this contradiction between theory and practice as a problem of clashing temporalities contains valuable lessons for the discordant global modernism.[12]

Creating an Art History for the Indians

While acknowledging this worldwide problem that exists across disciplines, let me focus on its particular ramifications in Indian art history. Contemporary and modernist artists in the subcontinent, in their denial of history, indeed carry the legacy of a century and half of colonial historiography. An art history for India was the collaborative work of colonial archaeologists and art historians. In 1874 Henry H. Cole offered the blueprint for the first art history of India in his brief introduction to the Indian objects at the South Kensington Museum (later renamed the Victoria and Albert Museum), though in fact German historians of world art, such as Franz Kugler in *Handbuch der Kunstgeschichte* (1842), Carl Schnaase in his monumental eight-volume work *Geschichte der bildende Künste* (1843–79), which faithfully applied the Hegelian concept of progress to world art, and Wilhelm Lübke's *Grundriss der Kunstgeschichte* (1860), had already included India in their universal art histories.[13] Cole correctly made the observation: "Up to the present time no work has, I believe, appeared which avowedly deals with the general subject of Indian art."[14] But he faced the vexing question of creating a convincing chronological framework that traced the

evolution of styles, or the question of how a particular style was related to previous or subsequent ones. This had been the central preoccupation of nineteenth-century art historians. Aesthetic judgments were directly interlinked with the morphology and evolution of styles.

It was left to the true father of Indian art history, the architectural historian James Fergusson, to construct the first clearly enunciated and secure chronology for the discipline. Fergusson acquired renown as the first universal historian of architecture in Britain. In 1876 he published the magisterial volume *The History of Indian and Eastern Architecture*. His Indian experience had indeed been formative in his work on world architecture.[15] Unlike Cole, Fergusson had ambitions of offering a convincing theoretical framework for the rise of historic architecture throughout Europe and Asia. Confronting ancient Indian architecture, he faced the problem of providing a chronological framework for its origin, rise, and decline. The nineteenth century saw the development of the discipline of art history in the West, which wedded Vasarian norms of artistic perfection to the newly fashionable evolutionary principles. These principles were implicit not only in Fergusson but also in the classificatory schema of colonial archaeology, officiated by the Archaeological Survey of India, about which I shall say more later.

As an architectural historian, Fergusson naturally concerned himself with the evolution of Indian architecture, of how perfection was reached and how then decline set in. The problem of the rise and fall of artistic styles, held together by a powerful teleological narrative, was by no means confined to Indian art. The question of periodization has haunted art historians since the late nineteenth century. Periodization goes back to classical antiquity, the fourfold schema, ages of gold, silver, bronze, and iron, parallel to the Indian *satya*, *dvapara*, *treta*, and *kali yuga* (based on the numbers of the dice, favourite game of the ancient Indians). The rise of history as a discipline in the nineteenth century led to conscious thinking about the problem of periodization in an effort to impose order on the flux or continuum of events from the past. A threefold periodization of European history, namely, ancient, medieval, and modern, has been drummed into the mind of every schoolboy and schoolgirl. More specific art historical periodization, such as Gothic, Classical, Baroque, and Rococo, was a reflection of the Vasarian rules of classical taste.[16] Fergusson faced the related problem of artistic decadence in *The History of Indian and Eastern Architecture*:

> Sculpture in India may fairly claim to rank, in power of expression, with mediaeval sculpture in Europe, and tell its tale of rise and decay with equal distinctness, but it is also interesting as having that Indian peculiarity of being written decay. The story that Cicognara tells [of medieval European art] is one of steady forward progress towards higher aims and better execution. The Indian story is that of backward decline from the sculptures of Bharhut and Amaravati topes, to the illustrations of Coleman's "Hindu mythology."[17]

The question that Fergusson faced with an unfamiliar artistic tradition was: how do you explain changes in the morphology of art objects or architecture because clearly the moment you study a series of related monuments, you need to account for their similarities and differences? Arguably, in most cases, one may trace development from simple forms to more complex ones, as each generation solves ever new artistic and architectural problems. Of course, such development often follows the religious and

cultural imperatives—the inner logic—of a particular society. Fergusson found it relatively simple to recognize this in medieval European art. In the case of ancient Indian monuments, he could similarly have traced their evolution in terms of steady improvements in technology and the growth of ever-higher aims, from the early Buddhist monuments to the late Hindu temples.

But instead of doing that, why did he apply a theory of "backward decline" to ancient Indian sculpture and architecture? There is no question that Fergusson had engaged in fieldwork in the subcontinent with admirable diligence, whose fruits not only enriched his ambitious work on India, but also benefited all subsequent colonial and nationalist scholarship on Indian architecture, not to mention his own work on world art. Furthermore, his documentation of antiquities, enriched by photographic images, had nourished the emerging discipline of Indian archaeology. But with inadequate knowledge of Sanskrit, he was less comfortable with indigenous literary sources, some of which were gradually being annotated and translated.[18] A sound knowledge of the literary sources would have provided him with the internal logic of ancient Indian architecture. Failing to see this logic, he took recourse to this novel solution. Ultimately, his theory of decline was dependent on an extraneous aesthetic judgment based on his classical bias. Equally, his choice of the Buddhist monuments, the Bharhut and Amaravati *stupas*, the earliest extant monuments in India, as the pinnacle of perfection in Indian sculpture and architecture, went back to the same Vasarian strictures on economy, order, and balance. On these criteria, Hindu temple architecture became a perfect example of decadence, in other words, of bad taste. Consequently, he drew the conclusion that Indian sculpture and architecture demonstrated a steady decline from its early perfection to the grotesque "monstrosities" of the late Dravidian temples of Southern India. This was a powerful if misguided chronology, but it provided a seemingly irrefutable scaffolding for the subsequent histories of art in India.[19]

Sensing the need to make his theory more convincing, Fergusson appealed to the prevailing Aryan racial theory, which claimed that those who spoke one of the Indo-European languages also belonged to the same racial family with its distinct culture. In the light of this, colonial scholars classified ancient Indian culture into two broad groups—the Aryans in the north and the Dravidians in the south. Accordingly, Fergusson categorized art and architecture of the north as Aryan and those of the south as Dravidian: two culturally separate people produced two totally separate, hermetically sealed, artistic traditions. Artistic decline began with racial mixture in the Hindu period; it led inexorably to the deterioration of the original pure race and consequently to the degraded religion and its product, decadent tasteless art. Here was a convenient peg to hold up his view of the "inverted" evolution of Indian art and architecture.[20]

It is interesting that Fergusson was convinced of the two racially self-contained monolithic parts of India. While trumpeting the essential cultural *difference* between north and south, he also, somewhat paradoxically, failed to recognize the greater truth of regional differences. With India, a culturally diverse landmass, each region boasts its own history of art and architecture, often with its distinct visual language. But instead of seeking a contextual analysis for each region, which recognized the rich diversity of regional expressions, Fergusson superimposed a linear chronology, colored by a powerful ideology of progress, on the artistic map of India, singling out the significant monuments throughout history that served to reinforce the dominant chronology.

Nationalist art historians naturally took Fergusson's magisterial presentation of a linear history with a singular chronology to be set in stone. The purported first vernacular venture in art history, *The Rise of the Fine Arts and the Artistic Skills of the Aryans* (1874), was published in Bengali by Shyamacharan Srimani, an instructor of drawing at the government art school in Calcutta.[21] Inspired by Fergusson, he traced the histories of world art in his slim volume, prefacing with a discourse on the origin of art. His objective in this was to refute colonial archaeologists who had denied fine arts to India. Nonetheless, accepting the representational criterion of artistic progress, he admitted its absence in Indian art.

Colonial Time and Rediscovery of the Indian Past

Early colonial scholars without exception—comparative linguists, archaeologists, not to mention the art and architectural historian Fergusson—were fired by the romance of rediscovering the lost civilization of ancient India. Their creation of a consistent image of the past was inspired by European notions of history, linear time and uniform chronology. The period also witnessed the growing institutionalization of the practice of documenting surviving antiquities in India, which went hand in hand with the discovery and annotation of key texts, led by the Asiatic Society of Bengal and later the Royal Asiatic Society of London. In this, once again, important foundations were laid by Fergusson with his pioneering studies of architectural remains, and by Alexander Cunningham, the redoubtable first director of the Architectural Survey of India, the official organ for surveying and recording systematically the monumental antiquities of India.[22] These above efforts at mapping ancient monuments and amassing ancient texts began to yield a framework for the construction of a coherent historical timeframe. Colonial scholars, engaged in the construction of a chronology for India, turned to the standard European historical schema of the ancient, medieval, and modern periods, but with added cultural refinements: Buddhist and Early Hindu (ancient); later Hindu and Islamic (medieval); colonial (modern). The triangular interlocking timeframe of Indian history into three broad periods was inspired by James Mill's influential history dating from 1817: the first two dominated by two major religions, Hindu/Buddhist, followed by Islam, giving way to secular British rule.[23]

Indians had a different sense of the past from that of the West. India's history shows the accumulations of successive layers of overlapping cultures, so that people in the recent period had not retained a clear idea of the earlier eras and saw the past as a continuum, as was the case with pre-modern Europe. The very ancient period had survived largely in ruined monuments and in Sanskrit and Pali writings, but the relevance of the material remains to written texts had been lost in the mists of time.[24] Extensive excavations and meticulous surveys undertaken by the Raj for better control of the territory paved the way for major archaeological discoveries. These scholarly endeavors re-valorized ancient monuments which had suffered oblivion.[25] One such sensational case was James Prinsep's decipherment of Ashokan inscriptions, which put this virtually forgotten Buddhist emperor firmly on the map of ancient India. The royal edicts on stone pillars and rock faces offered concrete evidence of this pacifist emperor's unique place in Indian history, indeed, world history. There were many other epigraphic sources that helped create a political history for ancient India. The colonial archaeologists, who were engaged in "restoring" the past of the subcontinent, were also keen to impose a rational order on the cumulative knowledge from the

middle of the eighteenth century. Archaeology made significant contributions to the construction of a historical narrative for India that was utilized by both colonial and nationalist historians. It is an ironic fact that while colonial rulers and nationalists of colonized countries are often in an agonistic relationship, both the colonizers and the nationalists tend to appeal to the same sources from the past. As I have shown elsewhere, one of the prime ingredients of collective memory in India was originally offered by colonial archaeology.[26]

The second aspect of this knowledge revolution was not only the creation of a new conception of time but also a new chronology for the colonized. We have touched upon the fact that in ancient India, as in classical antiquity, time was imagined as cyclical in the *longue durée*, though in the short span, conceived as in constant decline from a mythical golden age to the present. To put it in a nutshell, before the eighteenth century, everywhere (including Europe) the notion of decline prevailed. However, in Europe, the two strands, namely decline, co-existed with germs of progress derived from millenarianism.[27]

The situation changed dramatically in Europe in the mid-eighteenth century with the emergence of notions of progress as the engine of historical development, a period that coincided with European expansion overseas. Progress redefined the past in the light of the present and with an ever-expanding optimism about the future, drastically revising the medieval sense of time and history. A moral dimension was added to development, propelling it in a direction that maximized human happiness by means of social engineering. These changes were in conjunction with the revolution in the physical sciences. The conceptual framework of science was furnished by Greek empiricism and ancient Indian place value system of numbers, and the function of zero, while the Chinese provided the technology of paper and the printing press, distillery, gunpowder, and the compass.[28]

A new confidence was marked by Cartesian rationality and Pierre Bayle's historical criticism. The famous intellectual debate in France in the eighteenth century on the superiority of ancient knowledge vis-à-vis modern, celebrated as the *La Querelle des Anciens et des Modernes*, undermined the unquestioned reverence for ancient authority. Progress was seen as an impersonal historical process with a momentum of its own. The process culminated in Hegel's grand design of history as the progress of the Universal Spirit (*Geist*) through time.[29]

The late eighteenth-century Orientalists, most of whom were East India Company officials, came fully armed with ideas of progress. Consequently, their first encounters with Indian texts precipitated a conflict—European claims of "rational," objective historical time that always went forward, and notions of cyclical time and of decline in Hindu mythological and genealogical treatises containing historical material, such as in the *Purāṇas*.[30] The crisis was caused by practical administrative difficulties the East India Company officials faced, which they needed to resolve. In seeking to establish uniform legal and revenue systems, they were confronted with a plethora of regional time reckonings in a variety of indigenous documents.

But first, the calendar, whose function is to organize social, religious, administrative, and commercial activities. Before colonial rule, a host of regional calendars based upon a combination of solar and lunar systems predominated. By the end of the eighteenth century, when the Company gained control over eastern India, over thirty calendars were in use by Hindus, Muslims, Christians, and Parsis. For administrative efficiency, the Company embarked on "rationalizing" time by standardizing these

conflicting calendars and superimposing the Gregorian calendar on the subcontinent. Things were no clearer in Britain either and the need was felt for uniformity in clear dates for public events. In 1750, the Gregorian calendar was introduced in Britain and the Empire with the enactment of the Calendar (New Style) Act of the Parliament.[31] But perhaps the most significant aspect of the Gregorian calendar was not the changes it brought about, but rather its hegemonic role at the onset of the globalized era. Over the centuries, countries around the world had used a variety of uncoordinated calendars, each evolving in the light of local needs and geographic factors. The sun and the moon determined the days, months, and years in all calendars, and additionally the planets for the seven days of the week. Most calendars had to make intercalary adjustments of leap years, and in that sense the Gregorian calendar was no more "rational" than Indian ones. The systems used by mankind to track, organize, and manipulate time have often been arbitrary, uneven, and disruptive, especially when designed poorly or foisted upon an unwilling society by state power.

The western calendar, based on the solar system, with its division of the days, months, and seasons, with some intercalary (leap year) adjustments related to the lunar passage, was adopted by the colonial rulers for administrative departments, public institutions, schools, and places of higher learning. Within decades it became an essential part of Indian life. Nonetheless, Indian calendars, belonging to the Hindu and Muslim religions, to name the most important, continued to play an important part in indigenous trade and agriculture, as well as religious and social activities. Yet there were significant differences between the Gregorian and Indian calendars. To take the example of the Bengali *panjikā* (almanac), the months of the year were an amalgam of solar and lunar systems, with each of the twelve months varying between 28 and 32 days. The day was divided into two parts: 12 daylight and 12 nocturnal hours. The 24 indigenous hours were based on each unit of 3 hours called *prahar* (3 hours × 8 = 24 hours). Finally, unlike four European seasons, six Bengali (also Indian) seasons were Grishma (summer), Barshā (Monsoon), Sharat (Autumn), Hemanta (late autumn), Sheet (winter), and Basanta (spring).[32]

Second, the Christian Era, the reckoning of years calculated from the birth of Christ (Anno Domini or AD, now known as the Common Era or CE), was also imposed by the East India Company on the subcontinent for the sake of uniformity, replacing a number of indigenous eras (for example, the Shaka Era 68 CE, the Vikrama Era 58 BCE, Islamic Hijira Era 622 CE, and the Bengali Era or Bangābda 594 CE). It replaced the Bengali Era (594 CE), the best-known one in eastern India, legitimized by the Mughal Emperor Akbar (1556–1605), which had been effectively employed in the land revenue system that the Company inherited from the Mughal Empire.[33] The new era was invoked in official and public discourses. The irreconcilable nature of two parallel universes, namely, a singular dominant chronology in official transactions and the prevailing pre-colonial chronology in vernacular usage, led to a schizophrenic existence for the nationalists. Interestingly, Bengali writers, for example, used the Christian era in their English writings while employing the *shatābdi* (Bengali century) in vernacular literature. The leading Bengali journals, for instance, used the Bengali months as well as the Bangla Era (1900 AD = ca. 1307 *Bānglā Shatābda*).[34]

This ambivalence also affected profoundly the nationalist artists, who continued to use both reckonings in their evocation of the past. Nationalist history painting became a vehicle for sending the imagination back to the past, aided by Orientalist scholarship, the epics, and Paurānic mythology. Nationalist art history thus became beholden

to the principles of a singular chronology introduced by colonialism. The academic artist Ravi Varma, celebrated creator of the first nationalist art, drew upon the epics where the line between history and myth was thinly drawn, accepting however the unified linear chronology that transcended regional narratives, such as that of his native Kerala. The next generation of nationalist artists of the Bengal School, led by Abanindranath Tagore, condemned Varma's brand of Victorian painting as a colonial hybrid; nonetheless, they continued to rely on the same epics and classical Sanskrit literature for their invention of the past, drawing upon the same Pan-Indian history that transcended regional identities. In short, the singular chronology imposed by the colonial archaeologists became the bedrock of the nationalist artists in their "historicist" imaging of Indian's past. Only in the 1920s, when politicians started questioning the scope of urban Pan-Indian nationalism, did artists such as Jamini Roy seek to explore Bengali regional identity as part of a new consciousness of the countryside and the peasant.[35]

The impact of a standardized chronology fueled by a teleological re-imagining of the past had an immediate effect in eighteenth-century Europe. The first beneficiary of such standardization was colonial archaeology in India. The new approach enabled orientalists to plot the discoveries of Indian antiquities within a single timeframe. Thus was born a linear history for ancient India as told by its colonial historians, and adopted by various nationalists in the construction of their imagined communities. The problem is that, in a subcontinent inhabited by myriad communities with multiple collective memories, such a seemingly "rational" solution to the problem of history became plagued with inconsistencies. It became a case of competing inventions of the past and conflicting collective memories. The Hindus, the majority population, who welcomed the orientalist construction of ancient India, made exclusive claims to India's past, in effect disenfranchising other communities. In response to Hindu nationalist claims, the Muslims, the largest minority in India, constructed their own image of the nation's heritage. The most extreme example of this imagined chronology has been the recent attempts by extreme Hindu political parties to construct a historical narrative that would link up ancient Hindu India directly with the colonial era, thus erasing the intervening period of Turko-Afghan and Mughal rule. Moreover, linear colonial time, which sought to bury the epic time of traditional India, constantly came up against the indigenous re-fashioning of collective memory. Multiplicities of collective memory in India that created multiple temporalities could consequently offer multiple perspectives on modernism.[36]

What Now? Radical Changes in Our Historical Thinking

To bring this brief excursus on Indian historical imagination to a conclusion, recent critiques by contemporary Indian historians of orientalist historiography form part of a global paradigm shift of the whole discipline and practice of what is meant by history. One of the casualties of the aftermath of World War II was the optimistic universalism of the previous generation raised on Enlightenment values. The decolonisation process brought into question the primacy of Euro-American dominance, as minorities began to find their own voices. New approaches encouraged the study of other cultures, as relativism reared its inconvenient head. The decades from the 1960s to the present have seen a veritable revolution in our thinking about history,

undermining the staunch faith in the historical truth, the notion of progress, and a hard-nosed approach to facts.

These global sea changes affected what had been the bedrock of colonial history, dependent on the notion of linear time and the growth of the political state.[37] Orientalist historians were tutored in the European definition of history as a chronicle of ruling dynasties, the consolidation and dissolution of territorial integrity in wars, and the growth of the modern state. By this token, ancient India, with its lack of large empires and its loose federations of rulers, was an incomplete historical subject, a domain of prehistory rather than history.

However, even in the West, this notion of the history came under sustained attack as new histories started questioning the dominant narrative of the white elite patriarchy. They concentrated on historic communities that shared common values and memories, and on the history of minorities, such as women, gays and lesbians, the underclass, or the colonised. Therefore, the archive had to be newly defined and needed to take note of oral evidence, personal memoirs and ephemera.[38]

The history of the reception of ideas, later refined as intellectual history, completed the process, as it turned to the science of Hermeneutics, or historical interpretation of texts from the past.[39] In the 1960s, the emerging interest in Hermeneutics rediscovered Wilhelm Dilthey's notion of the historical character of our cultural expressions, and the universal structures of mental experiences.[40] While Dilthey emphasized the importance of texts, another group of textual interpreters placed equal importance on authorial intention, and warned against relying implicitly on the text itself.[41] The most radical rejection of authorial intention came from the opposite groups, allied with post-modernism, who declared the ultimate autonomy of the text, paraphrasing Jacques Derrida's notion: "Il n'y a rien hors du texte" (there is nothing outside the text).[42]

However, even among mainstream historians, the notion of a single historical truth and historical objectivity has come under attack. Gone are the days of Ranke's optimistic declaration of faith: to record dispassionately things as they were (*wie es eigenlich gewesen*), fueled by an underlying belief in the inevitability of social progress, commonly described as the Whig interpretation of history. In 1961, E. H. Carr made his celebrated intervention in the Macaulay Lectures, where he questioned Ranke's dictum, proposing the limits of historical truth and the idea that without an initial hypothesis, facts were useless.[43]

These developments were also witnessed in the field of Indian history, as linear teleological history began to be undermined by the radical historians, spearheaded by the influential group of Subaltern historians.[44] The Orientalists had claimed that India was unique among civilizations in lacking historical writing. Two standard textbooks of Indian history reiterated this "lacuna." *The Oxford History of India* (1911) laments the fact that chronological uncertainty spoils not only social and cultural history but also political history, concluding that no Hindu text attains the European ideal of a formal history. *The Cambridge History of India* (1922) complains that in ancient Indian literature, not a single work is comparable to that of Herodotus or Livy. The epics failed to develop into history because of religious preoccupation. Thus, "as records of political progress they are deficient."[45] To the Indian historians of today, the Hegelian framework with progress as its engine and the primacy of state power as its driving force, which informs much of European history, is inapplicable to the

Indian situation. Important challenges to the singular chronology of coloniality mark the historiographic landscape of the present post-colonial world. Dipesh Chakrabarty questions the primacy of the colonial definition of time to explain India's past, aiming to find ways of reducing its "rationalist" claims to universality.[46]

Ranajit Guha, historian and doyen of Subaltern Studies, makes one of the most original, radical, and, one may say, searching interventions. The "rational" and elegant solution imposed on the problem of ancient Indian history in a multi-cultural subcontinent with its different regional histories, became rather messy and far removed from reality. Second, in the "creation" of ancient India, despite the asserted accuracy of Orientalist historians, this interpretation of history was replete with speculations regarding dating and "facts," making the past a highly contested terrain. As Ranajit Guha puts it with compelling clarity, the Hegelian concept of history reduces the course of human history to an amoral record of states and empires, consigning the quotidian experience of the ordinary people to prehistory. In the case of India, where dates and other data are in short supply, the imposition of a Hegelian historical framework is particularly invasive. Arguably, a different experiential concept of history prevailed in the subcontinent and we need to consider a new approach for recapturing a fully human past of experience and "wonder" that will not be dependent on such Hegelian foundations.[47]

Two leading ancient historians have also dismissed the European complaint about the absence of historical imagination in ancient India: Vishwambhar Sharan Pathak and Romila Thapar. As they point out, ancient India drew its sense of the past from a vast range of sources, of which religious texts were one, and that its understanding of the past differed radically from western notions of history. Romila Thapar has sought to make the most extensive revision of the Orientalist approach to ancient India. In 1993, she observed that the Orientalist complaint about the absence of historical change was based on a misreading of Indian texts such as the Itihāsa-Purāna that failed to recognize change. Second, in India, the unit of history was not the empire, but the *janapada*, territories settled by tribes or communities that grew into kingdoms. The reality was a loose confederation of kingdoms, often under the nominal rule of an overlord. Therefore, the terms for an emperor, *chakravartin* or *samrāt*, were more abstractions than objective facts. However, the wider society was held together by means of myths and genealogies, while historical time was recorded precisely in inscriptions derived from the solar calendar. Historical consciousness, she concludes, grew out of what she terms "embedded history."[48]

In 2013 Thapar expanded her original thesis, observing that there was an urgent need to recognize the historical sense of societies whose past was recorded in ways that were different from prevailing European conventions. The history documented in Indian epics such as the Ramayana and the Mahabharata was less concerned with authenticating persons and events by means of an overriding chronology than with presenting a picture of traditions striving to retain legitimacy and continuity amid rapid social change. Thapar delineated three distinct historical traditions in ancient India: an *Itihāsa-Purāna* tradition of Brahman authors; a tradition consisting mainly of Buddhist and Jaina scholars; and a popular bardic tradition. The Vedic corpus, the epics, the Buddhist canon and monastic chronicles, inscriptions, regional accounts, and royal biographies and dramas were not sources to be mined for factual data, but as genres that disclosed how Indians of ancient times represented their own past to themselves.[49]

In *Time as a Metaphor of History: Early India*, Romila Thapar offers further argu-
ments against the western stereotype that Indians had no sense of history. She dis-
tinguishes between two different types of time that existed in ancient Indian texts:
cyclical time in sacred and mythological texts; and linear time that was used for texts
that documented actual reigns and other political events. One of the famous historical
texts is the *Rājataranginī* by the twelfth-century Kashmiri historian Kalhana (1148
CE) that deploys linear time. His work is less important for its accuracy than for its
critical model. Though his experience was limited to Kashmir, his historical explana-
tions and philosophical reflections as well as the use of a wide variety of sources—
royal chronicles, stone or metal inscriptions on royal eulogies, land grants, coins, and
family records—and a certain amount of unbiased objectivity presuppose the exis-
tence of a historiographic tradition.[50]

I began with the predicament of contemporary Indian artists. Faced with a secure
teleology of modernism that was underpinned by the western calendar and the Chris-
tian era as universal categories, these artists rejected history and linear time altogether.
But as I have tried to show, the problem lay deeper and is only now being properly
addressed by Indian historians. However, the mismatch between a universalist chro-
nology of colonial modern and different regional timeframes will continue to be a
central problematic of Indian modernism.

Notes

1. D. Hockney and M. Gayford, *A History of Pictures* (London: Thames & Hudson, 2016),
 cited in a review in the *Sunday Times* (October 2, 2016).
2. On the predicament of heterochronicity in present thinking about modernism and Con-
 temporary Art, see Keith Moxey, *Visual Time: The Image in History* (Durham, NC: Duke
 University Press, 2013), 37–50.
3. I am indebted to Parul Dave Mukherjee for the insight, whose essay, "Inventing the Popu-
 lar: When People Become Public," is in the forthcoming volume *Twentieth Century Indian
 Art*, eds. Partha Mitter, Parul Dave Mukherjee, and Rakhee Balaram.
4. National Gallery of Modern Art, New Delhi, December 18, 2014–February 15, 2015, www.
 raqsmediacollective.net/exhibitions.aspx (accessed December 28, 2017). Asamayavali/
 Untimely Calendar is a solo exhibition that was held at the National Gallery of Modern
 Art, New Delhi in 2014–15.
5. Geeta Kapur, "When was Modernism in Indian Art?," in *When Was Modernism: Essays
 on Contemporary Cultural Practice in India* (New Delhi: Tulika Books, 2000), 297–324.
 Kapur quotes Raymond Williams, *The Politics of Modernism: Against the New Conform-
 ists* (London: Verso, 1989), 35, who argues that modernism has become ahistorical and
 should be challenged with alternative traditions that lie on the margins. She is more ambiv-
 alent about western historical framework while seeking to provide a parallel trajectory.
6. Kapur, "When was Modernism . . .?", 298–99.
7. Kapur, "When was Modernism . . .?", 298.
8. N. G. Canclini, *Hybrid Cultures: Strategies for Entering and Leaving Modernity*, trans.
 C. Chiappari and S. Lopez (Minneapolis: University of Minnesota Press, 1995); Gerardo
 Mosquera, "Modernity and Africana: Wifredo Lam on His Island," in Fundació Joan Miró,
 cited in L. S. Sims, *Wifredo Lam and the International Avant-Garde, 1923–1982* (Austin:
 University of Texas Press, 2002), 236.
9. See www.nobelprize.org/nobel_prizes/literature/laureates/1990/paz-lecture.html (accessed
 December 1, 2017). I am deeply indebted to Devika Singh for drawing my attention to
 Paz's speech on receiving the Nobel Prize in 1990.
10. On Vasari's treatment of artists by their national differences, see Thomas Kauffman, "Ste-
 reotypes, Prejudice and Aesthetic Judgment," in *Art History Aesthetics Visual Studies*, eds.
 Michael Ann Holly and Keith Moxey (Williamstown, MA: Sterling and Francine Clark

Art Institute, 2002), 73. Thomas Kaufmann, Malaise dans la périodisation, *Perspective. La Revue de l'INHA, 2008–4: Périodisation et histoire de l'Art,* 2008(4): 597–601. See Pier Luigi De Vecchi and Giancarla Periti "Introduction," in *Emilia e Marche Nel Renascimento: L'Identita Visiva della "Periferia,"* , ed., Giancarla Periti (Azzano San Paolo: Bolis Edizioni, 2005), 7–11. See also Enrico Castelnuovo and Carlo Ginsberg's "Centro e periferia," in *Storia dell' arte italiana,* I (Turin: Einaudi, 1979), 285–354.

11. John Clark, "Open and Close Discourses of Modernity in Asian Art," in *Modernity in Asian Art,* ed. John Clark (Wild Peony, Australia: Asia Art Archive, 1993). Clark is one of the authors who have sought to resolve this issue of the incommensurability of Asian and western timeframes by considering modernisms in different Asian regions in their cultural contexts. See his introduction to *Modern Asian Art* (North Ryde: Craftsman House & G+B Arts International, Australia, 1998), 11–27.

12. Johannes Fabian, *Time and the Other: How Anthropology Makes its Object* (New York: Columbia University Press, 1983). See also the masterly summary "Strong Reading, Johannes Fabian, "Time and the Other,' " http://strongreading.blogspot.com/2011/07/johannes-fabian-time-and-other.html (accessed December 1, 2017). I am indebted to Ricardo Soares de Oliviera for the reference.

13. Franz Kugler, *Handbuch der Kunstgeschichte* (Stuttgart: Ebner & Seubert, 1842); Carl Schnaase, *Geschichte der bildende Künste,* 8 vols. (Düsseldorf: Julius Buddeus, 1843–79); and Wilhelm Lübke, *Grundriss der Kunstgeschichte* (Stuttgart: Ebner & Seubert, 1860).

14. H. H. Cole, *Catalogue of the Objects of Indian Art Exhibited in the South Kensington Museum* (London: Chapman & Hall, 1873) ix.

15. J. Fergusson, *A History of Architecture in All Countries from the Earliest Times to the Present Day* (London: John Murray, 1965–67); volume IV, *The History of Indian and Eastern Architecture,* was published in 1876 (London: John Murray).

16. E. H. Gombrich, "Norm and Form: The Stylistic Categories of Art History and their Origins in Renaissance Ideals," in *Norm and Form: Studies in the Art of the Renaissance* (London: Phaidon Press, 1966) 81–85.

17. Fergusson, *A History of Architecture,*34. Leopoldo Cicognara (1767–1834) was renowned in the nineteenth century for his writings on the monuments of Venice and for his art library, which eventually went to the Vatican (see *Dictionary of Art Historians,* https://dictionaryofarthistorians.org/cicognaral.htm (accessed December 1, 2017).

But of course questions of decadence (see Gombrich, "Norm and Form") were not confined to Indian art. The organic metaphor of the birth, maturity, and decay of a style had been the staple diet of historians of western art. See H. Wolfflin, *Principles of Art History: The Problem of the Development of Style in Later Art* (New York: Dover Publications, 1932). This is the English translation from the 1927 edition of *Kunstgeschichtliche Grundbegriffe: Das Problem der Stilentwicklung in der neueren Kunst* (which is virtually the same as the München 1915 first edition) on his rejection of the concept of decadence.

18. Rajendralala Mitra, a contemporary Indian scholar, drew attention to Fergusson's inadequate knowledge of Sanskrit, resulting in an acrimonious encounter with him. See Partha Mitter, *Art and Nationalism in Colonial India 1850–1922* (Cambridge: Cambridge University Press, 1994), 226–27.

19. Partha Mitter, *Much Maligned Monsters: History of European Reactions to Indian Art* (Oxford: Clarendon Press, 1977), 262–67.

20. Partha Mitter, "The Aryan Myth and British Writers on Indian Art and Culture," in *Literature and Imperialism,* ed. Bart Moore-Gilbert (Roehampton: University of Surrey Press, 1983), 69–92.

21. S. Srimani, *Sukshma Shilper Utpatti o Ārya Jātir Shilpa Chāturi* (Kolkata: Roy Press, 1874), reprinted in S. Som and A. Acharya, *Trends in Bengali Art Criticism (Bānglā Shilpa Samālochanār Dhārā)* (Kolkata: Anustup Prakāshani, 1986), 1–56 (my quotes are from the reprint). See also Mitter, *Art and Nationalism in Colonial India,* 224–26.

22. Guha-Thakurta, Tapati, *Monuments, Objects, Histories: Institutions of Art in Colonial and Postcolonial India* (New York: Columbia University Press, 2004), Part I, which sets out the important achievements of the early antiquaries and archaeologists in documenting ancient Indian monuments.

23. James Mill, *The History of British India,* 3 vols. (London: Baldwin, Cradock and Joy, 1817). On Mill, see Mitter, *Much Maligned Monsters,* 173–77.

24. Partha Mitter, 'Monuments and Memory for Our Times," in *The Afterlives of Monuments*, ed. Deborah Cherry (New York: Routledge, 2014), 159–67. Interestingly, the sense that the past was part of a continuum was a prevailing belief during the Renaissance. Only in the Romantic period was the past seen in essence as different from the present that needed to be interpreted, a sentiment that was in accordance with the rise of archaeology, and confirmed in the quarrel of the ancients and moderns. Winckelmann's profound nostalgia for the irrevocable loss of early civilization's innocence permeated much contemporary European art and literature. See Cherry (ed.), *The Afterlives of Monuments*, 161–62.

25. U. Singh, *Discovery of Ancient India: Early Archaeologists and the Beginnings of Archaeology* (Delhi: Permanent Black, 2004); S. and Roy, *The Story of Indian Archaeology* (New Delhi: Archaeological Survey of India, 1961).

26. Mitter "Monuments and Memory for Our Times," 163. Emperor Ashoka's conscious renunciation of aggressive wars after the bloody battle of Kalinga made him the first pacifist ruler in the world.

27. Medieval psychology at the end of the first millennium was complicated, with its mixture of fear and hope as unimaginable catastrophes were imagined with the arrival of Antichrist at the Apocalypse, as described in the Book of Revelation. See Norman Cohn, *The Pursuit of the Millennium: Revolutionary Millenarians and Mystical Anarchists of the Middle Ages* (London: Secker & Warburg, 1957). While the general feeling was that the end was near, millennarian movements also offered hope for an utopian future.

28. A. L. Basham, *The Wonder that was India* (London: Sidgwick & Jackson, 1954), 495–96; E. H. Gombrich, "Nova Reperta" (unpublished paper) on the arrival of new technology from China.

29. J. B. Bury, *The Idea of Progress: An Enquiry into its Origin and Growth* (London: Macmillan, 1920); H. Rigault, *Histoire de la Querelle des Anciens et des Modernes* (Paris: Librarie de la Hachette, 1856).

30. P. J. Marshall, *The British Discovery of Hinduism in the Eighteenth Century* (Cambridge: Cambridge University Press, 1970) discusses the discovery and study of the key ancient Hindu texts during the late eighteenth century by East India Company officials.

31. On the Calendar (New Style) Act of 1750, see https://en.wikipedia.org/wiki/Calendar_(New_Style)_Act_1750 (accessed December 14, 2017).

32. For a discussion of the indigenous system based on the Hindu time reckoning going back to the ancient times, see P. V. Kane, *History of Dharmaśāstra (Ancient and Mediaeval Religious and Civil Law in India)* vol.V, Part 1 (Poona: Bhandarkar Oriental Research Institute, 1958), 657–67. I am indebted to Mandakranta Bose for a discussion on this.

33. For a brief summary of the Bengali calendar and the Bengali era, see https://en.wikipedia.org/wiki/Bengali_calendars (accessed December 26, 2017).

34. See Mitter, *Art and Nationalism in Colonial India*, 430–34 notes 1–81.

35. Mitter, *Art and Nationalism*, 179–306; Mitter, *The Triumph of Modernism: India's Artists and the Avant-Garde* (London: Reaktion Press; Delhi: Oxford University Press), 100–22. This focus on the peasant and the locality was an outcome of Mahatma Gandhi's Satyagraha movement.

36. Mitter, *Monuments and Memory*, 164–65.

37. G. S. Morris, *Hegel's Philosophy of the State and of History* (Chicago: S. C. Griggs & Co., 1887), 147.

38. Fernand Braudel, *La Méditerranée et le Monde Mediterranéen à l'Époche de Philippe II* (Paris: Armand Colin, 1949); Emmanuel Le Roy Ladurie, *Montaillou: The Promised Land of Error*, trans. Barbara Bray (New York: Brazilier, 1978); G. Rudé, *The Crowd in History* (New York: Wiley & Sons, 1964); E. P. Thompson, *The Making of the English Working Class* (Harmondsworth: Penguin, 1968); Sheila Rowbotham, *Hidden from History* (London: Pluto Press, 1965).

39. The classic works of History of Ideas are Arthur O. Lovejoy and George Boas, *Primitivism and Related Ideas in Antiquity* (Baltimore: Johns Hopkins University Press, 1935) and Arthur O. Lovejoy, *The Great Chain of Being: A Study of the History of an Idea* (Cambridge, MA: Harvard University Press, 1936). The intellectual historians pointed out that the limitations of the History of Ideas (Lovejoy's much criticized unit-ideas) were that it studied concepts in the abstract, suggesting instead that the ideas were needed to be placed in their cultural contexts. But their objections were part of the internal debate within the

history of ideas, as practiced by later historians, such as J. W. Burrow, Quentin Skinner, Anthony Grafton, and so on. In practice, the terms are used interchangeably without doing violence to either side.

40. See the excellent summary of Dilthey's ideas in the *Stanford Encyclopedia of Philosophy*, https://plato.stanford.edu/entries/dilthey (accessed December 1, 2017). See P. Mitter, "Can We Ever Understand Alien Cultures? Some Epistemological Concerns Relating to the Perception and Understanding of the Other," in *Comparative Criticism*, vol. 9, ed. E. S. Shaffer (Cambridge: Cambridge University Press, 1987), 24–29 on Dilthey; H. P. Rickman, *W. Dilthey, Selected Writings* (Cambridge: Cambridge University Press, 1976), based on W. Dilthey, *Gesammelte Schriften*, 26 vols. (Göttingen:Vandenhoek & Ruprecht, 1914–2006).

41. Quentin Skinner, 'Meaning and Understanding in the History of Ideas," *History and Theory* Vlll, no. 1 (1969), 3–53, uses J. L. Austin's theory of speech acts to examine illocutionary effects of speeches.

42. Jacques Derrida, "La préface, qui n-est ni dans le texte, ni hors-texte, pose la question du hors-livre, du luminaire: une démarcation qui met le texte en marche (ce qui se lit de la dissémination." *Derridex, Index des termes de l'oeuvre de Jacques Derrida*. See: www.idixa.net/Pixa/pagixa-0512152008.html (accessed December 14, 2017).

43. E. H. Carr, *What is History?* (Harmondsworth: Penguin, 1964). These George Macaulay Trevelyan lectures were delivered at the University of Cambridge in January–March 1961. G. R. Elton's *The Practice of History* was published in 1967 (London: Fontana Books), partly in answer to Carr. Elton's contention was that historical facts existed independently of the historians' subjectivity, even though he agreed that absolute objectivity was not possible and there were limits to historical knowledge. Nonetheless, the historian's task was to uncover historical facts through rigorous analysis of the data. Elton was against new radical histories and considered Carr's relativism as dangerous. The debate between the two historians became celebrated in British universities. See also Herbert Butterfield, *The Whig Interpretation of History* (London: G. Bell, 1931).

44. The historian Ranajit Guha was the inspiration and guiding spirit of the *Subaltern Studies*. See *Subaltern Studies* I, ed. Ranajit Guha (Oxford: Oxford University Press, 1982), which is described as a product of collective work by a team of historians.

45. E. J. Rapson (ed.), *The Cambridge History of India*, vol. I, *Ancient India* (Cambridge: Cambridge University Press, 1922), 62; V. A. Smith, *The Oxford History of India* (Oxford: Clarendon Press, 1911), xiv–xix.

46. Dipesh Chakrabarty, *Provincializing Europe: Postcolonial Thought and Historical Difference* (Princeton: Princeton University Press, 2000).

47. Ranajit Guha, *History at the Limit of World-History* (New York: Columbia University Press, 2002), 24–47, "The Prose of History or the Invention of World-History," which analyses Hegel's historical method; and 48–75, "Experience, Wonder and the Pathos of Historicality," alternative histories that deal with the people and communities and are based on epics, tradition, and the Itihāsa-Purānas.

48. Romila Thapar, *Interpreting Early History* (Delhi: Oxford University Press, 1993).

49. Romila Thapar, *The Past Before Us: Historical Traditions of Early North India* (Delhi: Permanent Black; Cambridge, MA: Harvard University Press, 2013); V. S. Pathak, *Ancient Historians of India: A Study in Historical Biographies* (Bombay: Asia Publishing House, 1966).

50. Romila Thapar, *Time as a Metaphor of History: Early India* (Delhi: Oxford University Press, 1996).

Bibliography

Basham, A. L. *The Wonder that was India*. London: Sidgwick & Jackson, 1954.

Braudel, Fernand. *La Méditerranée et le Monde Mediterranéen à l'Époche de Philippe II*. Paris: Armand Colin, 1949.

Bury, J. B. *The Idea of Progress: An Enquiry into its Origin and Growth*. London: Macmillan, 1920.

Butterfield, Herbert. *The Whig Interpretation of History*. London: G. Bell, 1931.

Carr, E. H. *What is History?* Harmondsworth: Penguin, 1964.

Cohn, Norman. *The Pursuit of the Millennium: Revolutionary Millenarians and Mystical Anarchists of the Middle Ages.* London: Secker & Warburg, 1957.

Chakrabarty, Dipesh. *Provincializing Europe: Postcolonial Thought and Historical Difference.* Princeton: Princeton University Press, 2000.

Dilthey, Wilhelm. *Gesammelte Schriften,* 26 vols. Göttingen: Vandenhoek & Ruprecht, 1914–2006.

Elton, G. R. *The Practice of History.* London: Fontana Books, 1967.

Fergusson, James. *A History of Architecture in All Countries from the Earliest Times to the Present Day.* London: John Murray, 1965–67; vol. IV, *The History of Indian and Eastern Architecture.* London: John Murray, 1876.

Gombrich, E. H. *Norm and Form: Studies in the Art of the Renaissance.* London: Phaidon, 1966.

Guha, Ranajit, T. *History at the Limit of World-History.* New York: Columbia University Press, 2002.

Guha-Thakurta, T. *Monuments, Objects, Histories: Institutions of Art in Colonial and Postcolonial India.* New York: Columbia University Press, 2004.

Morris, G. S. *Hegel's Philosophy of the State and of History.* Chicago: S. C. Griggs & Co., 1887.

Kane, P. V. *History of Dharmaśāstra (Ancient and Mediaeval Religious and Civil Law in India)* vol. V, Part 1. Poona: Bhandarkar Oriental Research Institute, 1958.

Le Roy Ladurie, E. *Montaillou: The Promised Land of Error.* Trans. Barbara Bray. New York. Brazilier, 1978.

Lovejoy, A. O. *The Great Chain of Being: A Study of the History of an Idea.* Cambridge, MA: Harvard University Press, 1936.

Lovejoy, A. O. and George Boas. *Primitivism and Related Ideas in Antiquity.* Baltimore: Johns Hopkins University Press, 1935.

Marshall, P. J. *The British Discovery of Hinduism in the Eighteenth Century.* Cambridge: Cambridge University Press, 1970.

Mill, James. *The History of British India,* 3 vols. London: Baldwin, Cradock and Joy, London 1817.

Mitter, Partha. *Much Maligned Monsters: History of European Reactions to Indian Art.* Oxford: Clarendon Press, 1977.

Mitter, Partha. "The Aryan Myth and British Writers on Indian Art and Culture," in *Literature and Imperialism,* ed. Bart Moore-Gilbert (Roehampton: University of Surrey Press, 1983), 69–92.

Mitter, Partha. "Can We Ever Understand Alien Cultures? Some Epistemological Concerns Relating to the Perception and Understanding of the Other," in *Comparative Criticism,* vol. 9, ed. E. S. Shaffer. Cambridge: Cambridge University Press, 1987.

Mitter, Partha. *Art and Nationalism in Colonial India 1850–1922.* Cambridge: Cambridge University Press, 1994.

Mitter, Partha. *The Triumph of Modernism: India's Artists and the Avant-garde.* London: Reaktion Press; Delhi: Oxford University Press, 2007.

Mitter, Partha. "Monuments and Memory for Our Times," in *The Afterlives of Monuments,* ed. Deborah Cherry. New York: Routledge, 2014, 159–67.

Pathak, V. S. *Ancient Historians of India: A Study in Historical Biographies.* Bombay: Asia Publishing House, 1966.

Rapson, E. J. ed. *The Cambridge History of India,* vol. I, *Ancient India.* Cambridge: Cambridge University Press, 1922.

Rickman, Hans Peter. *W. Dilthey, Selected Writings.* Cambridge: Cambridge University Press, 1976.

Rowbotham, Sheila. *Hidden from History.* London: Pluto Press, 1965.

Roy, S. *The Story of Indian Archaeology.* New Delhi: Archaeological Survey of India, 1961.

Rudé, George. *The Crowd in History.* New York: Wiley & Sons, 1964.

Singh, U. *Discovery of Ancient India: Early Archaeologists and the Beginnings of Archaeology.* Delhi: Permanent Black, 2004.

Skinner, Q. "Meaning and Understanding in the History of Ideas," *History and Theory,* VIII, no. 1 (1969), 3–53.

Smith, V. A. *The Oxford History of India.* Oxford: Clarendon Press, 1911.

Srimani, S. *Sukshma Shilper Utpatti o Ārya Jātir Shilpa Chāturi.* Kolkata: Roy Press, 1874. Reprinted in in S. Som and A. Acharya, *Trends in Bengali Art Criticism (Bānglā Shilpa Samālochanār Dhārā).* Kolkata: Anustup Prakāshani, 1986.

Thapar, Romila. *Interpreting Early History.* Delhi: Oxford University Press, 1993.

Thapar, Romila. *Time as a Metaphor of History: Early India.* Delhi: Oxford University Press, 1996.

Thapar, Romila. *The Past Before Us: Historical Traditions of Early North India.* Delhi: Permanent Black; Cambridge, MA: Harvard University Press, 2013.

Thompson, E. P. *The Making of the English Working Class.* Harmondsworth: Penguin, 1968.

Wölfflin, Heinrich. *Principles of Art History: The Problem of the Development of Style in Later Art: The Problem of the Development of Style in Later Art.* Trans. M. D. Hottinger. London: Bell & Sons, 1932.

5 Artists, *Amateurs*, and the Pleated Time of Ottoman Modernity

Mary Roberts

> Time does not always flow according to a line . . . nor according to a plan but, rather, according to an extraordinarily complex mixture, as though it reflected stopping points, ruptures, deep wells, chimneys of thunderous acceleration, rendings, gaps—all sown at random, at least in a visible disorder.
>
> Michel Serres[1]

Latecomers

Doing business with the Sublime Porte in the latter decades of the nineteenth century was a highly competitive game of commercial intrigue as merchants from many countries jostled to negotiate government concessions. Reporting to the British Foreign Office in 1886, Consul William Henry Wrench, who was charged with the task of assisting British merchants to navigate this terrain, registered his frustration at being impotent to assist his commercial countrymen. He wrote:

> [T]he negotiations for concessions from the Ottoman Government are conducted with the utmost secrecy by special agents of the houses competing for them. It is therefore impossible for any British consular officer to ascertain the position of the negotiations while they are in progress. His report can only be made after the negotiations are concluded and too late to assist any English house wishing to compete.[2]

This matter had come to a head in 1886 as the British Foreign Office and Her Majesty's Government recognized that they were losing ground to their European competitors in trade with the Ottoman Empire. Wrench's astute diagnosis reveals that this predicament of belatedness was compounded by the fact that British merchants were equally reluctant to disclose trade secrets. According to Wrench, dialogue with his commercial countrymen would only yield "contradictory statements, misleading half truths and incomplete statistics."[3] The British Consul was invariably a latecomer to these deals.

The situation differed for Wrench in his other life as a collector of Islamic art. In this he was at the front line. As a resident of the Ottoman capital from 1872 to his death in 1896, as also in his previous appointments in Damascus, Beirut, and the Dardanelles from 1857 onward, Wrench was well positioned to create the small, but significant collection that is displayed in four photographs taken in the early 1890s in the living room of his Istanbul home (Figures 5.1–5.4).[4] These were the years when valuable

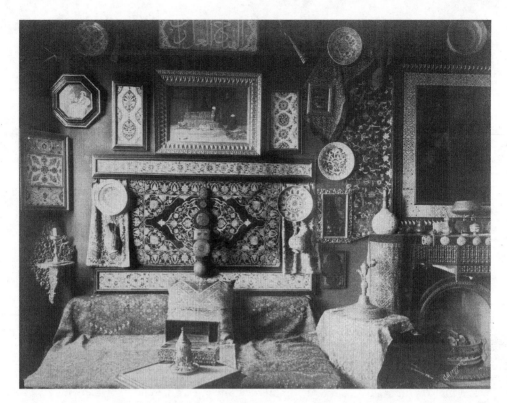

Figure 5.1 Guillaume Berggren, *Constantinople—Turkish House Interior (Constantinople—Intérieur de maison turque) (The Wrench Collection at Pera)*, n.d. Albumen print, 24.7 × 32.9 cm, Los Angeles, Getty Research Institute (96.R.14)

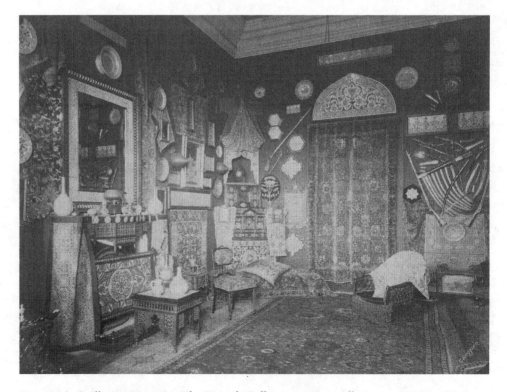

Figure 5.2 Guillaume Berggren, *The Wrench Collection at Pera*, Albumen print, 24 × 32.4 cm, V&A PH.332–1892 © Victoria and Albert Museum, London

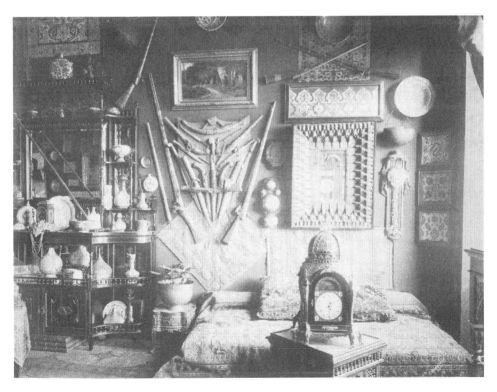

Figure 5.3 Guillaume Berggren, *Constantinople—Turkish House Interior (Constantinople—Intérieur de maison turque) (The Wrench Collection at Pera)*, n.d. Albumen print, 23.6 × 31 cm, Los Angeles, Getty Research Institute (96.R.14)

Figure 5.4 Guillaume Berggren, *The Wrench Collection at Pera*, Albumen print, 24.1 × 32.8 cm, V&A PH.334–1892 © Victoria and Albert Museum, London

items of Islamic art could be purchased by resident *amateurs* with the right local connections. One wonders if the pleasures of collecting, of being on the spot and ahead of the game in this commercial realm, provided a small measure of compensation for the frustrations of belatedness in Wrench's professional role.

In another report written a decade later, this time by South Kensington Museum Keeper Caspar Purdon Clarke, we encounter another record of frustration at British bureaucratic belatedness. This time it is about the race to secure William Henry Wrench's collection for the Museum after the Consul's death in October 1896. Clarke underscored to his Director the need to act fast:

> Capt W.H. Myers . . . has left for Constantinople hoping to secure some of the best specimens, and it is most probable that Dr Lessing of Berlin and Herr Von Scala of Vienna have already started.[5]

This museum paper trail reveals that in this marketplace as well, agility and secrecy were the order of the day. Stressing the need for the Museum's bureaucratic wheels to turn at speed, Clarke warned against replicating an incident a few years earlier, where after the death of Fleming Smythe, Manager of the Ottoman Bank in Istanbul, the South Kensington Museum had missed out on acquiring his collection because the Berlin Museum had beaten them to the prize: "Dr. Lessing within a few days purchased the whole collection which was removed by the German Government sending a man of war to fetch it away."[6] Clarke had seen Wrench's collection in his Istanbul home in 1891 and acquired four photographs of the installation. For five years this visual curatorial wish list had been lying in wait. The opportunity to acquire the collection for the South Kensington Museum came in late 1896 with the announcement of the Wrench sale. Clarke wanted to ascertain if the collection still contained its most valuable historical items. He was anxious not to be a latecomer and acted swiftly so as not to be caught out a second time.

What do we make of these anxieties about belatedness in our British bureaucratic documents? Post-colonial scholarship diagnosed belatedness as one of the most pervasive forms of discursive violence of colonial contact in the modern period.[7] Its effects have been felt in art historiography. Historians of modern Turkish art, like others around the globe, have been contending with a teleological narrative of the European avant garde that consigns regional modernisms as derivative and belated. So too historians of Islamic art have been grappling with a disabling temporal logic that circumscribed the sub-field for much of the twentieth century.[8] This is a decline narrative where art from the Islamic world from the eighteenth century onward was construed as a corruption of canonical traditional styles, the result of increased contact with Western Europe. In both scenarios we find Islamic art's modernity in ruins.

In this chapter my lens for reviewing these matters is Wrench's Istanbul salon— and the objects that moved into and out of that space in the latter decades of the nineteenth century. In this room, contemporary and early modern Islamic art was combined in ways that does not conform to the familiar temporal historiographic logic I have just described. And contemporaneous documentation reveals that anxieties about belatedness were not just the predicament of Ottoman players in this context; instead, it suffused the entire circuit in this economics of collecting. Moreover, the multiple conceptions of time that constituted the lived experience of modernity in

nineteenth-century Ottoman Istanbul inflected the cross-cultural art transactions that took place in this room.

This is the period when Islamic art was on the move physically and conceptually, when collections were being formed in Europe and the Ottoman capital, and categories and definitions were unsteady. Just as significantly, yet often overlooked, it is also the period when early, inchoate, histories of Islamic art were being created through collecting and display practices. In this period local dealers and *amateurs,* such as Wrench, were the major conduits for this cultural traffic between Europe and the Near East. The *amateurs* have an equivocal status within histories of Islamic art.[9] They are most often construed as dilettantes and aestheticists, ignorant of the complex histories of many of the treasures in their possession and as the advanced guard of western cultural imperialism. A more equivocal interpretation of the *amateur* emerges through analysis of Wrench's Istanbul home and its heterochronic poetics.

In the following account of the objects that came to rest momentarily in the British Consul's interior I move beyond the agency of the collector, tracing longer object biographies to see how they too narrate this space. The aesthetics of this display connects the interwoven transcultural time of Istanbul's modernity to multiple pasts, encompassing both Ottoman and orientalist aesthetics. Reading Wrench's Istanbul interior proleptically, I will argue that this late nineteenth-century installation anticipates our own historiographic moment as historians of Islamic art grapple with the status of modern art in a sub-field from which it had previously been marginalized.

"No Art Value"

Upon arrival in Istanbul, Clarke conducted a two-day inspection of all 400 items in Wrench's collection and annotated a copy of the recently printed sale catalog.[10] He chose seventy-two pieces and explained to his Director the rationale for his acquisition choices in the following terms:

> [My choice of only] this small proportion was principally due to the large number of Turkish arms, embroideries and other rich looking objects which being of the latter end of the eighteenth century or the earlier part of the present—were of mixed style and comparatively of no art value.[11]

Most of the items that Clarke selected from Wrench's collection are still housed in the Victoria and Albert Museum. Among the things he asserted were of no artistic value were two paintings by Wrench's contemporary, Ottoman artist Osman Hamdi Bey (Figures 5.5 and 5.6).

The aesthetic judgment Clarke exercised in 1896, sidelining the modern and contemporary Ottoman art in Wrench's collection, articulates a now all-too-familiar temporal bracketing for the definition of what was proper to the domain of Islamic art.[12] Clarke's choices are an early example of this aesthetic judgment in action, while the photographs of Wrench's interior testify to the fact that the amateur himself exercised other collecting criteria.

Aesthetic judgment governed Clarke's selection, but he was aware of other evaluative criteria at play that he feared could impact the export of his chosen pieces. He knew that the historical, religious, and patrimonial significance of some of them

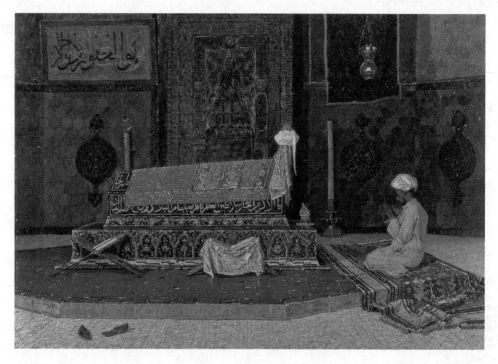

Figure 5.5 Osman Hamdi Bey, *Yeşil Türbe'de Dua (Prayer in the Green Tomb)*, 1882, oil on canvas, private collection

was what mattered to the Ottoman customs authorities. The legislation under which the Ottoman customs operated was drafted in 1884 and was designed to regulate the export of classical antiquities from Ottoman territory.[13] It was not until 1906 that Ottoman law first explicitly named Ottoman Islamic art in such preventive legislation.[14] But these South Kensington Museum records demonstrate that, in practice, the Ottoman customs authorities were already exercising prohibitions that were only significantly later explicitly enshrined in legislation.

In light of his prior experience, Clarke recognized that a substantial subset of the purchases from the Wrench collection, the revetment tiles, were going to be problematic.[15] There is enough in the paper trail to suggest that Clarke was aware that at least some of Wrench's collection came from significant Ottoman historic and religious sites, including Sultan Selim II's tomb in the grounds of the Hagia Sophia, Takkeci İbrahim Ağa mosque and the Piyale Paşa mosque complex.[16] Given this, one can see why he was working so hard to ensure that these items went under the radar of the Ottoman authorities. In August 1897, the Museum, the British Embassy and foreign office representatives colluded to circumvent an Ottoman Customs inspection by moving the items from Galata to the British naval ship *H.M.S. Imogene* moored off Tarabya, the Bosphorus village that was the summer residence of the British Embassy. The tiles sat in crates on this ship for a month before being transferred to *H.M.S. Melita* bound for Malta. From Malta they were sent to Paris and arrived in London in December 1897.[17]

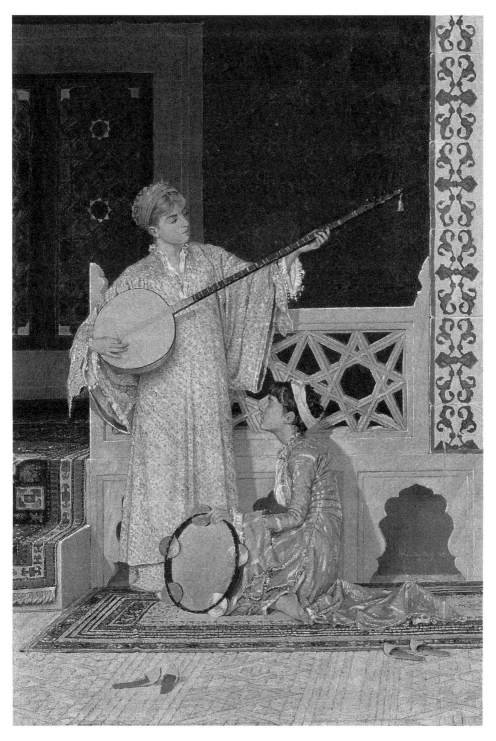

Figure 5.6 Osman Hamdi Bey, *Two Musician Girls*, 1880, oil on canvas, 58 × 39 cm, Suna and
İnan Kıraç Foundation Orientalist Painting Collection, Istanbul

Pleated Temporality

The trajectory of Wrench's collection that I have charted so far implicates our British amateur within an abduction narrative. Given this, it is tempting to foreclose on this interior and dismiss it as an expression of the amateur's atemporal, orientalist eclecticism in which Osman Hamdi's work is absorbed into decorative ornamentalism.

Yet the Museum's paper trail discloses a difference between Clarke's and Wrench's collecting criteria, and the Berggren photographs and auction catalog confirm this. In reckoning with the differences in site and collecting priorities between Istanbul and London, and the impact of the distinct temporal culture of the Ottoman Imperial capital on Wrench's display, it is important to consider all three of Wrench's roles in nineteenth-century Istanbul society: as embassy bureaucrat, collector, and artist. It is probably this third string to his bow that predisposed Wrench toward the two paintings by Osman Hamdi Bey that hang so prominently in his interior. In Istanbul, elite Ottomans and foreign expatriates interested in art and collecting were closely connected via local art networks. Wrench was one of the organizers of the ABC club exhibitions in Istanbul in the early 1880s, where he exhibited his own watercolors—Istanbul landscapes. Osman Hamdi exhibited *Two Musician Girls* in the Istanbul exhibition of 1880 and this is the likely context for Wrench's acquisition of Osman Hamdi's work.[18] Their prominence in his valuable collection indicates that he esteemed them. Wrench's interest in Osman Hamdi's art was not just a form of diplomatic flattery, as had explicitly been the case when the University of Pennsylvania Museum had cynically purchased Osman Hamdi's painting in 1895 to grease the wheels for their archaeological activities within Ottoman territory.[19] Given his own amateur efforts, Wrench must have admired the highly skilled painting of this Ottoman artist, who had trained in the French studio system under the tutelage of Gustave Boulanger in the 1860s.

Conversely, we have little evidence of Osman Hamdi's attitude toward Wrench, but the fact that he made a significant financial contribution to the posthumous fund for a memorial plaque to the British Consul indicates his regard.[20] We have no record of Osman Hamdi visiting Wrench's interior, but Wrench visited Osman Hamdi's home in Kuruceşme and thus it seems likely that the visit was reciprocated. Osman Hamdi was also a collector with significant holdings of historic artefacts, including İznik ceramics, embroideries, Tanagra figurines, and other Greek art that he displayed in the atelier in his home and would show visitors along with his latest painting.[21]

Wrench's salon, with its contemporary paintings by Osman Hamdi and its diverse collection that included so much early modern Ottoman work, is an interior that is inflected by both Ottoman and orientalist claims on the past. Its aesthetic logic, I argue, encompasses the divergent temporalities that constituted the lived experience of modernity in Ottoman Istanbul. I do not hinge this interpretation of Wrench's Istanbul interior around the elusive, biographical fragments that connect these two artist-collectors. I turn instead to the aesthetics of the installation and the ways in which its orientalist display principles are unsteadied by the object histories of its component parts. This counter-reading is premised upon the location of the interior in the modern Ottoman imperial capital.

The hundreds of objects Wrench attached to the walls of his salon are organized in a series of unfolding symmetric bays or panels. This is a mode of display that is familiar from ethnographic installations at European international exhibitions and also

resonates with longstanding European modes of displaying trophies of arms. Each symmetric arrangement invites the viewer to occupy a corresponding centered view-ing position. This brings to mind the first of Gottfried Semper's tripartite structural categories of ornament, the pendant in which symmetry is the dominant principle.[22] The structure of these object walls implies a mobile spectator whose journey around the room is punctuated by stopping points where groups of objects coalesce into sym-metric arrangements organized around their vantage point. The regular rhythm of these groupings along the walls is interrupted by three large mirrors and one smaller one that transpose parts of the installation across the room. The particular angle of visibility made available to us by the camera's position in relation to these mirrors draws our attention to the stasis of the photograph in contrast to the moving kaleido-scopic effect that would have attended the experience of walking around this mirrored room full of so many colorful objects. This effect is underscored in Figures 5.3 and 5.4 in which the same mirror is visible from differing angles. The mirror effect transmutes the objects into a mobile two-dimensional pattern of object as ornament.

Attachment to the wall placed most of these objects within a three-dimensional picture, situating them politely out of the visitor's reach as these objects are ornamen-tally dislocated from their prior use and social function. Elsewhere around this room, myriad objects such as those visible on the étagère and small tables in Figure 5.3 are positioned near wicker chairs, within the grasp of those who stood or sat near them. Within reach, they invite touch. The beautiful enamel mouthpiece and neck of the narghile seen in Figure 5.1, for example, a fragment of the water pipe that is missing its base, has been transformed from use to display value. This decommissioned object evokes a more luxurious historic Ottoman interior where it previously saw service. The ewer on the étagère in Figure 5.4 is another object that speaks to that Ottoman domestic past. This sixteenth-century İznik ceramic vessel (Figure 5.7) has an object history that signals it was an item held in such esteem that it was later repaired by an Ottoman metalworker.[23]

Wrench's room is a space of transformation and dislocation in which things hover between ornament, object, and art. Even European paintings bear an uncertain status as they compete in this room for the crowded wall space. A contemporary landscape in Figure 5.3, for instance, sits on the floor propped up provisionally underneath a small mosque table, a marginal site that codes it as much object as art.

Individual panels create divergent objects narratives. The configuration of objects in the panel on the left wall in Figure 5.3 has a morphology that creates a bizarre impression of absent human form. It conforms to a logic that positions these objects within orientalist fantasy outside historical time. A helmet with chainmail is situated on the wall at a height as if to mark out a head, one that is precipitously loomed over by a range of daggers and sharp swords, while below the women's nalın or bath shoes near the floor, face toward us, suggesting this uncanny bi-gendered body's absent pigeon-toed feet. The bath clogs sit on the small mosque table, high enough for the visitor to see the craft work on these beautiful mother-of-pearl inlaid shoes, but close enough to the ground to connect them conceptually with their former purpose elevat-ing the wearer above the hot, soapy surface of the bath house floor. Their purpose in the bath house is to prevent slipping; here they facilitate it. This panel's strange atemporal melange implies an absent present body that is uncanny and incongruous.

In contrast to the atemporal orientalism of this panel, a temporal theme grounded in Ottoman modernity predominates on the wall where clocks and watches manufactured

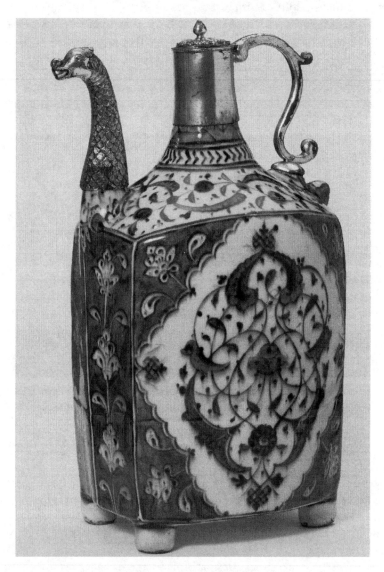

Figure 5.7 İznik Ewer, ca. 1520–25, Fritware, underglaze painted in cobalt blue, glazed; later silver mounts, V&A 349–1897 © Victoria and Albert Museum, London

for the Ottoman market are clustered (Figure 5.4). Wrench collected timepieces manufactured in Germany, the Ottoman Empire, and Britain, and their distinctive Ottoman Turkish numerals reveal that his primary interest was in timepieces made for the Ottoman market. A pocket watch by Markwick Markham and coach watch by George Prior, both of British manufacture, were the only two timepieces from Wrench's collection acquired by Clarke for the South Kensington Museum.[24] This choice distinguishes the nationally circumscribed horological interests of the Museum keeper from Wrench's cosmopolitan priorities in this sphere of his collection.

The sale of timepieces was an important component of British trade into the Ottoman Empire and timepieces such as those that Wrench collected had long been part of British diplomatic gift culture at the Ottoman court. When given to the Sultan and senior Ottoman officials by British envoys, they were often re-gifted to other Ottoman officials, thus encouraging a broader interest in the British product.[25] In the Consul's Istanbul interior, these Ottoman watches and clocks speak to the intertwined professional worlds of the Ottoman palace and British diplomatic communities in this city.

These timepieces cue us to the complex temporal culture of the Ottoman capital in this period and the multilayered metaphorics of time in Wrench's installation. As a functionary in the vast bureaucratic infrastructure of the British foreign service, Wrench's native time was marked according to the Greenwich mean. The pocket watches, coach and wall clocks in this interior bespeak the transplantation of these time-marking practices (a fulcrum of British Empire) to the Ottoman imperial capital. Wrench's connoisseurial interest in them marks him as a modern man of taste.

The adoption of the Greenwich mean—*alafranga saat*—was part of the Ottoman state's entry into global modernity. This co-existed with a second time measure—*alaturka saat*—a longstanding system of regulating time across the Empire where the two regular twelve-hour intervals marking day and night commenced at sunset, so clocks and watches such as these were reset daily at this seasonally variable time.[26] Wrench's timepieces would probably have been set to *alaturca* time by their former Ottoman owners in the eighteenth and early nineteenth centuries.

We have no way of knowing how many of these timepieces were in regular use in Wrench's interior in the 1870s, 1880s, and 1890s or if they too were mostly ornamental (our photograph has lost the clarity of detail that might once have revealed if more than one clock was set to the same time, indicating whether or not they were in use when our photograph was taken). But no doubt Wrench had at least one functioning clock in his home set to the Greenwich mean.

Whatever the operative status of the timepieces within this room, there was a third mode of time marking that echoed through this interior five times a day—the call to prayer. The rhythm of this temporal practice was regulated by the *muvakkithanes* attached to the city's major mosques. This was the oldest Ottoman time-marking practice where hours of variable length were regulated according to seasonal changes in daylight hours across which the five calls were interspersed. Although these elastic hours had been supplanted under the new temporal regulations required by systems of military, education, and administrative reform across the modern Ottoman Empire, quotidian time, where a day's activities were regulated solely by the times of prayer, remained current, particularly among the lower classes of the city's Muslim residents. Figures 5.1 and 5.4, which register the directional light streaming through the windows of this room's unseen fourth wall, remind us that this time with its religious cosmology, part of the exterior world of Ottoman Istanbul, impinged sonically upon this orientalist interior.

None of the three modes of marking time legible in this interior was anachronistic or foreign in 1890s Istanbul. These temporal registers were variously prioritized according to the nationality, social class, or religious affiliation of the city's residents, and could often be accommodated alongside one another by the same individual or within the same timepiece. Many of the clocktowers in public squares across the empire in the late nineteenth and early twentieth centuries displayed multiple clocks

set variously to *alafranga* and *alaturka* time.[27] It is precisely this temporal code shifting that characterized the experience of modern time in the nineteenth-century imperial capital. For William Henry Wrench as much as for Osman Hamdi Bey, being an effective bureaucrat entailed negotiating these diverse temporalities.

What makes both men of interest to historians of art is the ways in which their painting and collecting practices meditated on this pleating of time and turned it into a matter of modern aesthetics.

In Wrench's salon, the panel that emphasizes this modern temporal theme (Figure 5.4) faces a panel on the opposite wall where a religious theme predominates (Figure 5.1). The centerpiece of this panel is Osman Hamdi's *Prayer in the Yeşil Türbe*, which depicts a worshipper at the magnificent tiled royal green tomb of the fifteenth-century Sultan Mehmed I (r. 1413–21) (Figure 5.5). Wrench installed this painting amid a cluster of items that came from a religious context, in particular the calligraphic tile panel from Bursa containing one of the ninety-nine names of Allah and below it a cushion embroidered with prayers to the Prophet.

The same table appears in the foreground of Figures 5.1 and 5.4. Yet Wrench has replaced the incense burner and a penbox on this table in Figure 5.1 with a large Ottoman table clock in Figure 5.4, as if thereby to differentiate Islamic religious and technocratic modern temporality on his two walls. Yet for the visitor seated on the divans on either side of these two facing walls, the immersive experience would have made such distinctions less clear, especially because in the center of the clock wall is a mirror that embeds parts of the opposite wall on this side. And a modern notion of Ottoman historical time is implicit in the contemporary painting by Osman Hamdi Bey.

Osman Hamdi's canvas is one of a series of oil paintings he created in the 1880s of the historic Green tomb in the former Ottoman capital, Bursa, a city intimately linked with the Ottoman Empire's craft revival and modern notions of Ottoman cultural patrimony.[28] This fifteenth-century tomb was one of the structures analyzed within the first modern Ottoman history and theory of Ottoman architecture, the *Usul-i mi'mari-i 'Osmani* (*The Fundamentals of Ottoman Architecture*) published by the state in 1873 for the Vienna international exposition.[29] Osman Hamdi was the head of the commission for the Ottoman contribution to this exhibition. Within that narrative, the historic dynastic monuments in Bursa exemplify the formative period for a classical Ottoman architectural tradition premised upon cultural synthesis. Contemporary architects and design practitioners were exhorted to turn to these early Ottoman monuments for inspiration. This Ottoman revivalism was designed to boost the Empire's economy by harnessing Ottoman cultural heritage to modern Ottoman aesthetics. It was an especially urgent project for the Ottomans in the face of British and French economic imperial incursions and the crippling effects of an unfavorable balance of trade.

When one of Osman Hamdi's paintings of the Green tomb was exhibited at the Abdullah Frères studio in Istanbul in 1880, Ottoman critic Abdullah Kâmil's review of it in the journal *La Turquie* reveals its contemporary resonances for an Ottoman audience. All the details in this tomb painting focus on the act of devotion, a devotion that the critic articulates as encompassing a political and religious dimension. He writes:

> How could this emotion not communicate itself to every truly Ottoman heart
> with the same force as felt by the patriotic artist himself, for whom this ancient

splendor, with its shawls, carpets, enamels, bronzes, book bindings, embroideries, and its stained glass—all these wonders of art and industry brought together by Sultan Mohammed Chelebi in his own turbé, his greatest and final work, are not magical objects of art and curiosities to make all the *amateurs* crazy; but rather they are august witnesses of our beginnings, of the glory of our ancestors, which invite us to remember their great history so that we might be like them.[30]

Through an invocation to venerate the legacy of one of the Ottoman Empire's great forebears, this critic reads Osman Hamdi Bey's painting against orientalist collecting practices and recuperates fifteenth-century Ottoman art for a contemporary audience. He links the aesthetics of Osman Hamdi's tomb paintings to contemporary Ottoman ideology through an interpretive move I would call a devotional effect which proposes a mode of art spectatorship as an act of devotion encompassing a political and religious dimension. The language of academic painting inspires an affective response in the viewer that collapses the distance between people and things. The Ottoman past is reactivated in the present via this aesthetic experience. Responding to the pared-down space of the tomb, the "noble simplicity" of the composition, "the generally pure and gentle tone that reigns within," the "complete truth of all its detail" as well as their "simple and conscientious execution." "Taken together," he asserts, "all these impressive qualities produce upon the soul of the viewer exactly the same profound and grave emotion it would experience, and the artist himself truly experienced, in contemplating the actual objects, the sacred place and the moving scene that are the subject of his work."[31]

In his 1882 painting, Osman Hamdi renders an act of veneration within this historic site that unfolds from left to right in a distended devotional present tense. In the foreground on the left of this painting are the slippers that this man of faith removed to commence the ritual. On the two rahles we see closed and open books, invoking the process of recitation of the holy book before the prayer that the worshipper is now offering up.[32]

Let me interrupt the flow of this narrative with another story of entombment, a compelling visual metaphor from Michel Serres of the archaisms that, as he says, "can always be found among us." It's a compelling tale to assist us in unravelling the particular temporality of aesthetic experience at work in Osman Hamdi's *Prayer in the Yeşil Türbe*. Serres recounts the story of "some brothers in their seventies . . . grouped around their father for a funeral vigil, weeping for a dead man aged thirty or less." This young father, a mountain guide, had gone missing in a mountain crevasse following an accident, but his body re-appeared more than half a century later, "deposited in the valley by the glacier, perfectly conserved, youthful, from the depths of the cold." As a result, his children "having grown old, prepare to bury a body that is still young." Serres uses this moving tale of the father's preserved youth, a time capsule gifted by nature to his aged sons, to speak to the anachronistic power of art. This tale is uncanny because it is an aberration in generational time. However, Serres concludes that such anachronisms are more familiar in the realm of aesthetics and are "often observed between a writer and his critics. Art, beauty, and profound thought" he conjectures "preserve youth even better than a glacier!"[33]

Where nature's role in Serres' tale is one of destruction and preservation, in the case of the Yeşil Türbe, the destruction/preservation axis played across the nature/culture divide. In 1855 an earthquake compromised the structural integrity of the

Green mosque and tomb, and shattered many of the old tiles. The Ottoman resto-
ration project that followed endeavored to remedy this destruction. The impulse of
French architect Léon Parvillée and his team, acting under the instruction of Ottoman
governor Ahmet Vefik Paşa, was an effort to re-instate wholeness, to re-capture youth,
through a restoration project in which new tiles were created.[34] Perhaps this whole-
ness was only ever really achieved in representations such as Osman Hamdi's painting
with its seamless rendition of the tomb's tiled surfaces in oil on canvas.

 The Ottoman critic's response to Osman Hamdi's painting reveals the patronymic
significance of this gesture as the cult of the Ottoman ancestors promises a continuous
historical lineage that can be re-activated in the present through a devotional effect
of Ottoman spectatorship. The critic assumes the role of guide and translator for his
Ottoman audience, demonstrating how to interpret the painting. Serres' tale under-
scores the wonder of the sons' encounter with the youth and beauty of their father
that the glacier has archaically brought forward. Under the right conditions, certain
encounters with art promise the same transporting archaism. This is art's capacity to
touch us in the present tense. Serres' tale reminds us that the bringing forward is not a
bringing back to life of the father, but instead this pleating of time is a beauty haunted
by loss. So too, Osman Hamdi's fiction of wholeness is lodged in a photograph of
Wrench's interior that is filled with many dislocated tile fragments.

 Given this Ottoman interpretive context, what kind of dialogue does Osman Ham-
di's painting establish with these other Ottoman objects on Wrench's walls? The inclu-
sion of this painting of the Yeşil Türbe interior renders in meticulous academic realist
style the earliest example of extensive tile decoration in Ottoman architecture. This is
a combination of cuerda seca, monochrome glazed and underglazed tiles that exem-
plify, as Gülru Necipoğlu argues, the richness of the "international Timurid" decora-
tive repertoire.[35] This decorative program, created by the itinerant "masters of Tabriz"
under the supervision of Nakkaş Ali and produced in local Bursa kilns, demonstrates
the varied repertoire that influenced later Ottoman İznik tile production. The con-
junction of this painting and the later İznik tiles on these walls introduces that artistic
history while underscoring the prior architectural function of many of the tiles we
see on Wrench's walls. Calligraphic and long border patterned İznik revetment tiles
that we see here, produced from the sixteenth century onward for Ottoman religious
and palatial structures, could be seen by nineteenth-century Ottomans in buildings in
the current and former capitals and in other major cities across the Empire. The fact
that such tiles are encased in frames on Wrench's wall rather than attached directly
as they had been previously signals a new portability and a provisional connection
to this Istanbul domestic interior—a convenience for the peripatetic British career
bureaucrat.

 The tile pairs on either sides of Osman Hamdi's painting, for example, with their
continuous multi-unit designs signal their severance from a prior use in Ottoman
architecture. On the right, the tiles taken from Selim II's tomb with their floral devices
and rosettes on interlacing stems that are shown on the edge of the tiles in their part
form are simultaneously bounded by their frame and implicitly breach it.

 The conjunction of Osman Hamdi's painting and the calligraphic tile panel above
it that contains one of the ninety-nine names of Allah, and the cushion on the divan
embroidered with prayers to the Prophet, points to their severance from a religious
context.[36] Those visiting this room who could read Arabic would have realized that
the Bursa calligraphic panel at the top is incomplete because the left tile was part of
another inscription. In all likelihood they had been re-combined for sale to a foreign

collector by those who levered them from the walls. Osman Hamdi's painting reconnects these objects formerly from devotional spaces with the human agency of the Muslim worshipper, through representation of the act of prayer, a fundamental tenet of Islamic religious practice. The painting's devotional narrative is an assertion of place, of reverence, of the permanence of the past in the face of modernity's dislocations.

Yet this painting on canvas is itself a portable object, responsive to those conditions of modernity. Through its adaptation of the visual vocabulary of French academic realist painting Osman Hamdi's work of art, enclosed within a modern frame that adapts the muqarnas architectural form to new purposes, unframes and reframes the other objects in this interior, addressing the problem of modern Ottoman dislocation from the past.[37]

Time Lapse

> Sometimes things that seem to have been forgotten for a long time are actually conserved quite close to us. Which is the reason for the time lapse I'm talking about.
>
> <div align="right">Michel Serres[38]</div>

There is a letter in the Victoria and Albert Museum archives penned in 1897 by a representative of the firm charged with packing Wrench's Ottoman revetment tiles into their crates before shipment to London. This meticulous description of the packing process is a risk management disclaimer attuned to the physical vulnerability of these items in transit:

> I enclose herewith the account for 5 trunks containing the tiles taken out of 16 frames received from Mr Whitaker's house last March, packed in cotton wool separately and then well packed into these trunks which in consequence of their weight I had them strongly corded . . . I told Captain Steward to remind those thru whose hands they would pass to be careful *not* to throw them about to be handled gently here, Malta, and in England otherwise altho properly packed under the circumstances of being in trunks, still if carelessly thrown down, some of the tiles would probably get broken.[39]

In transit there were some casualties and yet it is hard to know if the extensive damage to some of these tile panels occurred when they were being levered off the walls of the Ottoman buildings for which they were created or if the damage occurred in transit to London. These damaged tiles in the Victoria and Albert Museum archives remind us that European collecting practices in the nineteenth century were as destructive as well as protective of the cultural treasures the amateurs and museum keepers prized so highly. These İznik wall tiles resist mobility. When adhered to the walls for which they were created, their glassy surfaces and bright glaze colors have a durability that seems to defy the deteriorating effects of time's passage, but once dislodged or damaged, their fragile surfaces accrue marks of age.

The nineteenth-century painter, by contrast, could crack or restore their İznik tiles at will. Jean-Léon Gérôme did a bit of both in his famous *Snake Charmer* (Figure 5.8). Comparing his tiled wall with the Abdullah Frères photograph of the tiled panels in the Topkapı Palace's Altın Yol (Figure 5.9), a photograph from which he

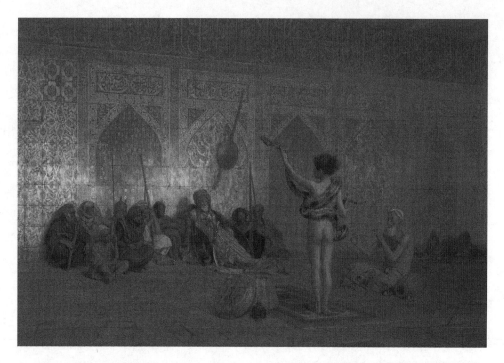

Figure 5.8 Jean-Léon Gérôme, *The Snake Charmer*, ca. 1879, 82.2 × 121 cm, © Sterling and Francine Clark Art Institute, Williamstown, Massachusetts, USA

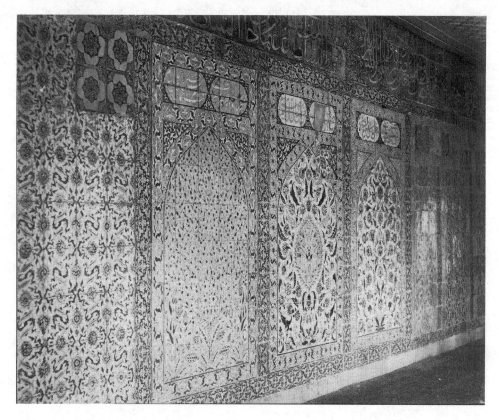

Figure 5.9 Abdullah Frères, *Polychromatic Tile Panels (c. 1575) from the Imperial Baths, Installed in the Altın Yol, Topkapı Palace*, n.d. Albumen print, 30 × 24 cm, Los Angeles, Getty Research Institute (2008.R.3)

is likely to have worked, shows us that he has rearranged the large floral panels to create a more regularized alternating rhythm of blue and white backgrounds. This tile wall contains the most impasto of Gérôme's mark making in the blinding glare of white light reflected off the tiled surfaces. These self-disclosing paint marks are reminders of the material difference between painted and glaze tiles. This difference is asserted more insistently where Gérôme has slammed a nail into one of these panels in order to hang his painted shield and gun. A nail retrospectively added in this way would shatter a brittle tiled surface, but here there are no signs of damage. It is an assertion of mastery in the hands of the orientalist painter. Elsewhere on this painted wall, Gérôme has created flaws in a few of his İznik tiles, or rather has re-located the damage to more peripheral parts of the pattern.[40] In the seventh row from the bottom of the first panel on the left and in the top row of the border in the panel next to it, we see extensive damage that did not exist on these parts of the wall when the photograph was taken. On Gérôme's canvas this magnificent Ottoman İznik tiled corridor in the harem precinct of the Topkapı Palace, the most secluded realm within this vast palatial edifice, is incongruously peopled by a motley group of eastern men, spectators to a trifling entertainment. Seated with their backs to this wall, they are spellbound in a moment when the boy is most vulnerable to the power of the snake wrapped around his young torso. Here early modern Ottoman material culture is severed from any relationship to Ottoman modernity and drafted into an incongruous, temporally and spatially indeterminate place. In this context those cracked tiles readily lend themselves to an orientalist narrative of Eastern cultural decline.

Since the publication of Gérôme's iconic painting on the cover of Edward Said's *Orientalism* and in Linda Nochlin's essay "The Imaginary Orient," a post-colonial interpretation of orientalist painting's pernicious atemporality is well understood.[41] But histories of nineteenth-century orientalist painting need to be written in tandem with a nuanced account of the intersecting temporalities of the Middle East's multiple modernities. The temporal aesthetics of nineteenth-century visual culture from the region, its distinctive art time, and a networked understanding of practices of collecting Islamic art in Europe and across the Near East are part of this larger story.

In this chapter's particular narrative of Ottoman modernity within elite cultural circles in the Empire's capital, these photographs of Wrench's Istanbul interior are a condensation of convergent nineteenth-century Ottoman and orientalist impulses—in this sense they are time-lapse photography. In this salon the atemporality of orientalist ornamentalism is brought into dialogue with other forms of modern Ottoman temporality. Through these photographs we see that the life of objects in this room was riven by the collaborative and conflicting aesthetic, religious, and temporal cultures of foreign and local elites in the late Ottoman Imperial capital. The conjunction of Ottoman timepieces, the aesthetics of modern historical time in Osman Hamdi's tomb painting (its numinous aesthetics), and the sound of the call to prayer inscribe the pleated temporality of Ottoman modernity into this photographic space. Accordingly, an interior that might readily be dismissed as orientalist eclecticism comes to us across time, like Serres' father, contextually and proleptically as an Istanbul zone of cultural contact in which are created entangled Ottoman and orientalist histories of what would later be called Islamic art.

Notes

My special thanks to Keith Moxey, Dan Karlholm, Moya Carey, Robert Wellington, Catherine Blake, Ariel Kline, Evra Günhan, and Nurullah Şenol.

1. Michel Serres, *Conversations on Science, Culture, and Time: Michel Serres with Bruno Latour*, trans. Roxanne Lapidus (Ann Arbor: University of Michigan Press, 1995), 57.
2. William Henry Wrench, Consul, Constantinople, "Official Assistance to British Commerce. Reply to Foreign Office Circular 9th April," April 26, 1886, Constantinople. Foreign Office: FO78/3907, January–December 1886, The National Archives, Kew, London.
3. Wrench, "Official Assistance to British Commerce."
4. For accounts of Wrench's career, see "Obituary. Mr. W.H.Wrench, C.M.G.," *The Times*, October 14, 1896; "Death of Mr Wrench," *South Australian Register*, October 16, 1896, 5.
5. C. P. Clarke, "Report to Sir John Donnelly," November 11, 1896. Victoria and Albert Museum archives, SF516 Purchases by Officers on Visits Abroad Part III 1896–1898, MA/2/P7/3.
6. Clarke, "Report to Sir John Donnelly." This is probably Frederick Smythe who died in 1890.
7. The literature on this is extensive; see, for example, Johannes Fabian, *Time and the Other: How Anthropology Makes its Object* (New York: Columbia University Press, 1983); and in art history, Keith Moxey, *Visual Time: The Image in History* (Durham, NC: Duke University Press, 2013).
8. Finbarr Barry Flood, "From the Prophet to Postmodernism? New World Orders and the End of Islamic Art," in *Making Art History. A Changing Discipline and its Institutions*, ed. Elizabeth Mansfield (London: Routledge, 2007), 31–53; Nebahat Avcıoğlu and Finbarr Barry Flood (eds.), "Globalizing Cultures: Art and Mobility in the Eighteenth Century," *Ars Orientalis* 39 (2010), 7–38; and *Islamic Art in the Nineteenth Century, Tradition, Innovation and Eclecticism*, eds. Doris Behrens-Abouseif and Stephen Vernoit (Leiden: Brill, 2006).
9. See the special issue of *Ars Orientalis* 30 (2000) "Exhibiting the Middle East: Collections and Perceptions of Islamic Art," guest edited by Linda Komaroff, especially David Roxburgh, "Au Bonheur des Amateurs: Collecting and Exhibiting Islamic Art, ca. 1880–1910," *Ars Orientalis* 30 (2000), 9–38; Andrea Lermer and Avinoam Shalem, *After One Hundred Years. The 1910 Exhibition 'Meisterwerke muhammedanischer Kunst' Reconsidered* (Leiden: Brill, 2010); the special issue of *Journal of Art Historiography* 6, June (2012), guest edited by Moya Carey and Margaret S. Graves; Deniz Türker, "Hakky-Bey and His Journal *Le Miroir de l'art Musulman*, or *Mir'at-i Sanayi-i İslamiye* (1898)," *Muqarnas* 31 (2014), 277–306.
10. *Catalogue of the Oriental Antiquities and Curiosities Composing the Collection of the late Mr W. H. Wrench, C.M.G. of Constantinople. Arms and Carpets, Embroideries, Clocks and Watches, Enamels, Silver and Metal Work, Pictures, Tiles, Pottery and Sundries*, 1896. V&A Archives, SF516 Purchases by Officers on Visits Abroad, Part III 1896–1898, MA/2/P7/3.
11. Caspar Purdon Clarke to John Donnelly, "Reports purchase from Mr E. Whitaker of objects from the collection of the late Mr W. H. Wrench of Constantinople for £1233," December 8, 1896. V&A Archives, SF516 Purchases by Officers on Visits Abroad, Part III 1896–1898, MA/2/P7/3.
12. The perception that objects from the late eighteenth century onward were aesthetically insignificant because of their "mixed style" informed acquisition policy for many museums and governed academic discourse about Islamic art for much of the twentieth century. Over the last decade, this chronological chauvinism has been called into question. See note 8.
13. Wendy Shaw, "The Dialectic of Law and Infringement," in *Possessors and Possessed: Museums, Archaeology and the Visualization of History in the Late Ottoman Empire* (Berkeley: University of California Press, 2003), 108–30. For attitudes to antiquities up to 1869, see Edhem Eldem, "From Blissful Indifference to Anguished Concern: Ottoman Perceptions of Antiquities, 1799–1869," in *Scramble for the Past. A Story of Archaeology in the Ottoman Empire, 1753–1914*, eds. Zainab Bahrani, Zeynep Çelik, and Edhem Eldem (Istanbul: SALT, 2011), 281–329.
14. Shaw, "The Dialectic of Law and Infringement." On the role of Osman Hamdi's brother Halil Edhem in the establishment of the Museum of Islamic Foundations in 1914 and the

efforts to prevent the loss of Islamic art, see Edhem Eldem, *1001 Faces of Orientalism* (Istanbul: Sabancı University Sakıp Sabancı Museum, 2013), 200–07.

15. He wrote: "the Turkish Custom House refuses to pass tiles unless the names of the native vendors are given, in order to trace the origin of the tiles and prevent the export of those taken from Mosques." Caspar Purdon Clarke to John Donnelly, "For sanction to remaining portion of Wrench collection of tiles being brought from Constantinople by Capt Stewart Foreign Office messenger owing to difficulties with Turkish Customs," July 24, 1897. V&A Archives, SF516 Purchases by Officers on Visits Abroad, Part III 1896–1898, MA/2/P7/3.

16. The Wrench sale catalogue lists the following: 1 Frame, 2 tiles, from the tomb of Sultan Selim I, 1530 A.D. (V&A 1888–1897). My research reveals these tiles are instead more likely to have come from the tomb of Selim II in the courtyard of Hagia Sophia, where other examples of the same tiles are still present. The same tomb has gaps in its border tiles, versions of which can be seen in Wrench's interior and which again are listed in the Wrench catalogue as "Sultan Selim's tiles." Three of these were purchased by Clarke for the South Kensington Collection, V&A 1884–1897. The lunette (V&A 1889–1897) is either from the Piyale Paşa Mosque complex or mansion. There are other tiles from the Wrench collection purchased by Clarke that are also likely to be from Ottoman historic religious buildings, although it is less clear whether or not Clarke would have known this. The calligraphic tile panel listed in the V&A registration records as from Bursa (V&A 1890–1897) was probably also from a religious building in the former Ottoman capital. Eight tiles, likely taken from the Takkeci İbrahim Ağa mosque (V&A 1881–1897), were de-accessioned from the V&A to the School of Oriental and African Studies collection. A document that I have discovered in Stanisław Chlebowski's papers in Krakow discloses that Wrench purchased the majority of his İznik ceramics from this Polish expatriate. Had this been known to Ottoman customs, it would have rung alarm bells because in 1892 Ottoman government officials were alerted that when Chlebowski was working as Sultan Abdülaziz's court painter in the 1860s and 1870s, he had been purchasing and stealing items from the Palace collection, including an old Koran and book of poems by Süleyman the Magnificent that were later sold in Paris.

17. C. P. Clarke Report to Sir John Donnelly, August 17, 1897 and December 31, 1897. Purchases by Officers on Visits Abroad Part III 1896–1898. V&A archives document MA/2/P7/3.

18. Mary Roberts, "Istanbul's Art Exhibitions," in *Istanbul Exchanges: Ottomans, Orientalists and Nineteenth-Century Visual Culture* (Berkeley: University of California Press, 2015), 111–36. Two of William Henry Wrench's watercolors depicting the Dardanelles were sold at Christie's in the *Travel, Science and Natural History Sale,* 22 April 2010, London, South Kensington, Lot 220/Sale 5489.

19. Heather Hughes and Emily Neumeier, "From İstanbul to Philadelphia: The Journey of *At the Mosque Door,*" in *Osman Hamdi Bey and the Americans: Archaeology, Diplomacy, Art* (Istanbul: Pera Müzesi, 2011), 103–17.

20. "Wrench Memorial Fund. List of Subscribers," *Levant Herald,* December 1, 1896, 1.

21. James Theodore Bent, "Hamdi Bey," *Littell's Living Age,* no. 2319, December 8, 1888. Article republished from *The Contemporary Review.*

22. Gottfried Semper, "Concerning the Formal Principles of Ornament and its Significance as Artistic Symbol (1856)," in *The Theory of Decorative Art: An Anthology of European and American Writings, 1750–1940,* ed. Isabelle Frank, trans. David Britt (New Haven: Yale University Press, 2000), 95.

23. The narghile is V&A 367–1897 and the ewer is V&A 349–1897.

24. George Prior Coach Watch, V&A 366–1897 and Markwick Markam Clockwatch V&A 365–1897. *Catalogue of the Oriental Antiquities and Curiosities composing the collection of the late Mr. W. H. Wrench, C.M.G. of Constantinople* (Istanbul, 1896).

25. Ian White, *English Clocks for the Eastern Markets: English Clockmakers Trading in China and the Ottoman Empire 1580–1815* (Ticehurst: Antiquarian Horological Society, 2012). Wrench's George Prior coach watch is remarkably similar to one in the Topkapı Palace Museum. See *Topkapı Palace Clock Collection: Exceptional Timepieces at the Seraglio* (İstanbul: T C Kültür Bakanlığı, 2013), 96.

26. Avner Wishnitzer, *Reading Clocks Alla Turca: Time and Society in the Late Ottoman Empire* (Chicago: University of Chicago Press, 2015).

27. Kemal Özdemir, *Ottoman Clocks and Watches* (Istanbul: Creative Yayıncılık ve Tanıtım, 1993); Zeynep Çelik, *Empire, Architecture and the City: French-Ottoman Encounters, 1830–1914* (Seattle: University of Washington Press, 2008), 146–53.

28. Beatrice St Laurent, "Ottomanization and Modernization: The Architectural and Urban Development of Bursa and the Genesis of Tradition, 1839–1914" (PhD diss., Harvard University, 1989).
29. Victor-Marie de Launay et al., *Usul-i Mi'mari-i 'Osmani (The Fundamentals of Ottoman Architecture) / L'architecture ottomane / Die ottomanische Baukunst* (Constantinople Imprimerie et lithographie centrales, 1873); Ahmet A Ersoy, *Architecture and the Late Ottoman Historical Imaginary: Reconfiguring the Architectural Past in a Modernizing Empire* (Aldershot: Ashgate, 2015).
30. Abdullah Kiamil, *La Turquie*, August 20, 1880, 3. This painting was exhibited at the French Embassy in Tarabya and later at the Abdullah Frères photographic studio in Istanbul.
31. Kiamil, *La Turquie*, 3.
32. Samuel Williams, "The Untimely Meditations of Osman Hamdi Bey: Competing Visions of History and Belonging in the Late Ottoman Empire," paper presented at the Turkish Studies Association Graduate Student Session, Middle East Studies Association Annual Meeting, Boston, MA, November 17, 2006.
33. Michel Serres, *Conversations on Science, Culture, and Time: Michel Serres with Bruno Latour*, trans. Roxanne Lapidus (Ann Arbor: University of Michigan Press, 1995), 61.
34. As part of this process, Vefik Paşa worked to revitalize the Ottoman ceramics industry. So too, for Léon Parvillée, the work he did on this restoration project inspired his own later involvement in production of ceramics in France. See Ersoy, *Architecture and the Late Ottoman Historical Imaginary*, 103.
35. Gülru Necipoğlu, "From International Timurid to Ottoman: A Change of Taste in Sixteenth-Century Ceramic Tiles," *Muqarnas* 7 (1990), 136–70; Walter B. Denny, *Iznik: The Artistry of Ottoman Ceramics* (London: Thames & Hudson, 2005).
36. The calligraphic tile panel is V&A 1890–1897.
37. This is just one of many paintings of the Yeşil Türbe that Osman Hamdi produced in which he experimented with placing both men and women in front of the tomb. In other paintings by Osman Hamdi, the religious implications are more equivocal; see Edhem Eldem, "Making Sense of Osman Hamdi Bey and His Paintings," *Muqarnas*, 29 (2012), 354–63.
38. Michael Serres, *Conversations on Science, Culture, and Time: Michel Serres with Bruno Latour*, trans. Roxanne Lapidus (Ann Arbor: University of Michigan Press, 1995), 54.
39. Letter from Alfred C. Laughton to C. Purdon Clarke, South Kensington Museum, Constantinople, August 26, 1897, V&A Archives, SF516 Purchases by Officers on Visits Abroad, Part III, 1896–1898, MA/2/P7/3.
40. For analysis of these panels and their earlier relocation into the Altın Yol, see Walter B Denny, "Quotations in and out of Context: Ottoman Turkish Art and European Orientalist Painting," *Muqarnas* (1993), 220–23; and Esin Atıl, *The Age of Sultan Süleyman the Magnificent*, exh. cat. (Washington, DC: National Gallery of Art, 1987), 281–83; and Tahsin Öz, *Turkish Ceramics* (Ankara: Turkish Press, Broadcasting and Tourist Department, 1954), black and white pls. XLVI, XLVII. For analysis of *The Snake Charmer* in the context of his trip to Istanbul in 1875 and the paintings by Gérôme purchased for the Ottoman palace in that year, see Mary Roberts, "Gérôme in Istanbul," in *Istanbul Exchanges*, 75–110.
41. Edward Said, *Orientalism* (New York: Pantheon, 1978); and Linda Nochlin, "The Imaginary Orient," reprinted in *The Politics of Vision: Essays on Nineteenth-Century Art and Society* (New York: Harper & Row, 1989), 33–59.

Bibliography

1001 Faces of Orientalism. Istanbul: Sabancı University Sakıp Sabancı Museum, 2013.
Atıl, Esin. *The Age of Sultan Süleyman the Magnificent*, exh. cat. Washington: National Gallery of Art, 1987.
Avcıoğlu, Nebahat and Finbarr Barry Flood, eds. "Globalizing Cultures: Art and Mobility in the Eighteenth Century," *Ars Orientalis* 39 (2010), 7–38.
Behrens-Abouseif, Doris and Stephen Vernoit, eds. *Islamic Art in the Nineteenth Century: Tradition, Innovation and Eclecticism*. Leiden: Brill, 2006.

Çelik, Zeynep. *Empire, Architecture and the City, French-Ottoman Encounters, 1830–1914.* Seattle: University of Washington Press, 2008.

De Launay, Victor-Marie et al. *Usul-i Mi'mari-i 'Osmani (The Fundamentals of Ottoman Architecture)/L'architecture ottomane/Die ottomanische Baukunst.* Constantinople: Imprimerie et lithographie centrales, 1873.

Denny, Walter B. "Quotations in and out of Context: Ottoman Turkish Art and the European Orientalist Painting," *Muqarnas* (1993), 219–30.

Denny, Walter B. *Iznik: The Artistry of Ottoman Ceramics.* London: Thames & Hudson, 2005.

Eldem, Edhem. "From Blissful Indifference to Anguished Concern: Ottoman Perceptions of Antiquities, 1799–1869," in *Scramble for the Past: A Story of Archaeology in the Ottoman Empire, 1753–1914,* eds. Zainab Bahrani, Zeynep Çelik, and Edhem Eldem, Istanbul: SALT, 2011, 281–329.

Eldem, Edhem. "Making Sense of Osman Hamdi Bey and His Paintings," *Muqarnas,* 29 (2012), 339–83.

Ersoy, Ahmet A. *Architecture and the Late Ottoman Historical Imaginary: Reconfiguring the Architectural Past in a Modernizing Empire.* Aldershot: Ashgate, 2015.

Fabian, Johannes. *Time and the Other: How Anthropology Makes its Object.* New York: Columbia University Press, 1983.

Flood, Finbarr Barry. "From the Prophet to Postmodernism? New World Orders and the End of Islamic Art," in *Making Art History: A Changing Discipline and its Institutions,* ed. Elizabeth Mansfield, London: Routledge, 2007, 31–53.

Hughes, Heather and Emily Neumeier, "From İstanbul to Philadelphia: The Journey of *At the Mosque Door,*" in *Osman Hamdi Bey and the Americans: Archaeology, Diplomacy, Art.* İstanbul: Pera Müzesi, 2011, 103–17.

Journal of Art Historiography 6, June (2012), guest edited by Moya Carey and Margaret S. Graves.

Lermer, Andrea and Avinoam Shalem, eds. *After One Hundred Years: The 1910 Exhibition "Meisterwerke muhammedanischer Kunst" Reconsidered.* Leiden: Brill, 2010.

Moxey, Keith. *Visual Time: The Image in History.* Durham, NC: Duke University Press, 2013.

Necipoğlu, Gülru. "From International Timurid to Ottoman: A Change of Taste in Sixteenth-Century Ceramic Tiles," *Muqarnas* 7 (1990), 136–70.

Nochlin, Linda. "The Imaginary Orient," reprinted in *The Politics of Vision: Essays on Nineteenth-Century Art and Society.* New York: Harper & Row, 1989, 33–59.

Öz, Tahsin. *Turkish Ceramics,* Ankara: Turkish Press, Broadcasting and Tourist Department, 1954.

Özdemir, Kemal. *Ottoman Clocks and Watches.* Istanbul: Creative Yayıncılık ve Tanıtım, 1993.

Roberts, Mary. *Istanbul Exchanges: Ottomans, Orientalists and Nineteenth-Century Visual Culture.* Berkeley: University of California Press, 2015.

Roxburgh, David. "Au Bonheur des Amateurs: Collecting and Exhibiting Islamic Art, ca. 1880–1910," *Ars Orientalis* 30 (2000), 9–38.

Said, Edward. *Orientalism.* New York: Pantheon, 1978.

Semper, Gottfried. "Concerning the Formal Principles of Ornament and its Significance as Artistic Symbol (1856)," in *The Theory of Decorative Art: An Anthology of European and American Writings, 1750–1940,* ed. Isabelle Frank, trans. David Britt. New Haven: Yale University Press, 2000, 91–104.

Serres, Michel. *Conversations on Science, Culture, and Time: Michel Serres with Bruno Latour,* trans. Roxanne Lapidus. Ann Arbor: University of Michigan Press, 1995.

Shaw, Wendy. *Possessors and Possessed: Museums, Archaeology and the Visualization of History in the Late Ottoman Empire.* Berkeley: University of California Press, 2003.

St Laurent, Beatrice. "Ottomanization and Modernization: The Architectural and Urban Development of Bursa and the Genesis of Tradition, 1839–1914", PhD diss., Harvard University, 1989.

Topkapı Palace Clock Collection: Exceptional Timepieces at the Seraglio. İstanbul: T C Kültür Bakanlığı, 2013.

Türker, Deniz. "Hakky-Bey and His Journal *Le Miroir de l'art Musulman, or Mir'at-i Şanayi-i İslamiye* (1898)," *Muqarnas* 31 (2014), 277–306.

White, Ian. *English Clocks for the Eastern Markets: English Clockmakers Trading in China and the Ottoman Empire 1580–1815.* Ticehurst: The Antiquarian Horological Society, 2012.

Williams, Samuel. "The Untimely Meditations of Osman Hamdi Bey: Competing Visions of History and Belonging in the Late Ottoman Empire," paper presented at the Turkish Studies Association Graduate Student Session, Middle East Studies Association Annual Meeting, Boston, MA, November 17, 2006.

Wishnitzer, Avner. *Reading Clocks Alla Turca: Time and Society in the Late Ottoman Empire.* Chicago: University of Chicago Press, 2015.

6 The Time of Translation

Victor Burgin and Sedad Eldem in Virtual Conversation

Esra Akcan

During his artist residency in Istanbul in 2010, the British and American artist Viktor Burgin created *A Place to Read*, a work composed of a narrative poem and a digital modeling of a coffee house originally designed by the Turkish architect Sedad Eldem (Figure 6.1). An icon of the early Republican architecture conceived in the 1930s and built in 1947, Eldem's building no longer exists, as it has been torn down to make room for a luxury hotel in 1988. Today, a high-rise hotel with freestanding blocks and curtain walls stands in its place behind the Dolmabahçe Palace. Tennis courts, a car park, and a swimming pool with a panoramic view of the Bosphorus waters, the historical peninsula's domes and minarets, and the Asian shore have replaced the public garden and terrace of the coffee house.

With *A Place to Read*, Burgin added Eldem's Taşlık Coffee House to the repertoire of his work that thinks through psychic and political dimensions of space with architectural masterpieces, including Mies van der Rohe's Barcelona Pavilion, Rudolf Schindler's house in West Hollywood, Le Corbusier's Villa Savoye, and Frank Lloyd Wright's Seth Peterson Cottage. In his book *In/Different Spaces*, which explains the theoretical foundations of his artworks, Burgin had contested the idea of space in relation to the Euclidian geometry and the Kantian conception that construes space as a neutral, empty vessel to be filled in with people, objects, or buildings. Instead, each perception and representation of space is historically inflected and involves the projection of the psychic apparatus onto the actual void.[1] Similarly, in his essay "Brecciated Time" published in the same book, Burgin had discussed his Bergsonian concept of time in opposition to the Kantian *a priori* time.[2] The conception of time as a supposedly empty vessel to be filled in with the linear, continuous progression of events hardly captures a human subject's experience of time. Much of Burgin's writing and visual artwork therefore tries to represent the time of the human subject, such as memory, amnesia, and being a witness of traumatic events.[3] Even though his works refer to the well-known actual historical facts, they represent these events through the virtual stories that operate in nonlinear, fragmented, or overlapping times of the human subject. In the same article, Burgin also mentions the need for another time conception in order to come to terms sufficiently with the histories of places around the world, rather than subsume them under the established Eurocentric history that operates with the linear, continuous notion of time. Referring to post-colonial theory, he admits that this would require "a radical questioning of History's status as the one story of Western progress and culture." He proposes the concept of imbricated time to allow each place its own time.[4] "[The] apt analogy for the representation of time is . . . an assembly of simultaneously present events, whose separate origins and durations

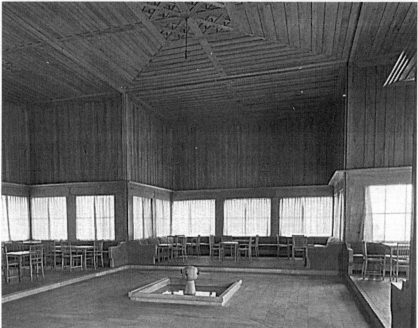

Figure 6.1 Sedad Eldem, Taşlık Coffee House, Istanbul, 1947–48 (SALT, Istanbul)

are out of phase, historically overlapping. This is the imbricated time of our global lived space."[5] This article discusses Burgin's *A Place to Read*, which translates Sedad Eldem's building into a digital video installation as an opportunity to think about alternative time conceptions for the accomplishment of a global, intertwined history of art and architecture, which replicates neither the Eurocentric frameworks nor the clash-of-civilizations convictions.

I was initially drawn to Burgin's artwork because it is a translation of one of the most significant buildings discussed in my book *Architecture in Translation: Germany, Turkey and the Modern House.*[6] This book offered an opposite framework

to recent global histories that either extend established European narratives to the rest of the world, or consciously or subconsciously maintain the clash of civilizations theory by dividing the world into Art History's nineteenth-century field categories such as "Islamic", "Asian", and "Chinese" art. In this book, I argued instead that there is enough evidence to re-write the past in a much more intertwined way by foregrounding multiple contacts between places that had previously been assumed to be separate and self-contained. It is necessary to improve theories and concepts that will help us shape architectural history, theory, and criticism as a discipline modeled on non-Eurocentric humanism and global justice. *Architecture in Translation* thus offered a way to understand the global circulation of architecture that extends the notion of translation beyond language to visual fields, by particularly demonstrating the intertwined histories of residential architecture in Germany and Turkey between the 1920s and the 1950s. I defined translation as the bi-lateral and multi-lateral, international transportation of people, ideas, objects, technology, information, and images that generates processes of change. Translation takes place under any condition where there is a cultural flow from one place to another. It is the process of transformation during the act of transportation. This is in contrast to the mainstream perception of lingual translation as a second-hand copy that has fabricated the myth of the original, on the one hand, and the conventional belief of translation as a smooth bridge between cultures, as if translations are devoid of geopolitical inequalities, tensions or psychological anxieties, on the other hand. Realizing that translations make history, the book aimed to establish a terminology to write this history by observing different types, modes, items, channels, agents, ideologies, and qualities of translations.

Translation as Digital Model Visualization

Burgin's *A Place to Read* is an unordinary act of architectural history and preservation, because it bears witness to the power of transversal dialogues against the absences created by historical violence. The transversal dialogues are the translations between architecture and art, as well as between Eldem and Burgin situated at two different places on earth and times in history. Burgin explained his work as an "access to history in a moment of crisis":

> There is something of this idea in Walter Benjamin's notion that our access to history is a matter of the activation of a memory in a moment of crisis. One way that I understand that moment of crisis is as the experience of affect, or even the lack of it, in our first encounter with a place . . . *A Place to Read* was the outcome of an invitation to make a work in response to Istanbul. After several visits to the city, I found myself preoccupied by the ongoing process of destruction of some of the most beautiful public aspects of Istanbul in the pursuit of private profit. What came to metonymically represent this present process for me was the past destruction of an architecturally significant coffee house and public garden, on a beautiful site overlooking the Bosphorus, to make way for a hideous orientalist luxury hotel. The house and garden had to be disinterred from oblivion . . . resurrected as "memory."[7]

Three years later, Burgin referred to the Gezi events of the summer of 2013 as yet more evidence for the erasure of Turkey's early Republican architectural icons. The Gezi protests mobilized the biggest mass movement in Turkey to prevent the government's

attempted destruction of two modernist architectural icons, the Gezi Park and the Ataturk Cultural Center—a protest that faced extreme police violence as a result of which seven citizens died, 7,478 were injured, ninety-one had a head trauma and ten lost an eye by the twelfth day. As Burgin explained: "The destruction of Istanbul's heritage of fine public architecture in the interests of private profit seemed to me to be an urgent contemporary political issue. (Three years later, in May 2013, a no less brutal development plan for Gezi Park, by the Taksim Square, would spark massive anti-government protests)."[8]

Burgin's *A Place to Read*, initially exhibited at the Istanbul Archeological Museum, is composed of a poem and a 3D digital model visualization, both presented in three parts that make a ten-minute video with six segments. The intertitles that show the three parts of the text and the three parts of the animation interrupt each other in the video that perpetually loops. The storyline of the text and the digital anima-tion are continuously translated into each other without setting one as the original and the other as its paraphrase. It does not matter which comes first as the video constantly loops. There are four characters in Burgin's narrative that can be named as the reader, the writer, the architect, and the avatar, whose stories intertwine in a poetic ambiguity.

The reader, introduced in the first video segment, is reading in the original cof-fee house in Istanbul designed by Eldem, as evidenced from her view that overlooks the Bosphorus with "ferries, freighters, fishing boats and tankers passing by the Dol-mabahçe Palace." The clock in the Ottoman palace, an edifice built by the Armenian Balyan architects, has stopped at 9.05 in the morning, at the time of Atatürk's death, as an obvious sign of the early Republic of Turkey when the coffee house was built. The reader is reading a book in which the coffee house has been replaced by a luxury hotel, and its garden by a car park. Then, the text is interrupted by the first sequence of the 3D digital model's simulation, where the camera pans over the digital replica of Eldem's coffee house, creating a full-circle panoramic view of the building from the outside.

The second character, the writer, may be hinted at the end of the first part but is introduced in the second part of the text that corresponds to the third video segment. The writer is writing a book in another coffee house on the Quai des Bergues at Lake Geneva. Her melancholy for Istanbul is revealed when she sees "on the faded blue label of a bottle in the window of a bric-a-brac shop, a municipal ferry . . . plying the Bosphorus." This is when "wave upon wave of longing wash over her." The architect, also introduced in this segment, is a character in the writer's story. He is building a digital replica of the "coffee house in a garden overlooking the Bosphorus," so that the avatars of a man and woman can meet in this virtual world. Next, the moving images of the 3D digital model fill in the screen, taking the audience to a walk in the garden behind the coffee house toward its entrance. This strikes the audience as a possible visualization of the public park that was introduced in the text's very first lines. We had been told that in this park "one finds the Ink Tree of which Evliya Çelebi spoke," the legendary seventeenth-century Ottoman traveler. We had been told that the pruned branches of this tree poured a "black and shiny ink" that was taken "to the land of the Franks who use[d] it to print books." Already in the very first video segment, we had been given the hints of the many connections between coffee houses, printed books, Istanbul, and French-speaking Europe, which had continued to unfold in the poem with the passage from one verse to the next.

Finally the architect's avatar is introduced in the final part of the text. We now learn that the architect who has built the digital replica of the coffee house for his own avatar is sitting in another coffee house in the Istiklal street, the famous cosmopolitan pedestrian spine of contemporary Istanbul leading to the Taksim square. He is "struggling to ignore the music from the loudspeakers, a man who is talking on his mobile phone, [. . . and the] streams of people [who] pass an old man on a plastic stool playing the bağlama." We learn only now that the coffee house that the architect has rendered has already been replaced by a building whose "restaurant overlooks a rooftop tennis court with advertisements for telephone companies," just like the coffee house that has been replaced by a luxury hotel in the book the reader was reading in the first video segment. The avatar walks "sixty-eight steps in the garden," enters the coffee house, contemplates its fountain, and enjoys the panoramic view of the historical peninsula with "the four minarets in the Ayasofya and the six of the Sultanahmet mosque." In the third and final part of the 3D modeling, the camera moves inside the coffee house, registering the horizontal windows that open to the panoramic view outside. The sequence records the sunlight washing the room from dawn to twilight, as the beams enter from one façade and move to the one across.

There are multiple ways of diagramming the timeline of the narrative in *A Place to Read* (Figure 6.2). Perhaps, the reader, the writer, and the architect are unrelated in three detached stories, where they are reading, writing, and drawing about different coffee houses independently of each other. Perhaps, the reader is reading the book that the writer is writing, and the architect in the second part of the text is the same figure as the architect in the third part of the text: he is the character who is building a digital replica of the coffee house so that his avatar could meet his loved one's avatar in the book that the writer is writing and the reader is reading. Or, perhaps, the reader, the architect, and the avatar are all characters in the writer's book, i.e. doubly virtual, in which case the reader in the coffee house may be no other than the avatar of the woman for whom the writer builds a replica and where his avatar does actually meet her avatar—all happening in the book that the writer writes. In yet another possible interpretation, the reader, the writer, the architect, and the avatar all refer to the same person, Burgin himself—the artist who has imagined to have read a book in the old coffee house is indeed the same artist who has written a book about an architect who is building a digital replica of the coffee house so that his avatar could meet the avatar of his loved one.

The number of possible interpretations due to the indeterminate relationship between the characters is multiplied by virtue of the looping video, a common feature in Burgin's work. As the artist explains, a loop never returns to the exact same place, a repetition never re-creates the exact same psychic experience, as each re-seeing, re-reading, or re-habiting is inflected by the memories of what was seen, read, or habited in between the first and the last sequence.[9] In Homay King's words, "[unlike] the linearity of narrative film, [e]ach seeming recurrence of the same—the same woman, room, gesture, or phrase of text—is shadowed by a stream of prior and future images that are connected to it, but that do not depend on chronological ordering in order to operate in this way."[10] Much like many other works by Burgin, the video loop creates an intentional ambiguity about the concept of time. The time and place of the building's story intertwine with the time and place of reading, writing, rendering and occupying the building's story in an indeterminate number of ways. Accordingly, placing each possible character in time would change the order of events and the diagram of the

Figure 6.2 Diagramming Victor Burgin's *A Place to Read*, 2010 (diagrams by Esra Akcan)

narrative. If the reader is actually reading in Eldem's coffee house, she is situated in a time before its destruction and before the melancholic writer imagines an architect who is building the digital rendering of the absent coffee house. In this case, chronologically, she cannot be reading the book that the writer is writing. If the reader is actually reading the writer's book, then she must be anachronistic (unless the writer is a fortune-teller). The times before and after the coffee house's destruction are collapsed into each other so that we can hardly speak of a continuous, linear conception of time in a neat chronological order. If we were to translate Burgin's theory of time established in his text "Brecciated Time" into his visual artwork, we might as well argue that the loop in an open narrative with multiple possible meanings is video-art's way of coming to terms with the nonlinear conception of time that calls on to write alternative histories of the world.

A Place to Read hints at the intertwinedness of places by mirroring the events in different cities onto each other:

> The story is about conspiracy and corruption,
> environmental devastation, exile and loneliness,
> longing and sex.
> A journalist is murdered, a tanker explodes
> and flames bridge the Asian and European shores [of Istanbul].
> The action takes place in a parallel world
> where the oceans are rising, and the glaciers are gone
> from the peaks beyond Lake Geneva.

If Burgin's early writing, which employed psychoanalytic knowledge to expose the hidden pathologies of subject formation and the spatial unconscious, is of any guidance for these lines,[11] the mirroring of murder in Istanbul and climate change in Geneva might well be alluding to the construction of the western self by dividing it from his "other." The "other" is formed at the unfortunate division from the natural on the one hand and the Eastern on the other hand. If we adopt the interpretation that all characters represent the artist himself, the gendered signification of the reader and the writer with the feminine pronoun as opposed to the architect and the avatar with the masculine pronoun refers to the division of man as "self" from its "other" as woman. On yet another layer, the collective memory and the virtual memory are intertwined with each other. Burgin's narrative reveals that the fate of the digital replica is no different than the actual, physical coffee house, because the architect character's server space that is controlled by profit-oriented companies is also about to be exhausted:

> His lease on the digital space has expired,
> And large hotel companies have bid for the site.
> The garden and coffee house still might be saved
> if more server space could be added online.
> But a ruthless suppression of unlicensed servers
> now maintains the market in virtual land.

Needless to say, Burgin is using the word "virtual" not as a synonym of "digital," but in its Deleuzian/Bergsonian sense: "To have an interest in the relation between real exterior space and psychological space is quite simply to be interested in the *image* . . .

defined as the virtual."[12] In this sense, the narrative poem, the photograph, the pan-orama, and the memory image are neither less nor more virtual than the 3D digital model. Therefore, Burgin's recent occupation with computer rendering, which he undertakes himself rather than employing a professional renderer, is an extension of what he has been arguing and practicing all along.[13] In Gülru Çakmak's words, "the virtual reality created by digital technology stands in, on the one hand, for the overall experience of the world through mental images, while on the other it represents the final frontier being conquered by global capitalism, the manipulation of preconscious meaning-making."[14]

Moreover, the choice of video animation through the 3D modeling of the building is consistent with Burgin's previous interest in the photo-filmic medium, such as the panorama and the image-sequence. Anthony Vidler has praised Burgin's panoramas about Mies' Barcelona Pavilion and Dominique Perrault's Library of France as artworks that both carefully use and critically analyze their genre in order to open up the problematic relationship between the panoramic conception and modernist space.[15] In the case of *A Place to Read*, the panorama takes on an additional significance, precisely because of its place in the making of the absent coffee house on which Burgin's digital image is modeled.[16]

Translation as Architecture

What is still left to global architectural history, then, is to uncover the additional layers of Burgin's possible translations from Sedad Eldem, the architect of the absent coffee house with a panoramic view. Perhaps no other person was as comprehensive, as devoted, and as productive as the Turkish architect Sedad Eldem (1908–88) in researching and documenting Istanbul's endangered wooden houses during the early Republican period. Eldem was melancholically cautious of the mainstream cultural values and policies of his time, when these houses were considered outdated due to the pretext of modernization, and were slowly disappearing either because they were left to decay as storages or because they caught fire and burned into ashes in one night. As a reflection of the new nation-building sentiment during the early Republican period, Eldem referred to these houses in Istanbul and the rest of Turkey as the "old Turkish houses"—a nationalist umbrella term that disavows their Ottoman past, as well as their multi-ethnic and multi-religious habitants.

The Taşlık Coffee House in Istanbul (1947–48) was one of Eldem's most recognized buildings, admittedly based on the seventeenth-century Köprülü Amcazade Hüseyin Paşa waterfront house on the Bosphorus (Figure 6.3). Eldem had written an article on this waterfront mansion, warning about its state at the verge of collapse, and calling architects to a better appreciation and preservation of Istanbul's anonymous architectural heritage.[17] In other words, much like Burgin did in digital space, Eldem built a translation of a threatened wooden house so that it was "disinterred from oblivion [. . .] resurrected as memory." Like many of his early careeer designs, Eldem drew the first sketches for this building during his study-trip in Europe in the late 1920s and early 1930s, soon after graduating from the Academy of Fine Arts in Istanbul, where he constantly hybridized the new designs that he studied in Europe with the old Turkish houses in his memory. Tracing Eldem's steps during this travel would present a myriad of possibilities where we might identify as the moment for the emergence of the coffee house's design concept. It would also confirm that Eldem's ideas were never

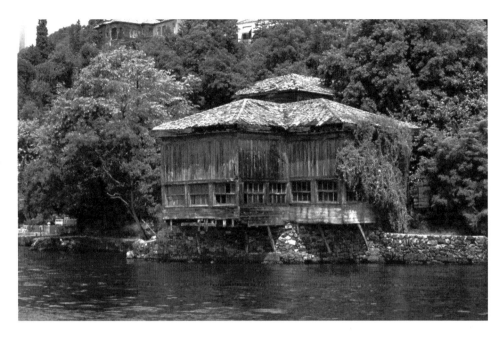

Figure 6.3 Köprülü Amcazade Hüseyin Paşa waterfront house, Istanbul, seventeenth century (photo by Esra Akcan)

shaped insularly, but at each instance formed in a moment of translation. In Paris, Eldem exhibited some of his watercolors of the "old Turkish houses" on the one hand, and drew several hypothetical houses on the other hand, emphasizing the exposed reinforced concrete structure that was filled in with textured aggregate and linear windows. The architect said he felt an implicit familiarity between the construction logic of Auguste Perret's buildings and that of the wooden framework of anonymous houses in Turkey: "I dreamt of the infill walls colored as they were in [Anatolia] when I realized that the concrete framework had to be visible without any conceal-ment."[18] In Berlin, Eldem was drawn to a number of architects with different stylistic preferences, including Erich Mendelsohn, Paul Schultze-Naumburg, and Frank Lloyd Wright that he discovered in a publication. It was as if Eldem, in trying to find a way that would help him modernize the Ottoman houses, was fluctuating between competing expressions. Eventually, the emphasis on horizontality in Mendelsohn and Wright, and the large eaves of the pitched roofs in Istanbul's houses were combined, leading to a formal expression that would become his signature in a fruitful career. As a matter of fact, it is arguable that Eldem had worked on the preliminary sketches of many of his early buildings during this trip, including the Taşlık Coffee House.[19]

The final design of the coffee house extended over a retaining wall with a large projection bay and wide eaves. Despite the wooden buttresses, the structure was rein-forced concrete rather than wood, a decision Eldem must have hardly deemed con-tradictory, given his appraisal of reinforced concrete construction as an extension of the wooden frame during his stay in Paris. The coffee house followed many themes that Eldem explored throughout his career. In many of his buildings, he used familiar

elements of Istanbul's houses such as wide extending eaves and *cumbas* (projection bays) that made a panoramic view possible, while usually defamiliarizing them with large linear windows, flat roofs, and non-ornamented surfaces of the stucco paint. He used modular exposed frames, sometimes with totally dematerialized infills, as an extension of the analogy he had drawn between wooden construction and reinforced concrete frame.

Despite his approval of the transformed and modern ways in which his spaces would be inhabited, Eldem did not follow the new modernist plan conceptions, such as Le Corbusier's *plan libre*, Mies' open plan, or Adolf Loos' *Raumplan*, but organized most of his designs as a T-plan or around a central space that he called the *sofa*. The Taşlık Coffee House also employed a T-plan. Composed of three identical bays, this plan-type was a recognizable element of Istanbul's wooden houses, enabling maximum fenestration on a given span. A T-plan opens the interior to a maximum panoramic view of Bosphorus, enabling the look not only in one but in four directions, while also providing cross-ventilation. Eldem made the most use of this possibility by encircling all the edges of the T-plan with continuous horizontal windows that let the light and panoramic Bosphorus view inside.

In Eldem's mind, these decisions were a confirmation of the already existing hints of modernism in the "old Turkish houses," given Perret's emphasis on construction frames, Le Corbusier's and Mendelsohn's on horizontal windows, or Frank Lloyd Wright's on the flat lands like those in Anatolia. The expression of structural lightness through the excessive use of wood in the coffee house not only alluded to the timber-frames of traditional houses, but also made the new building compatible with European modernism. So did the horizontal windows, the long low lines, the wide extending eaves. It was precisely this claim to compatibility, the claim for the "modernness" of the "Turkish house," and the "Turkishness" of the modern achievements that helped Eldem resolve the dilemmas of modernization in Turkey between westernization and nationalization. Scholars have later traced Le Corbusier's and Wright's sources in Anatolia, making some of his claims plausible, but this is not my point.[20] Eldem's formulation may sound to us today like a forced understanding of both Istanbul's anonymous houses and European modernism, anguished to confront the discontinuities between the two. However, it was this make-believe that allowed him to pursue his practice at the time. The faith in the universality and translatability of cultures enabled Eldem to avoid both exoticism that would have searched for the "essential difference" of Turkey, and cultural supremacism that would have unproblematically extended European modernism to the rest of the world.

Let me then re-phrase the possible translations happening around this coffee house and its virtual models. During his trip to Istanbul arriving from Europe, Victor Burgin translated Sedad Eldem's coffee house into a digital model, accompanying it with some virtual characters such as the writer in Geneva who possibly created the doubly virtual character of the architect in Istanbul, who created the triply virtual character of his avatar in the digital world so that he could visit the 3D computer model of Eldem's coffee house, which was a building that had been the result of a transversal act itself, given that during his trip to Europe arriving from Istanbul, Eldem had translated his mental images of the European buildings and the "old Turkish houses" into the design of the coffee house that he had possibly sketched during this trip in Europe and had built after his return to Istanbul. The more we look back at history, the more

the narrative loop of this article's story spirals between different times, places, characters, and media.

Translation as Photography

Looking even further back in historical time, it is possible to add one more layer to this set of translations. One would hardly miss the panoramic view of the Bosphorus waters, the historical peninsula and the Asian shores represented in Eldem's interior sketches and photographs of the coffee house. The most circulated image of this building in contemporary journals both in Turkey and abroad was the photograph with the historical peninsula's panoramic view. Burgin also alludes to this panoramic view once the avatar in the digital replica enters the virtual coffee house. Given the history of the panoramic genre as a device for panoptic control, totalizing aerial gaze, and Orientalist exoticizing, it may be hard to understand why Burgin chooses to evoke panoramic viewing with appreciation. But a counter-history of the panoramic photograph in Istanbul may reveal why it is hard to dismiss this medium as purely panoptic or Orientalist.

Many nineteenth-century panoramas of the historical peninsula did indeed maintain the Orientalist myth of Istanbul as a beautiful but exotic, frozen, non-changing, and non-modernizing city without the transformative power of history—a very common form of latent Orientalism as Edward Said characterized it.[21] These panoramas of the Golden Horn from the Galata Tower adopted the same vantage point, reproduced the same composition, the same center, the same frame, the same narrative, even though they were taken years apart. They maintained the very same view of the painted panoramas that had already circulated in the European market as Istanbul's most conventional depiction. However, panoramas from other vantage points also existed. A comparison of the first photography panorama from the Seraskier tower by James Robertson in 1855 and another one in 1900 would confirm the changing urban fabric around the Galata and Pera neighborhoods. Moreover, during the heights of photography in the late nineteenth century, the panoramic medium commonly depicting the Golden Horn was also used to represent the Bosphorus, not necessarily in the form of actual panoramas—although this also existed—but in the form of panoramic city albums.

Nowhere is this as visible as in the engravings of Antoine Ignace Melling in his *Voyage pittoresque de Constantinople* (ca. 1800–10) and in the albums prepared by minority photographers such as Abdullah Frères and Pascal Sebah throughout the second half of the nineteenth century (Figure 6.4). Mapping their albums, one realizes how these artists moved outward from the historical peninsula to the Bosphorus, and how they constructed a mental image of Istanbul as a panoramic city. I argued elsewhere that Bosphorus photographs in city albums of the period opened up a specific genre that constructed a distinct way of looking at the city that we might call panoramic.[22] The panoramic city albums did not necessarily contain panoramas in the technical sense—images composed of two or more prints attached to each other— although some albums included single prints taken for the purpose of a larger panorama. The panoramic city photographs did not necessarily reproduce an aerial gaze from a high point overlooking the city, although such images also burgeoned. Rather, these albums constructed a specific perception that marked the city as panoramic.

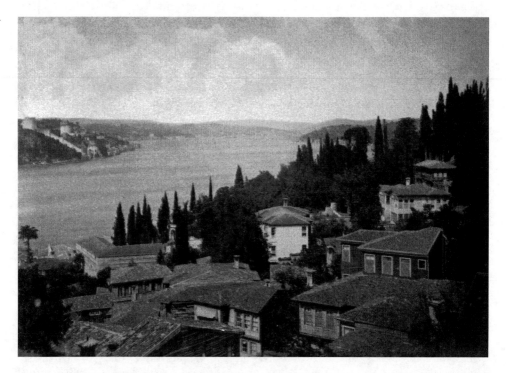

Figure 6.4 Abdullah Freres, page from the album "Vues et Types de Constantinople," ca. 1870 (Canadian Center for Architecture, Montreal)

These photographs were placed side by side in albums as if to invite the eye to look beyond the frame. Rather than staging monuments in carefully constructed frames that froze their image as in most travelers' guides, they represented buildings in a slice of the Bosphorus. This visualization invited the viewer to expand the actual frame of the photograph to its outside, to imagine the sea and the city off-the-frame, to locate the object in the context of the city, and then to complement the view by imagining the continuity of the Bosphorus.[23] These sliced views could only be appreciated in the context of a virtual full panorama, a map in the mind's eye that consciously or sub-consciously located these images on their exact places along the Bosphorus. One of the well-deserved criticisms against the Orientalist artists was their second-hand portrayal of the lands and people they depicted. Orientalist painters produced countless scenes of Turkish baths and the harem without ever having been there. It may be hard for the audiences who have never been to Istanbul to appreciate these cityscapes by placing them in the virtual panorama of their mental eye, but it is quite likely that the local habitants and photographers themselves who regularly went up and down the shores and seas of the Bosphorus had mastered this virtual panorama. This is how these photographs differed from stereotypical Orientalism, even though they simultaneously constructed an idealized image of Istanbul devoid of its many tensions. Years later during the early Republican period, it was this virtual panorama that the Istanbulite authors and architects including Eldem longed for, but they were silent or failed to recognize the Armenian, Levantine and Greek-Ottoman artists' contribution

to the city's urban and photography culture. Eldem politicized the visual memory carried in Melling's engravings, and Abdullah Frères' and Pascal Sebah's panoramic photographs by translating their images into views from his own buildings, precisely because he feared the city's historical urban fabric was under threat.

Walter Benjamin and Yunus Kazım Köni specified a good text as one that is translatable and a good translation as one that opens a language to transformation, because translations would ensure that the texts will continue to live, and translatability would remind us that a future for true conversation is imaginable.[24] It is, after all, translations that make it possible for a population, wherever in the world, to be enriched by what was its outside, rather than being consumed in its own claims to national/regional/religious superiority. A place opens itself to what was hitherto foreign through translation; it modifies and enriches its political institutions and cultural forms through translation, while it simultaneously negotiates its local norms with those of the globe. Translation manifests an openness to the foreign, despite the different levels of appropriation, foreignization, or resistance that might take place during the process. It is not translations *per se*, but rather the uneven, uni-directional and forced translations that have produced the dominant geopolitical hierarchies of modernism. Instead, a commitment to a new culture of translatability from below and in multiple directions might be the prerequisite of a truly cosmopolitan ethics and global justice today.[25]

The works that Victor Burgin's *A Place to Read* invokes bring to the fore translations between mediums: from building to photograph, from photograph to building, from building to digital model, from storyline to digital animation and vice versa. Through these translations between mediums, we also understand the importance of translation between places as that which makes history, as well as the necessity of new time conceptions to sufficiently come to terms with this global history. Going back to Burgin's call for a new conception of time for precisely this reason, it seems that the linear and homogeneous time conception fueled by Eurocentric histories would hardly accomplish an appropriate global history. On the contrary, the writing of a global history is predicated on the questioning of a set of premises that had construed art and architecture history as a discipline with conceptual schemata that lend to the monophonic and monochronic narrative prioritizing white male architects. However, nor would a relativist time conception come to terms sufficiently with the frequent translations happening between parts of the world, as it would lead to arguments that claim separated and isolated histories of different areas. Proponents of such arguments pretend as if these geographic areas have never shared ideas, images, objects, and technologies that travel back and forth between them, and as if they were territories of secluded sedentary people who made up communities with unchanging and essential bonds. Instead, an intertwined history foregrounding translations across space and time offers an opposite framework both to uniform narratives and to those that revive the art history discipline's nineteenth-century field categories. The former sweeps all parts of the world under one and the same narrative, while the latter construes them as self-contained, separate and often hierarchically organized entities. Instead, an intertwined history acknowledges how translations across time and space continuously make the world. Time may unfold at different speeds and at different rhythms in different places and at different periods of those places, but these durations are always connected to each other just like in a web of strings where the movement of one cord affects all others to varying degrees. The time conception in such

an intertwined history allows for the depiction of world events less as homogeneous occurrences that linearly follow European history from several years behind, and less as simultaneous but unrelated happenings in different places, but more as events whose beginnings and durations may be out of phase, overlapping, or divergent, but always affected by each other.

Notes

1. Victor Burgin, "Geometry and Abjection," in *In/Different Spaces: Place and Memory in Visual Culture* (Berkeley: University of California Press, 1996), 39–56.
2. Victor Burgin, "Brecciated Time," in *In/Different Spaces*, 179–275.
3. See, for instance, "Victor Burgin, "Monument and Melancholia," in *Situational Aesthetic* (Leuven University Press, 2009), 315–29.
4. Burgin, "Brecciated Time," 180.
5. Burgin, "Brecciated Time," 184.
6. Esra Akcan, *Architecture in Translation: Germany, Turkey and the Modern House* (Durham, NC: Duke University Press, 2012).
7. Full sentence: "The house and garden had to be disinterred from oblivion through the agency of surviving drawings and photographs, and was resurrected as "memory" in the form of virtual camera movements through a computer modelled space." Victor Burgin and David Campany, "Victor Burgin and David Campany in Conversation," in *Projective* (Geneva: Mamco, 2014), 147.
8. Victor Burgin, *5 Pieces of Projection* (Berlin: Sternberg Press, 2014), 88.
9. See, for instance, Victor Burgin, *Components of a Practice* (Milan: Skira, 2008).
10. Homay King, "Beyond Repetition: Victor Bugin's Loops," in *Projective*, 73.
11. See, for instance, "Perverse Space" and "Paranoiac Space," in *In/Different Spaces*, 57–78, 117–60.
12. "To have an interest in the relation between real exterior space and psychological space is quite simply to be interested in the *image*. The 'image' is neither a material entity nor simply an optical event, an imprint of light on the retina, it is also a complex psychological process. It is in this sense that the image is defined as essentially 'virtual' in the phenomenological perspective that Gilles Deleuze drives from Henri Bergson." "Victor Burgin and David Campany in Conversation," 142.
13. In a recent interview, Burgin explains that in his early work, he thought there were too many images in the world, which pushed him to interpret existing images rather than creating new ones. But the digital video allows him to edit images, much like editing a text: "I am trying to represent something that is at the interface of what is outside and what is inside, that psychological object . . . I always did the same thing." "Tate Shots," https://www.youtube.com/watch?v=p5TcayyP4OY (accessed December 1, 2017).
14. Gülru Çakmak, "Victor Burgin's *A Place to Read* and the Panoramic Subject of the Bosphorous," in *Projective*, 39–69, at 50.
15. Anthony Vidler, "The Panoramic Unconscious: Victor Burgin's Spatial Modernism," in *Shadowed*, ed. Pamela Johnston (London: AA Publications, 2000), 8–19.
16. Reception: "A woman at the opening of the installation at the Archeological Museum in Istanbul was in tears—she had known the original coffee house as a child." "Victor Burgin and David Campany in Conversation," 148.
17. Sedad Eldem, "Amca Hüseyin Paşa Yalısı," *Arkitekt* 12 (1933), 377.
18. Sedad Eldem, "Toward a Local Idiom: A Summary. History of Contemporary Architecture in Turkey," in *Proceedings of Conservation as Cultural Survival* (Singapore: Aga Khan Publishing, 1980).
19. For more discussion, see Akcan, *Architecture in Translation*, Chapter 2.
20. See for instance: Adolf Max Vogt, *Le Corbusier, the Noble Savage: Toward an Archeology of Modernism*, trans. Radla Donnell (Cambridge, MA: MIT Press, 1998).
21. Edward Said, *Orientalism* (New York: Vintage Books, 1978), 201–11.
22. Esra Akcan, "Off the Frame: The Panoramic City Albums of Istanbul," in *Photography's Orientalism*, eds. Ali Behdad, Luke Gartlan (Los Angeles: Getty Publications, 2013), 93–115.

23. See also Stephan Oettermann, *The Panorama: History of a Mass Medium*, trans. Deborah Lucas Schneider (New York: Zone Books, 1997), 22, 30.
24. Walter Benjamin, "The Task of the Translator," in *Illuminations*, ed. Hannah Arendt, trans. Harry Zohn (New York:Schocken Books, 1968), 69–82. Translated from "Die Aufgabe des Übersetzers." 1923; Yunus Kazım Köni, "Tercümeye Dair Düşünceler," *Tercüme* 5, no. 26 (10 July 1944), 157–59.
25. For more discussion, see Akcan, *Architecture in Translation*.

Bibliography

Akcan, Esra. *Architecture in Translation: Germany, Turkey and the Modern House*. Durham, NC:Duke University Press, 2012.

Akcan, Esra. "Off the Frame: The Panoramic City Albums of Istanbul." In *Photography's Orientalism*, ed. Ali Behdad and Luke Gartlan. Los Angeles: Getty Publications, 2013, 93–115.

Benjamin, Walter. "The Task of the Translator." In *Illuminations*, ed. Hannah Arendt, trans. Harry Zohn. New York: Schocken Books, 1968, 69–82.

Burgin, Victor. *In/Different Spaces: Place and Memory in Visual Culture*. Berkeley: University of California Press, 1996.

Burgin, Victor. *Components of a Practice*. Milan: Skira, 2008.

Burgin, Victor. "Monument and Melancholia." In *Situational Aesthetic*. Leuven University Press, 2009, 315–29.

Burgin, Victor. *5 Pieces of Projection*. Berlin: Sternberg Press, 2014.

Burgin, Victor and David Campany. "Victor Burgin and David Campany in Conversation." In *Projective*. Geneva: Mamco, 2014, 133–69.

Çakmak, Gülru. "Victor Burgin's *A Place to Read* and the Panoramic Subject of the Bosphorous." In *Projective*. Geneva: Mamco, 2014, 39–69.

Eldem, Sedad. "Amca Hüseyin Paşa Yalısı," *Arkitekt* 12 (1933), 377.

Eldem, Sedad. "Toward a Local Idiom: A Summary. History of Contemporary Architecture in Turkey." In *Proceedings of Conservation as Cultural Survival*. Singapore: Aga Khan Publishing, 1980, 89–99.

King, Homay. "Beyond Repetition: Victor Bugin's Loops." In *Projective*. Geneva: Mamco, 2014, 70–102.

Köni, Yunus Kazım. "Tercümeye Dair Düşünceler." *Tercüme* 5, no. 26 (10 July 1944), 157–59.

Oettermann, Stephan. *The Panorama. History of a Mass Medium*. Trans. Deborah Lucas Schneider. New York: Zone Books, 1997.

Said, Edward. *Orientalism*. New York: Vintage Books, 1978.

Vidler, Anthony. "The Panoramic Unconscious: Victor Burgin's Spatial Modernism." In *Shadowed*, ed. Pamela Johnston. London: AA Publications, 2000.

Vogt, Adolf Max. *Le Corbusier, the Noble Savage: Toward an Archeology of Modernism*. Trans. Radla Donnell. Cambridge, MA: MIT Press, 1998.

Part III
Artist's Time

7 Arresting What Would Otherwise Slip Away
The Waiting Images of Jacob Vrel

Hanneke Grootenboer

> In its promiscuity, form has a way of detaching works of art from people who worked
> and from the time and place in which they were made, not by transcending history . . .
> but by transgressing . . . our linear conception of it.
>
> Amy Powell, *Depositions: Scenes from the Late Medieval*
> *Church and the Modern Museum*

Around 1655, Jacob Vrel painted *Woman by the Hearth* (Figure 7.1). We see a woman
from the back, seated by a drab fireplace that is adorned with blue-and-white plates,
tin bowls, and a copper candle holder. The eye for symmetry evident in this simple
arrangement, which livens up an otherwise dull and joyless room, is somehow quite
touching. The scenery recalls better-known paintings by Delft artists such as Pieter de
Hooch (1629–84) and Emmanuel de Witte (1617–92), to which Vrel's has been com-
pared; however, we note here a sharp contrast with their spick-and-span, sunlit inte-
riors, where well-dressed women, assisted by servants, are blissfully involved in light
housework or leisurely tasks (Figure 7.2). *This* woman—this space, this life—is of an
altogether different class, her body patently worn out from heavy labor. Placing an
empty bowl at her feet and her body onto the chair in a single movement (we almost
hear her sigh), she does nothing; she is just being-there. What would otherwise have
passed without being noticed, not even by the woman herself—a brief pause in a stark
existence—is here made present. As her body is lowered onto the chair, everything
else in the image has, in a most uneventful way, come to a standstill. Something has
been made heavy, akin to the weightiness of a clock whose loud ticking has suddenly
stopped. It is this heavy silence—rather than the interrupted household activity—that
identifies what this woman's existence consists of, that gives her the face we are not
meant to see. Or rather, this facelessness *is* her face. The painting tells us not of this
precise event, but of the invariability of its recurrence, referring to all previous and
future breaks that will look exactly the same as this moment. Bolstering this structure
of recurrence is the woman's apparent rocking in her chair, its rear legs just lifted off
the floor. In a profoundly unpretentious way, Vrel has the transcendent touch the
immanent through this visualization of an in-between moment, the interval between
the lowering of one's body in the seat and the moment that one bends over to stir the
pot hanging over the fire.

Though we know little about Vrel's life and practice, his small oeuvre of thirty-eight
paintings reveals that he is an absolute master of the interval.[1] This image (and others
like it) depicts a separation between two already insignificant moments that, in the

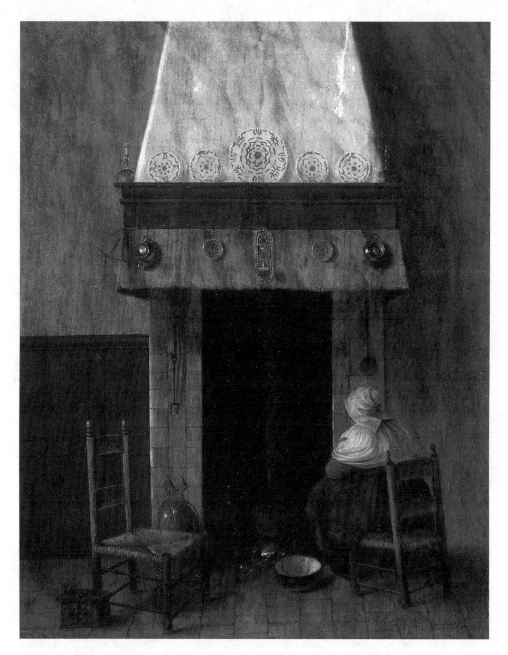

Figure 7.1 Jacob Vrel, *Woman by the Hearth*, ca. 1650. Oil on canvas, 36 × 31 cm. St Petersburg, Hermitage

light of posterity, hardly deserve to be called occupations: cleaning, cooking, carrying out the tasks necessary to ensure a meager existence in a humble dwelling. Vrel's small panel is not even a recording of mundane household tasks, as we see in de Hooch or de Witte, *but a break from them.* The woman's shapeless body and posture reveal that her full day, her routine, her life does not in principle allow for this moment's rest.

Having turned her back to us, she prefers not to be seen. Is she stealing a moment that only the painting has given to her? If this is an in-between moment, a pause, why would an artist go to the trouble of depicting such a non-event? And why should we spend our own precious time to look at it?

Indeed, we may *waste* our time here. Our lingering to see what she is not doing makes us aware that our inquisitive gaze is futile: whereas other domestic scenes would by now have revealed the keys to their signification as depictions of determinacy, of professionalism, this painting does *not* yield anything. The room's arrangement is unexciting; the bowl is empty; the woman's expression is invisible and her occupation obscure. The lack of stimulation that we find here has become the very experience depicted in the image, with a productive side-effect. Waiting for this painting to serve us something, we barely notice that we, too, have fallen into a lull. To tune into this painting is to adapt own our lives' restless acceleration to its slow cadence. As we wait, the panel as an object of the past slowly transforms into a mindset that we are somehow in. We are, in fact, as pensive as this woman, letting this moment (that we now share with her) and this space (that our eyes have entered) fill up with thoughts that are thought neither by the woman nor by us, but are nonetheless *there*, in the painting. Although the painting asks us to pause, it does so without promising anything in return—it wants us to come to a standstill, but is unwilling to reveal itself fully to us (as evinced by the woman stubbornly showing us her back). But in this attitude of indisposition, Vrel's modest interior is surprisingly able to serve as a site where our thoughts begin silently to emerge in the moment they are slipping away.

Erwin Panofsky famously wrote (in 1955) that scholars working in the humanities "are not faced by the task of arresting what otherwise would slip away, but of enlivening what otherwise would remain dead."[2] The aim of bringing the past back to life can be said to drive traditional art historical practice, in particular under the banner of Walter Benjamin's nostalgic understanding of historical research as a form of rescue from oblivion, and often with excellent results. Explaining that the meaning of art historical objects lies precisely in their loss of meaning, Michael Ann Holly considers melancholy to be the central trope of art historical writing.[3] Taking a different direction, Amy Powell has claimed that artworks, appearing and re-appearing over time, should be seen as allegories on their own deadness.[4] We as art historians should realize, she insists, that all the writing in the world cannot restore life to an object that never had it in the first place. In developing their contrasting views, Holly and Powell each demonstrate that the art object—always—anticipates the course of its interpretation: not only do we reflect on painting, but the object as such can reflect deeply on the various conceptions of history and of the rhetoric of temporality that it has helped establish.

Unlike what Holly and Powell (or Panofsky, for that matter) suggest, this chapter argues that Vrel's painting opens up an alternative pathway that may lead away from traditional interpretation and toward a mode of thinking. If we take up this painting's incentives to linger and to wait, we are invited not to animate what would otherwise remain dead, but to arrest what otherwise would slip away: our own thoughts, to begin with. Starting from the premise that art is a mode of thought, I propose to call Vrel's panel a pensive image, which neither tells a story nor conveys a specific meaning, but rather articulates, through its form and materiality, a form of thinking.[5] Its pensiveness does not generate a sense of loss (of meaning, of life), but rather evokes in us a feeling of *being at loss*, which might direct us not to understanding or interpretation, but to reflection. While we are standing in front of this small panel, waiting

for something to happen, the utter lack of visual stimulation becomes the ground against which our rising thoughts are pictured. Vrel's painting evokes in us a kind of contemplative stillness inasmuch as it attempts to think the weight of this waiting, yet without giving us the gratification of beauty and harmony that, for instance, a work by Vermeer provides. The pensive image's resistance forces us to step out of the safety of our methods of looking so as to find a kind of confrontation that leaves us frustrated—and, as such, actively involved—rather than passively fulfilled. This chapter explores this double-bind instance of waiting as embodied by the figure in the painting, and as experienced by us, its contemporary viewers. In particular, I am interested in waiting as an activity that the painting, awaiting the moment of our viewing, carries out. Alois Riegl implies something like this for seventeenth-century group portraits when he suggests that in these pictures the sitters eagerly await the viewer, seeming to crane their necks to greet us. Indeed, Riegl argues that the history of the group portrait's development finds its completion when the painting starts to exist "solely for the viewing subject."[6] Following Jean-Luc Nancy's Hegelian reading of portraits as being concerned for us, existing for themselves as well as for the viewer, I will raise the question as to whether Vrel's painting, even though it is not a portrait, might wait for us in a similar, concerned way. As we have seen, the image's pensiveness generates a profound sense of indeterminacy which stops us in our tracks. We reach a kind of endpoint that nonetheless becomes extended, as it suspends, and makes suspenseful, any possible conclusion. I wonder what exactly we are waiting *for*.

I will discuss Hegel's contrasting view on Dutch art to further explore temporal modes and disjunction in Vrel's work. His oeuvre shows an understated yet consistent preoccupation with time, or rather with a kind of open-endedness that leads us, first and foremost, back to our own thoughts. Reflection, from the Latin *re-flectere*, literally means "to bend," "to bring back"; this, precisely, is what Hegel thought painting capable of when he wrote that "in painting we see what is effective and active in ourselves."[7] While it might present what is effective and active in ourselves in Hegelian terms, Vrel's work runs against Hegel's idealized and totalizing view. The alternative it offers—pensiveness and thinking power—can be seen as what has haunted art history as its great, unfulfilled potential (Panofsky, after all, envisioned a philosophical art history). By way of a conclusion, I will discuss a particularly spooky painting by Vrel—unquestionably his most exciting—to speculate on what might be art history's specter.

Waiting for What?

The life and practice of Jacob or Jacobus Vrel (sometimes spelled "Frel") are shrouded in mystery. Very little is known about his small oeuvre of thirty-eight paintings, mostly comprising small, non-specific interiors like the one we have seen, as well as a handful of street scenes that are equally repetitive in composition and subject matter. Generally considered a follower of de Hooch in the nineteenth and early twentieth centuries, Vrel might actually have been his predecessor, a source of inspiration even, if we are to believe the years indicated on a few dated panels. Likely one of a group of artists essentially establishing genre painting, in terms of style and atmosphere, Vrel made interiors that can be compared to creations by Pieter Jansen Elinga and Esaias Boursse during the 1660s.[8] Yet his name does not appear in any guild record, and though he has been linked to the so-called Delft School to which de Hooch, de Witte, and Vermeer belong, it remains unknown whether he ever set foot in that city. In the only

comprehensive essay on the painter, Elizabeth Honig has suggested that the artist, who was active between 1654 and 1670, might have lived in Haarlem at some point.[9] His cramped street views show an affinity to scenes of Haarlem such as those by Nicolaes Hals (1628–86), although with the difference that Vrel's neighborhoods are so generic that no evidence can be found that would connect him specifically to Haarlem. Not even his churches reveal concrete details that could link them to an actual building or site.

Vrel's equally nonspecific interiors are all versions of *Woman at the Hearth*, all showing bare corners of the same dimly lit room, invariably occupied by a seen-from-behind female figure clad in dark clothes, with a white cap and cape. They are almost identical: each woman is involved in some menial activity, such as poking at the fire or looking out a window. In only rare instances is a hint of narrative implied, as in *The Little Nurse*, where we see a woman with her hand propped up against her cheek in a gesture of pensiveness or melancholy, seated near a sleeping figure in bed. Another instance is the *Interior of a House with a Seated Woman* (ca. 1654, Museo Thyssen-Bornemisza, Madrid), where we see a woman before a fireplace with a cradle placed behind her, her face buried in her hands, succumbing for a moment to the exhaustion of nursing a child. It is remarkable that Vrel is uninterested in a performative composition, in which the figures would face the viewer as if in a tableau vivant or theater; instead, he shows intensely private, even intimate moments that are supposedly not meant to be seen. His women are alone with themselves, absorbed in thought, yet we do not feel as if we are spying on them. In addition, nothing suggests a moralistic, Calvinist message about the duty to work. The painting's sympathy is entirely on the side of the resting figure. Vrel's almost naïve style further underscores his unassuming subject matter, as most of his work is rendered without underdrawing, and he refrains from the detailed rendering of material surfaces so typical of Dutch realism. As a result, he has been categorized as an amateur, though at least three of his works appeared in the collection of Archduke Leopold Wilhelm and are listed in the inventory drawn up in 1659, indicating that he must have had access to the powerful art center of Antwerp, where David Teniers acted as the Archduke's agent.[10]

Vrel's works in the Archduke's collection included *A Woman at a Window* (1654) (Figure 7.3), now in Vienna's Kunsthistorisches Museum, which is probably the artist's best-known work. We see a female figure leaning out of an open window, apparently, once again, in a moment of distraction, her sewing abandoned on the table beside her. Whereas *her* gaze onto the street might alight on some passers-by, we, as viewers, see only the wall and blind window of the house opposite the narrow street. Incidentally, some of his street scenes represent the opposite perspective of a passer-by who, upon looking up, would see a similar woman hanging out an almost identical window in the façade of the bakery. The woman probably wanted a breath of fresh air and a brief escape from her depressing room, an interior space that is, however, neat and clean. The copper pots are carefully and orderly stored, the stove, stool, and chair are all in place; yet these objects carry no trace of any deeper meaning. The only striking detail, perhaps because it is redundant, is the spider-shaped crack in the middle of the fireplace, suggesting that a wall decoration, a painting perhaps, had been put there but turned out to be too heavy for its nail. Another visible nail, just below, indicates an unsuccessful second attempt. But this is the most we can make of it. If Vrel's idle female figures signify anything, they might be regarded as unromantic precursors of Caspar David Friedrich's *Rückenfigure*, which they closely resemble.

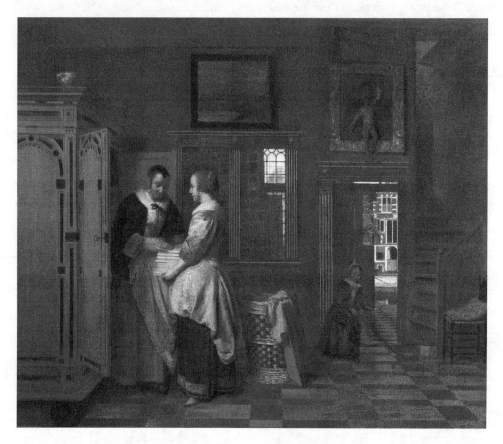

Figure 7.2 Pieter de Hooch, *The Linen Chest*, 1663. Oil on canvas, 70 × 75.5 cm. Amsterdam, Rijksmuseum. On loan from the City of Amsterdam. In the public domain

Vrel's drab interiors, inhabited by solitary figures, are in stark contrast to the images of privileged burghers we meet in the works of de Hooch or de Witte from around the same time, who are cheerfully involved in running their perfect households or leisurely enjoying their riches in glamorized spaces. Hegel enthusiastically bought into this idealized image of seventeenth-century domestic life, arguing that what made these recordings truly lifelike was the expression of shine on perfectly polished surfaces. "With what skill have the Dutch painted the lustre of satin gowns with all the manifold reflections and degrees of shadow in the folds, etc., and the sheen of silver, gold, copper, glass vessels, velvet, etc.," he writes with rising amazement.[11] He was fascinated by what he called the pure appearance of a painted object, uncoupled from its material counterpart. Hegel saw the manifold reflections in these works to represent a further dematerialization from the physical object, through which something greater was shining through—namely, the Spirit. For the Protestant philosopher, Dutch painting was the example par excellence of a perfect match between the subjectivity of the increasing self-consciousness of the Dutch burgher ruling his own country and the Spirit of freedom permeating the young Republic, which had successfully thrown off

the despotism of both the Spanish crown and the Catholic Church. The function of painting, Hegel writes, or rather of its shine, is to evoke contemplation in the viewer so that the Spirit can realize itself *through* him or her by way of the viewer's awareness of it. Hegel's most daring passages in his *Lectures* occur where he argues for painting's major role as a site for contemplation, or rather as a pathway through which the subject's consciousness as well as the Spirit found their realization. The hard-fought freedom of the Dutch burghers came to full expression in the detailed, sparkling, idealized appearance of domestic space that is devoid, he insists, of vulgarity. "In this very heedless boisterousness there lies the ideal feature," Hegel writes, "it is the Sunday of life which equalizes everything."[12] Though not the only exception, Vrel's painting clearly does not fit Hegel's definition of Dutch painting. No Sunday of life in this existence, no shining surfaces despite the clear commitment to keeping the room spotless—not even color permeates this space. It is not difficult to imagine how Hegel, on a stroll through a gallery, would have quickened his pace to pass this picture that did not correspond to his theory, drained as it is of brightness and sheen. But had he stopped and waited with us, he might have been drawn in eventually, if he realized that he was seeing not the triumph of the Dutch Spirit coming self-consciously to its full realization, but its undercurrent, its unconscious perhaps. As a consequence, Vrel insists on the image's indeterminacy, an infinite openness that does not find fulfillment and thus runs counter to Hegel's totality. It generates not light-effects, but thought-effects. That Hegel might have ignored Vrel's modest painting is of no consequence, as it has been patiently waiting for us, twenty-first-century viewers, to arrive at its doorstep.

Riegl revealed himself to be an early theorist of waiting when, in *The Group Portraiture of Holland* (1902), he suggested that sitters in portraits actively seek a confrontation with the viewer. Following Hegel in his conviction that the development of a particular form finds its ending only in its full realization, Riegl argues that from its conception in the fifteenth century, the group portrait was headed straight for the endpoint of its evolution, its eventual perfect form as revealed in Rembrandt's *Syndics of the Draper's Guild* (1662, Amsterdam, Rijksmuseum). He observes the development of the sitters' gazes, from empty stares into nowhere into meaningful glances that deliberately lock eyes with the viewer. Their careful attention to the viewer ultimately leads Riegl to make the bold statement that the seventeenth-century group portrait is in fact *concerned* about its viewers, to the extent that we can say that its sitters have been waiting for us to come to the scene. Rembrandt's *Syndics of the Draper's Guild* is exemplary in this respect, as the guild members seem to have turned their heads, as if they have eagerly been awaiting our entrance into the room, the official on the left rising to step forward to greet us. Rembrandt's *Syndics* exists solely for the viewing subject, Riegl suggests, as it is the viewer who is not just as the sitters' focus of attention but also the actual subject of this painting as such. Following Hegel's notion that an artwork does not exist for itself, but for us, Jean-Luc Nancy, in *The Look of the Portrait*, ultimately takes Riegl's insights to an extreme when he argues that the sitter's self can exist for itself only under the viewer's gaze. He explains that the actual space in front of a portrait is always already conditioned by the sitter's gaze, even before we arrive on the scene. Stepping into the sitter's field of vision, we find ourselves suddenly confronted with her gaze, rather than the other way around. Even though we assume an identity between the sitter and a one-time, real-life model, the resemblance between the two will always remain an assumption, Nancy writes, so that the portrait's actual identity is wholly contained within the picture as such, and manifests itself under

the gaze of the viewer. Because of this locking of eyes between viewer and sitter, the portrait does not *represent*, but exists: it *is*. As a consequence, Nancy reasons, the encounter between sitter and viewer always happens in the present, that is, it takes place in the present tense, so to speak.[13]

The sense of completion that Hegel and Riegl seek for the painting in the viewer's arrival is lacking in Vrel's *Woman by the Hearth*. As we have seen, the woman is hiding from the gaze, so that our presence does not result in any form of confrontation or perfection, and the painting keeps us in suspense. Yet what happens instead is our slow surrender to ourselves as much as to the painting as such—not through an encounter of gazes, but through an adaptation of our pace to the cadence of the painting. By giving in to the painting, we fall, so to speak, into its interval, confronting us with an awareness of the *nowness* of looking. The interval is not, strictly speaking, represented; it can only happen the moment we fall into it, when we have already embarked on an alternative trajectory that leads us toward a form of thinking that directs us not to the unknown but to the unthought. There is an infinite openness to Vrel's pensive image, a state of indeterminacy that is characterized by the absence of any result. Through its lack of clues, it does not bring us anywhere, so that we are only driven aimlessly by our own thoughts deeper into ourselves, very much like what is happening within the seated figure's consciousness. A short digression to consider Fiona Tan's *Nellie*, a video installation that has been included in the overview exhibition *Geography of Time* (2016–17), might illuminate the particularity of Vrel's female figures even further.

For this short, three-minute video loop, Tan was inspired by the life of Cornelia van Rijn (1654–84), the non-marital daughter of Rembrandt and Hendrikje Stoffels whose life details have remained almost completely unknown. After the death of her parents and her half-brother Titus, she married, at age fifteen, the painter Cornelius Suythof, who in 1670 brought her to Batavia in the Dutch colonies (present-day Jakarta in Indonesia). We know nothing about her other than that she gave birth to two sons (at least these are the children we know of) who were named after her parents: Rembrandt and Hendrick. She died at age thirty, probably in childbirth.

Whereas in formal terms, Tan's video resonates with interior paintings by Vermeer and de Hooch, it does not breathe their peaceful calm and is more in line with the slightly depressing scenes of Vrel. Tan depicts Cornelia, or Nellie, as captured by a place and time that failed to preserve any trace of her. We see her clad in a seventeenth-century-style dress, made—in an anachronistic gesture that is almost grotesque—of the same material as the blue-and-white wallpaper in a period room in the Van Loon Museum in Amsterdam where the film was shot. The wild pattern of exotic plants and birds evokes the geography of the East Indies, an effect amplified by a soft soundtrack of muffled jungle noises and bird screaking that enters the room from outside. In a series of filmed stills, we see Nellie leaning against the wall or lying on a bed staring at the ceiling, and in both cases, as if she were engaged in an act of mimicry, her slender figure almost blends with the wallpaper. A woman unable to stand out in history like her father (and of course her mother, too, whose appearances have been captured by her father's brush), she has become the very image of camouflage, much in the same way that the figure in Vrel's painting fades away into the shabby backdrop of hard labor and poverty, overshadowed by the splendid scenes of his fellow painters. The viewer's expectation rises when we see Nellie reading a letter at a window, a composition that transforms her for a brief moment into the subject of a serene Vermeer

painting. However, the letter brings only momentary relief and, apparently, no good news; in a next scene we find her lying on the floor breathing heavily, her face red and sweaty. Whether she is suffering from malaria, dying in childbirth, or having an attack of what would later be termed hysteria, we don't know. In light of her agony, we expect some kind of denouement, but the loop starts over, and we see Nellie once more leaning against the wall, seemingly recovered or at least strong enough to make the same rounds all over again: the waiting, the blending in, the becoming invisible, the suffering, ad infinitum. The future ahead of her and her past have become identical, which might account for the feelings of anxiety and depression evident via Nellie's body. She likely went to the East Indies with high expectations, but Tan's film evokes more than a sense of utter disorientation in showing her haunted by disillusion in the realization that her hoped-for future had not arrived. Her despair is at having to live under the shadow of lost futures, haunted by what Herbert Marcuse once called the peculiar temporality of historical alternatives, the values of which become facts when translated into reality through practice.[14] A far cry from the portrayal of the self-satisfied burghers enjoying complete self-fulfillment within their spotless houses that we encounter in Vermeer and de Hooch, Tan's *Nellie* is more in line with Vrel's women, who, though they do not show signs of real agony, could equally be waiting ad infinitum like Nellie, overshadowed by the indeterminacy that the very thought of historical alternatives bring about. What might they be waiting for? The answer to this question—at least within Vrel's closed-off world—may be given in what is unquestionably his most action-packed composition ever: an image of an actual encounter.

Greeting Ghosts

Woman at a Window (ca. 1650, Paris, Fondation Custodia) (Figure 7.4) is an unusual composition in which we see a woman in front of a window that spans almost the entire width of the panel. What could have been a cute little scene (the panel is 46 × 32 cm) turns out to be strangely unnerving. The room, even barer than Vrel's other interiors, is basically empty. It is oddly shaped, its right wall askance, and the bright light makes it slightly uncanny. The eerie atmosphere is intensified by Vrel's recurrent motif of a female figure with her back turned toward us, her face hidden under her cap. Balancing on a fine black chair, two of its legs lifted high off the floor, she is leaning forward toward the window, her heavy behind almost slipping from its seat, her hand lifted as if waving. Not at first but only later do we, as viewers, become aware of a face emerging, apparition-like, from the darkness. Pale and unsmiling, the spooky countenance of a child (a girl?) remains largely obscured by the panes, giving it an almost transparent appearance. Is the woman greeting a ghost? Though Vrel probably intended to create a realistic painting, the spooky face breaks with such an aesthetic. But this is not the painting's only dissonance. Several elements somehow do not add up, and thus the composition is unbalanced: the empty room, the darkness outside, the width of the window all contribute to general ambiguity as to whether the child is present or absent and whether the woman is seeing something or imagining it; we also wonder why the room is not furnished. The woman might be looking through an internal window facing a narrow courtyard or a hallway, as we have seen in de Hooch's *The Linen Chest* (Figure 7.2), but that still does not explain the sharp contrast between the qualities of light in the different spaces.[15] Even if we assume for a moment that it is evening, then the room should be filled with the warm, yellow light

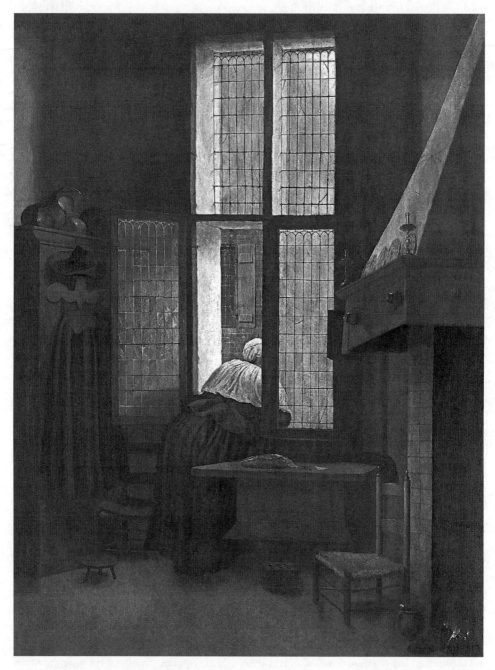

Figure 7.3 Jacob Vrel, *Woman at a Window*, 1654. Oil on panel, 66.5 × 47.4 cm. Vienna, Kunsthistorisches Museum. © KHM-Museumsverband

Figure 7.4 Jacob Vrel, *Woman at a Window*, ca. 1650. Oil on panel, 45.7 × 39.2 cm. Paris, Fondation Custodia, Collection Frits Lugt

of oil lamps or candles. Instead, it resembles a shadowless laboratory. Perhaps even more unconventional than the spooky face is the reflection of light in the upper right of the composition, which looks as if it were derived from the flash of a camera rather than a seventeenth-century light source. The element typical of Dutch realism yet lacking in all Vrel's other work (except for one other painting), namely reflection, finally makes an appearance here.

Fond of luster and shine as he was, Hegel might have been interested in its unusual placement. We can imagine him contemplating the link this painting provides between

the two distinct meanings of the German *Geist*: Zeitgeist or Spirit, and haunting ghost. This painting's ambiguity and peculiarity are captivating. Compared to Vrel's other— literally clueless—paintings, this fascinating composition swarms with meaning that we, as viewers, are quick to pick up on: the oddly placed reflecting light on the window contributes to an *unheimlich* atmosphere, and in combination with the emerging face creates a feeling of haunting. Do we sense a ghostly presence? Is the darkness a metaphor for the past? Has something returned from it, flashing up in the shape of a face that seeks contact with the woman inside? Is this what she, and all her identical twins in Vrel's other paintings, have been waiting for all along, not for us, the viewers, but for the vision of a specter? What does this specter, if it is one, stand for? Derrida wrote in *Specters of Marx* that in Hamlet, everything begins with the apparition of a specter, "or rather, by the *waiting* for this apparition. The anticipation is at once impatient, anxious, and fascinated: this, the thing ('this thing') will end up coming. The *revenant* is going to come."[16]

Derrida's engagement with ghosts had begun in *Of Spirit: Heidegger and the Question* (1987), where he writes that even Hegel's *Geist*, driving history forward while reproducing itself in thinking, is always haunted by its own *Geist*: "Metaphysics always returns, I mean in the sense of a *revenant*, and *Geist* is the most fatal figure of this *revenance* [returning, haunting]. Of the double who can never be separated from the single."[17] Aside from the question of what drives art history forward, we may want to think about what haunts it or, following Derrida, what kind of metaphysics always returns to haunt it. In "Seeing Ghosts: The Turn of the Screw and Art History," Alexander Nemerov takes the governess in Henry James' *The Turn of the Screw* to be a model of the historian (remarkably, he does not write art historian), who, like her, sees glimmers of the past with extraordinary lifelikeness, even though she might be the only one to perceive them.[18] It wouldn't be possible to consider Vrel's painting as a model for art historical practice, if only because we can never determine whether we as art historians should be placed in the position of the woman, happily if unstably greeting the ghost of the past, or rather that of the spooky child, appearing and disappearing before the painting-as-a-window-onto-history, not quite mature enough to really peep in.

If anything, Vrel's pensive images have offered us a way of finding a slightly different approach to deal with artworks that stir us to move away from interpretation, out of a historical paradigm, and toward a state of suspension where thinking can start. What has been haunting art history is perhaps not the ghosts of the past, but the artwork's capacity to philosophize, to think. If we decide to let Vrel's paintings take the lead, they, having waiting for us for so long, might take us forward by going backwards: they might direct us toward a (re)discovery of art history's philosophical foundations, forming a possible basis for an emergent area of philosophical art history, invoked by Panofsky yet never systematically explored.

Notes

1. The limited literature on Vrel includes C. Brière-Misme, "Un 'intimiste' hollandaise: Jacob Vrel," *Revue de l'art ancient et modern* 68 and 69 (1935), 97–114 and 157–72; Elizabeth Honig, "Looking in(to) Jacob Vrel," *Yale Journal of Criticism* 3, no. 1 (Fall 1989), 37–56; Linda Stone-Ferrier, "Jacobus Vrel's Dutch Neighborhood Scenes," in *Midwestern Arcadia: Essays in Honor of Alison Kettering* (2015), DOI:10.18277/makf.2015.07 (accessed December 1, 2017).

2. Erwin Panofsky, "The History of Art as a Humanistic Discipline," in *Meaning in the Visual Arts* (Garden City, NY: Doubleday, 1955), 24.
3. Michael Ann Holly, *The Melancholy Art* (Princeton: Princeton University Press, 2013).
4. Amy Knight Powell, *Depostitions: Scenes from the Late Medieval Church and the Modern Museum* (New York: Zone Books, 2012).
5. The notion of the pensive image has been coined by Roland Barthes in *Camera Lucida* (New York: Hill and Wang, 1983), 38. See also Jacques Rancière, "The Pensive Image," in *The Emancipated Spectator* (London: Verso, 2011), 108–31; and my article "The Pensive Image: On Thought in Jan van Huysum's Still Life Paintings," *Oxford Art Journal* 34, no. 1 (2011), 13–30. DOI: https://doi.org/10.1093/oxartj/kcr011.
6. Alois Riegl, *The Group Portraiture of Holland*, trans. Evelyn M. Kain and David Britt (Los Angeles: Getty Publications: 1999), 366.
7. Georg Wilhelm Friedrich Hegel, *Aesthetics: Lectures in Fine Art*, trans. T.M Knox, 2 vols. (Oxford: Clarendon Press, 1975), vol. 1, 797. For more on Hegel's interest in shine in Dutch art, see my article "Photorealism as Pictorial Reflection" in *The Art of Hegel's Aesthetics*, ed. Paul Kottman and Michael Squire (Munich: Wilhelm Fink Verlag, 2017).
8. Honig, "Looking in(to) Jacob Vrel," 40.
9. Honig, "Looking in(to) Jacob Vrel."
10. Honig, "Looking in(to) Jacob Vrel," 53.
11. Hegel, *Aesthetics*, vol. 2, 843. On shine in Dutch art, see also: Angela Vanhaelen, "Boredom's Threshold: Dutch Realism," *Art History* 35, no. 5 (November 2012), 1004–23; John Sallis, "Carnation and the Eccentricity of Painting," in *Hegel and the Arts*, ed. Stephen Houlgate (Evanston: Northwestern University Press, 2007), 90–118.
12. Hegel, *Aesthetics*, vol. 1, 887.
13. Jean-Luc Nancy, "The Look of the Portrait," in *Multiple Arts: The Muses II*, ed. Simon Sparks (Stanford: Stanford University Press, 2006). See also his "On Painting and Presence," in *The Birth to Presence* (Stanford: Stanford University Press, 1994), 341–67.
14. Herbert Marcuse, *One-Dimensional Man: Studies in the Ideology of Advanced Industrial Society* (London: Routledge Classics, 2002), xi. Quoted in Avery Gordon, *Ghostly Matters: Haunting and the Sociological Imagination* (Minneapolis: University of Minnesota Press, 2004), xvii.
15. Honig, "Looking in(to) Jacob Vrel," footnote 48.
16. Jacques Derrida, *Specters of Marx: The State of the Debt, the Work of Mourning and the New International*, trans. Peggy Kamuf (New York: Routlegde, 1994), 2.
17. Jacques Derrida, *Of Spirit: Heidegger and the Question*, trans. Geoffrey Bennington and Rachel Bowlby (Chicago: University of Chicago Press, 1987), 40.
18. "Seeing Ghosts: *The Turn of the Screw* and Art History," in *What is Research in the Visual Arts?: Obsession, Archive, Encounter*, ed. Michael Ann Holly and Marquard Smith (Williamstown, MA: Sterling and Francine Clark Art Institute, 2008), 13–32.

Bibliography

Brière-Misme, C. "Un 'intimiste' hollandaise: Jacob Vrel," *Revue de l'art ancient et modern* 68 and 69 (1935), 97–114 and 157–72.

Derrida, Jacques. *Of Spirit: Heidegger and the Question*, trans. Geoffrey Bennington and Rachel Bowlby. Chicago: University of Chicago Press, 1987.

Derrida, Jacques. *Specters of Marx: The State of the Debt, the Work of Mourning and the New International*, trans. Peggy Kamuf. New York: Routledge, 1994.

Gordon, Avery. *Ghostly Matters: Haunting and the Sociological Imagination*. Minneapolis: University of Minnesota Press, 2004.

Grootenboer, Hanneke. "The Pensive Image: On Thought in Jan van Huysum's Still Life Paintings," *Oxford Art Journal* 34, no. 1 (2011), 13–30.

Hegel, Georg Wilhelm Friedrich. *Aesthetics: Lectures in Fine Art*, trans. T. M Knox, 2 vols. Oxford: Clarendon Press, 1975.

Holly, Michael Ann. *The Melancholy Art*. Princeton: Princeton University Press, 2013.

Honig, Elizabeth. "Looking in(to) Jacob Vrel," *Yale Journal of Criticism* 3, no. 1 (Fall 1989), 37–56.

Marcuse, Herbert. *One-Dimensional Man: Studies in the Ideology of Advanced Industrial Society*. London: Routledge Classics, 2002.

Nancy, Jean-Luc. *The Birth to Presence*. Stanford: Stanford University Press, 1994.

Nancy, Jean-Luc. *Multiple Arts: The Muses II*, ed. Simon Sparks Stanford: Stanford University Press, 2006.

Nemerov, Alexander. "Seeing Ghosts: *The Turn of the Screw* and Art History," in *What is Research in the Visual Arts?: Obsession, Archive, Encounter*, ed. Michael Ann Holly and Marquard Smith. Williamstown, MA: Sterling and Francine Clark Art Institute, 2008, 13–32.

Panofsky, Erwin. "Introduction: The History of Art as a Humanistic Discipline," in *Meaning in the Visual Arts*. Garden City, NY: Doubleday, 1955, 1–25.

Powell, Amy Knight. *Depostitions: Scenes from the Late Medieval Church and the Modern Museum*. New York: Zone Books, 2012.

Rancière, Jacques. *The Emancipated Spectator*. London: Verso, 2011.

Riegl, Alois. *The Group Portraiture of Holland*, trans. Evelyn M. Kain and David Britt. Los Angeles: Getty Publications: 1999.

Sallis, John. "Carnation and the Eccentricity of Painting," in *Hegel and the Arts*, ed. Stephen Houlgate. Evanston: Northwestern University Press, 2007, 90–118.

Stone-Ferrier, Linda. "Jacobus Vrel's Dutch Neighborhood Scenes," in *Midwestern Arcadia: Essays in Honor of Alison Kettering* (2015), DOI:10.18277/makf.2015.07 (accessed December 1, 2017)

Vanhaelen, Angela. "Boredom's Threshold: Dutch Realism," *Art History* 35, no. 5 (2012), 1004–23.

8 Twisted Time

Fernando Bryce's Art of History

Miguel Ángel Hernández Navarro

Art of History

Since the mid-1990s, artists from different places and backgrounds have begun to reflect on the past, as if they were virtual historians, through a wide range of poetics, techniques, and media—films, videos, photography, montages, painting, or drawing. By means of archival research, historical document analysis, and visual and material writing performed with images and objects, these artists are concerned with the processes of construction of history as a discipline, begging a whole series of questions that hitherto seemed to be the reserve of scholars: how is history written, who writes it, in what way, with what purpose, who owns it, who benefits from it, who is forgotten . . . and, above all, how is it possible to elaborate a different history, far-removed from the ways in which it has traditionally been produced and transmitted? These questions, plus many others, have gradually shaped a specific field of issues, concepts, and interests that encourage us to claim the existence of a kind of "historiographic turn" in recent art.[1]

Located one step beyond the "memory turn," the archive metaphor, the accumulator or collector of the past, these practices of critical reflection on the past have been identified by some authors as "new historiography" (Ernst van Alphen), "art as historiography" (Dieter Roelstraete), "historical representation" (Mark Godfrey), or "art as history" (Jacinto Lageira).[2] Inverting the term "history of art," I prefer to call them "art of history."[3] Besides their different work strategies and practices,[4] these "artist-historians"—including Jeremy Deller, Matthew Buckingham, Deimantras Narkevicius, the Atlas Group, Tacita Dean, and Francesc Torres, to name but a few—appear to share a sensitivity as regards history, whose attributes could be described as follows: the tangible presence of the past in the present—which takes shape through a material conception of time and the use of objects and images as places replete with time; the need to imagine and visualize the past—the awareness that history appears to us in images and therefore it is possible to use them to transmit it, to write it; and the sense of history as something open that can be modified—hence, the commitment to the past which links history to politics. On reflection, this perception of the past has much to do with the mode of historical thinking developed by Walter Benjamin during the 1930s, both in his theses "On the Concept of History" (1939) and throughout his unfinished project on Parisian arcades and modernity.[5] In both works, Benjamin deploys a particular conception of history—as an open, multiple time with the possibility of being completed or refined; a specific mode of historical knowledge—history is presented in the form of fleeting images that monadologically condense time; and

a unique form of constructing or transmitting history—a writing of time established through the montage or constellation of images, quotes, and materials from the past. In a way, the work mode of the artists of the historiographic turn exemplifies the materialist historian's model envisaged by Benjamin.[6]

As Christine Ross has observed, these practices of history should be understood within the more general framework of the ongoing re-consideration of established time models.[7] The realization of history as something open and modifiable, the rupture of linearity through the anachronism, and the search for models of experience and temporal knowledge other than those proposed by the prevailing chronological regimes are, at heart, strongholds of resistance of a whole stream of contemporary art against contemporary chronological imperialism, attempts to interrupt or alter the inexorable path to the absolute synchronization of the world and the elimination of the differences established by hegemonic global monochrony.[8]

On the basis of that general framework of debate, in this chapter I would like to explore the work of the Peruvian artist Fernando Bryce (Lima, 1961). His oeuvre articulates the concern for history and altered time. Using a particular work method, which the artist himself calls "mimetic analysis"—and which, broadly speaking, consists of Indian ink drawings based on newspapers, magazines and other mass-circulation documents—Bryce reflects on the construction of history, geopolitics, and identity in Latin America, above all in Peru, the armed conflicts of the twentieth century, and the genealogy and validity of revolutionary thought. With an archival aesthetics, Bryce selects documents that he then manipulates (by copying, drawing, and altering them) in order to propose new interpretations of history using montage and juxtaposition. His selection, de-contextualization, and visualization of prior and forgotten histories contributes to bring the past to the present, but it is primarily his work method—anachronistically copying documents—that activates history. To copy history, to repeat it parodically, *to perform it*, to make it act again as a reverberation is a means of twisting time and disarticulating the hegemonic discourses that have constructed the past and continue to operate in the present.

Beyond the Archive: A Parahistorian

Bryce researches in archives, selects documents from the past, processes the data, and "publishes" them—by exhibiting them. There is therefore something of the historian's profession in his practice; a historian, however, who works above and beyond what Michel de Certeau identified as systems for legitimizing and accrediting established knowledge;[9] a historian at the fringes of academia; or, as he has defined himself on occasion, a "parahistorian."[10]

The starting point of Bryce's work is always the document—a particular kind of document: magazines, newspapers, leaflets, books, etc. It is by selecting and manipulating the remains of history that the critique of official histories takes place. It is perhaps for this reason—this document-based approach—that his oeuvre has been studied within the framework of the "archival impulse" of contemporary art.[11] For instance, Andrea Giunta has placed it in the context of the glamour of and work with archives; Agustín R. Díez Fischer has seen it as an example of what he calls "archival painting"; and Anna Maria Guasch has examined it as a form of "counter-archive," capable of altering transmitted histories, pointing to their flaws and paradoxes.[12]

Since the end of the 1990s, Bryce has worked on several series about particular issues pertaining to the history of above all the first half of the twentieth century. Case studies that could almost be chapters of a "broad, but always incomplete, *general history*"[13] which prominently feature matters such as national identity building and the continuity of colonization processes, the media representation of war and its impact on the international geopolitical situation or genealogy, and the vicissitudes of the ideas of progress and revolution. One of his most relevant works in this regard is *El mundo en llamas* (*The World in Flames*) (2010–11) (Figure 8.1), a series consisting of ninety-five drawings based on both the front pages of newspapers of different bents and provenances (*L'Humanité*, the *New York Times*, *Le Matin*, *Brusseller Zeitingung*, and *El Comercio*) and the advertisements of major film productions at the time (*Citizen Kane*, *The Invisible Menace*, or *The Shadow*) appearing in *El Comercio* of Lima. Bryce uses these documents, which encompass the period of World War II (1939–45), to suggest collusions and relationships between two particular forms of narration, namely, journalism and advertising, and, at the same time, to observe the ways in which spectacle seeps into the information, while the violence and anxieties of war make their way into films and the entertainment industry. The juxtaposition of both realities in the same space, now embodied by the unifying drawings of Bryce, makes us aware of the uncanny, not always visible similarities between war and cinema.

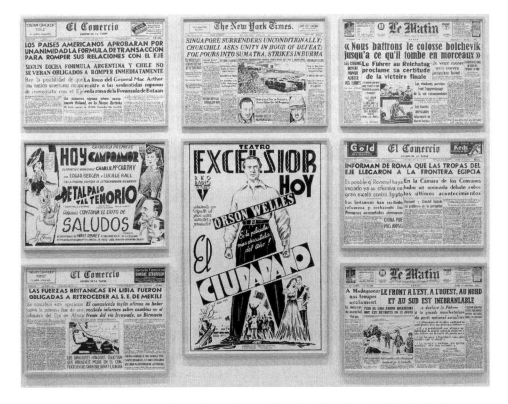

Figure 8.1 Fernando Bryce, *El mundo en llamas* (*The World in Flames*) (2010–11). Fragment. Photo: Joerg Lohse. Courtesy of the artist

This work falls within the framework of the series on the major armed conflicts of the twentieth century and their consequences which Bryce produced from the turn of the century onward. These works, which also include others such as *The Spanish Revolution* (2003) and *The Spanish War* (2003), depict the century as a tumultuous period of continuous struggles between ideologies and world views. A century converted—to use the words of Enzo Traverso—into a "battlefield,"[14] a world in flames in which the mass media and the entertainment industry, news and advertising combine to construct imaginaries and to promote ideologized visions of reality. In this specific case, the confrontation between news and film advertisements goes a step further. Bryce selects news stories from Peruvian and international newspapers (German, French, and English), but the film advertisements all proceed from the Lima newspaper. The major international film productions, as with the news about the war, appear in a medium located in a particular space. Without a shadow of a doubt, this contrast accounts for the globalization of the conflict, but it also expresses, as Natalia Majluf suggests, a particular point of view, a concrete location that intends "to pose an alternative narrative to the official history produced from Europe."[15] This is one of the focuses of thought in Bryce's work, always absorbed in the vision of Western conflicts from another perspective, a kind of "de-Westernization" of the way of mobilizing and shifting established interpretations of the past.

This re-reading of history and interpretive shift is brought about, initially, by retrieving documents from the past, selecting them, and juxtaposing them by means of montage. In this selection and juxtaposition, there is already a sense of history and an awareness of the ways in which it has been transmitted. As Adrián Cangi suggests, Bryce works here with the model of the Warburgian *Atlas*,[16] a dialectic model that employs interval and juxtaposition to break the linear narrative of history and open it up to unexpected associations.[17] The mere de-contextualization and arranging of documents helps to reveal the history that lies behind them; a break in linear history and the deployment of anachronisms. In the words of Didi-Huberman: "The montage is an *exhibition of anachronisms* precisely because it proceeds like an *explosion of chronology*. The montage cuts up things that are usually connected and connects things that are usually separate. It thus creates a shake and a movement."[18] History is dismantled and depicted through its own process of construction as something malleable, mobile, and contingent.

By means of intervals and silenced spaces, we can clearly perceive the decision-making and artificiality of the historical construction that Bryce's pieces offer. Its "order" is not seen as natural, but rather refers to a decision-making process that can be re-assembled by the viewer. It is perhaps for this reason that Miriam Basilio suggests that Bryce operates with an "open archive" in which the receiver becomes involved in the new meaning of history: an archive that "creates possibilities for the viewer to dwell on the process of research into historical events."[19]

The Anachronic Copyist

The opening of the narrative and the appeal to the viewer, which on its own opens up time and history, goes a step further in Bryce's work, which by means of information processing transcends the mere selection and montage of the elements encountered. This information processing occurs at several times. After researching and selecting, the artist scans and retouches the documents to unify them digitally. Following this,

he photocopies them, and only then does he copy them with Indian ink and brush on the paper of the documents that he has chosen for the exhibition—only a small part of those that have been gathered. Thus, the artist modifies the document: the research and selection processes are only a part of the procedure; the real information processing comes afterwards, by means of the work method that Bryce himself calls "mimetic analysis."

At first glance, we are faced with a work of drawing: Indian ink applied with a paintbrush to absorbent paper. After a brief stint in painting, Bryce came to drawing at the end of the 1990s and discovered in this technique the immediacy, speed, and economy that allowed him to produce large amounts of work with greater reliability. This use of drawing is not new in contemporary art and would have to be categorized as a sort of return to the craft-like approach in which drawing occupies a special place.[20] All it takes is a quick look at recent art to realize how many artists have returned to drawing in recent years, adopting it as their core practice.[21] Among these, some have explored its potential in representing social issues and reflecting on the documentary image. This is what occurs, for example, in the work of Andrea Bowers and Sam Durant, whose drawings based on photographs convey a meaning that is different from the mass images that have circulated and shaped our experience of historical events. As Claire Gilman has noted, in their drawings a translation of media breaks the original sense of the image and reproduces it in the present, calling our attention to the ways in which the past is transmitted.[22] Through drawing and manual copying, these artists appropriate the image and "exercise their own form of agency. At a time of global strife and chaos, when it is unclear what to do or how to respond, drawing as translation confirms that action is still possible."[23]

In the work of these artists, drawing functions as a kind of resistance to contemporary image technologies; a medium that seems to be out of sync with its purpose, i.e. outside of its time. This so-called "out of sync" has been identified by Hal Foster as one of the core features of a certain type of contemporary art that uses outmoded technology to comprehend the present world, thus producing a kind of temporal "mismatch" with it. To Foster's mind, the "non-synchronous"—a concept taken from Ernst Bloch[24]—occurs as a result of juxtaposing and assembling objects, aesthetics, technologies, or procedures that belong to different time registers. In essence, it is about constructing "a new medium from the remains of old forms and keeping together different time indicators in a single visual structure."[25] Examples of these practices include the collapse between media produced by the drawings for projection of William Kentridge, the wall silhouettes of Kara Walker, the interrupted movement of James Coleman's slides, or the use of images from the past and their montage with present images and realities that can be seen in the works of Stan Douglas. All of them bring about a collapse of history, of the progressive linearity of time, by slowing down and interrupting the medium.[26]

In Bryce's work, it is possible to identify an outmoded aesthetics in the sepia tone of the paper, in images that seem to return from the past, a kind of rhetoric of obsolescence in the very use of drawing. Yet it is without a doubt the work method, the meaning of the drawing, which links it to that impression of non-synchronous forms Foster mentions, to a montage of times that breaks chronology. As Rodrigo Quijano observes, it is possible to note a kind of resistance to hyper-technologization, since "drawing was, ultimately, and in the midst of the digital and technologized wave, a low-fi tool for exploration, for privileged rescue in time."[27]

Bryce uses drawing as a kind of analog copying of the document. "What I do is like a very slow fax," says the artist.[28] In an age dominated by the culture of the copy and the technology of instant reproduction, Bryce uses an obsolete method of copying that is reminiscent of the medieval monks prior to the invention of the printing press. He therefore works like a medieval copyist: "an untimely copyist," as Carlos Jiménez has written;[29] an anachronistic copyist who convolutes or twists time. He uses a copying technology that precedes the (mechanical) technology with which the document was produced. And he uses it from the present. It is as if time were twisting and turning, as if the document being copied were captured between the view from the present— the backward projection—and the technology of the past, which propels the object forward in order to drive it out of the sense of its time, to disrupt it and displace it. In his own words: "What really interests me, before 'transmitting a message', is the anachronistic strategy of transporting these images from the past to a current context, and this is achieved through mere contrast with the present. The image is old, but the drawing is new."[30]

It is a kind of hacking or alteration of technology, albeit a precarious kind, performed by hand by means of something that we could call "second-hand technology," one that is obsolete and employed here with its program memory. He somehow uses technology in an aberrant way, for a purpose that is not the "socially established" one at present. In a sense, as Cuauhtémoc Medina observes, "Bryce's methodology constantly plays with the allure and aberration of an anachronism: it suggests that we have stumbled upon an unemployed amanuensis, a notary public without a portfolio, a time travelling Luddite determined to undo with his iconoclastic pen, in a perpetual onslaught of strokes, the age of the printing press and photography."[31]

The result of the process of copying creates a work that is halfway between writing and drawing and which leads us to beg the question as to whether Bryce's works are seen or read; as to what extent are they drawings or texts or both at the same time. As W. J. T. Mitchell or Mieke Bal have studied in detail, above and beyond the artificial separation between these spheres established by modernism, the relationships between the legible and the visible, words and images are a constant in the visual arts.[32] In the domain of modern and contemporary art, there is a large variety of examples of interaction between words and images from the avant garde to the present day.[33] In the field of drawing, the borders between stroke and letter are, if possible, even more blurred. It is the meaning that we project onto certain strokes that turns signs into language, into words. Some artists like Robert Morris took this to the limit and erased the differences between drawing and text. His *Memory Drawings* (1963) are an example of this text-drawing in which the shape and the meaning, the image and the word merge.[34]

Bryce's works employ texts and images. They are composed of strokes, lines, and abstractions that are read as texts, but nonetheless do not lose their formal condition. For instance, on each one of the copied pages there are elements that change and those that are repeated. The words are different, but the layout of the page, the headline, the lines separating the texts, apparently remain the same, as if they were minimalist repetitions of some kind of abstract form.

This questioning of the boundaries between drawing and writing is evident from the moment we enter any exhibition of his work (Figure 8.2). Our eyes have to adjust, like a constant zoom, between the image of the series—which we see as a whole—and the different pieces making it up. Because Bryce's pieces do not function in isolation;

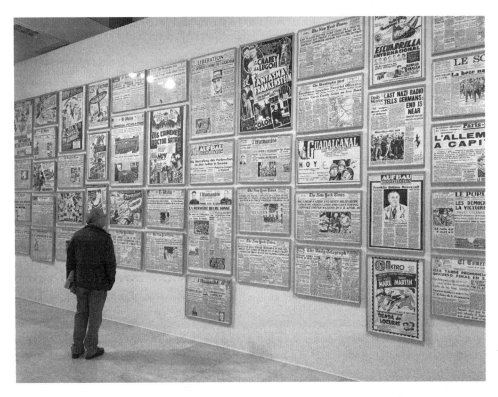

Figure 8.2 Fernando Bryce, *El mundo en llamas* (*The World in Flames*). Installation view: Sala Alcalá 31, Madrid, in the context of the exhibition *Próxima Parada. Artistas peruanos de la Colección Hochschild*, curated by Octavio Zaya (February–April 2017). Photo: Fernando Bryce. Courtesy of the artist

they are like the pages of a book; an open book in which there is a sequence of reading, a specific order established by the artist, but which is not imposed on viewers, whose gaze shifts from one place to another, building their own reading order—an order that also has to do with the time they devote to each piece and the number of times they return to it.

Yet these works do not only operate in the field of reading. Many of the texts are in fact unintelligible to many viewers, since they are written in Spanish, English, French, German, even Russian or Chinese. The overall experience that they offer is not only the literal reading of that which "is written" in the texts. There is another dimension above and beyond it in which the viewer is surrounded by an amalgam of signs and images. Besides the intentional meaning of the artist, of the research work, and of the historical knowledge, the pieces unfold in space like a book in which history resounds beyond words.[35]

Re-enacting History

Whenever I visit one of Bryce's exhibitions, I cannot resist photographing all the pieces with my cell phone in order to read them carefully at home and arrive at the

interpretation of history that the artist proposes. Thus, I end up generating a digital photograph of a drawing of a copy on my cell phone. I find this dimension of reproduction relevant. This also happens with the exhibition catalog, which is a paradox in itself: a multiple object of originals that are no longer anything of the kind. A sort of inverse facsimile. This kind of relationship between copy and original is typical of Bryce's work. In his series, his manual copy of multiple documents ultimately becomes an original. This is how Sergio Chejfec sees it: "the original becomes the serial product—a bit like a Warhol-style appropriation—but it is the 'copy', by being meticulously manual, that is the element that takes on the attributes of the aesthetic inspiration."[36]

In this way, the work opens up the discussion not only about the original and the copy, but also about the concept of simulacrum, since his drawings ultimately function as second-grade documents, simulating the original that they replicate.[37] Somehow, his drawings, like the simulacrum in the sense understood by Gilles Deleuze, question the very notion of copy and model.[38] Yet, as copies, we should almost see them as replicates, as doubles that end up as doubles with their own entity. In this way, Bryce's drawings are the creation of a second document, rather than an indistinct and transparent copy. This is how it has been viewed by Medina, who understands the artist's oeuvre as "a shadow that both refers to and revokes, pays homage to and replaces its referent. More than a copy, mimetic analysis aims to construct a segmented and deviated *doppelgänger* from the archive."[39]

This "deviation" occurs because, among other things, each of the drawings, though similar in appearance to the source, is nonetheless essentially different. A close examination of them reveals that the typography differs subtly from the original and that traces of the process of writing—or "reading"—remain: marks, crossings out, and shadows that break the transparency of the copy and call attention to themselves. This memory of writing also entails a kind of "re-auratization" of the task of writing, an attempt to "produce an aura from a serial materiality."[40] And when beholding Bryce's works, it can be seen that they are much more than a serial document; they represent a process that unfolds through their imperfections and remnants. This is when the artist's act of creation is evoked; in a way, the time spent on the task of "drawing history" can be felt.

Bryce therefore marks the document, leaving the memory of the writing process on it. His work cannot be understood without this allusion to its performative dimension. The "ritualized" copying of the document is a kind of action in itself; a writing performance that involves reading. He thus functions as a sort of medium that transcribes the document as if possessed by history, but, in that process of writing, he transforms it precisely through action. It is in this transformation that the artist appropriates the narrative and makes it his own. Its presence, its tangible mark, interrupts the flow of meanings, as if it were a temporary hiatus from another time—our own—in order to break the illusion of transparency of the inherited discourse. The artist is a medium that, literally, stands "in the way."

The artist's body is involved in this laborious process that the viewer continues to evoke and feel when contemplating Bryce's work; a laboriousness that has something of the absurd, of unnecessary, supposedly unproductive work, but that nevertheless functions here to take control of the media and of history. By means of this repetitive action, the artist "incorporates" history, transforms it, and acts it out in the present. Miriam Basilio has related this action in the present with the meaning that Diana Taylor attributes to body actions, "repetitive acts," and "modes of knowledge" by

means of which it is possible to recover the historical memory suppressed or defined by hegemonic groups.[41]

It could be said that action in the present is a way of evoking history and transforming it. In this sense, Bryce's work would be similar to the series of "historical performances" carried out by artists like Jeremy Deller, in his parodic re-creation of the Battle of Orgreave (*The Battle of Orgreave (An Injury to One is an Injury to All)*, 2001)[42] or Doris Salcedo, in her evocation of the assault on the Palace of Justice in Colombia in November 1985 (*Noviembre 6 y 7*, 2002).[43] They are ways of not only convoking history as a tangible reverberation in the present, but also of establishing in it a difference capable of transforming it. In the case of Bryce, the copy of the document repeats the document, it performs it, it imitates it, but, at the same time, it also modifies and alters it. It can be argued that its action literally "changes the writing of history," introducing difference by repetition. A difference that could also be understood as that excess of mimesis, capable of serving as a resistance strategy against that colonial discourse about which Homi Bhabha spoke.[44] The parody that can be deduced from the act of imitating a document thus converts the action of Bryce into a kind of "preposterous performance," in the dual sense of the word: an apparently absurd, deranged action, but also a way of disrupting and twisting time.[45]

Conclusion

In *Staging the Archive*, Ernst van Alphen notes some perverse, unproductive, and nostalgic uses of the archive by contemporary artists: "Some, and perhaps even most, of these practices show a kind of naive, nostalgic and sentimental celebration of the past, usually limited to a personal past, without actively engaging this past in our political present."[46] If employed conventionally and acritically, these types of practices (archiving, photography, filming, or genres such as documentaries, family albums, and home movies) act like a mirror of the crisis of memory. Archives must necessarily be revived and mustered. For this art to really function as a resistance strategy capable of generating alternative history and memory models, it should be developed critically and self-reflectively, questioning the means employed from the outset. "This is how, in other words, historiography can resume its mission to serve and preserve, rather than to dictate and erase what we are and do today, with that past in our present world."[47]

Bryce's work resides in this critical use of the archive. It displaces, transforms, and appropriates the document. He employs the traces and debris, the fragments of history, builds non-authoritarian reading devices with them that open up time and, above all, display that history in the present, connecting it with the problems of our world. As Rodrigo Quijano points out, "the material that Bryce's series exhume serves a dual purpose: to rescue documents and images, duly concealed by the dust of official history, from the past; and, simultaneously, to retain from the present all that which the media network of the powers that be rapidly consign to oblivion."[48] In this sense, it could be stated that Bryce pursues his vocation like a Benjaminian historian, aware that history is not a question of the past, but a problem of the present and that, to his mind, as with Benjamin, making history is a political task, insofar as to re-write history, to construct it, is a way of establishing possibilities for change in the present. To this end, it is necessary to twist time, turn it upside down, take it out of joint, feel that *the world in flames* of the past continues to smolder, that history consumes us, alludes to us, compels us to act here and now.

Notes

1. See Dieter Roelstraete, "After the Historiographic Turn: Currents Findings," *E-Flux Journal* 6 (2009), www.e-flux.com/journal/after-the-historiographic-turn-current-findings (accessed March 3, 2016).
2. Ernst van Alphen, "Towards a New Historiography: Péter Forgács and the Aesthetics of Temporality," in *Cinema's Alchemist: The Films of Péter Forgács*, ed. Bill Nichols and Michael Renov (Minneapolis: University of Minnesota Press, 2011), 59–74; Roelstraete, "After the Historiographic Turn"; Mark Godfrey, "The Artist as Historian," *October* 120 (2007), 140–72; Jacinto Lageira, *L'Art comme Histoire: Un entrelacement de poétiques* (Paris: Éditions Mimésis, 2016). For a broader discussion on this genre, see Frank van der Stok, Frits Gierstberg and Flip Bool (eds.), *Questioning History. Imagining the Past in Contemporary Art* (Rotterdam: Nai Publishers, 2008); Dieter Roelstraete (ed.), *The Way of the Shovel: On the Archaeological Imaginary in Art* (Chicago: University of Chicago Press, 2013); Jaimie Baron, *The Archive Effect: Found Footage and the Audiovisual Experience of History* (London: Routledge, 2014); Nicolas Bourriaud and Jean-Yves Jouannais (eds.), *L'ange de l'histoire* (Paris: Palais des Beaux-Arts, 2013); and Jane Blocker, *Becoming Past: History in Contemporary Art* (Minneapolis: University of Minnesota Press, 2016). A philosophical approach to the relationship between art and history can be found in Jacques Rancière, *Figures of History*, trans. Julie Rose (Cambridge: Polity Press, 2014). The use of contemporary art and visual culture as historical documents is also seminal in Enzo Traverso, *Left-Wing Melancholia: Marxism, History, and Memory* (New York: Columbia University Press, 2016).
3. Miguel Ángel Hernández Navarro, *Materializar el pasado. El artista como historiador (benjaminiano)* (Murcia: Micromegas, 2012).
4. A possible clarification has been proposed by Frank van der Stok ("Mental Images," in *Questioning History*, 104–18), for whom it is possible to talk about a division into parallel histories, alternatives histories, and deconstructions of history.
5. Walter Benjamin, "On the Concept of History" and "Paralipomena to 'On the Concept of History'," in *Walter Benjamin: Selected Writings*, vol. 4, eds. Howard Eiland and Michael W. Jennings, trans. Edmund Jephcott et al. (Cambridge, MA: Harvard University Press, 2003), 389–400 and 401–11, respectively; "Convolute N: On the Theory of Knowledge, Theory of Progress," in *The Arcades Project*, trans. Howard Eiland and Kevin McLaughlin (Cambridge, MA: Harvard University Press, 1999), 456–88.
6. That is the thesis that I tried to defend in detail in *Materializar el pasado: el artista como historiador (benjaminiano)*.
7. Christine Ross, *The Past is the Present; It's the Future Too. The Temporal Turn in Contemporary Art* (New York: Continuum, 2014), 21–52.
8. This is also the argument of Graciela Speranza, *Cronografías. Arte y ficciones de un tiempo sin tiempo* (Barcelona: Anagrama, 2017).
9. Michel de Certeau, *The Writing of History*, trans. Tom Conley (New York: Columbia University Press, 1988), 76.
10. Natalia Majluf, "Seeing History," in *Fernando Bryce. Dibujando la historia moderna*, ed. Natalia Majluf (Buenos Aires: Fundación Eduardo Constantini, 2012), 113–20, at 113.
11. See Hal Foster, "An Archival Impulse," *October* 110 (2004), 3–22. An actualization of this argument can be seen in Hal Foster, *Bad New Days: Art, Criticism, Emergency* (London: Verso, 2015).
12. Andrea Giunta, "The *Glamour* of Archives," in *What is Contemporary Art Today*, ed. Alexander Alberro, 247–72 (Pamplona: Universidad Pública de Navarra, 2011); and *¿Cuándo empieza el arte contemporáneo?* (Buenos Aires: Fundación ArteBA, 2014); Agustín R. Díez Fischer, "Pintura en el reino de la imagen. Archivo y práctica pictórica en el arte contemporáneo," *Nierika. Revista de estudios de arte* 5 (2007), 55–67; Anna Maria Guasch, *Arte y archivo 1920–2010: Genealogías, tipologías y discontinuidades* (Madrid: Akal, 2011), 291–93.
13. Majluf, "Seeing History," 113.
14. Enzo Traverso, *L'histoire comme champ de bataille: interpréter les violences du XXe siècle* (Paris: La Découverte, 2010).
15. Majluf, "Seeing History," 119.

16. Adrián Cangi, "El caso Warburg. Enfermedad, expresión y anacronismo," *Psicoanálisis ayer y hoy. Revista digital* 10 (March 2004), www.elpsicoanalisis.org.ar/nota/el-caso-warburg-enfermedad-expresion-y-anacronismo-adrian-cangi (accessed February 20, 2016).

17. A translation of Warburg's introduction to the *Mnemosyne Atlas* can be found in Aby Warburg, "The Absorption of the Expressive Values of the Past," trans. Matthew Rampley, *Art in Translation* 1, no. 2 (2009), 273–83. On Aby Warburg's *Mnemosyne Atlas* and memory, see Christopher D. Johnson, *Memory, Metaphor, and Aby Warburg's Atlas of Images* (Ithaca, NY: Cornell University Press, 2012). On the impact of the *Atlas* on contemporary art, see Georges Didi-Huberman, *Atlas: How to Carry the World on One's Back?* (Madrid: MNCARS, 2010).

18. Georges Didi-Huberman, *Cuando las imágenes toman posición. El ojo de la historia I*, trans. Inés Bértolo (Madrid: Antonio Machado, 2009), 159.

19. Miriam Basilio, *Visual Propaganda, Exhibitions, and the Spanish Civil War* (Burlington, VT: Ashgate, 2013), 228.

20. Karen Kurczynski, "Drawing Is the New Painting," *Art Journal* 70, no. 1 (2011), 93–110.

21. See Emma Dexter (ed.), *Vitamin D: New Perspectives in Drawing* (London: Phaidon Press, 2005); Matt Price (ed.), *Vitamin D2: New Perspectives in Drawing* (London: Phaidon Press, 2013); Philippe van Cauteren and Martin Germann (eds.), *Drawing: The Bottom Line* (Brussels: Mercatorfonds, 2015); Elizabeth A. Pergam (ed.), *Drawing in the Twenty-First Century: The Politics and Poetics of Contemporary Practice* (Farnham: Ashgate, 2015); Martin Germann and Elsy Lahner (eds.), *Drawing Now* (Munich: Hirmer Publishers, 2015).

22. Claire Gilman, "Marking Politics: Drawing as Translation in Recent Art," *Art Journal* 69, no. 3 (2010), 115–27.

23. Gilman, "Marking Politics," 125.

24. Ernst Bloch, "Nonsynchronism and the Obligation to its Dialectics," trans. Mark Ritter, *New German Critique* 11 (1977), 22–38.

25. Hal Foster, *Design and Crime: And Other Diatribes* (London: Verso, 2002), 137.

26. Rosalind E. Krauss, "Reinventing the Medium," *Critical Inquiry* 25, no. 2 (1999), 289–305.

27. Rodrigo Quijano, "El presente aludido," in *Fernando Bryce*, ed. Helena Tatay (Barcelona: Fundació Antoni Tàpies, 2005), 115–27, at 116.

28. Carlo Trivelli, "Like a Really Slow Fax Machine. Interview(s) with Fernando Bryce," in *Fernando Bryce. Dibujando la historia moderna*, ed. Majluf, 121–29.

29. Carlos Jiménez, "Fernando Bryce: The Untimely Copyist," *Art Nexus* 9, no. 76 (2010), 44–49.

30. Personal correspondence with Kevin Power. Quoted by Kevin Power, "Fernando Bryce: pensar con la historia," in *Fernando Bryce*, ed. Tatay, 169–87, 183.

31. Cuauhtémoc Medina, "Historio(a)grafía," in *Fernando Bryce. Dibujando la historia moderna*, ed. Tatiana Cuevas and Natalia Majluf (Lima: Museo de Arte de Lima, 2012), 254–89, at 268.

32. W. J. T. Mitchell, *Picture Theory: Essays on Verbal and Visual Representation* (Chicago: University of Chicago Press, 1994); Mieke Bal, *Reading Rembrandt: Beyond the Word-Image Opposition* (Cambridge: Cambridge University Press, 1991); *The Mottled Screen: Reading Proust Visually* (Stanford: Stanford University Press, 1997).

33. See Simon Morley, *Writing on the Wall: Word and Image in Modern Art* (Berkeley: University of California Press, 2003).

34. Mitchell, *Picture Theory*, 241–79.

35. On historical experience that exceeds linguistic boundaries, see Frank Ankersmit, *Sublime Historical Experience* (Stanford: Stanford University Press, 2005).

36. Sergio Chejfec, *Últimas noticias de la escritura* (Zaragoza: Jekyll & Jill, 2015), 99.

37. See Jean Baudrillard, *Simulacra and Simulation*, trans. Sheila Glaser (Ann Arbor: University of Michigan Press, 1994). For a clarification on simulacra in contemporary art, see Hal Foster, *The Return of the Real: The Avant-Garde at the End of the Century* (Cambridge, MA: MIT Press, 1996).

38. Gilles Deleuze, *The Logic of Sense*, trans. Mark Lester with Charles Stivale (New York: Columbia University Press, 1990).

39. Medina, "Historio(a)grafía," 277.

40. Chejfec, *Últimas noticias de la escritura*, 83.

41. Diana Taylor, *The Archive and the Repertoire: Performing Cultural Memory in the Americas* (Durham, NC: Duke University Press, 2003). Quoted by Basilio, *Visual Propaganda, Exhibitions, and the Spanish Civil War,* 230.
42. See Cuauhtémoc Medina (ed.), *Jeremy Deller: el ideal infinitamente variable de lo popular / The Infinite Variable Ideal of the Popular* (Madrid/Mexico, D.F.: CA2M Centro de Arte Dos de Mayo/MUAC, Museo Universitario Arte Contemporáneo, UNAM, 2015).
43. See Mieke Bal, *Of What One Cannot Speak: Doris Salcedo's Political Art* (Chicago: University of Chicago Press, 2010).
44. Homi S. Bhabha, *The Location of Culture* (London: Routledge, 1994).
45. Mieke Bal, *Quoting Caravaggio: Contemporary Art, Preposterous History* (Chicago: University of Chicago Press, 1999).
46. Ernst van Alphen, *Staging the Archive: Art and Photography in the Age of New Media* (London: Reaktion Books, 2014), 265.
47. Van Alpen, *Staging the Archive,* 266.
48. Quijano, "El presente aludido," 121.

Bibliography

Ankersmit, Frank. *Sublime Historical Experience.* Stanford: Stanford University Press, 2005.

Bal, Mieke. *Reading Rembrandt: Beyond the Word-Image Opposition.* Cambridge: Cambridge University Press, 1991.

Bal, Mieke. *The Mottled Screen: Reading Proust Visually.* Stanford: Stanford University Press, 1997.

Bal, Mieke. *Quoting Caravaggio: Contemporary Art, Preposterous History.* Chicago: University of Chicago Press, 1999.

Bal, Mieke. *Of What One Cannot Speak: Doris Salcedo's Political Art.* Chicago: University of Chicago Press, 2010.

Baron, Jaimie. *The Archive Effect: Found Footage and the Audiovisual Experience of History.* London: Routledge, 2014.

Basilio, Miriam. *Visual Propaganda, Exhibitions, and the Spanish Civil War.* Burlington: Ashgate, 2013.

Baudrillard, Jean. *Simulacra and Simulation.* Trans. Sheila Glaser. Ann Arbor: University of Michigan Press, 1994.

Benjamin, Walter. *The Arcades Project.* Trans. Howard Eiland and Kevin McLaughlin. Cambridge, Mass. and London: Harvard University Press, 1999.

Benjamin, Walter. "On the Concept of History." Trans. Edmund Jephcott et al. In *Selected Writings,* eds. Howard Eiland and Michael W. Jennings. Vol. 4. Cambridge, MA: Harvard University Press, 2003, 389–400.

Benjamin, Walter. "Paralipomena to 'On the Concept of History'." Translated by Edmund Jephcott et al. In *Selected Writings,* eds. Howard Eiland and Michael W. Jennings. Vol. 4. Cambridge, MA: Harvard University Press, 2003, 401–11.

Bhabha, Homi S. *The Location of Culture.* London: Routledge, 1994.

Bloch, Ernst. "Nonsynchronism and the Obligation to its Dialectics." Trans. Mark Ritter. *New German Critique* 11 (1977), 22–38.

Blocker, Jane. *Becoming Past: History in Contemporary Art.* Minneapolis: University of Minnesota Press, 2016.

Bourriaud Nicolas and Jean-Yves Jouannais, eds. *L'ange de l'histoire.* Paris: Palais des Beaux-Arts, 2013.

Cangi, Adrián. "El caso Warburg. Enfermedad, expresión y anacronismo," *Psicoanálisis ayer y hoy. Revista digital* 10 (March 2004), www.elpsicoanalisis.org.ar/nota/el-caso-warburg-enfermedad-expresion-y-anacronismo-adrian-cangi (accessed February 20, 2016).

Chejfec, Sergio. *Últimas noticias de la escritura.* Zaragoza: Jekyll & Jill, 2015.

De Certeau, Michel. *The Writing of History.* Trans. Tom Conley. New York: Columbia University Press, 1988.

Deleuze, Gilles. *The Logic of Sense*. Trans. Mark Lester with Charles Stivale. New York: Columbia University Press, 1990.

Dexter, Emma, ed. *Vitamin D: New Perspectives in Drawing*. London: Phaidon Press, 2005.

Didi-Huberman, Georges. *Cuando las imágenes toman posición. El ojo de la historia I*. Trans. Inés Bertolo. Madrid: Antonio Machado, 2009.

Didi-Huberman, Georges. *Atlas: How to Carry the World on One's Back?* Madrid: MNCARS, 2010.

Díez Fischer, Agustín R. "Pintura en el reino de la imagen. Archivo y práctica pictórica en el arte contemporáneo," *Nierika. Revista de estudios de arte* 5 (2007), 55–67.

Foster, Hal. *The Return of the Real: The Avant-Garde at the End of the Century*. Cambridge, MA: MIT Press, 1996.

Foster, Hal. *Design and Crime: And Other Diatribes*. London: Verso, 2002.

Foster, Hal. "An Archival Impulse," *October* 110 (2004), 3–22.

Foster, Hal. *Bad New Days: Art, Criticism, Emergency*. London: Verso, 2015.

Germann, Martin and Elsy Lahner, eds. *Drawing Now*. Munich: Hirmer Publishers, 2015.

Gilman, Claire. "Marking Politics: Drawing as Translation in Recent Art," *Art Journal* 69, no. 3 (2010), 115–27.

Giunta, Andrea. "The *Glamour* of Archives," in *What is Contemporary Art Today*, ed. Alexander Alberro. Pamplona: Universidad Pública de Navarra, 2011, 247–72.

Giunta, Andrea. *¿Cuándo empieza el arte contemporáneo?* Buenos Aires: Fundación ArteBA, 2014).

Godfrey, Mark. "The Artist as Historian," *October* 120 (2007), 140–72.

Guasch, Anna Maria. *Arte y archivo 1920–2010: Genealogías, tipologías y discontinuidades*. Madrid: Akal, 2011.

Hernández Navarro, Miguel Ángel. *Materializar el pasado. El artista como historiador (benjaminiano)*. Murcia: Micromegas, 2012.

Jiménez, Carlos. "Fernando Bryce: The Untimely Copyist," *Art Nexus* 9, no. 76 (2010), 44–49.

Johnson, Christopher D. *Memory, Metaphor, and Aby Warburg's Atlas of Images*. Ithaca, NY: Cornell University Press, 2012.

Krauss, Rosalind E. "Reinventing the Medium," *Critical Inquiry* 25, no. 2 (1999), 289–305.

Kurczynski, Karen. "Drawing is the New Painting," *Art Journal* 70, no. 1 (2011), 93–110.

Lageira, Jacinto. *L'Art comme Histoire: Un entrelacement de poétiques*. Paris: Éditions Mimésis, 2016.

Majluf, Natalia. "Seeing History," in *Fernando Bryce. Dibujando la historia moderna*, ed. Natalia Majluf. Buenos Aires: Fundación Eduardo Constantini, 2012, 113–20.

Medina, Cuauhtémoc. "Historio(a)grafía," in *Fernando Bryce. Dibujando la historia moderna*, eds. Tatiana Cuevas and Natalia Majluf. Lima: Museo de Arte de Lima, 2012, 254–89.

Medina, Cuauhtémoc, ed. *Jeremy Deller: el ideal infinitamente variable de lo popular/The Infinite Variable Ideal of the Popular*. Madrid/Mexico, D.F.: CA2M Centro de Arte Dos de Mayo/MUAC, Museo Universitario Arte Contemporáneo, UNAM, 2015.

Mitchell, W. J. T. *Picture Theory: Essays on Verbal and Visual Representation*. Chicago: University of Chicago Press, 1994.

Morley, Simon. *Writing on the Wall: Word and Image in Modern Art*. Berkeley: University of California Press, 2003.

Pergam, Elizabeth A., ed. *Drawing in the Twenty-First Century: The Politics and Poetics of Contemporary Practice*. Farnham: Ashgate, 2015.

Power, Kevin. "Fernando Bryce: pensar con la historia," in *Fernando Bryce*, ed. Helena Tatay. Barcelona: Fundació Antoni Tàpies, 2005, 169–87.

Price, Matt, ed. *Vitamin D2: New Perspectives in Drawing*. London: Phaidon Press, 2013.

Quijano, Rodrigo. "El presente aludido," in *Fernando Bryce*, ed. Helena Tatay. Barcelona: Fundació Antoni Tàpies, 2005, 115–27.

Rancière, Jacques. *Figures of History*. Trans. Julie Rose. Cambridge: Polity Press, 2014.

Roelstraete, Dieter. "After the Historiographic Turn: Currents Findings," *E-Flux Journal* 6 (2009), www.e-flux.com/journal/06/61402/after-the-historiographic-turn-current-findings (accessed March 3, 2016).

Roelstraete, Dieter, ed. *The Way of the Shovel: On the Archaeological Imaginary in Art*. Chicago: University of Chicago Press, 2013.

Ross, Christine. *The Past is the Present; It's the Future Too. The Temporal Turn in Contemporary Art*. New York: Continuum, 2014.

Speranza, Graciela. *Cronografías. Arte y ficciones de un tiempo sin tiempo*. Barcelona: Anagrama, 2017.

Taylor, Diana. *The Archive and the Repertoire: Performing Cultural Memory in the Americas*. Durham, NC: Duke University Press, 2003.

Traverso, Enzo. *L'histoire comme champ de bataille: interpréter les violences du XXe siècle*. Paris: La Découverte, 2010.

Traverso, Enzo. *Left-Wing Melancholia: Marxism, History, and Memory*. New York: Columbia University Press, 2016.

Trivelli, Carlo. "Like a Really Slow Fax Machine. Interview(s) with Fernando Bryce," in *Fernando Bryce. Dibujando la historia moderna*, ed. Natalia Majluf. Buenos Aires: Fundación Eduardo Constantini, 2012, 121–29.

Van Alphen, Ernst. "Towards a New Historiography: Péter Forgács and the Aesthetics of Temporality," in *Cinema's Alchemist: The Films of Péter Forgács*, eds. Bill Nichols and Michael Renov. Minneapolis: University of Minnesota Press, 2011, 59–74.

Van Alphen, Ernst. *Staging the Archive: Art and Photography in the Age of New Media*. London: Reaktion Books, 2014.

Van Cauteren, Philippe, and Martin Germann, eds. *Drawing: The Bottom Line*. Brussels: Mercatorfonds, 2015

Van der Stok, Frank, Frits Gierstberg and Flip Bool, eds. *Questioning History. Imagining the Past in Contemporary Art*. Rotterdam: Nai Publishers, 2008.

Warburg, Aby. "The Absorption of the Expressive Values of the Past." Trans. Matthew Rampley. *Art in Translation* 1, no. 2 (2009), 273–83.

Part IV

Narrative Time

9 Heterochronies

The Gospel According to Caravaggio

*Giovanni Careri**

I enter the Contarelli Chapel in the church of San Luigi dei Francesi in Rome: three large paintings present themselves to me installed in an imposing architectural frame, dominating in their scale since their lower frame is located at the height of my head.[1] Facing me above the altar, St. Matthew writes instructed by an angel, to the left Christ calls the saint to follow him, to the right he suffers martyrdom. Many temporalities interact in this situation: the moment of the *Now-Time* belonging to the spectator, the time of the *Then* in which these scenes are supposed to have taken place, the time of the creation of these works at the end of the sixteenth century.[2] These different times are the object of a singular elaboration in *The Calling of Saint Matthew* because the saint and those seated around him wear sixteenth-century costume, while Christ and St. Peter wear antique garb in order to demonstrate that they belong to another time (Figure 9.1). In other words, the picture itself shows that the interaction of times is included in this representation of the gospel, before being re-played by the viewer in a *Now-Time* that might belong to any moment in history. The two lateral pictures represent two decisive episodes in the life of the saint that are presented to the believer so that he can follow his example even to the extreme sacrifice of martyrdom. This incitement is not reserved to the men and women of Caravaggio's own time, for this is a device susceptible to activation at any time. There is nothing remarkable about this conclusion apart from the fact that *The Calling of Saint Matthew* makes this interaction of different times one of its explicit goals. In locating ordinary people in the context of a tavern, Caravaggio tells us, in effect, that Christ can manifest himself now, and in any place, to invite men and women to follow him. While the call to follow St. Matthew in his martyrdom is a summons to become an exceptional individual, the invitation to abandon one's everyday life to be converted is an appeal to which everyone can respond—even if the painting shows that this does not happen without great difficulty. In identifying him or herself with Matthew and the other people around him, the viewer is asked to overcome the hesitations that prevent him from being "converted"; the spectator's involvement in the picture establishes a bridge between different times. The figures who ignore the appearance of Jesus and Peter belong to a "position" that the witness will share if he or she does not adopt the "position of the convert." The device that I have just described is determined by its real or presumed efficacy; it can be compared to a ritual to the extent that it seeks to transform whoever is included, but also because it belongs to a vast anthropological framework, a set of beliefs and Catholic practices that have their foundation in the imitation of Christ, the son of God.[3] In that regard one must remember that the actualization of the Gospels is not the sole property of painting in the age of Caravaggio. *The Spiritual Exercises* of Ignatius Loyola, for example, suggest that the devout believer project himself or

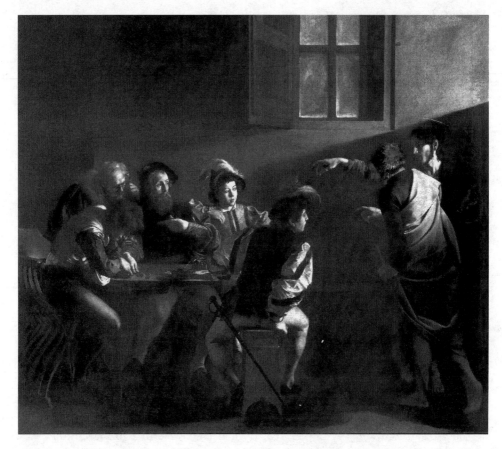

Figure 9.1 Michelangelo Merisi called Caravaggio, *The Calling of Saint Matthew*, 1599–1600, oil on canvas, 322 × 340 cm, Rome, Church of San Luigi dei Francesi. Wikipedia Commons

herself imaginatively into the scenes of the life of Christ using those around him or her as "models" to play the actors in episodes used in this mental and emotional theater.

If one sets aside the anthropological frame of Catholicism that I have just evoked, the experience of the observer can be described as a matter of aesthetics, that is, as an intense exercise of sensibility, one involving the intellect and the emotions. Not only is this dimension not excluded by the anthropological experience that I have described, but the three pictures of the chapel produce, in addition and by their own means, a reflection on the act of presenting a visual narrative. The imbrication of the aesthetic and the anthropological dimensions in the experience of the observer can be undone if it is situated outside the pale of "Catholic Christianity." This is not only the case of many visitors who come to San Luigi dei Francesi to see "works of art," but the possibility already existed in Caravaggio's day. We have the testimony of the painter Taddeo Zuccaro's visit to the Contarelli Chapel, who went there to verify whether Caravaggio's paintings were as innovative as he had heard. Zuccaro came to the conclusion that there was no need to make such a noise about them because what he

saw was nothing more than an imitation of the style of Giorgione.[4] Once it has been disassociated from its anthropological milieu, aesthetic experience is as ahistorical as that of the believer, except that the work's location in the past itself belongs and conditions that experience. If we place this conditioning into parentheses (something that is possible given the expectations and knowledge of the spectator), we can exclude the history of art from this situation, but not time which is qualitatively engaged by means of strategies that capture, intensify, and prologue attention. Further, Zuccaro's visit to the Contarelli Chapel teaches us that the inscription of aesthetic experience in a history of forms can play an important role from the point of view of the temporality that belongs to works of art. In citing and radically transforming forms belonging to the generations that preceded him, notably Raphael and Michelangelo, Caravaggio was conscious of this, and the canvases in the chapel demonstrate it. This inscription in the history of art is itself another form of temporal interaction: in their citation, certain forms are placed in the past, thus recognizing an anteriority often filled with prestige, while through their transformation, the citation actualizes them to remarkable effect. Moreover, the anecdote suggests an additional consideration: in referring to Giorgione, Zuccaro plays the art historian. He mobilizes the power of the name in order to remove the painting of Caravaggio from view: "there is nothing to see" seems to say "this has already been seen." The history of art can exercise a remarkable power of occlusion: placing Caravaggio in the shadow of Giorgione, Zuccaro places him in an art historical genealogy in which he does not have the right to assume a major role. The temporality invoked by this statement is familiar to the history of art; it is a pseudo-genealogical form of time whose exceptional power lies in its parental nature: "Caravaggio is nothing but a son of Giorgione." But the power of the name does rest there, for the work of denomination implies a pre-established historical and classificatory frame. An ensemble of historical and stylistic categories is available to situate the picture within the history of art and thus to protect the viewer from the disquieting polysemy of images by means of a reassuring screen of verbal knowledge. Just as in our museums the labels identifying the artist serve as anti-anxiety medications, the history of art provides a classificatory frame authorized to enable this anesthetic measure to function. I certainly do not pretend that one can reduce the history of art to this prophylactic role; it can follow another path and surround the work with links essential to its comprehension. Here we find a form of temporality that is properly historical, that in which the history of art is articulated along with other forms of history: social history, religious, economic, political, descriptive, but also the history of ideas, that of techniques, of sciences, of poetry. The ensemble of such links constitute that which one calls the "context" of the work: a reservoir of relationships that the art historian must construct, but from which he must know how to protect himself to the extent that the context can serve as a work's sole principle of explanation, reducing its meaning to the historical testimony of a period. One of the implications of this principle is directly related to our concern, because the contextual history of art is founded on a temporality that is contemporary with the age in which the work was conceived and produced. If one allows this principle of contemporaneity to dominate the experience and analysis of the work of art, one ends by excluding any form of anachronism beginning with that pointed out by Walter Benjamin when he writes:

> The history of art is a history of prophesies. It can only be described from the point of view of the actual, immediate, present: for each epoch possesses its own

new possibility, which cannot be transmitted by legacy, to interpret the prophesies that the art of the past contains in a specific address. The most important task of history is to decipher, in the great works of the past, the prophesies which gave them value in the time that they were made. The future, in fact, not always immediately given and never strictly definite. Moreover, nothing is more capable of transformation in the work of art, than that obscure and brewing space of the future out of which those prophesies step into the light, separating the works of art that have soul from those without interest: never a single one, but always a sequence developing, intermittently the course of centuries.[5]

Criticism of a history of art as rigidly contextual and "homochronic" began thirty years ago with the notion of the "theoretical object" conceived by Hubert Damisch, who was concerned to keep the history and theory of art together and to remove works of art from the powerful grasp of contextual history.[6] The elaboration of Warburgian notions such as *Nachleben* and *Pathosformel* have also enabled work on the "posthumous" temporality of works of art. The concept of the *constellation*, proposed by Walter Benjamin, has finally opened the way to a history of art that is both rigorous *and* anachronic.[7] While situating my position within this critical position, I prefer to concentrate on the heterochronies and other forms of temporal interaction constructed and reflected in the three pictures of the Contarelli Chapel rather than to develop it in any more general sense. I ascribe the theory of art an essential function of perspective and criticism, but I prefer to proceed in a deductive manner: in running the risk of creating a paradoxical theory of the singular, this has the advantage of minimizing the reductive power characteristic of any general theory. Furthermore, the possibility of proceeding with this type of analysis rests on the assumption that certain works, such as those by Caravaggio, have the potential to create a form of visual theory, which the interpreter can attempt to render explicit by mobilizing the theoretical tools of "anachrony."[8]

I described the anachronism of the clothing in *The Calling of Saint Matthew* in terms of *actualization*: the saint and the figures seated in his company wear the costume of Caravaggio's time to suggest that the redemption occasioned by Christ's coming is active in the *Now-Time* and not limited to some moment in the *Then*. This actualization could, however, have been produced if Christ and St. Peter had also worn modern habits. "Antique" clothing introduces a temporal difference—a heterochrony—whose implications are worth grasping. It has been observed that the figures around the table in *The Calling of Saint Matthew* recall the *Card Players* in the Kimball Museum (ca. 1596), which is called a "genre" painting because it represents anonymous figures occupied in an everyday activity (Figure 9.2). The *Calling* of the Contarelli Chapel presents itself as an unusual mixture of a genre painting and a history painting, if we understand that to mean a visual narrative of a memorable episode that involves nameable personages (in this case, Christ, St. Peter, and St. Matthew). The meeting of the two genres is problematized in the picture by the obstacles that hinder the identification of Matthew, who is, after all, the protagonist of the narrative. Is the saint the bearded man with the black hat or the young man seated to his right? The gesture of the man with the black hat is ambiguous because he points to himself as well as to the man leaning across the table. I will return to this ambiguity, limiting myself for the moment to suggest that it designates the suturing and stitching of a montage operation between the anonymous genre of the "tavern painting" and the genre of the "history painting." Imagining Matthew among the clients of an ill-lighted tavern is a

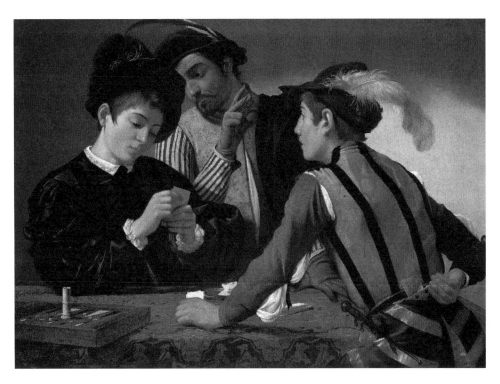

Figure 9.2 Michelangelo Merisi called Caravaggio, *The Card Players*, 1595–96, oil on canvas, 91.5 × 128.2 cm, Fort Worth, Kimbell Art Museum

way of stating that the history related in the Gospels concerns the present, but it is also a means of making Christ's appearance in the iterative quotidian temporality of the genre painting.[9]

With his *Fortune Teller*, the *Concerts*, and the *Card Players*, Caravaggio significantly contributed to defining the characteristics of this type of painting which had been invented by artists of the preceding generation. This is not a "minor genre" as classical criticism has insisted, but rather an innovative construction allowing an aspect of the human condition that had hitherto been excluded from sight to become visible. In other words, by means of his participation in a "mixing of genres," the heterochronic interaction of times enables the "ordinary" time of everyday life to become a border that Matthew's response must cross. The habitual reunion of a group of anonymous figures around a table where one counts money thus becomes a memorable episode in the life of one of the four Evangelists. In other words, when Matthew responds to Christ's appeal, genre painting transcends its constitutive limits. The saint's reaction, however, is so ambiguous and deferred in its action that the movement from one genre to another remains ill-defined. Whereas the same subject is treated as a realized event worthy of memory in contemporary pictures, in Caravaggio's painting it assumes the "aspectual" mode of an imminent action.[10] The picture is also home to those who are immersed in the temporality of everyday life and who do not react to the arrival of Christ and Peter, evincing by their demeanor, a strong determination to stay put

"in their time," that is, the temporality of their ordinary lives. These reflections on an immersion in quotidian time, and on its limits, form a "constellation" with twentieth-century plays , such as those of Beckett, as well as with Heideggerian and post-Heideggerian philosophy.[11] I could say, therefore, that the prophesy that ferments in the *Calling of Saint Matthew* offers to *Now-Time* a critique of ordinary life in a capitalist regime (see the decisive placement of money). Otherwise expressed, my interpretation is both anachronic in a Benjaminian sense and authorized by the picture's temporal structure.

One can, in addition, ask whether Jesus and his companion come from a contiguous space, one that is continuous with the space that is presented to us, or from another that is more radical or *absolute*, according to the term used by Gilles Deleuze, who has proposed an interesting distinction relating to the *hors-champ*: "In one case, the *hors-champ* designates that which exists alongside or nearby; in another it testifies to a more disquieting presence, which, while if one cannot say that it exists, it nevertheless 'insists' or 'subsists,' a space more radical, outside of homogeneous space and time."[12] The *hors-champ* of the *Calling*, if one can use this anachronic notion in reference to a classical painting of the sixteenth century, accentuates the second alternative; it is an "outside" that insists on an "inside" by means of the light that invades the scene, but also by means of the gaze of one of the two boys seated face to face. The question of the *hors-champ* is also posed by the anachronism of the costumes: do Jesus and Peter come from *another time*? In questioning Deleuze's distinction, Damisch comes to a conclusion that fits our case when he remarks that the two types of *hors-champ* can merge.[13] In Hitchcock's film *The Birds*, writes Damisch, the moment when the birds take control of exterior space and confine the humans to their house presents a scene which "mixes both meanings (of the *hors-champ*) with the effect that exterior space appears to be not only an extension of the space within, but as its antithesis."[14] In other words, the *hors-champ* of the scene is that which is found outside the walls of the house attacked by the birds, but also a "birded" space, antithetical, disquieting, and radically other that "knocks from beyond."[15]

In the *Calling*, the *hors-champ* is similarly mixed: the light that unfurls from outside the scene is both natural and unnatural, Christ and Peter come from outside, but also from the past. Their return prompts a heterochronicity that implies that the power of the church transcends history because the evangelical narrative on which it is founded never ceases to return from the time of its origin. The *hors-champ* gaze of the boy seen from the back problematizes the border that distinguishes the picture from its "outside" and participates in the history's lack of completion. As Lorenzo Pericolo has well demonstrated, this eccentric gaze questions Christ's visibility and joins a number of disruptive strategies that aim to destroy the coherence of a narrative that we must now describe and contextualize.[16]

Five men, three quite young and two quite old, are grouped around a table on which there is an open book, an ink well, a small closed bag, and some money. To the extreme right of the table stand two figures: Jesus Christ, who raises his arm in the direction of the group of men, while the other, whom we can call Peter, is seen from the back. He also raises his hand toward the table as he advances toward the group. According to the gospel, Christ was passing the shop of the tax collector Matthew, of the family of Levi, when he asked him to join him, something he did right away. In a subsequent episode, recounted in the Gospels of Mark and Luke, the convert offered a banquet in Jesus's honor, to which he also invited other publicans and tax collectors.

When questioned by the scribes and Pharisees as to why he consented to dine with contemptible people, Jesus replied: "I have not come to ask for the penitence of the just, but that of sinners."[17] These words are explained when one remembers that Matthew's profession was doubly questionable: on the one hand because of the suspicion of cupidity and dishonesty, and on the other because his office was exercised on behalf of the Roman government. Like that of St. Paul, the conversion of Matthew is all the more exemplary because it involves a sinner, a man corrupted by illicit gain and by his collaboration with the enemy. In connection with these observations, we must remember, together with Irving Lavin, that the patron who commissioned the Contarelli Chapel, Matthieu Cointrel, a cardinal who died in 1585, was a "new Matthew," not only because of his first name, but also because of his role as controller of ecclesiastical benefices, an office bestowed on him by Pope Gregory XIII.[18] When, after his death, Cointrel was accused of corruption by the reforming Pope Sixtus V, the inquiry stained the memory of Gregory XIII himself. Cointrel's inheritance was for a time threatened with confiscation, but the affair was shelved without further action. As Lavin suggests, this episode merits being taken onto account. He advances the hypothesis that by means of the picture, the cardinal's heirs desired to restore dignity to his name. These considerations bear on the contemporary context of the painting, but they also render visible the interaction of different forms of time: Mathieu Cointrel and Mathieu Levi are condensed into a single figure belonging both to the *past* and to the *present*. This condensation is not a simple identification, but an operation that affects nature of the painted figure: if Caravaggio's Matthew is slow and indecisive in responding to Christ's appeal, it is, without doubt, in order to make the identification less flattering. Mathieu Cointrel is "another Matthew," but the picture does not hide his weakness or his sluggishness.

Having brought together these historical points, we must now confront a picture that is intentionally complex, not only obscured by its night setting, but because its narrative is difficult to read. The work's complexity becomes clear when it is compared with the preparatory sketch made by the Cavaliere d'Arpino, once Caravaggio's employer and the first beneficiary of Cointrels' commission before having been replaced for taking too long to deliver the work (Figure 9.3). In the drawing in the Abertina, Christ walks down the road and addresses Matthew with two gestures, one of which might be translated as "you!" and the other as "it is I!" The apostle rises from his office raising his hand to his chest in a sign of self-identification. The scene is clearly a brief but effective face to face, as it is recounted in the evangelical narrative. In Caravaggio's picture, the extended arm with which Christ calls Matthew is cut in half by the body of Peter furthermore the line projected by his gesture must traverse the entire space of the picture before reaching the bearded man who is perhaps Matthew, but who, with his own gesture, returns it to the seated juvenile figure who leans with his elbows on the table.

The identification of Matthew has given rise to much discussion among art historians. For most of them, Matthew is the mature man with the red beard dressed in black, while for others, it is the young man seated at the end of the table, with his head leaning over the coins he handles. According to Andreas Prater, the gesture of the man with the red beard would mean "who me, or the young man?"[19] The structure of the picture would deliver the reply because the figure leaning over the table is the one best lit and the one who is situated opposite of the figure of Christ. In representing Matthew still engaged in the act of counting money, the artist would have introduced

Figure 9.3 Giuseppe Cesari called Il Cavalier d'Arpino, *The Calling of Saint Matthew*, ca. 1599, chalk and sanguine, 22.3 × 26.4 cm, Vienna, Albertina

a new element: the young man had not yet realized his conversion. For Herwarth Röttgen, by contrast, Matthew is indeed the middle-aged man who points to himself with his left hand, while his right does not count, but rather asks for money.[20] The collector would thus be the older man who, in addition, wears a coin, symbol of his profession, on his hat.

Approaching the picture from a larger semiotic perspective, Peter Burgard demonstrates the indetermination invested in the whole composition: the protagonists are placed on either side of the painting while the center is occupied by a figure seen from behind.[21] In terms of the lighting, the figure who is most intensely lit is the young man counting coins, but while this should confer him an important role, the lighting does not help clarify the narrative. According to Burgard, we cannot know who is Matthew. Furthermore, Christ's gesture, reminiscent of Adam's on the Sistine ceiling, is passive rather than active. *The Calling of Saint Matthew*, in sum, is a systematic display of narrative ambiguity: a play with space (decentering the protagonists and blurring the distinction between outside and inside), with time (the anachronism of the antique clothing of Christ and Peter in relation to the other figures), and with light, whose

relation to the figures does not cohere with that of the narrative (the structural logic of the action is unclear). Reacting in haste, scarcely a year after the presentation of the picture, Ludovico Caracci corrects the ambiguities in his own *Calling of Saint Matthew*: the tax collector kneels, while on the other hand, he holds the coin between his fingers exactly like the person in the Caravaggio (Figure 9.4). The Bolognese painter

Figure 9.4 Ludovico Carracci, *The Calling of Saint Matthew*, 1605–07, oil on canvas, 449 × 265 cm, Bologna, Pinacoteca Nazionale

could not have been more explicit in his critique of the *Calling* by Caravaggio, particularly his lack of clarity in rendering Matthew's response. However, in repeating Christ's feeble gesture, Ludovico appears to appropriate part of the ambiguity of the Contarelli *Calling* by emphasizing that the *appeal* of this passive hand is actually a *welcome* to a person who was converted in the moment that he heard the Lord's voice. Lorenzo Pericolo has developed Burgard's conclusions by interesting himself in the young man seen from behind who does not seem to see Christ, but looks out of the border of the painting at the place from which the light comes. Furthermore, the figures of Jesus and the apostle seem invisible and inaudible to the man wearing glasses as well as the young man sitting at the head of the table. This problematization of the visibility of Christ is continued in a whole series of Italian and Flemish paintings inspired by Caravaggio's *Calling* and convincingly addressed by Pericolo. One could also bring to bear Francoise Bardon's observation that the chromatic consistency of the hands and faces of Peter and Jesus are composed of a clear color mixed with black layers that permit transparency. Bardon describes this manner of treating these two bodies as a "technique of emergence," a device that is rich with meaning because it denies a distinction between figure and ground. It invests the figures with what she describes as a fragility resulting from their unstable condition between a re-absorption into darkness and what is without form, and their emergence into visibility and the adoption of form.[22] The narrative and chromatic problematization of Christ's visibility has a double effect on the viewer's experience of time: on the one hand, it extends indefinitely the time of the narrative (I will never know whether the young man seen from the back will ever perceive the presence of Christ), while on the other hand, it prolongs the perceptual experience of the spectator, enriching it with a battle between visibility and invisibility that destabilizes his or her subject position.

From a narrative point of view, the most remarkable element in Caravaggio's picture is not the difficulty in knowing who is Matthew, but the disorientation provoked in the observer by the ambiguity of a gesture that could point to its author as well as to the young man seated beside him. The link between the gesture and the astonishing proximity of their hands makes these figures a couple that one could compare to that constituted by Christ and St. Peter at the other end of the picture. X-ray images reveal that the apostle was added at a later time, an addition that has institutional implications because it suggests that the call to conversion is incumbent upon the Church. A "substitutive temporality" is installed—along with projective and iterative characteristics—because the relationship between Christ and Peter is destined to be repeated "in the future" every time a new pope replaces the preceding one, thus receiving the original charge that made Peter the first responsible representative of the Church. To my knowledge, no one has suggested that Peter's deictic gesture mimics that of Christ. In timidly repeating his gesture, the apostle humbly assumes a resemblance that is also a heavy responsibility. Through the superimposition of the two bodies, Christ and Peter appear as a single figure with two heads, by which means the picture suggests the conformation of one with the other and of the Church with Christ. The resemblance between Christ and Peter is echoed by that of the two boys at the center of the painting, but here its significance reminds one of the specular device of the Narcissus myth as painted by Caravaggio. *The Calling of Saint Matthew* is built upon a structure that opposes narcissistic resemblance with one's own image with that of compliance with Christ. One could imagine that before the appearance of Christ and his companion, the two boys faced each other as if in a mirror and that Christ's

arrival "broke" this "narcissistic circle," producing two different responses: the boy facing us sees Christ, while the other does not.[23] This difference associates the young man seen from behind with the man with glasses as well as the one who looks fixedly at the table. By contrast, the young man who faces us leans on Matthew's shoulder and enters a process that could lead to his conversion. The flight of imagination I have just sketched is authorized by the inscription of this "rupture of the narcissistic circle" in a number of comparable devices used to disturb and invert symmetry, beginning with the "hand of Adam" found in the Michelangelesque citation (Christ's gesture) and with the troubling apparent doubling of the right hand of the young man sitting at the head of the table. One might think that these are atemporal devices belonging to a spatial or topological order if the quotation did not include in this game a process of actualization of a more ancient form, that of Michelangelo's Adam. To see in the divergent responses by the young men to Christ's call a rupture of symmetry obliges us to "go back in time" and to imagine the specular situation that preceded it.

It is time, before moving on to the *Martyrdom*, to attempt to describe Matthew's situation. His indicative gesture seems to suggest that there is a tie that binds him to the seated young man, a relation that is confirmed by proximity and by the specular monstrosity of the two hands leaning on the table. The body of the saint is presented as if divided: the left hand imitates Christ's deictic gesture, instantaneously making him a convert who transmits the call to his neighbor; the right hand, by contrast, associates him with the young man who does not lift his head from the table, remaining obstinately immersed in a condition that St. Paul would call "carnal." The figure that marks this link is a monstrous specular reflection that makes it appear as if the young man has two right hands. This monstrosity touches a profound chord in our perceptual apparatus since it is entirely organized by the bilateral symmetry of our limbs. The monstrosity is unmade when one attributes one of the two hands to Matthew, but the detail of the hand remains suggestive and seems to represent a specular rupture comparable to that produced between the two men seated facing one another and in the "inversion" of the "hand of Adam."[24] One could quote Matthew's own words to Caravaggio's painting of him: his left hand does not know what his right hand is doing.[25] This signals a conversion that might heal Matthew's split subject. The coupled construction that links Peter to Jesus, the two young men seated face to face, and Matthew with the young man who is seated form a sort of system that opposes a good likeness—imitation of Christ's gesture—with a bad likeness. This specular construction prepares for the moment when the man seated at the head of the table will raise his head and turn his face to Christ, a moment that is indefinitely deferred. These devices of specular symmetry and of the rupture of symmetry are topologically determined, but, as I already mentioned, their construction invites us to produce a time before and a time afterward, thus making the time of the narrative more complex. This "montage" situates the figure of Matthew, and the spectator with him, in an unresolved conflict of likenesses, so that the indetermination observed by Burgard is not an end in itself, but an invitation to conversion.

The construction of a relation between a disjointed narrative and a spatiality shaped by the bond between light and shade is also at work in the *Martyrdom of Saint Matthew* (Figure 9.5). At first the narration seems to be much clearer here: at the center of the picture, a young assassin prepares to stab for the second time an old priest who has fallen to the ground, while witnesses flee hither and thither. Matthew's death is told in the apocryphal gospels as well as in other non-canonical texts. The saint is said

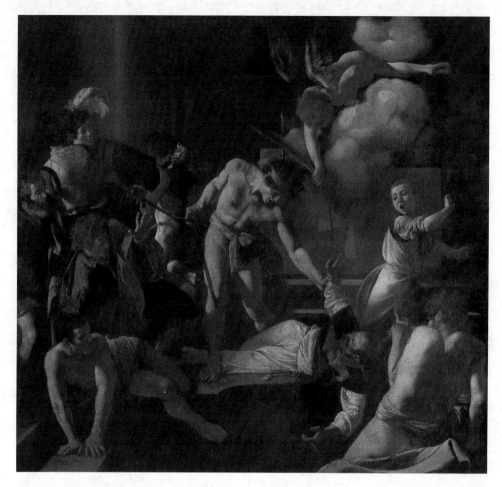

Figure 9.5 Michelangelo Merisi called Caravaggio, *The Martyrdom of Saint Matthew*, 1599–1600, oil on canvas, 323 × 343 cm, Rome, Church of San Luigi dei Francesi. Wikipedia Commons

to have been killed in Ethiopia by two killers sent by Hirtacus, brother of King Egippus, who coveted a young woman converted by Matthew, who had taken a vow of chastity. The decision to place this episode within a church, thus making the murder a profanation, was explicitly ordered by the patron, whose instructions state that the saint should suffer his death before the altar at which he had been celebrating mass, just as had been depicted by Girolamo Muziano barely a year earlier.

The story takes place within a very short span of time defined precisely by the interval between the immanent fatal blow and the angelic reward of the traditional palm branch. The cries and the flight of the altar boy fit with the brevity of the principal event, but the two nude young men viewed from the back seem to belong to another time. One of them leans back as if falling, while the other rests his head on his hand in a gesture of melancholy. On the other side of the picture, a man rests both hands on a

rock that frames the scene, while behind him there is a kind of choreography: a couple of men in unbalanced poses look at the scene in surprise and horror, while another couple turn away along with a third who is further away. Among the two figures of the middle couple, one looks back as he leaves the scene. Both men in the couple that is furthest away turn around; one of them, who faces us, has been identified as a self-portrait of Caravaggio. The centrifugal movement is contradicted by those figures who turn around in the background. This is a means of demonstrating the cowardice of the witnesses while allowing signs of their compassion to be discerned, as a well as their attraction to a violence that is eroticized by the heroic beauty of the half-nude aggressor. The oscillation between pity and voyeurism is a delicate way of defining the situation of the picture's viewer as someone who cannot come to the aid of the victim and in whom compassion is at every moment threatened by an inadmissible pleasure in "seeing death." The figure of the painter thus represents ourselves while assuming a larger part of the responsibility because he is in a position to do something but does not. The construction of an image of a frightened, unheroic subjectivity implicated in the act of witnessing is one of the great innovations of the work. The figure of the painter is accompanied by another person who, seen from behind and also turned toward the back, serves as a sort of mirrored double. The similarity between these figures renders visible the specular rupture of their faces and consequently the rupture of a specular narcissism comparable to that which linked the two young men in the *Calling*. Here, however, it is provoked by the intrusion of a Real that imposes itself on account of its terrible violence.

It seems difficult to understand the relation between the dark zone situated in the foreground of the painting and the figures who are in part immersed in it: for certain authors, it is to be identified as a basin destined for the baptism of the semi-nude neophyte who immerses his left leg. According to Giulio Carlo Argan, this ditch is the tomb of the saint that has already been prepared by the two grave diggers seen from the back, one of whom one might lean on a shovel.[26] Argan insists, quite rightly, on the aporetic contraction of narrative time into a single "event." One might add to these observations by pointing to the properly tragic nature of the story's temporality in which what precedes the cathartic conclusion, and that which follows it, is super-imposed in one narrative that is untenable from a logical point of view. This is dem-onstrated in exemplary fashion by the gesture of the saint's right hand, which is *still* raised in defense, but *already* set upright to receive the palm branch. In the same way, his body is *already* half in the tomb while he is *still* alive and *already* admitted into heaven. In the economy of heterochronic narratives, hung between before and after an event, the grave diggers mark the greatest interval—the greatest temporal distance in relation to the event that has upset the course of the story. In addition, if one accepts that the semi-nude man lying before Matthew is a convert whom the saint is preparing to baptize, one can associate his figure with that of the saint, which he repeats quite precisely while inverting it so that the torsion of the body is in *contrapposto*. The fig-ure of the convert is then caught in a paradox: it plunges into the tomb together with Matthew, but, at the same time, it rises from the baptismal water, embarking on a path that will lead him to turn around, to open his arms, and thus to become a mirror of the saint whose cross-like pose implies, furthermore, that he is on the path to "become an analogue" of the Christ of the Passion. The fingers of the raised right hand also seem to touch the cross inscribed on the altar at the back of the painting, so that along with the palm, he receives the cross. To see the obscure cavity dug at the center of the

picture as a basin for the celebration of baptism and at the same time as a grave is possible if one considers that this sacrament is justly conceived as a birth that follows a passage through death. The untenable position of this figure can resolve itself in a fall, and thus in death, or in conversion, and thus in life, should he happen to rise again and to open his arms and so assume the appearance of Christ's martyrdom. Furthermore, the torsionate movement implied by the formal agreement between the two figures repeats a comparable reversal that one sees appear in the similarity between Matthew's figure in *contrapposto* and that of the angel which is also in *contrapposto*. The spreading of the legs of the angel is similar, while the reversal of the torso and head is pushed to the limit. The three figures are disposed in a series of movements of opening and torsion that creates the picture's space by constructing a relation between the abyssal obscurity of the base and the sky. The figure of the martyr is the hinge and the figural matrix of this junction. In opening his arms in the form of a cross, he opens the space of the painting, a movement which is also conceived as the place where shadow is converted into light and death into life. In a different way, a link is forged between the space, the form, at once concise and disjointed of narrative time, and the content of a story that is comparable to that of the *Calling*.

Furthermore, *The Martyrdom of Saint Matthew* represents the profanation of a church exhibited inside a very similar church. There is nothing that allows the episode to be placed in Ethiopia, not even the costume of the figures. The effect realized by these means is striking: the infraction committed by the aggressors against the church represented in the picture introduces the "outside" of the secular world into the "inside" of sacred space, but this profanation can be immediately transposed into the space of the church in which the picture is located. The violence unleashed by this intrusion emphasizes the fragility of the border that separates the sacred from the profane. This exceptional actualization signals the presence of an "outside" that the Church of that period tried to deny, but could no longer ignore.

Making the "real" enter the space of representation is one of the principles of Caravaggio's poetics. In *The Martyrdom of Saint Matthew*, the eruption of the real is thematized by the construction of a painting whose laborious creation is now visible by means of exceptional X-ray photographs taken during the restoration of 1951. Without getting into a detailed analysis of the modifications Caravaggio carried out, these images still allow us to have a better understanding of the working method of an artist who did not use preparatory sketches, but who modified his composition directly on the canvas covering earlier stages by means of superimposed strata. The fantastic palimpsest of these X-rays testifies to a long and complex pictorial labor (a time that technology has re-discovered) that contradicts the simplification that allowed the painting of the Lombard to be reduced to an imitation of "what he saw before him," as Bellori claimed.[27] The transformations experienced by the picture reveal a concern to construct an image that was concisely and ambitiously "tragic," one that authorizes the most exacting theoretical interpretations.

The Inspiration of Saint Matthew, in both its versions, does not present problems of narration. We will rapidly evoke these two works in order to complete our insight into the Contarelli Chapel from the point of view of the time of the visual, and also to introduce the question of the condensation of a number of gestures and times within a single figure—a procedure resorted to by Caravaggio on a number of occasions. Destroyed in Berlin at the end of World War II, the first version of the altarpiece was rejected by the parish priests of the church, bought by the marquis Vicenzo

Giustiniani, and later replaced by the painting that is currently in place. In the first picture (Figure 9.6) the evangelist is seated and he reveals his amazement as he sees his own hand trace Hebrew letters on the first page of a large volume. An angel of feminine allure guides his hand so that instead of inspiring him, it looks as if she is teaching him to write. Argan proposed that we find a model for the link between Matthew and the Angel in the face-to-face communion of the old and muscled Zeus and the charming infant Eros painted *al fresco* by Raphael in the loggia of the Villa Farnesina.[28] The relation between the celestial grace incarnated by the angel and the

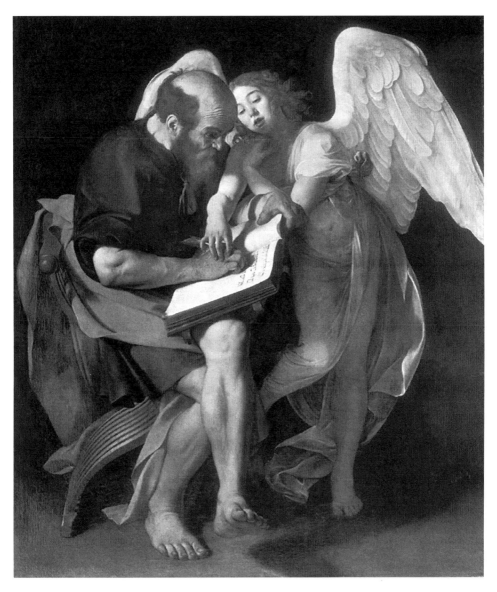

Figure 9.6 Michelangelo Merisi called Caravaggio, *Saint Matthew and the Angel*, 1602, oil on canvas, 223 × 183 cm, destroyed in Berlin in 1945. Wikipedia Commons

terrestrial corporeality of the saint in both versions of Caravaggio's *The Inspiration of Saint Matthew* can be associated with the content of the text that Matthew is writing. Irving Lavin has recognized the first lines of the gospel, those that enumerate "Christ's ancestors" using an unvarying formula that announces the name of the father, the verb to "engender" followed by the name of the Son forty-two times, until arriving at Joseph "husband of Mary, mother of Jesus."[29] The apostle's text halts at the phrase "And Abraham engendered . . ." According to tradition, Matthew's gospel was not written in Greek, like the others, but in Hebrew so as to facilitate the conversion of the Jews. During Caravaggio's time, there was a polemic between Catholics and Protestants about the existence of an autograph Hebrew manuscript of the Gospel of Matthew dictated directly by God. According to Lavin, Caravaggio and his advisor, who could have been Fulvio Orsini, found a model for the Hebrew characters in an edition of Matthew's gospel by the Protestant Hebrew scholar Sebastian Munster printed in Basel in 1537. In doing so, they sought to emphasize the gospel's function in the propagation of the faith, and to re-affirm that the idea of this project, which was dear to the hermeneutic ambitions of the Protestants, could be traced back to divine will. The beginning of Matthew's gospel places Jesus—king of Israel—in the line of Abraham, David, and the patriarchs. However, in the pages that immediately follow the list of ancestors, the Annunciation introduces a divine father, thus undermining the very principle of the transmission of the name, of the royal function, and of the priesthood by blood, and, at the same time, opening Christian proselytization to "all the nations" beyond that of the single chosen people.[30]

The painting contrasts the plebeian carnality of Matthew and his amazed expression with the delicate elegance of the angel who is his guide. Caravaggio seems thus to translate the intervention of divine grace into the genealogical history that the Gospel of Matthew recounts in borrowing from the language and the formulas of the Old Testament. To see in the evangelist's perplexity a reaction to the historical break that begins with the Incarnation by means of the intervention of the Spirit in the midst of the natural sequence of the generations is to attribute to the painter and his advisors a profound understanding of the foundational role of scripture in the battle between Christianity and Judaism. If one can interpret Matthew's clumsiness as an image of the difficulty faced by the Jews in leaving "old" time in order to enter the "new," it is because the list that he is in the process of recounting has no other reason than to prepare for the event of the Incarnation that serves to abolish the very principle of genealogical history. In the context of the conversion of the Jews that took place in San Luigi dei Francesi, the sluggishness of Matthew's writing becomes an echo of their reluctance to be converted. This confirms Lavin's thesis on the importance accorded by the painter and by the clergy of the church to the conversion of the Jews, a motif that is also present in the two lateral canvases of the chapel. One could object to this reading that according to the Gospels, Matthew, the collector of taxes, was certainly already a convert when he began the redaction of his text. To this can be added the fact that far from being incapable of writing, he was a scribe by profession. This type of argument undoubtedly counted in the clergy's decision to refuse the work, as well as accounting for the transformations it experienced in the second version. It appears, however, that Caravaggio did not renounce implying the passage from the Old to the New Testament because the angel enumerates the generations of Christ's ancestors with his hands, while the composition of the scene recalls that of an Annunciation, the episode that closes the time of the Law to open that of Grace (Figure 9.7). The rupture

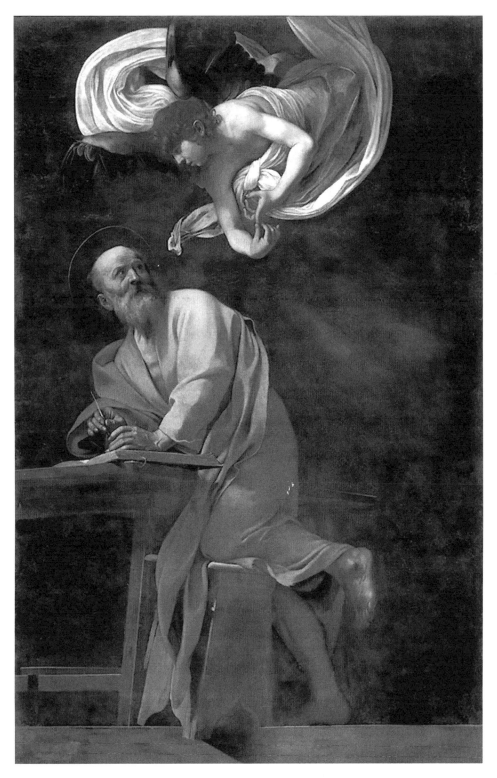

Figure 9.7 Michelangelo Merisi called Caravaggio, *Saint Matthew and the Angel*, 1602, oil on canvas, 296.5 × 195 cm, Rome, Church of San Luigi dei Francesi. Wikipedia Commons

between the list of ancestors and the Annunciation is thus implied by the condensation of the iconographic scheme of Inspiration with that of the Annunciation. The visual relationship between the genealogy of Christ and the Annunciation is seen in the form of a juxtaposition in the iconography of Tree of Jesse, for example, in the first page of a Flemish book of hours from the end of the fifteenth century, but also in a more complex form in Michelangelo's cycle of the ancestors of Christ on the Sistine ceiling, where the Virgin of the Annunciation interrupts the course of "ancient" history in order to open the new.[31] The second version of the *Inspiration* constitutes a response to the criticisms addressed to the first; the painter turns toward Raphael in renouncing his plebeian characterization of the saint. However, he maintains the ambition to make visible the historical rupture introduced by the Annunciation and institutionalized by scripture. If, as Argan emphasizes, the act of writing is here an image of the act of painting, the inspiration of the Contarelli Chapel seems to express a subtle reflection: painting is not only an inspired action, but it is also an incarnated one, clear in its visual evidence yet capable of making the mystery of the Incarnation the complex object of its thought on time.

Notes

* Translated by Keith Moxey.
1. This article develops an analysis I proposed in my book, *Caravage. La peinture et ses miroirs* (Paris: Citadelles and Mazenod, 2017), 192–221.
2. In using a terminology that links *Now-Time (Jetztzeit)* to *Then*, I refer to the dialectical image; see Walter Benjamin, *Paris, Capital du dixneuvième siècle* (Paris: Cerf, 2006).
3. The theological foundations of the imitation of Christ and the role this plays in the image are presented by Paul Lamarche, "Image et resemblance," in *Dictionnaire de spiritualité* (Paris: Beauchesne, 1969) vol. 7, col. 1425–34. On a number of occasions, I have tried to show the importance played by the notion of "conformation" in Christian painting; see *La torpeur des ancêtres. Juifs et chrétiens dans la chapelle Sixtine* (Paris: EHESS, 2013), 21–88.
4. Giovanni Baglione, *Vite de pittori, scultori e architetti* (Rome, 1642), ed. J. Hess and H. Röttgen (Vatican City: Biblioteca apostolica Vaticana, 1995).
5. Walter Benjamin, "Paralipomena zur zweiten Fassung von Das Kunstwerk im Zeitalter seines technischen Reproduzierbarkeit," Benjamin-Archiv, ms 397, now in *Walter Benjamin Gesammelte Schriften*, eds. Rolf Tiedemann and Hermann Schweppenhäuser (Frankfurt am Main: Suhrkamp, 1990), I, 1046.
6. Hubert Damisch defined "theoretical object" as the historical and theoretical construct produced by a particular work of art. He elaborates that just as the work is explained by the application of different interpretative paradigms, these paradigms will themselves be transformed by the resistance offered by the work. See Yve-Alain Bois, Denis Hollier, and Rosalind Krauss, "A Conversation with Hubert Damisch," *October* 85 (1998), 3–17; Louis Marin also practiced, in his own way, a heuristics of the theoretical object, notably in *Opacité de la peinture* (Paris: EHESS, 2006).
7. The bibliography on the theoretical interpretation of Warburg and Benjamin is vast. I limit myself to mentioning Georges Didi-Huberman, *The Surviving Image: Phantoms of Time and Time of Phantoms: Aby Warburg's History of Art* (University Park: Pennsylvania State University Pres, 2017); Manuela Pallotto, *Vedere il tempo. La storia warburghiana oltre il racconto* (Rome: Neu, 2007); Giovanni Careri and Georges Didi-Huberman, *L'histoire de l'art depuis Walter Benjamin* (Paris and Milan: Mimesis, 2015); Angela Mengoni, "Anachronie. La temporalità plurale delle immagini," in *Carte semiotiche*, ed. Angela Mengoni (Lucca: VoLo, 2013), 135–44.
8. See Louis Marin, "Le texte passé comme objet théorique contemporain," in *Opacité de la peinture* (Paris: Usher, 1991), 15.
9. A good definition of genre painting has been proposed by R. Bianchi Bandinelli, "Genere, pittura di," in *Enciclopedia dell'arte antica* (Rome: Treccani, 1960).

10. I refer here to the linguistic and semiotic notion of the "aspect," such as is defined by Algirdas Greimas; see "Aspectualisation," in Algirdas Julien Greimas and Joseph Courtés, *Semiotique, dictionnaire raisonné de la théorie du langage* (Paris: Hachette, 1979), 21–22. See also Jacques Fontanille (ed.), *Le discours aspectualisé* (Limoges: Nouveaux Actes, 1991); Francesco Marsciani, "Aspetto," in *Il lessico della semiotica*, ed. Lucia Corrain (Bologna: Esculapio, 1991), 135–44.
11. See Giovanni Careri, "En attendant Godot dans la chapelle Sixtine," in *La torpeur des ancêtres*, 305–13.
12. Gilles Deleuze, *L'image-mouvement* (Paris: Minuit, 1983), 30.
13. Hubert Damisch, "Trouer l'ecran," in *La dénivelé* (Paris: Seuil, 2001), 168–91.
14. Damisch, "Trouer l'ecran," 180.
15. Damisch takes this expression from Emmanuel Levinas, *Nouvelles lectures talmudiques* (Paris: Minuit, 1996), 55–56.
16. Lorenzo Pericolo, *Caravaggio and Pictorial Narrative* (Turnhout: Harvey Miller, 2007), 223 ff.
17. Mt. 9:10–13.
18. Irving Lavin, "Caravaggio's Calling of St. Matthew: The Identity of the Protagonist," in *Past and Present: Essays on Historicism in Art from Donatello to Picasso* (Berkeley: University of California Press, 2003), 85–99.
19. Andreas Prater, "Wo ist Mattäus. Beobachtungen zu Caravagios anfängen als Monumentalmaler in der Contarelli-Kapelle," *Pantheon* XLIII (1985), 70–74.
20. Herwarth Röttgen, "Da ist Matthäus," *Pantheon* XLIX (1991), 97–99.
21. Peter Burgard, "The Art of Dissimulation: Caravaggio's Calling of St. Matthew," *Pantheon* LVI (1998), 95–102; Pericolo, *Caravaggio*, 223 ff.
22. Francoise Bardon, *Caravage ou l'experience de la matière* (Paris: Presses Universitaires de France, 1978).
23. Hubert Damisch, "D'un Narcise a l'autre," *Nouvelle revue de psychanalyse* 13 (1976), 109–46.
24. I developed this question in "La Vocazione di san Matteo di Caravaggio. Montaggio e conversion," in Ipercorsi dell'immaginazione. *Studi in onore di Pietro Montani*, eds. D. Guastini and A. Ardovino (Cosenza: Pellegini, 2016), 351–67. On lateralization in the history of art, see Andrea Pinotti, *Il rovescio dell'imagine. Destra es sinistra nellastoria dell'arte* (Mantua: Tre Lune, 2010).
25. Mt. 6:1–4.
26. Giulio Carlo Argan, "Caravaggio e Raffaello," in *Immagine e persuaione* (Milan: Feltrinelli, 1976), 161–69.
27. Giovanni Pietro Bellori, *Le Vite de' pittori; scultori e architetti moderni* (Florence, 1672; Turin: Einaudi, 1976), 211–13, 229–30.
28. Argan, "Caravaggio e Raffaello," 161.
29. Irving Lavin, "Divine Inspiration in Caravaggio's Two Saint Matthews" *Art Bulletin* LVI (1974), 59–81.
30. Giovanni Careri, *La torpeur des ancêtres: Juifs et chrétiens dans la chapelle Sistine* (Paris: EHESS, 2013), 156–65.
31. Careri, *Caravage*, ill. 192.

Bibliography

Argan, Giulio Carlo. "Caravaggio e Raffaello," in *Immagine e persuaione* (Milan: Feltrinelli, 1976).
Baglione, Giovanni. *Vite de pittori, scultori e architetti* (Rome, 1642), ed. J. Hess and H. Röttgen. Vatican City: Biblioteca apostolica Vaticana, 1995.
Bandinelli, R. Bianchi. "Genere, pittura di," in *Enciclopedia dell'arte antica*. Rome: Treccani, 1960.
Bardon, Francoise. *Caravage ou l'experience de la matière*. Paris: Presses Universitaires de France, 1978.
Bellori, Giovanni Pietro. *Le Vite de' pittori; scultori e architetti moderni* (Florence, 1672). Turin: Einaudi, 1976.

Benjamin, Walter. "Paralipomena zur zweiten Fassung von Das Kunstwerk im Zeitalter seines technischen Reproduzierbarkeit" [Benjamin-Archiv, ms 397], in *Walter Benjamin Gesammelte Schriften*, eds. Rolf Tiedemann and Hermann Schweppenhäuser. Frankfurt am Main: Suhrkamp, 1990.

Benjamin, Walter. *Paris, Capital du dixneuvième siècle*. Paris: Cerf, 2006.

Bois, Yve-Alain, Denis Hollier and Rosalind Krauss, "A Conversation with Hubert Damisch," *October* 85 (1998), 3–17.

Burgard, Peter. "The Art of Dissimulation: Caravaggio's Calling of St. Matthew," *Pantheon* LVI (1998), 95–102.

Careri, Giovanni. "Trouer l'ecran," in *La dénivelé*. Paris: Seuil, 2001.

Careri, Giovanni. *La torpeur des ancêtres. Juifs et chrétiens dans la chapelle Sixtine*. Paris: EHESS, 2013.

Careri, Giovanni. *Caravage. La peinture et ses miroirs*. Paris: Citadelles and Mazenod, 2016.

Careri, Giovanni. " La Vocazione di san Matteo di Caravaggio. Montaggio e conversion," in *I percorsi dell'immaginazione. Studi in onore di Pietro Montani*, eds. D. Guastini and A. Ardovino. Cosenza: Pellegini, 2016.

Careri, Giovanni and Georges Didi-Huberman, *L'histoire de l'art depuis Walter Benjamin*. Paris and Milan: Mimesis, 2015.

Damisch, Hubert. "D'un Narcise a l'autre," *Nouvelle revue de psychanalyse* 13 (1976), 109–46.

Deleuze, Gilles. *L'image-mouvement*. Paris: Minuit, 1983.

Didi-Huberman, Georges *The Surviving Image. Phantoms of Time and Time of Phantoms: Aby Warburg's History of Art*. Trans. Harvey L. Mendelsohn. University Park: Pennsylvania State University Press, 2017.

Fontanille, Jacques, ed. *Le discours aspectualisé*. Limoges: Nouveaux Actes, 1991.

Greimas, Algirdas Julien and Joseph Courtés. *Semiotique, dictionnaire raisonné de la théorie du langage*. Paris: Hachette, 1979.

Lavin, Irving. "Divine Inspiration in Caravaggio's Two Saint Matthews," *Art Bulletin* LVI (1974), 59–81.

Lavin, Irving. "Caravaggio's Calling of St. Matthew: The Identity of the Protagonist," in *Past and Present: Essays on Historicism in Art from Donatello to Picasso*. Berkeley: University of California Press, 2003.

Lamarche, Paul. "Image et resemblance," in *Dictionnaire de spiritualité*. Paris: Beauchesne, 1969.

Levinas, Emmanuel. *Nouvelles lectures talmudiques*. Paris: Minuit, 1996.

Marin, Louis. "Le texte passé comme objet théorique contemporain," *Opacité de la peinture*. Paris: Usher, 1991.

Marin, Louis. *Opacité de la peinture*. Paris: EHESS, 2006.

Marsciani, Francesco. "Aspetto," in *Il lessico della semiotica*, ed. Lucia Corrain. Bologna: 1991.

Mengoni, Angela. "Anachronie. La temporalità plurale delle immagini," in *Carte semiotice*, ed. Angela Mengoni (Lucca: VoLo, 2013), 135–44.

Pallotto, Manuela. *Vedere il tempo. La storia warburghiana oltre il racconto*. Rome: Neu, 2007.

Pericolo, Lorenzo. *Caravaggio and Pictorial Narrative*. Turnhout: Harvey Miller, 2007.

Pinotti, Andrea. *Il rovescio dell'imagine. Destra e sinistra nella storia dell'arte*. Mantua: Tre Lune, 2010.

Prater, Andreas. "Wo ist Mattäus. Beobachtungen zu Caravagios anfängen als Monumental-maler in der Contarelli-Kapelle," *Pantheon* XLIII (1985), 70–74.

Röttgen, Herwarth. "Da ist Matthäus," *Pantheon* XLIX (1991), 97–99.

Part V
Ontological Time

10 The Phenomenal Sublime

Time, Matter, Image in Mesopotamian Antiquity

Zainab Bahrani

The sublime is a fascinating thing. "The mere ability even to think [of infinity] indicates a faculty of the mind transcending every standard of the senses." These are the words of Immanuel Kant in his explanation of the sublime in the second book of his treatise, *Critique of Judgement*.[1] The awe-inspiring, the infinite, the grandeur and terror of nature, the luminous sheen of grand architectural structures—all these definitions of the sublime were described under a number of concepts that appear in ancient Sumerian and Akkadian texts as early as the third millennium BC. Among the Kantian definitions of the sublime, the attempt to comprehend vastness in nature, the cosmos and in monuments, the grand scale which he described as the mathematical sublime, has particular resonance in the ancient Mesopotamian world for spatial and temporal expanse and wonder.[2] Awe in the face of vastness of time emerges in relation to the contemplation of ancient images and monuments, ruins in the landscape, and things discovered in the depths of the earth surviving from the unfathomable past, such as texts and small statues placed in the ground (Figure 10.1). How can we understand this perception of a direct encounter with the trace of the past? The past did not simply cease to be, but could be encountered in things that survived from other eras. These encountered images were instances of what Aby Warburg would understand as *Nachleben* or afterlives, and carried *Pathosformeln*, which came directly from antiquity. Monuments and works of art were thus both historically specific and forms of infinite presence at the same time. This duality of historical specificity (of event or identity in a monument) and presence without duration is the subject of this chapter.

When an image or an artefact from the past re-appeared, the chance encounter was one of awe and wonder at this ability to see the past. This wonder and astonishment was understood in terms of a mathematical, temporal sublime that encompassed the temporality of images and monuments, a duration that inhered in the works, fastened to them as a material property. When texts were written on stone or clay and small statues were placed in the ground, below architectural edifices as foundation deposits, they were a contemporary sacred rite, an architectural ritual for fixing the foundation at a particular moment in time, but they were also proleptic images and things for the future, in that they anticipated a future discovery of the work. We can say, then, that Ancient Near eastern art and monuments traverse time; they project their presence into the future while dwelling in the past. At the moment that they were created, these works looked to anachronicity as a significant part of the horizon of their reception.

Figure 10.1 Foundation statue of the god Shulutula and text of Enannatum I of Lagash, in situ
in Lagash, Tell al Hiba, Iraq, arsenical copper and clay brick, ca. 2450 BC. Photo:
Donald P. Hansen

The Image in Time

The ontological correctness or the truth of a work of art, especially those works produced in antiquity and relegated to the category of artefact rather than art, is seen as its original moment or context of manufacture. This has been the unproblematic common-sense view of understanding ancient art works or archaeological artefacts that are visually or aesthetically formed by means of practical function. Other and later uses of such artefacts are known and studied, such as antiquarian interest or the revivalist gaze, the appropriation of earlier iconographies and deliberate archaizing as a style; however, these are usually seen as the mistaken erroneous or anachronistic uses. But what if the original meaning of the work was projection to a future time? That is, what if the original meaning of a work considered anachronistic views at the moment of its production? What if the pushing forward of the horizons of time was the entire point, central to the creation of the work? The true meaning of the work of art might then be defined not simply as its practical function or genre (a stele, a portrait, and so on), but as a truth about experiences of the grand scale of time.

Peter Osborne recently defined art-time as the ability of the post-modern work to distract, to prolong, or to abbreviate spans of temporal experience, and this definition

clearly has significant implications for what a work can do.[3] Osborne's idea of art-time seeks to explain an experiential temporality that results from the work and is effected by it, its art-time or no time, being something similar to the non-place of postmodern spaces. But art-time, it can be claimed, also has to do with the substance of images themselves, with their ontological nature. This art-time within the substance of images (rather than in their reception only) can be recognized in Mesopotamian art and aesthetic thought. It is true that it requires an epistemological shift in reason that takes us out of western philosophical thought to an earlier time when images were solid material appearances, but the excursion is worthwhile.

In fact, works of art from the Ancient Near East often resist the standard art historical definitions and categories. They shake up the chronological fixing in a limited moment of use time, use value, or manufacture. They are specifically and emphatically diachronic in nature.[4] Nor do we have to stretch our imaginations or interpretive language far in order to make this case. A reading of ancient texts written directly on the works of art or inserted into architectural edifices can make this concern with continuity clear, and where a monument survives intact from antiquity, it consistently includes a text, one that often alludes to time and is addressed to those who will encounter the image or monument in the future.

The Great Monolith of Ashurnasipral II (883–859 BC) from Nimrud, now in the British Museum, can be taken as an example of this awareness of the monument in time. It bears a long inscription on both front and back recounting the accomplishments and works of the king. About seventy-five lines of the long inscription are addressed to people in the future who may encounter the monument.[5] The inscription asks unknown princes yet to come to protect the monument and curses anyone in the future who would harm it. It recounts a series of concerns regarding any damage or deliberate harm that may come to the image or monument at any point in the distant future. The image (*Ṣalmu* in Akkadian) was not a work that follows the formulation of mimesis as secondary copy; it was understood not as representation, but as a vital *presence*. Images were thus a form of appearance in the real.[6] Ostensibly a representation of royal power on a monumental stele, it was a conjuring of an essential presence in an image. The central concern of the extensive text seems to be the continuing survival of the image and the memory of events and deeds. This is not an unusual emphasis. The weight given to possible future encounters with the work is clear, and calls for their protection and preservation appear in many other works from the monumental to the small scale. While a monument was produced as a historical work, inscribed with texts that mark it clearly, tie it to events, and locate it in a specific moment or historical age, its efficacy was understood to be unlimited.

It is not that the ancient Mesopotamian image or artwork is unanchored in time or simply a signifier waiting for the interpretations of future eras. It is deeply anchored in a continuous time, a time of its own. Thus, we can say that the ontological status of the work of art is precisely as a thing that transcends time.[7] It was conceived of as such at its moment of production, so that ontological *presence* was its original historical contextual meaning and that presence was projected in time. This is not to say that the pastness of history was not important. On the contrary, historical consciousness and the concern with the past can be claimed as one of the hallmarks of Mesopotamian culture. As the place of the invention of writing and historical annals, it was a society profoundly concerned with history and past events. Yet beyond historical events, ancient monuments and works of art reveal to us other things about representation.[8]

The ontological status of image as *presence* within the real rather than representation can also be understood as a temporal difference. In addition to being somewhat unlike the idea of mimesis as pure representation, I would argue that the Mesopotamian notion of image as presence implies duration and that Ṣalmu is not a transitional medium or a mere copy. Rather, it is a being within the register of the real.[9] To think of the image in terms of Ṣalmu is unlike the scheme of mimesis, which by means of its removal away from the original is a second step in time.

The (ontological as well as the historical) duration of images is underscored in monuments and statues, and also in rock reliefs carved into the mountains. The past did not cease to be, but continued, not simply as a memory or a recollection but in tangible entities within the world. Things found in the ruins of ancient *Tillu* (the Akkadian term for archaeological mound, also *Tell* in Arabic) or in the depth of the foundations of historical architectural structures consequently produced a discourse of deep time, associated with the sublime. The earliest ekphrastic texts regarding monuments and architecture often describe them as emitting a sublime force or aura, and such terms are also found in the Mesopotamian literary descriptions of aspects of nature. The Akkadian concept of *Melammu* is one of several terms appearing in ancient texts that I would say indicate a descriptive language of the sublime in artworks and in the natural landscape. Thus, in both arenas of what today we would categorize as nature and works of art and architecture, there is the understanding of a continuous presence of things across time, projected into an immeasurable future.

The Sublime

Ever since Jean François Lyotard defined it as the aesthetic term that is best suited to the characterization of the art of our era, the sublime has had a strong resurgence in theoretical writings on art and aesthetics.[10] More recently, the Kantian division of the sublime and the beautiful, and Lyotard's adoption of it were challenged by Jacques Rancière. Rancière's concern is that for Kant, the sublime cannot designate works of art or aspects of style as it is an aspect of response that lies within human cognition and apprehension. Therefore, the question of how we can ground theoretically a sublime art remains to be answered.[11] Does such a thing as sublime art exist? According to the claims of contemporary aesthetic theory, there can be no such thing. But a sublime work, a sublime sculpture or edifice, for example, a work that is sublime in itself, and not in its reception only, is clearly expressed in Near Eastern antiquity. In ancient Mesopotamian thought, the sublime is not a category of reception, but is an essence of the work itself. It is an aspect of the materiality of the work of art, which was seen to be agentive. Monuments carried a continuing potential to provoke a sublime response in those who encounter them. The discussion of the Kantian Sublime that we find in Jacques Derrida's "The Colossal" in his discussion of the "Analytic of the Sublime" is perhaps more useful for explaining the ancient Mesopotamian works. In particular, the recognition that the colossus is not a work as such (*ergon*) because the infinite is presented in it and that this infinite cannot be bordered or contained, either visually or temporally.[12] It is this idea of an artwork's sublime presence that comes closer to the Near Eastern image, which is both a work and not a work, because it is an appearance, a phenomenon within the real. Derrida also points to the etymology of *kolossos*, a word that originally meant an aniconic thing similar to *xoanon* or *bretas*, forms of "idols" that are not mimetic.[13] These kinds of images or works are agentive forms of

presence. They were the source of both material agency and an aesthetic force, so that aesthetic qualities were not ascribed to them by viewers, but were seen to be inherent to the works themselves, in their forms and their organic materials such as particular types of stone or wood, metals, and so on. In the ancient Near Eastern world, inherent qualities of materials were a part of their destiny set by the gods at the moment of creation, and remained within the worked images or architectural structures, many of which are described as sublime. The sublime is thus also a consequence of materials and is not contradicted by materiality.

Melammu, an Akkadian word derived from the earlier Sumerian ME-LEM, is a category of abstract thought that spans a range of meanings also covered by the later term *sublime*. *Melammu* refers to luminosity, splendor, or gleaming shine, but it also refers to an intangible aura emitted from a work or a thing in nature, a splendor that inspires wonder and astonishment, and a magnificence and greatness of scale that inspires awe and even terror. Besides the noun *Melammu*, there are other words that can be translated as sublime.[14] These terms are found in numerous ancient texts. Names and descriptions of monuments (and the epithets that are often applied to them) also refer to qualities and terms of the sublime. The ancient name of the great Ziggurat at Ur (2100 BC), for example, was *E-temen-ni-gur-ru* (the house whose foundation platform is clad in shivers/terror). This massive stepped pyramid was a temple tower measuring 15 meters (50 feet) high at its lowest step alone, and was 60 × 45 meters at its base. In the flat landscape of southern Mesopotamia it emerged as a remarkable vision, grand and imposing. A nearby monumental portal in the sacred precinct, the *temenos* at Ur, was called *Edubla-mah* (meaning the sublime or exalted portal). These names are references to exalted emotions as effects of grand scale, awe-inspiring, architectural works, just as Kant had used the pyramids of Giza as an example of the apprehension of the mathematical sublime.[15]

The Deep

In this Mesopotamian tradition, awe-inspiring grandness and scale refers to sheer size, but also to the vast expanses of time: of time that can be encountered in the foundation deposits discovered in the deep (*nagbu*), as we know from the legend of Gilgamesh; and, conversely, to the time of monuments such as rock reliefs carved into the natural landscape, in places that are often very difficult to reach. What Kant referred to as the mathematical sublime was thus also understood in relation to time.

In the Epic of Gilgamesh, the world's earliest known literary epic first written down at the end of the third millennium BC, the overwhelming scale of time in ruins and traces of the past is a clear motif at the start of the text. In the version of the epic written in the late second millennium BC, the transcendent time of monuments forms the opening line of the epic, "He who saw the Deep, the foundation of the Land," which is also the ending of the story.[16] The narrative tale is thus framed as one that is enclosed in a self-referential circular form. The first scene presented to us takes place after the end of the tale that recounts the travels and accomplishments of Gilgamesh. With the opening lines, we hear of the inscription of a lapis lazuli tablet text recording his deeds so that the conclusion is also the start of the story that is about to follow:

> See the tablet box of cedar,
> release its clasp of bronze

life the lid of its secret,
pick up the tablet of lapis lazuli and read out
the travails of Gilgamesh, all that he went through[17]

Gilgamesh saw "the deep," a sublime and dizzying timescale, which he encountered in the unfathomable depth below, that is to say, in the foundation box buried in the earth. The opening verses then go on to describe the viewing of (in fact, calls on the reader to view) the massive walls of the city of Uruk as a historical monument, its bricks and foundation built by the seven sages of a mythical time, long ago. This is part of an extensive tradition of the exaltation of monuments and historical edifices as being breathtaking evidence of the astonishing expanse of time. The city of Uruk was known as one of the first cities of civilization in Mesopotamian thought, its great antiquity referred to often in the later texts of the first millennium BC. Ruins in the landscape also inspired awe.[18] Hundreds of ruined mounds (*Tillu*) evidenced the passage of time in man-made things that came to be aspects of the natural terrain. The natural and the artificial thus merged together into a landscape that carried traces of the past, both on the surface and within the ground.

Foundation statues and foundation texts, beads and stones of various colors, and types and bits of metal were placed in the foundations of buildings from the middle of the third millennium BC and continue to be used throughout Mesopotamian history well into the Seleucid (Hellenistic era). The statues were first of demi-gods, divine creatures in charge of protection throughout time. At a later time, at the end of the third millennium BC, images of the king, depicted in the pious activity of a builder, a laborer for a day, came to be inserted into the ground with texts. The stones and pieces of metal had essential powers that were apotropaic and carried particular abstract qualities. The foundation texts explain very clearly that these buried statues and texts were meant to remain well into the distant future. They address the viewer who may accidently encounter the statue or the text at a future time, perhaps while conducting construction work on a later building when deep foundations were dug, or while excavating specifically in order to find the traces of earlier historical buildings. The statues buried in the foundations were not for contemporary viewership, but for the vast scale of future time with which the Mesopotamians were concerned. Interred images were thus not intended primarily for their own historical moment of creation, but as objects meant to transcend the millennia. In one well-recorded archaeological series of events, a stone tablet carved with a scene in relief and a text that recounts the creation of a cult statue was interred in Sippar, the city of the Sun god by the king Nabu-apla-iddina (887–855 BC). It was re-discovered by architects working in the service of the Babylonian king, Naboplassar, in 620 BC. Nabopolassar had clay molds made of the image, and an inscription added explaining the re-discovery of the deposit, before having it re-interred in a new, inscribed ceramic container. When the stone relief in its ceramic inscribed box was found in the nineteenth century AD and taken to the British Museum in London, it was not the first time that the deposit had been discovered in the ground. Although this understating of a time of images and things as pushing beyond a historical horizon is most clear in the foundation statues, it is a conception of a time of art that is at play in all Mesopotamian images, from large-scale statues in the round to the smallest relief images.

The discourse of deep time associated with the immanence of the unseen and its potentiality, and also with re-discovered works, became translated into a *mise en*

abyme of images in the visual arts. This reverberation of images into images is carried out in a striking way in the royal reliefs of the palace of Ashurnasirpal II (883–859 BC) at Kalhu (modern-day Nimrud).[19] Here, images of winged genies flanking palm trees entwined with streams of water, mirror images of the king, his courtiers, winged horses, bulls, and lions are echoed at a miniscule scale, hidden within the incised details of the large wall reliefs (Figure 10.2). They are incised into the hems of the garments worn by the king and courtiers, repeating the images of the large-scale palace compositions of courtly and magical scenes. Repeating into the invisible infinite, these hyper-icons echo within the details of their own representations, into a conceptual space where we can no longer see them, but within which we know that they reverberate. Some of the winged genies were also made in small terracotta, inscribed with texts and buried beneath the floorboards of the palace, repeating the two levels of relief representation into the unseen depth below the palace.

In order to consider the sublime by means of an image that utilizes this concept (known for example under the category *Melammu*) for its own logic and presence in deep time, let us consider another work: a Mesopotamian rock relief. Usually rock art is understood as a form of representation distinctive of early prehistoric and nonliterate peoples and communities. Rock art, however, was also distinctive of the highly literate ancient societies of Mesopotamia, Egypt, Anatolia, and Iran.[20] The ancients seem to have held the view that "there can be sublime in art if it is submitted to the conditions of an 'accord with nature' ".[21]

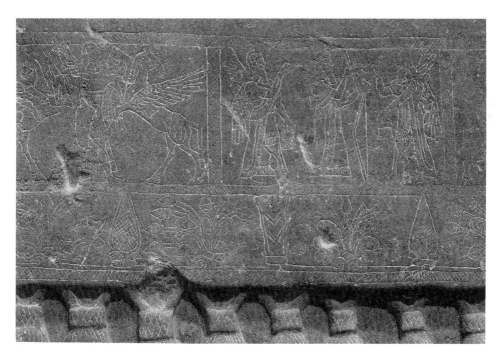

Figure 10.2 Relief from the Palace of Ashurnasirpal II, from Nimrud, Iraq, gypsum alabaster, 883–859 BC, Hood Museum. Photo: Hood Museum of Art, Dartmouth College, Hanover, New Hampshire; gift of Sir Henry Rawlinson through Austin H. Wright, class of 1830. Courtesy of Ada Cohen

Two thousand years before Christ (and more than a thousand years after the invention of writing) a sculptor carved a colossal image of a king into the cliffs of the Qara Dagh range of the Zagros Mountains (Figures 10.3–10.4). Visible to few visitors other than goatherds, the mountain jinns and the gods, the image is cut next to a shallow cave in the cliffs of Derbend i-Gawr. The location of the relief, like many rock reliefs in this region, contradicts much of the art historian's usual focus on viewership.

At 10 feet high, the relief is colossal and impressive in scale. In iconography and composition, it follows the well-known earlier victory stele of Naramsin: a massive warrior appears, trampling upon the miniscule defeated bodies below his feet. Despite the similar composition, the king at Derbend i-Gawr is not wearing the horns of a divinity as Naramsin chose to do in his image, but only a simple woolen cap. He carries a battle-axe and a bow, and wears a beaded necklace and bracelets. Bare-chested and heroic, we see him in profile, striding assertively and with determination, upwards at an angle as he tramples the bodies of long-haired enemies in his wake. Nevertheless, he is not in control of life and death in the way that Naramsin is in his famous stele. In Naramsin's stele, the king holds power over the pleading, defeated enemies who are not yet dead, their fate dependent upon his decision. In the earlier stele, Naramsin's was a commanding, disruptive image. He took on the divine emblems of the gods (this is clear from the horned headdress), turning himself into a divinity, thus crossing boundaries in a startling way. The Derbend i-Gawr relief has a different power, I would contend. Perhaps we can paraphrase Rancière and refer to this power as "the discord specific to the experience of the sublime."[22]

The iconographic references to the earlier powerful and divine king Naramsin are interesting, but there is something even more thought-provoking here. That is the way in which the sculptor inserts the figure into the geological layers, into the rock formation, and thus into a timescale of deep time. The sculptor has used the geological layering of the limestone rock as the ground-line for the striding warrior king. The image merges into nature as if pushing outward from the rock surface. The rock relief is thus pure materiality and sign at the same time. It is a conquest of the mountains, but it is a presence that transcends the event, as the mountains mark a different temporality and scale of time in natural landscape.

The Derbend-i-Gawr relief is just one instance where we can see the insistence on the temporal duration of the image as a presence that continues rather than records the past. Beyond all other meanings and iconographies that they carry, the rock reliefs expand the limits of time. As literature exalts monuments, *tells*, and archaeological remains, works of art such as the Derbend-i-Gawr relief make use of that exaltation, of the *melammu* of the mountain and the man-made edifice, to create an image that we might theorize as a sublime work of art, a sublime phenomenal appearance.

How was *melammu* associated with landscape? The connotations of the term *melammu* include much of what Enlightenment thinkers such as Kant and others would explain as the aesthetic concept of the sublime in connection with nature, including what Kant called the dynamic sublime as well as his category of the mathematical sublime. In the ancient Near East, *melammu* is part of sculpture and manufactured things when they are impressive (as I have already pointed out above) and was considered to inhere in these things, rather than being defined only as a response to them, but *melammu* was also associated with the divine and nature. It is a power, an aura that overwhelms. To return to the Epic of Gilgamesh, in the story of Gilgamesh and Enkidu's battle with the monster Humbaba who dwelt in the cedar forest

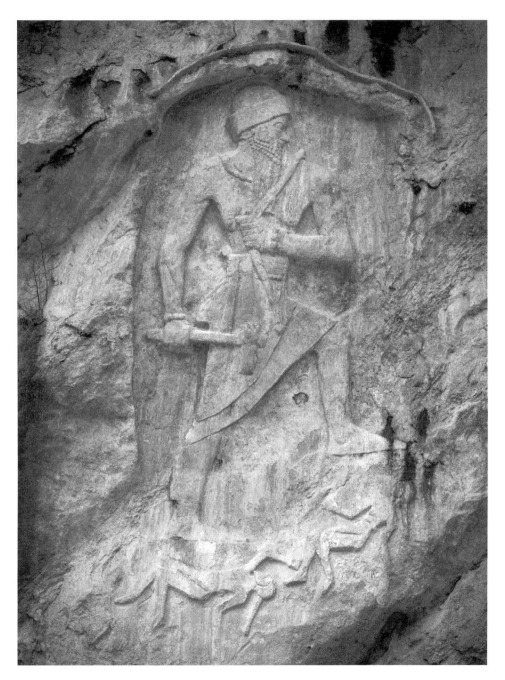

Figure 10.3 Derbend-i Gawr rock relief, Iraqi Kurdistan, ca. 2100 BC. Photo: Columbia University, Mapping Mesopotamian Monuments, Gabriel Rodriguez

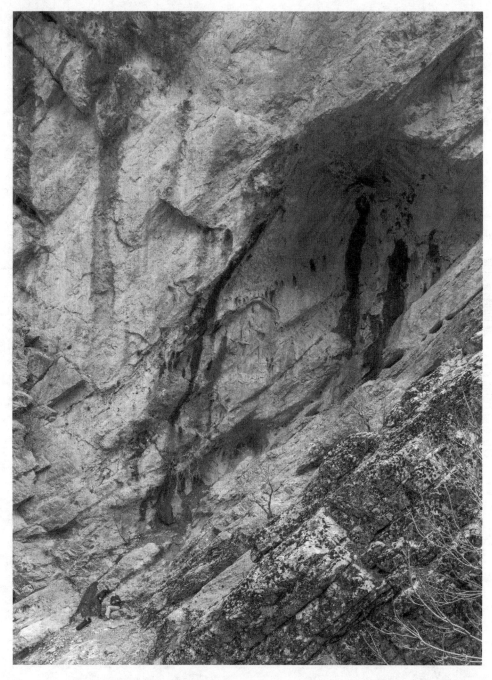

Figure 10.4 Derbend-i Gawr rock relief in situ (with author and colleague below), Iraqi Kurdistan, ca. 2100 BC. Photo: Columbia University, Mapping Mesopotamian Monuments, Gabriel Rodriguez

(or in another version of the tale, in the Zagros mountains),[23] Humbaba's powerful auras are *melammus*. When Humbaba is defeated by the hero, Gilgamesh takes these powers from him and re-distributes them into the landscape. This passage can be seen an etiological explanation of how *melammu* exists in the natural landscape. The overwhelming sublime was thus to be found in mountains and forests, and also in wild beasts such as lions, as well as in the colossal human-headed winged bulls and lions of the Assyrian palaces, meant as an infinite presence.

Kant's dynamic sublime—a power in nature to be observed in storms, waterfalls, the steep cliffs of mountains, and so on—is clearly paralleled by many references to the awesome power of storms and natural elements, including specifically waterfalls and mountains, in Mesopotamian literature. A letter of Sargon II, King of Assyria (r. 721–705 BC) to the gods and citizens of the city of Assur describes the marvels of nature in the language of the sublime: the dizzying heights of the mountains and depths of the chasms, the thunderous waterfalls, the thick and impenetrable forests are all detailed.[24] Assyrian kings had rock reliefs carved upon cliffs and cave walls in places such as the source of the Tigris River in eastern Anatolia, and on the cliffs of Maltaya and Khunnusa in the Assyrian heartland. These rock reliefs, most often difficult to locate and to view, are embedded in the open landscape as foundation deposits are hidden in the depth of the earth.

That the past had a continuous presence in monuments and in material traces such as *tells* is clear. It was also to be encountered in the deep abyss of the foundations where things erupt as images and text, like water from a spring. The deep was something like a source from the past. The opposite was also true: above ground in the hoary steep cliffs in crevices and ravines, image-time intermingled with geological time as an expansive scale beyond the moment of its creation. It was thus also a projection into the future. The landscape by definition carried aspects of time within it, so that nature and culture, the man-made and the natural were not the clear-cut divisions that we now take to be given categories.

Notes

1. Immanuel Kant, *Critique of Judgment* [1790], trans. James Creed Meredith (Oxford: Clarendon Press, 1973), S26, 254.
2. This chapter introduces ideas that depend on the extensive arguments I made in *The Infinite Image: Art, Time and the Aesthetic Dimension in Antiquity* (London: Reaktion, 2014), where I was also able to contextualize them within my larger critique of the continuing (and now re-invigorated) Eurocentricity of the discipline. Unfortunately, I am not able to address these issues in this short chapter.
3. Peter Osborne, *Anywhere or Not at All: Philosophy of Contemporary Art* (London: Verso, 2013), ch. 7.
4. See Bahrani, *The Infinite Image*.
5. For a translation of the text, see A. K. Grayson, *Royal Inscriptions of Mesopotamia, Assyrian Periods*, vol. 2 (Toronto: University of Toronto Press, 1991), 237–54.
6. I have made the argument regarding the image as presence in some detail in Z. Bahrani, "Assault and Abduction: The Fate of the Royal Image in the Ancient Near East," *Art History*, 18, no. 3 (1995), 363–82; and *The Graven Image: Representation in Babylonia and Syria* (Philadelphia: University of Pennsylvania Press, 2003).
7. Bahrani, *The Graven Image*; see also Bahrani, *The Infinite Image*. This survival through time was most clearly expressed in the texts and images places in the ground as foundation deposits, but it is not limited to these contexts.

8. For those readers who prefer a philological model of evidence, ontology, *ta onta* in Greek is *mimma shumshu* in Akkadian; see Z. Bahrani, "Assyro-Babylonian Aesthetics," in *Oxford Encyclopaedia of Aesthetics*, ed. Michael Kelly (Oxford: Oxford University Press, 2014).

9. See "Ṣalmu: Representation in the Real," in Bahrani, *The Graven Image*, ch. 5.

10. Jean-François Lyotard, *The Inhuman*, trans. Geoffery Bennington and Rachel Bowlby (Stanford: Stanford University Press, 1991). Other scholars have announced the death of the sublime. See James Elkins, "Against the Sublime," in *Beyond the Finite: The Sublime in Art and Science*, eds. R. Hoffman and I. Boyd White (Oxford: Oxford University Press, 2011). However, the many volumes that have appeared on the notion of the sublime in recent years contradict that end.

11. Jacques Rancière, *Aesthetics and its Discontents* (Cambridge: Polity, 2009), 89.

12. Jacques Derrida, *The Truth in Painting* (Chicago: Chicago University Press, 1987), 128.

13. Derrida, *The Truth in Painting*, "The Parergon" section IV; and see the seminal discussion in Jean-Pierre Vernant, "Figuration de l'invisible et categorie psychologique du double: le colossus," in *Mythe et pensée chez les Grecs* (Paris: Maspéro, 1965).

14. See *Chicago Assyrian Dictionary: Melammu, Pulhu, Siru, Šaqu*. The translation of these terms as equivalent to the sublime in aesthetic discourse is my own.

15. The Latin term rather than the Greek is the focus of discussion in aesthetic theories and art history. According to the *Oxford English Dictionary*, the term sublime derives from *sub* (up to) and *limin* (lintel or threshold), while subliminal has a meaning of "below the threshold." These connotations were certainly present in the ancient Akkadian literature, as were the connotations of height and greatness indicated in Greek *hupsous*.

16. In the earlier versions of the epic dating to the late third millennium (Sumerian) and the early second millennium (Old Babylonian period), the story starts by describing Gilgamesh as having no equal.

17. *The Epic of Gilgamesh*, trans. Andrew George (London: Penguin, 2000).

18. Another important area of writing in ancient Mesopotamia was concerned with restoration and preservation practices, and the ritual of preserving ancient sites and architectural structures. I have addressed these concerns in Z. Bahrani, *Rituals of War* (New York: Zone Books, 2008); *The Infinite Image*; and *Art of Mesopotamia* (London: Thames & Hudson, 2017).

19. For a discussion of these images, see "The Double: Difference and Repetition," in Bahrani, *The Infinite Image*, ch. 4.

20. See Matthew Canepa, "Topographies of Power: Theorizing the Visual, Spatial and Ritual Contexts of Rock Reliefs," *American Journal of Archaeology* 114, no. 4 (2010), 563–96; and Omür Harmansah (ed.), *Of Rocks and Water: Towards an Archaeology of Place* (Oxford/Havertown PA: Oxbow, 2014), 55–92. In addition, the extraordinary ancient Egyptian tradition of rock cut architecture and monuments carved into living rock must also be taken into account.

21. Derrida, *The Truth in Painting*, 127.

22. Rancière, *Aesthetics and its Discontents*, 92. The identity of the king and the date of the relief have been debated in the archaeological scholarship. Earlier writing mistakenly identified him as Naramsin, but the king is far more likely to be a ruler of the Ur III Dynasty. For an in-depth discussion of the stele of Narmasin, see my *Rituals of War*, ch. 4.

23. Stephanie Dalley, *Myths form Mesopotamia* (Oxford: Oxford University Press, 1989).

24. A. L. Oppenheim, "Man and Nature in Mesopotamian Civilization," in *Dictionary of Scientific Biography*, ed. C. C. Gillespie (New York: Scribner's, 1981), vol. 15, Supplement 1, 634–66.

Bibliography

Ankersmit, Frank. *Sublime Historical Experience*. Stanford: Stanford University Press, 2005.

Bahrani, Zainab. "Assault and Abduction: The Fate of the Royal Image in the Ancient Near East," *Art History* 18, no. 3 (1995), 363–82.

Bahrani, Zainab. *The Graven Image: Representation in Babylonia and Assyria*. Philadelphia: University of Pennsylvania Press, 2003.

Bahrani, Zainab. *The Infinite Image: Art, Time and the Aesthetic Dimension in Antiquity*. London: Reaktion, 2014.

Burke, Edmund. *The Sublime and Beautiful*. 1796.

Cassin, E. *La Splendeur divine*. Paris: La Haye, Mouton & Co., 1968.

Chicago Assyrian Dictionary. The Assyrian Dictionary of the Oriental Institute of the University of Chicago (CAD). Chicago: Oriental Institute Publications.

Derrida, Jacques. *The Truth in Painting*. Trans. Geoff Bennington and Ian McLeod. Chicago: University of Chicago Press, 1987.

Destrée, Pierre and Penelope Murray, eds. *A Companion to Ancient Aesthetics*. John Wiley & Sons, 2015.

George, Andrew, trans. *The Epic of Gilgamesh*. London: Penguin Classics, 2000.

Hegel, G. F. W. *Aesthetics, Lectures on the Fine Arts*. Trans. T.M. Knox. Oxford: Clarendon Press, 1975.

Kant, Immanuel. *Critique of Judgement*. Trans. James Creed Meredith. Oxford: Clarendon Press, 1973.

Lyotard, Jean-François. *The Inhuman*. Trans. Geoffery Bennington and Rachel Bowlby. Stanford: Stanford University Press, 1991.

Oppenheim, A. L. "Akkadian Pul(u)h(t)u and Melammu," *Journal of the American Oriental Society* 63, no. 1 (1943), 31–34.

Oppenhiem, A. L. "Man and Nature in Mesopotamian Civilization," in *Dictionary of Scientific Biography*, ed. C. C. Gillespie. New York: Scribner's, 1981, vol. 15, Supplement 1, 634–66.

Rancière, Jacques. "La concept d'anachronisme et la verite de l'historien," *L'inactuel* 6 (1996), 53–68.

Rancière, Jacques. *Aesthetics and its Discontents*. Trans. Steven Corcoran. Malden: Polity Press, 2010.

Winter, Irene J. "Radiance as an Aesthetic Value in the Art of Mesopotamia," in *Art: The Integral Vision, a Volume of Essays in Felicitation of Kapila Vatsyayan*, eds. B. N. Saraswati et al. New Delhi, 1994, 123–32.

Zelig-Aster, Shawn. *The Unbeatable Light: Melammu and its Biblical Parallels*. Münster: Ugarit Verlag, 2012.

11 Resisting Time

On How Temporality Shaped Medieval Choice of Materials

Avinoam Shalem

Time is not inert. It does not roll on through our senses without affecting us. Its passing has remarkable effects on the mind.

Saint Augustine, *Confessions*, 397–400

Back in the early 1970s, on one of the annual school trips organized by the high school I attended in Haifa, we, young eighth-grade students, were taken to visit the newly occupied (in Hebrew "conquered") regions of the Golan Heights. Most of the country was still immersed in the grand euphoria that had engulfed Israeli society after the victory of 1967, though one should admit that some of the political complications inside and outside the Green Line—the consequences of the occupation—started to bear some bitter fruits. However, the main focus on the "united" city of Jerusalem as a symbol for uninterrupted Jewish life in Palestine seemed to have lost its sole dominance in the collective Israeli mind, and other spaces, such as the Sinai, Gaza, and especially the Golan Heights, were discovered. In addition to the Golan's attractiveness as the only place for Israelis to experience the winter and the long, lasting snow on Mount Hermon (Jabal al-Shaykh), the new archaeological discoveries in this region of Jewish settlements of the early Christian and Late Antique eras served as a magnet for domestic tourism. In these places, such as Gamla or Chorazin, heroic stories of Jewish communities struggling to maintain their religious identity in oppressive pagan and Christian worlds seemed to serve domestic political, Zionist ideologies and to justify Israeli repudiation of any withdrawal and the rejection of the United Nations Security Council Resolution 242. Fascinated by archaeology— the Zionist machine then at work propelling national identity—I bought a souvenir, an ancient, or so I was told, tiny glass flacon. It had a flat, globular, perhaps slightly elliptical body and a relatively long and circular neck. What I loved about this object was the shimmering and iridescent surface of its body. It covered the entire surface of the bottle in a thin colorful layer of green, grayish blue, and turquoise, all of which appeared as if sprayed with some silver powder, and, as soon as some light fell on the surface, the bottle skin, so to speak, changed color, like a peacock's feathers. It didn't last very long. For some inexplicable reason, I started to peel off this surface, scratching at it with my nails. Piece after piece, the thin skin-like surface fell onto the ground, and the lower surface of the bottle's "real" substance, namely glass, appeared. I did not stop until the entire bottle was cleansed of this extra surface. And, at the end, it emerged as if naked, presenting to its beholder its initial state as a light-green transparent glass flacon. I had felt as if I excavated this object and, like

an archaeologist, disclosed the bottle's lost past that was hidden behind the deceitful lustrous colors of its extra skin.

Years later, in 2011, while watching Pedro Almodóvar's film *The Skin I Live in*, memories of this naked bottle came back to my mind. The image of Vera, the main character in the film who becomes captive in her "own" new skin after undergoing plastic surgery, seemed to me like the bottle I had purchased. The layers of patina accumulated on the bottle's surface resembled, I thought, Vera's new, imposed body. Vera becomes a prisoner of her own new skin. The bottle too became trapped in a body that was imposed on it by Father Time, causing a physical change of embodiment that concealed the bottle's "identity." This identity was first and foremost linked to its materiality and its basic nature, namely glass and transparency. The act of peeling off the bottle's iridescent surface was an act of liberation and, like Vera, who by the end of the film has freed herself from being captive in her own skin and has declared her identity, the souvenir bottle from the Golan Heights was also liberated. The whole material world appeared to me, then, as if imprisoned by the skin imposed on it by time. Moreover, it appeared, as in Almodóvar's film, as punishment, like that inflicted on Adam and Eve, as their expulsion from the Garden of Eden marks a moment of rupture in time, designating the end of the eternal and unchangeable time, and the start of the time-bound, terrestrial world.

And yet, one of first stages of the art historian's main endeavors concerns the dating of objects. His or her observation is thus based on metamorphosis, namely the change in the form, shape, and even the texture and consistency of materials as related to time. Ruins, cracks, discoloration, and patina are therefore main indicators substantiating the art historian's measurement of time. Indeed, we unquestionably accept that change cannot be divorced from time and movement, and that the absence of change simply suggests immobility, as if time is frozen. This chapter challenges these conventions by focusing on specific artifacts made out of materials that "want" to resist time; in other words, natural materials such as gold, precious stones, rock crystals, and marble— materials associated in medieval times with the concepts of the everlasting and the eternal. Objects like these, it seems, vehemently reject nature, refusing the theory that time triumphs over material. Divided into three main themes—monumentality, against metamorphosis, and petrification—the chapter discusses the perplexed gaze in medieval time (and today) when confronted with objects made of these materials and highlights specific strategies that enhanced their associations with ideas of timelessness and the "eternal."

Monumentality in Stone

Although the adjective *monumental* should be used carefully and must be clearly distinguished from its borrowed application to what is diminutive,[1] the common use of this term across cultures and times usually refers to size. As James Osborne suggests, a clear distinction should be made between the terms *monument* and *monumental*, because whereas the first relates to form, the latter involves the construction of meaning.[2] Typically, monumentality denotes the human predilection to build and form public objects that are huge; in other words, proportionally distinct in size from the ratio of the human body. Moreover, the exaggerated size suggests going beyond the human, typically competing with other creations of nature such as gigantic rocks, immense mountains, vast rivers, and towering plants and trees. The monumental

therefore seems to be a human desire involving an act that aspires to take part in cosmic creation, thus overcoming the transient and ephemeral state of the animated vis-à-vis the permanent and relatively eternal existence of nature. Yes, morally speaking, this act can be deemed *vanitas*, and yet, the dream of the overproportioned and monumental object embodies our wish to conquer time, as if the monumental suggests eternity and secures the object from decay, from its waning, and falling into oblivion.[3] It is a dream, and the numerous and ruinous states of these monumental human endeavors spread all over the universe, from the large walls in ruins of the Roman Empire to the Pharaonic pyramids and the great Sasanian Iwan of Khosrau (Taq-i Kisra) near Ctesiphon in Iraq: all attest to this human delusion. At any rate, large and great monuments, and especially those made of solid stone, were conceptualized with the great human desire to overcome time. It is no wonder that burial monuments tend to adopt this aesthetic, as if wishing to overcome their own raison d'être, namely monuments to death, by suggesting monumentality that aims at transcending forgetfulness.[4]

Monumentality as an aesthetic notion undoubtedly cannot be separated from power propaganda and the making of the image of the potentate. And, indeed, an inclination to monumentality in the medieval history of the arts of Islam clearly attests that notions of the monumental in the great Abbasid capital city of Samarra, in Mamluk Cairo, or in the Mongol-Timurid power in Samarkand were usually bound to the aesthetic of power.[5] And yet, I would like to stress that my focus in this short study is to establish a link between the monumental and the concept of resisting time. Perhaps the best account to illustrate this link between the two is the description of the pyramids by 'Abd al-Latif al-Baghdadi (1162–1231/32 CE). Though he was born and died in the city of Baghdad, al-Baghdadi was one of the most itinerant scholars and scientists of the Ayyubid period. He studied and taught in different schools and learning centers, including those in Baghdad, Mosul, Damascus, Aleppo, Jerusalem, Cairo, and various scholarly centers in the courts of different rulers of East Anatolia. His fascination with ancient Pharaonic monuments in Egypt found an echo in his writings.[6] Al-Baghdadi tells us:

> The shape chosen for the pyramids and their solidity are alike admirable. To their form is owing the advantage of their having resisted the attack of centuries: they stayed continuously against time, and time patiently waits on them . . . The most singularly remarkable fact presented by these edifices is the pyramidal form adopted in their structure, a form which commences with a square base, and finishes in a point. Now one of the properties of this form is that the centre of gravity is the centre of the building itself, so that it leans on itself, itself supports the whole pressure of this mass, all its parts bear respectively one upon the other, and it does not press on any external point.
>
> Another admirable peculiarity is the disposition of the square of them in such a manner that each of their angles fronts one of the four winds. For the violence of the wind is broken when cut by an angle, which would not be the case if it encountered a plane surface.[7]

The particular comment by al-Baghdadi about the pyramids' shape, that it contributes to "the advantage of their having resisted the attack of centuries: they stayed continuously against time, and time patiently waits on them," is illustrative. Al-Baghdadi even goes into detail to explain why the pyramids resist the teeth of Father Time.

His argument is based on the specific geometry of their shape providing extra stability, and the ability of the pyramids' four corners to break the "violence of the wind." It is worth mentioning al-Baghdadi's interest in the materiality of these pyramids. He assures us that most were built of cut stone, and even refers to white stone and red granite as the specific materials used in their construction. The stress on stone or a hard material such as granite for fighting against time is interesting. It might be suggested that, especially in desert areas in which sand and soft stone clearly exhibit their vulnerability, hard stones such as granite and marble were considered enduring, if not eternal.

It is thus illuminating to look at certain poetry of the pre- and early Islamic period in which ruins of stones are described, as these poetic verses are obsessed with time and might shed new light on the values of hard materials such as stone. Imru' al-Qais, the sixth-century poet from Najd in northern Arabia, is amazed by the power of the heavy stone-built edifices in the gardens of Taimma that resisted natural catastrophes.[8] But, in another poem cited in the *Book of Strangers*, a collection of graffiti sayings incised on stones—probably gathered by Abu'l-Faraj al-Isfahani (897–967 CE)—we hear how time ruined the Abbasid city of Samarra.[9] The following poem, also related by Abu'l-Faraj al-Isfahani, tells of poetic verses incised on folding doors of onyx secured by a golden lock, namely made of materials that resist time:

> We have built and we shall perish.
> What we have built will [only] survive us for a while.
> Nothing endures against time except God,
> whom we do not see, but who sees us.[10]

The stone remains a stone. And even if the whole structure fell apart, and despite the fact that the building is not intact, the hewn stones that were used for erecting this monumental architecture are still there. They are able to function again as stone, namely to be re-used, if so desired. This observation suggests that the idea of resisting time should not be solely linked to the monumental but also to the material. Moreover, it demonstrates that the duration of the material can be divorced from the duration of the building. Hard materials such as granite, onyx, and marble, used for the construction of these monuments, survive the erosive forces of water and wind, and their constituents of re-crystallized carbonate minerals, especially the calcite found in metamorphic marble, make it hard for plants to grow. In fact, this is the main reason for using marble slabs for gravestones. It is the duration of marble, its capacity to resist time, which makes it apt for this function. The well-planned inscriptions incised in marble, be it on architecture or gravestones, or particularly the effort expended on the part of numerous visitors to scratch their names on the surface of these hard materials, illustrate the human belief in the long duration of specific materials, but not necessarily that of sites or architectural complexes. Furthermore, one can even argue that the graffiti in marble and other hard materials accentuates the carvers being cognizant of the ephemeral state of these ruins, and particularly if made of long-living materials. At times the graffiti includes specific dates, as if the present moment is stamped on the relatively unending time of the stone, and the contents of these inscriptions suggest the great desire for long life, namely for being "washed" of any sins and to secure resurrection.[11] Thus, the chiselled inscriptions on any gravestone, publicizing the date of birth and death of the one interred, declare episodes in life on a material that is assumed to have a much longer life.

It is quite tempting to speculate that the decision taken most probably by Roger II of Sicily (1095–1154) to entomb the royal kings of the Norman dynasty in porphyry sarcophagi might hint at a strong desire for eternity (Figure 11.1). The sarcophagus of King Roger II himself has the shape of a simple rectangular chest with a gabled roof. The idea of the eternal is associated with or rather embodied in this material, namely the hard, solid, and durable porphyry marble, a material that over time has accumulated a definite royal iconography, but also in the fact that the slabs are devoid of all decoration, including any engraved inscription. Like a contemporary minimal sculpture employing only plain materiality and a simple form as its main aesthetic weapons, the clear-cut and plain rectangular slabs appear as a solid piece of natural beauty that eschews the ephemeral character of any artistic style.[12] The placement of this spartanly designed sarcophagus in the lavishly decorated cathedral of Palermo, at the center of a carved stone pavilion decorated with variegated colors, gives prominence to the absolute contrast between the setting and the unembellished porphyry tomb. Like graffiti on marble that accentuates the ephemeral, the lavish carved marble and particularly the mosaic-like decoration (*opus sectile*) of the slender columns of the pavilion accentuate the eternal power of Roger II's undecorated sarcophagus.[13] Turning back to ruins: ruins, like the idea of the fragmented, are therefore topoi—a symbol for the ephemerality of the world, built by the hand of man. But their materials—the product of nature or of divine power—are eternal. As if achieving a paradoxical effect, ruins and to some extent artistic décor initiate thoughts of the change brought about by time, and this thought of ephemerality is accentuated by the durable substances they are made of. But can substances defeat time?

Against Metamorphosis

I would like to start this second discussion with a medieval account known as the story of the Well of the Leaf (*Bi'r al-Waraqa*). This fantastic story appears in writing in the thirteenth century, at the beginning of the decline of the Frankish Crusader hegemony in the Holy Land, though it must be noted that the account tells us a story that goes back to the early days of Islam, to an event that took place, most probably, in Jerusalem, after its conquest by Umar in 637 CE.

The fifteenth-century historian Shams al-Din al-Suyuti recounts the detailed version of this story about a man who entered Paradise and came back to earth alive. This person, he adds, called Shuraik ibn Habashah, "went off to get water (from the well). And his bucket falling down into the well, he descended and found a door there opening into gardens, and passing through the door into the gardens, he walked therein. Then he plucked a leaf from one of the trees, and placing it behind his ear, he returned to the well and mounted up again." On the governor's doubting of this marvelous story told by Shuraik, Umar, the second caliph, wrote in answer: "Look ye to the leaf, whether it be green and do not wither. If this be so, verily it is a leaf of Paradise, for naught of Paradise can wither or change; and it is recorded in the aforesaid tradition of the Prophet that the leaf shall not suffer change."[14]

The main theme in this account, which al-Suyuti provides us in his compilatory book *Ithaf al-akhissa bi-fada'il al-masjid al-aqsa* (ca. 1470), stresses the fact that the color and shape of the leaves of paradise will never change. And, in fact, this was also the test that Shuraik was to go through in order to verify his own story about his travel to and from paradise. According to tradition, his leaf withstood this test. The leaf kept its green color and did not weather or twist. The idea of evergreen plants of paradise are

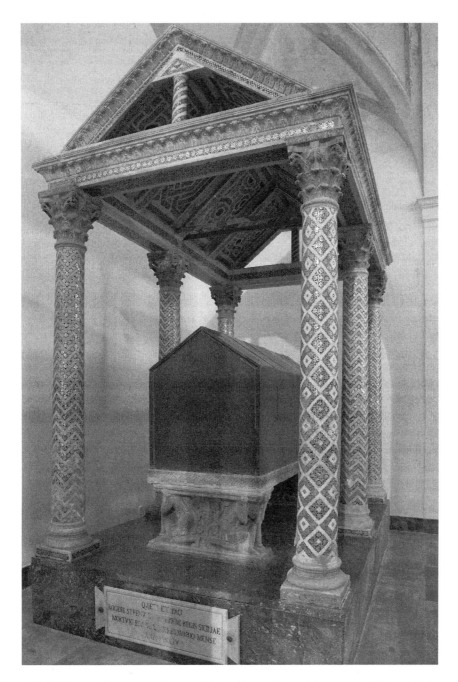

Figure 11.1 The porphyry sarcophagus of King Roger II, twelfth century, Palermo Cathedral.
Photo: Matjaz Kacicnik, 2016

most probably rooted in the opulent source of fresh water in the Garden of Eden and the specific curative properties this water possesses. Moreover, these healing properties are blessings that secure longevity—the quality bestowed upon each of the inhabitants of paradise. The evergreen color is the state of no change, the state that resists time and consequently death. It is as if time stopped at the very instant of the tree's prosperous state. But whereas no death dwells in Paradise, on earth, as time presses on, the leaves' changing color marks the transformation of the seasons of the year. In fact, were we capable of tracking the minute changes that each leaf goes through in the autumn, we could invent the leaf clock; similar to the shadow a sundial marks that tells us the hour of the day, a leaf could tell us the precise point at that season of the year. Changes, namely the transformations of colors and shapes, are time marks stamped on material. The drastic changes in form during the lifespan of a butterfly accentuates my point about metamorphosis and time. And as al-Biruni, one of the greatest scholars of medieval Islam, tells us in his famous and popular *Kitāb al-jamāhir fi ma'rifat al jawāhir*,[15] a guidebook and treatise on mineralogy written on the eve of the author's death, between 1041 and 1049, at the court of Sultan Mawdud ibn Mas'ud in Ghazna:

> The foam-ridden water of floods remains on the ground for a specified period, but nothing on earth remains ever the same: everything goes back to its origin.[16]

And in another paragraph he says:

> A thing, through the passage of time, keeps on getting converted into some other thing.[17]

Al-Biruni stresses the fact that nothing on earth remains the same and that there is a constant process of metamorphosis. And his saying that "everything goes back to its origin" most probably refers to the moment of death—a moment in which each part of creation returns to its originary substances and sources. Thus, the whole process of things changing is linked to the transformation of the material world as it follows its natural progression toward a final decay: death. The growth and decay of the human body is no less illustrative for establishing the direct link between metamorphosis and time. One is reminded of Oscar Wilde's famous novel *The Picture of Dorian Gray*, first published in 1890. I would like to focus on another aspect of this story, which involves the relationship between the animated and its image, namely Dorian Gray and his picture. As time marks its progression on one's face, Basil Hallward (the artist who painted the picture), Lord Henry Wotton (the art lover and connoisseur), and Dorian Gray curiously tend to think that time has less effect on objects. Thus, in this story, the picture of Dorian Gray, which should remain unchanged because the lifeless, still, and inanimate are unaltered by time, switches roles with the animated figure it portrays. Time therefore works upon and leaves its marks on the portrait of Dorian Gray rather on the young man himself. In reality, however, time leaves its mark on both the animated and the lifeless. In avoiding the marks of time, one, in this case Dorian Gray, acts against time. But as far as Oscar Wilde's fictional story is concerned, in which a supposed distinction exists between subject (Dorian Gray) and object (his image, the picture) as they relate to time, the moment time starts to have its influence on the one, the other remains intact, and vice versa. At any rate, the unchangeable beauty and youth of Dorian Gray is similar to the evergreen leaf from

paradise. Dorian Gray and the leaf are the symbols of man's desire for time-resistant objects that triumph over death.[18] And yet, the change of form is the very tool used by art historians, archaeologists, and historians who focus on the visual world and draw from it tangible traces that congeal or encage time in materials.[19] Among all these traces, patina is perhaps the most obvious one, the mundane indicator of the residue of time upon the surface of any material.[20]

The image of the "Twisted Leaf" is a common metaphor for the passage of time. The twisted leaf is in fact visual evidence, through which the passage of time can be measured, and the poetic verses telling us of King Annu'man, as related by the early Abbasid historian al-Tabari (839–923 CE), illustrate it well:

> And after victory, kingship and leadership following them there is the tomb
> And they end as if they were only dry leaves
> Twisted by the winds.[21]

It is no wonder that some late nineteenth-century Ottoman calligraphers put such effort into creating a delicate Arabic calligraphy inscribed on a gold-painted leaf. The leaf is carefully perforated, most probably with the help of a slender and pointed needle, creating a pattern that follows the vein-like pattern of the leaf and on which the Arabic letters are elegantly inscribed. It is most likely that this specific calligraphic aesthetic derives from delicate Ottoman cut-out papers and embroideries. The calligraphy on these gold leaves typically uses specific verses from the Quran, names of holy figures, or aphorisms that accentuate the sole power of the divine, as is the case of one of the leaves in the Khalili Collections in London (Figure 11.2) on which the inscription reads: "Allah wahduhu" (God Alone).[22] The perfection of the Arabic writing and the intact shape of the leaf suggest immaculate harmony, as if the perfection indicates a work of art beyond human ability.[23] The covering of the leaf with gold also suggests the divine, which is not only linked to the idea of the resplendence and light emanating from the golden leaf but is also associated with the permanency and endurance of the material gold––a metal substance that resists corrosion and wear. It is tempting to suggest that the production of the magnificent gold Quran from the Bayerische Staatsbibliothek in Munich (cod. arab. 1112), the leaves of which are painted gold, might also hint at the adoption of the aesthetic of the "eternal."[24]

The use of the material gold opens up another line of thought, that of substances that resist time and reject metamorphosis, namely specific metals and minerals. According to medieval traditions, these specific materials escape the wear and tear of time.

Minerals and Metals

> The creation of mineral deposits—or inorganic things—their order, arrangement and the capacity to remain in existence are all the works of God.
>
> Al-Biruni

Al-Biruni's observation in his book on mineralogy claims that minerals and metals, as opposed to the ephemeral nature of other organic substances in our cosmos, have "the capacity to remain in existence."[25] It is rather interesting that al-Biruni opens his discourse on minerals and metal by describing the historical uses of quicksilver (mercury; *zawuq* in Arabic), and undoubtedly the fascination that this material aroused

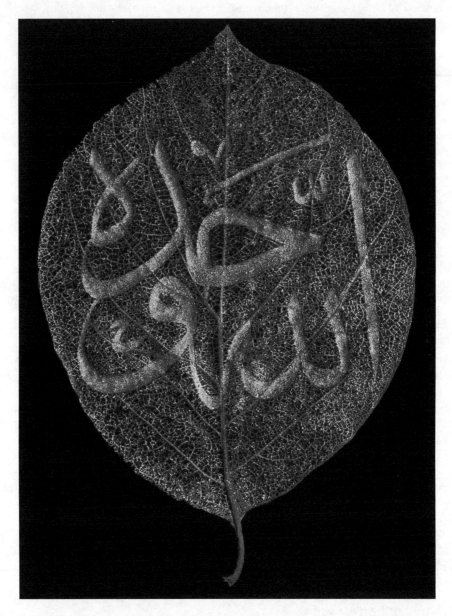

Figure 11.2 A calligraphic leaf bearing the inscription "God Alone," most probably nineteenth century, Ottoman Turkey. Perforated and gold-painted leaf, approx. 12–14 cm in length. The Khalili Collection in London (CAL 399). Photo: Khalili Collection, London

was rooted in its silvery-white fluid state. It is the only known liquid metal (its freezing point is –38.8°C/–37.9°F), and the alchemists' belief that it is the "first matter" from which all materials are formed accorded it its primary place. However, it must be noted that this material was and still is used for fighting against time, namely removing unwanted tarnish or any corrosion from other metals. It fights patina, the best

evidence for the work of time on materials, which, as Shannon Lee Dawdy suggests, becomes the authentication for time.[26] Yes, as Meyer Schapiro says in his essay "On the Aesthetic Attitude in Romanesque Art," "[w]e detect also an antiquarian piety, an absorbing interest in the fact of antiquity itself, which is shown in the repeated observations on the evidences of time, the changes effected by the passage of the centuries," and, while discussing the twelfth-century account of Reginald of Durham about an ivory comb, he cites Reginald's remarks: "its natural appearance of white bone is changed by its great age into a reddish tint."[27] As opposed to organic substances, the specific minerals and metals that do not accumulate patina seem to resist time. This is their allure and value, which typically associates them with concepts such as the paradisiac and the eternal. As far as the art historian is concerned, objects made of these materials, especially those that were merely rounded or polished, present a great challenge because they neglect the "shape of time."[28]

It is no wonder that the next two materials presented by al-Biruni are gold (*dhahab*) and silver (*fiddah*). These materials were hoarded and became used for monetary purposes because of their purity and the fact that they do not allow time to wreck their substance, namely lose their value; this is relatively speaking, of course, because though the substance of silver remains intact, its surface tends to blacken over time due to oxidization. Nevertheless, these two substances, in full synchronization, seemed to affect the entire economy of the ancient and medieval worlds.[29] Commenting on the white and dark types of rubies, al-Biruni informs us that, according to tradition—as he emphasizes—the red and transparent ruby is the one that reached the permanent state of perfection. He says:

> When transformed to another state, the ruby becomes more clarified and is generally yellowish, ultimately becoming red. People subscribe to this belief because they have heard from the scholars of physics that the ruby, when it reaches the state of perfection, becomes red, as gold when it is at the maximum of its equable state, is inclined towards a little redness. They also believe that the ruby progressively shifts towards different colours till it finally becomes red and remains red permanently, as this is the state of its perfection; and beyond this there is no other stage.[30]

This information provided by al-Biruni is important because it suggests that popular acceptance exists concerning the full perfection of the red ruby. The ruby's attainment of this stage of absolute perfection, after which no transformation could occur, underscores the red ruby's accomplishment of reaching the state of resisting time. The same can be said about the yellow pearl:

> The slightly yellowish pearl is better than the one that is completely white. In a like manner, gold is superior to silver. The reason for this is that a very white pearl which has been only recently taken out of the sea becomes transformed with age, with the change in its colour coming to suffuse the whole of it. It gradually becomes dark shading to brown. But if it has a little of desirable yellowness, it would be immune from this disease. It can be well believed that such a colour will not fade out.[31]

Diamonds are also interesting in this respect, because their hardness is thought to be unmatched by any other material, and thus it is almost impossible to shape them or to

engrave any mark on their surface. Al-Biruni agrees with this assumption and writes: "Diamond is not affected by anything superior to it or by anything that is inferior." However, he adds: "But it belongs to this world which is inherently corrupt, and therefore, a thing having a certain weight and quantity does exercise its effect upon it. Diamonds are ranked among jewels like a king in relation to his subjects."[32] Accounts from this period suggest that the widespread, common perception of several minerals and metals, especially of mercury, gold, rubies, and, to some extent, diamonds, was that of substances resisting time.

Petrification

In this last section, I would like to discuss the third concept that involves materials' resistance to time. To some extent this discourse takes us back to notions concerning monuments because it also involves the qualities of stones. As discussed above, monumental structures built of solid stone are structures that aspire to gain permanence, albeit unsuccessfully. In this discussion, the process of becoming stone, which is visually captured within a substance's natural structure, plays the main role in establishing the idea of resisting time. In other words, the notion of duration is at the core of this discussion. It is the duration that involves the material's process of petrification. It is remarkable how paradigmatic the biblical story of the petrified body of Lot's wife is (Genesis 19:26). Her turning into a pillar of salt is of course the result of her seeing the forbidden. As the story goes, it was probably the horrific vision of the destruction of the sinful city of Sodom by God. But this vision was in fact the vision of the divine in action. For example, Moses' enduring desire to see the face of God or even to be confronted by him at his very last moment before death emphasizes how impossible this demand is and what concessions need to be made in order to fulfill it, at least partially.[33] The visualizing of God causes the petrification—in other words, death—of any living creature, and Lot's wife became a pillar of salt.[34]

The solid character and the transparency of rock crystal seem to illustrate this notion of petrification, in this case the traditional belief in the petrification of the limpid water of paradise that was congealed into solid rock. Thus, the aquatic iconography of carved rock crystals of the Late Antique and early Byzantine periods can be interpreted as relating to traditions concerning the aquatic origin of this material. We are speaking, for the most part, of vessels: dishes and bowls decorated with sea creatures and small containers with fish-shaped form.[35] The medieval mineralogist al-Biruni accepts early traditions about the nature of rock crystals as made from congealed water,[36] even adding that several remnants of plants and leaves that were seen inside two rock crystal bowls in his possession attest to the fact that "quite obviously these things were found in the crystal when it was torrential and had greater tenuity and finer essence than pure water."[37] But according to al-Biruni, grass, wood, gravel, earth, and air bubbles could also be found in rock crystal. This is visual evidence that the stone was transformed suddenly into crystal.[38] This sudden petrification is relevant to this discussion because it differs from the gradual, constant transformation into a solid substance through which most precious stones pass.[39] This instantaneous effect of petrification reminds one of paradisiac and celestial scenes in which rivers of crystal are described,[40] and especially the description of a "sea of glass, like crystal" in Revelation 4:6. Most probably, the solid transparent sea around the throne of God was suddenly transformed into solid substance at the appearance of the divine. Thus,

the petrified rock crystal attests to the material's previous proximity to God. It is the immobilizing effect caused by the witnessing of God. The petrification is therefore an act that aims at memorizing the divine presence; however, it is not simply document- ing past memories of the Holy, but rather recording just one moment, namely the moment of Revelation.[41] Rock crystals are therefore substances that visualize through their materiality the amazing experience of confronting the Holy. The petrified rock crystal stabilizes an instance rather than the past. Like the transformation of Lot's wife into a pillar of salt, which memorializes a specific moment of her looking onto the city of Sodom turned into ashes by the power of God, the rock crystal is also the result of a momentary view of the power of the divine. It symbolizes rupture because it celebrates but one instance, and does not allow this moment to merge into the flow of time. It would be tempting to suggest that the cruciform reliquary of Henry II (973–1024), currently held in the Treasury of the Wittelsbach dynasty in the collection of the Munich Residenz (Figure 11.3), transmits this idea. This lavish gold reliquary was transformed into a portable altar by adding to it a thick, smooth, rectangular rock crystal plate that covers the cross-shaped relic that was once enshrined within.[42] The large piece of rock crystal attached to the reliquary appears as congealed limpid water that was turned into stone by the one-time presence of the Holy Cross.

A group of carved cylindrical bottles of rock crystal, mostly datable to ca. 1000 and typically decorated with elegantly curved and carved palmette leaves, has preoccupied scholars for the last century.[43] These bottles raise questions as to the specific place of their manufacture and their particular use. It is commonly accepted that these flacons could have functioned as perfume bottles or lavish containers for sanctified fragrances from the Holy Land, similar to the rock crystal ampoule of Charlemagne.[44] At any rate, carrying either fragrance or sanctified substances, their import from the East to the West probably endowed them with holiness and associated their contents with curative and benedictory powers. The expensive material and the difficult craftsman- ship invested in the making of these objects suggest that expensive substances were held within. But unfortunately we are left in the dark. Nevertheless, the customary decoration of perfectly designed palmette leaves carved into these cylindrical bottles might evoke the memories of the stunning green leaves of paradise. Both the material- ity and the décor might then transmit the idea of eternity. And if the content within was indeed used for curative or benedictory ends, one might speculate whether the scent of paradise and the curing properties of its plants might have been called to one's memory with the use of these bottles.[45]

Like rock crystal, marble also seems to have been regarded, in ancient and medieval times alike, as a petrified substance—a frozen sea. As Fabio Barry recently demon- strated, the nautical visual effect of the numerous "sea floors" in Christian churches evoked the idea of walking on water.[46] Thus, marble is also water that turned to stone. Furthermore, the name *marmor* (marble) given to this material derives from the San- skrit, in which the *mar* refers to the motion, the murmuring of the sea.[47] The marble thus seems to illustrate the saying in Job 38:30: "The waters are hid as with a stone, and the face of the deep is frozen." The undulating marble veins were seen then as waves that froze at a moment—most probably the moment of creation in which the division of the waters by God took place or the specific eschatological moment of the end of time that involves the metamorphosis of materials.[48] The use of marble in the decoration of the Dome of the Rock in Jerusalem by the end of the seventh century might illustrate the idea of frozen material at the very site that tells of histories of

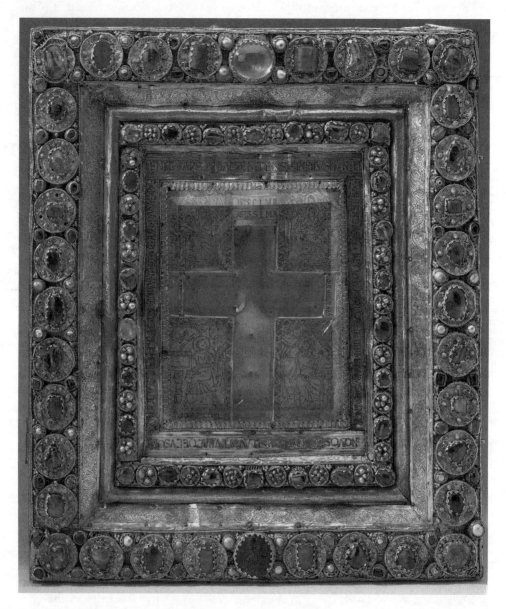

Figure 11.3 The cruciform reliquary of Henry II, ca. 1010, most probably Metz or Reichenau. Oak wood, gold and gilded silver, precious stones, rock crystal, and silk. The Wittelsbach Treasury, Munich Residenz

human interaction with the divine. And perhaps the organization of marble panels in mirror-like settings accentuates the idea of the site as the location of visioning (the sacred).[49] But, apart from these speculative suggestions, from a formalistic point of view, the common juxtaposition of marble panels in a prismatic-like order alludes to the natural and sudden petrification of water; in other words, to the rapid gathering

of thin and flat icy panels erratically clattering into each other. Yet the strong and major aesthetic impression that marble and its zigzagging veins leaves is that of the abrupt and the immobile. It is probably the hardness and coldness that this material transmits, producing impressions such as "emotionless," "detached," or "cold." But the sense of immobility in marble is dominant. This might explain the ancient habit or rendering the images of kings in stone.[50] The restricted movement, up to the almost total immovable appearances, of the royal body in official public ceremonies, as if made of stone, probably refers to the connection made between the static and the unchangeable, hence the resisting of time. Movement can take place only in time and cannot avoid its impact on material.[51] The fixed-in-time appears then as unchanged, and the royal king appears at the very center, the fixed spot around which all move.[52]

In sum, three major aesthetic views have been discussed here, all of which aim at resisting time: monumentality in stone, the rejection of metamorphosis, and the process of petrification as related to the immobile. It seems as if time appears as the major enemy of the material world because it determines the ephemeral characteristics of all substances. Patrons of art and artists aware of this decree of time have occupied themselves in searching for specific materials that could overcome the power of life, especially when there exists an aspiration to transmit notions of eternity and endurance. Stone, rock crystal, marble, gold, and other minerals and precious stones such as mercury and rubies were therefore chosen for this purpose. And yet, time seems to dictate if a work will be remembered or forgotten, as it is directly linked to human remembrance of the phenomenological world. The main approach of overcoming time in the Middle Ages was to associate these crafted materials with the ideas of the "beyond time," thus forcing them into memory, aiming to transform them into eternal entities. The presence of the divine as visually reflected in these materials appears as the main cause and source for this particular faculty of substances. A separate aesthetic approach typically associated with these "eternal" materials relates to the effect of shine, of radiance, but this is another subject that merits further study elsewhere. And yet, as the history of nature attests, all materials, and I would add ideas too, are doomed to change over time, because, as Bruno Latour says in "Reflections on Étienne Souriau's *Les différent modes d'existence*": "What is impossible is persistence without change, and this applies to rocks as much as to God."[53]

Notes

1. James S. Osborne, "Monuments and Monumentality," in *Approaching Monumentality in Archaeology*, ed. James S. Osborne (Albany: State University of New York, 2014), 1–19.
2. Osborne, "Monuments and Monumentality." See also Christiane C. Collins and George R. Collins, "Monumentality: A Critical Matter in Modern Architecture," *Harvard Architecture Review* 4 (1984), 15–35; José Luis Sert, Fernand Léger, and Sigfried Giedion, "Nine Points on Monumentality," *Harvard Architecture Review* 4 (1984), 62–63.
3. The origin of the word *monument* derives from the Latin verb *monére*, which means "to remind." See Osborne, "Monuments and Monumentality," 3–4; Ömür Harmanşah, "Monuments and Memory: Architecture and Visual Culture in Ancient Anatolian History," in *The Oxford Handbook of Ancient Anatolia, 10,000–323 B.C.E.*, eds. Sharon R. Steadman and Gregory McMahon (Oxford: Oxford University Press, 2011), 623–56; for monument and memory in the contemporary German context, see mainly Andreas Huyssen, "Monumental Seduction," *New German Critique* 69 (1996), 181–200; and James E. Young, "The Counter-monument: Memory against Itself in Germany Today," *Critical Inquiry* 18 (1992), 267–96.

4. Another aspect, which for questions of brevity cannot be discussed fully, concerns monumentality and the sense of the archaic. The archaic could have been, and in fact still is, associated with the giant. This notion of creating a sense of the archaic past by erecting giant works of art is interesting. It goes back to the biblical account on the archaic age of giants (Nephilim) in Genesis 6:4 that preceded the Flood. This account is also found in the apocryphal literature of the Book of Enoch; see James C. WanderKam, "The Enoch Literature," *Guest Lectures*, School of Divinity, University of Saint Andrews, 1997, available at www.st-andrews.ac.uk/divinity/rt/otp/guestlectures/vanderkam (accessed December 11, 2017); see also Brannon Wheeler, *Mecca and Eden: Ritual, Relics, and Territory in Islam* (Chicago: University of Chicago Press), 99–122. The association of the giant with the divine, namely the biblical account that claims that these huge creatures are the "Sons of God," is quite interesting because it suggests that monumentality and endurance (the giants reached great age too) are linked to the divine. See Philip S. Alexander, "The Targumim and Early Exegesis of 'Sons of God' in Genesis 6," *Journal of Jewish Studies* 23, no. 1 (1972), 60–71; David J. A. Clines, "The Significance of the 'Sons of God' Episode (Genesis 6:1–4) in the Context of the 'Primeval History' (Genesis 1–11)," *Journal of the Study of the Old Testament* 13 (1979), 33–46.

5. On the monumentality of Samarra, see mainly Alastair Northedge, *The Historical Topography of Samarra* (London: British School of Archaeology in Iraq, 2005); and Alastair Northedge and Derek Kennet, *Archaeological Atlas of Samarra* (London: British Institute for the Study of Iraq, 2015). Bernard O'Kane, "Monumentality in Mamluk and Mongol Art and Architecture," *Art History* 19, no. 4 (1996), 499–522; Sheila S. Blair and Jonathan M. Bloom, "Timur's Quran: A Reappraisal," in *Sifting Sands, Reading Signs: Studies in Honour of Professor Géza Fehérvári*, eds. Patricia L. Baker and Barbara Brend (London: Furnace Publishing, 2006), 5–13.

6. S. M. Stern, "'Abd al-Latif al-Baghdadi," in *Encyclopaedia of Islam*, 2nd ed., vol. 1 (Leiden: Brill, 1986), 74; Claude Cahen, "Abdallatif al-Baghdadi, portraitiste et historien de son temps: Extraits inédits de ses mémoires," *Bulletin d'Études Orientales* 23 (1970), 101–28; Shawkat M. Toorawa, "Abd al-Latif al-Baghdadi," in *Interpreting the Self: Autobiography in the Arabic Literary Tradition*, ed. Dwight F. Reynolds (Berkeley: University of California Press, 2001), 156–64; Shawkat M. Toorawa, "The Educational Background of 'Abd al-Latif al-Baghdadi," *Muslim Education Quarterly* 13, no. 3 (1996), 35–53.

7. 'Abd al-Latif al-Baghdadi, *The Eastern Key: Kitab al-Ifada wa'l-I'tibar*, trans. Kamal Hafuth Zand and John A. and Ivy E. Videan (London: Allen & Unwin, 1964), 107–13.

8. "The Hanged Poems: The Poem of Imru-ul-Quais," trans. F. E. Johnson, with revision by Sheikh Faiz-ullah-bhai, in *The Sacred Books and Early Literature of the East*, vol. 5: *Ancient Arabia*, ed. Charles F. Horne (New York: Parke, Austin, and Lipscomb, 1917), 26.

9. Abu'l-Faraj al-Isfahani, *The Book of Strangers: Medieval Arabic Graffiti on the Theme of Nostalgia*, trans. Patricia Crone and Shmuel Moreh (Princeton: Markus Wiener Publishers, 2000), 25.

10. Abu'l-Faraj al-Isfahani, *The Book of Strangers*, 63.

11. On graffiti such as on the stones of the Holy Sepulchre in Jerusalem, see Sebastian Brock, Haim Goldfus, and Aryeh Kofsky, "The Syriac Inscriptions at the Entrance to Holy Sepulchre, Jerusalem," *Aram* 18–19 (2006–2007), 415–38.

12. See Alexander Nagel, "Style-Eating Granite," *Cabinet* 53 (2014), 81–84.

13. Hubert Houben, *Roger II of Sicily: A Ruler between East and West*, trans. Graham A. Loud and Diane Milburn (New York: Cambridge University Press, 2002), 24; József Deér, *The Dynastic Porphyry Tombs of the Norman Period in Sicily*, trans. G.A. Gillhoff (Cambridge, MA: Harvard University Press, 1959); Ingo Herklotz and Paolo Delogu, "*Sepulcra*" *e* "*Monumenta*" *del Medioevo. Studi sull'arte sepolcrale in Italia* (Rome: Rari Nantes, 1985); Lucilla de Lachenal, *Spolia. Uso e reimpiego dell'antico dal III al XIV secolo* (Milan: Longanesi, 1995), 179–81; Neslihan Asutay-Effenberger and Arne Effenberger, *Die Porphyrsarkophage der öströmischen Kaiser. Versuch einer Bestandserfassung, Zeitbestimmung und Zuordnung* (Wiesbaden: Reichert, 2006).

14. R. A. Ahmad, ed., *Muhammad ibn Ahmad al-Suyuti, Ithaf l-akhissa bi-fada'il al-masjid al-aqsa* (Cairo: al-Hay'ah al-Miṣrīyah al-'Āmmah lil-Kitāb, 1982), 206–09; the English translation is taken from Guy Le Strange, *Palestine under the Moslems: A Description of Syria*

and the Holy Land from AD 650 to 1500 (London: Alexander P. Watt, 1890), 198–200. See also Avinoam Shalem, "Bi'r al-Waraqa: Legend and Truth; A Note on Medieval Sacred Geography," *Palestine Exploration Quarterly* 27 (January–June 1995), 50–61.

15. For the Arabic edited edition of this book by al-Biruni, see Fritz Krenkow, ed., *Kitāb al-Jamāhir fi Ma'rifat al Jawāhir* (Hyderabad: Maṭba'at Jam'īyat Dā'irat al-Ma'ārif al-'Uthmānīyah, 1936). The English translation cited here is taken from *The Book Most Comprehensive in Knowledge on Precious Stones: Al-Biruni's Book on Mineralogy (Kitāb al-Jamāhir fi Ma'rifat al Jawāhir)*, trans. Hakim Muhammad Said (Islamabad: Pakistan Hijra Council, 1989).

16. *The Book Most Comprehensive in Knowledge on Precious Stones*, 198.

17. *The Book Most Comprehensive in Knowledge on Precious Stones*, 67. He also adds to this sentence his critique of poets: "But the poet's vision that clay becomes transformed into ruby is an expression of his exaggeration. When poets heap encomia, they resort to this exaggeration and hyperbole."

18. The medieval belief in the intact state of the bodies of saints probably belongs to this line of thought. Their bodies resist time because they are part of heaven, the transcendental realm. See Paul Freedman, *Out of the East: Spices and the Medieval Imagination* (New Haven: Yale University Press, 2008), esp. 76–103; Mary Thurlkill, *Sacred Scents in Early Christianity and Islam* (Lanham: Lexington Books, 2016); Maximilien Durand, *Parfum de sainteté* (Paris: Les Allusifs, 2007).

19. George Kubler, *The Shape of Time: Remarks on the History of Things* (New Haven: Yale University Press, 1962). The best review of the scholarly response to Kubler's book is his article "The Shape of Time Reconsidered," *Perspecta* 19 (1982), 112–21; see also the discussion on Kubler's theory in E. McClung Fleming, "Artifact Study: A Proposed Model," *Winterthur Portfolio* 9 (1974), 153–73, esp. 158–59. See also the various articles by Reva Wolf, Mary Miller, Shelly Rice, Ellen K. Levy, and Suzanne Anker, in *Art Journal* 68, no. 4 (2009); Sarah Maupeu, Kerstin Schankweiler, and Stefanie Stallschus, eds., *Im Maschenwerk der Kunstgeschichte: eine Revision von George Kublers "The Shape of Time"* (Berlin: Kulturverlag Kadmos, 2014).

20. Shannon Lee Dawdy, *Patina: A Profane Archaeology* (Chicago: University of Chicago Press, 2016), esp. 143–55. See also Ian Frazier, "Patina: How the Statue of Liberty Colors the City," *New Yorker*, September 19, 2016, 46–49; and Lambros Malafouris, *How Things Shape the Mind: A Theory of Material Engagement* (Cambridge, MA: MIT Press, 2013).

21. Cited in Mohammed Hamdouni Alami, *Art and Architecture in the Islamic Tradition: Aesthetics, Politics and Desire in Early Islam* (London: I. B. Tauris, 2011), 146.

22. On the Khalili Collection of calligraphic leaves, see J. M. Rogers, ed., *Empire of the Sultans: Ottoman Art from the Khalili Collection* (London: The Nour Foundation, 2000), 290–94, cat. nos. 217–26. See also the leaf with the following inscription: "And my success can come from none but God" (*wama tawfiqi ila billah*), available online at http://islamic8.com/my-success-is-only-from-god-calligraphy-in-the-shape-of-leaf (accessed December 11, 2017).

23. Several depictions of flowers with broken stems that begin to appear in the decoration of Ottoman underglazed ceramics, Iznik ware, are usually interpreted as alluding to the ephemeral nature of beauty in this world. See, for example, the Ottoman Iznik cup in the Louvre (datable 1570–80); depicted in Walter B. Denney, *Osmanische Keramik aus Iznik* (Munich: Hirmer, 2005), 170. It might also be suggested that the depiction of flowers bowing their head as if in deepest humility on the outer walls of the Taj Mahal in Agra might also suggest, in addition to lamentation, their sadness about the ephemeral condition of human beings in this world. See also Avinoam Shalem and Eva Maria Troelenberg, "Beyond Grammar and Taxonomy: Some Thoughts on Cognitive Experiences and Responsive Islamic Ornaments," in *Beiträge zur islamischen Kunst und Archäologie*, vol. 3, ed. Ernst-Herzfeld-Gesellschaft (Wiesbaden: Reichert Publishing House, 2012), 385–410, esp. 391–93.

24. Markus Ritter and Nourane Ben Azzouna, *Der Goldkoran aus der Zeit der Seldschuken und Atabegs: vollständige Faksimile-Ausgabe von Cod. arab. 1112 der Bayerischen Staatsbibliothek München* (Graz: Akademische Druck- u. Verlagsanstalt, 2015).

25. *Al-Biruni's Book on Mineralogy*, 197.

26. Dawdy, *Patina: A Profane Archaeology*, esp. 143–55.
27. Meyer Schapiro, "On the Aesthetic Attitude in Romanesque Art," in *Art and Thought: Issued in Honor of Dr. Ananda K. Coomaraswamy on the Occasion of His 70th Birthday*, ed. K. Bharatha Iyer (London: Luzac and Company Ltd., 1947), 130–50; reprinted in Meyer Schapiro, *Romanesque Art: Selected Papers* (New York: George Braziller, 1977), 1–27 (citation at 18).
28. I use this phrase to emphasize Kubler's idea of the "Shape of Time"; see Kubler, *The Shape of Time*.
29. Andrew M. Watson, "Back to Gold—and Silver," *Economic History Review*, 20, no. 1 (1967), 1–34.
30. *Al-Biruni's Book on Mineralogy*, 96.
31. *Al-Biruni's Book on Mineralogy*. It should be noted that popular traditions also claim that the Black Stone of the Ka'ba in Mecca used to be white and became dark with time as a result of the impure touching of the Muslims visiting this site. Thus, the stage of perfection and of reaching eternity is associated with purity, and, if contaminated by sins, might change color, that is to say, will age.
32. *Al-Biruni's Book on Mineralogy*, 75.
33. Avinoam Shalem, "Verbildlichung Allahs: Für eine andere Bildtheorie," in *Das Bild Gottes in Judentum, Christentum und Islam: Vom Alten Testament bis zum Karikaturenstreit*, eds. Eckhard Leuschner and Mark R. Hesslinger (Petersberg: Michael Imhof, 2009), 81–92; Rachel Milstein, Karin Rührdanz, and Barbara Schmitz, *Stories of the Prophets: Illustrated Manuscripts of Qisas als-Anbiyā'* (Costa Mesa, CA: Mazda Publishers, 1999); and Rachel Milstein, "The Iconography of Moses in Islamic Art," *Jewish Art* 12–13 (1986–87), 199–212.
34. On the visualization of God, see Eckhard Leuschner and Mark R. Hesslinger, eds., *Das Bild Gottes in Judentum, Christentum und Islam: Vom Alten Testament bis zum Karikaturenstreit* (Petersberg: Michael Imhof, 2009).
35. Daniel Alcouffe, "Rock-Crystal Lamp with Marine Life" and "Rock-Crystal Lamp in the Shape of a Fish," in *The Treasury of San Marco, Venice*, exh. cat. Metropolitan Museum of Art, New York (Milan: Olivetti, 1984), 82–87.
36. *Al-Biruni's Book on Mineralogy*, 160.
37. *Al-Biruni's Book on Mineralogy*, 163.
38. *Al-Biruni's Book on Mineralogy*, 163–64.
39. Like the long and gradual processes through which diamonds (congealed smoke) and rubies went through. See *Al-Biruni's Book on Mineralogy*, 70–71, 79.
40. See Avinoam Shalem, "Fountains of Light: The Meaning of Medieval Islamic Rock Crystal Lamps," *Muqarnas* 11 (1994), 1–11, esp. 4–5.
41. On the idea of the "frozen gaze" in front of the divine, see Jean-Luc Marion, *God without Being: Hors-Texte*, trans. Thomas A. Carlson (Chicago: University of Chicago Press, 1991), 14–15.
42. Hermann Fillitz, "Das Kreuzreliquiar Heinrichs II. in der Münchener Residenz," *Münchner Jahrbuch der bildenden Kunst* 3, nos. 9–10 (1958–59), 15–31; Percy Ernst Schramm and Florentine Mütherich, *Denkmale der deutschen Könige und Kaiser*, vol. 1: *Ein Beitrag zur Herrschergeschichte von Karl dem Großen bis Friedrich II. 768–1250* (Munich: Prestel, 1962), 164, no. 134. For a recent discussion, see Holger A. Klein, *Byzanz, der Westen und das "wahre" Kreuz: die Geschichte einer Reliquie und ihrer künstlerischen Fassung in Byzanz und im Abendland* (Wiesbaden: Reichert, 2004), 172.
43. Paul Kahle, "Bergkristall, Glas und Glasflüsse nach dem Steinbuch von el-Berúní," *Zeitschrift der deutschen morgenländischen Gesellschaft* 15 (1936), 322–56; Avinoam Shalem, *Islam Christianized: Islamic Portable Objects in the Medieval Church Treasuries of the Latin West* (Frankfurt am Main: Peter Lang, 1996), 25–29, 56–62, 177–226; Carl Johann Lamm, *Mittelalterliche Gläser und Steinschnittarbeiten aus dem Nahen Osten*, 2 vols. (Berlin: D. Reimer, 1929–30); Kurt Erdmann, "Islamische Bergkristallarbeiten," *Jahrbuch der königlichen Preussichen Kunstsammlungen* 61 (1940), 125–46; Kurt Erdmann, "Fatimid Rock Crystals," *Oriental Art* 3 (1951), 142–46; Kurt Erdmann, "Die fatimidischen Bergkristall-kannen," in *Wandlungen christlicher Kunst im Mittelalter* (Baden-Baden: Verlag für Kunst und Wissenschaft, 1953), 189–205; David S. Rice, "A Datable Islamic Rock Crystal," *Oriental Art* 2 (1956), 85–93; Kurt Erdmann, "Neue islamische Bergkristalle," *Ars Orientalis* 3

(1959), 200–05; Gia Toussaint, "Cosmopolitan Claims: Islamicate Spolia During the Reign of King Henry II, 1002–1024," *Medieval History Journal* 15, no. 2 (2012), 299–318. For a recent article that summarizes the earlier literature, see Anna Contadini, "Facets of Light: The Case of Rock Crystals," in *God is the Light of the Heavens and the Earth: Light in Islamic Art and Culture*, eds. Jonathan Bloom and Sheila Blair (New Haven: Yale University Press, 2015), 125–55.
44. Avinoam Shalem, "Islamic Rock Crystal Vessels—Scent or *Ampullae*?" in *Bamberger Symposium: Rezeption in der islamischen Kunst, Beiruter Texte und Studien* 61 (1999), 289–99.
45. On the possibility of these bottles as containers for sanctified substances from the famous Garden of Matariyya, near Cairo, see Shalem, *Islam Christianized*, 17–36; and Marcus Milwright, "The Balsam of Matariyya: An Exploration of a Medieval Panacea," *Bulletin of the School of Oriental and African Studies* 66, no. 2 (2003), 193–209.
46. Fabio Barry, "Walking on Water: Cosmic Floors in Antiquity and the Middle Ages," *Art Bulletin* 89, no. 4 (2007), 627–56.
47. Barry, "Walking on Water," 631.
48. Barry, "Walking on Water," 634–37. On the water iconography of marble, see mainly Marcus Millwright, "'Waves of the Sea': Responses to Marble in Written Sources (Ninth–Fifteenth Centuries)," in *The Iconography of Islamic Art: Festschrift in Honour of Professor Robert Hillenbrand*, ed. Bernard O'Kane (Edinburgh: Edinburgh University Press, 2005), 211–21; Bissera V. Pentcheva, "Hagia Sophia and Multisensory Aesthetics," *Gesta* 50, no. 2 (2011), 93–111; for the connectivity made between marble and water in rabbinic literature of the Late Antique period, see Moshe L. Fischer and Tziona Grossmark, "Marble Import and *Marmorarii* in Eretz-Israel during the Roman and Byzantine Period," *Eretz-Israel: Archaeological, Historical and Geographical Studies* 25 (1996), 471–83, esp. 477–78 (Hebrew).
49. For the talismanic qualities of marble, see Finbarr B. Flood, "Animal, Vegetal, and Mineral: Ambiguity and Efficacy in the Nishapur Wall Painting," *Representations* 133 (2016), 46.
50. Irene J. Winter, "'Idols of the Kings': Royal Images as Recipients of Ritual Action in Ancient Mesopotamia," *Journal of Ritual Studies* 6, no. 1 (1992), 13–42.
51. See Mieke Bal, "Heterochrony in the Act: The Migratory Politics of Time," in *Art and Visibility in Migratory Culture: Conflict, Resistance, and Agency*, eds. Mieke Bal and Miguel Á. Hernández-Navarro (Amsterdam: Rodopi, 2011), 211–38.
52. For this tactic, see Paula Sanders, *Ritual, Politics, and the City in Fatimid Cairo* (Albany, NY: State University of New York Press, 1994), 33. Here there is a description of the Fatimid royal ceremony in which the caliph appears in the center and is immobile. The immobility of the caliph suggests stagnation of time. Thus, unity of time and form are bound. This unity embodied in the petrified and the static enforces the negation of change.
53. Bruno Latour, "Reflections on Étienne Souriau's *Les différent modes d'existence*," trans. Stephen Muecke, in *The Speculative Turn: Continental Materialism and Realism*, eds. Levi R. Bryant et al. (Melbourne: re.press, 2010), 327.

Bibliography

'Abd al-Latif al-Baghdadi, *The Eastern Key: Kitab al-Ifada wa'l-l'tibar*, trans. Kamal Hafuth Zand and John A. and Ivy E. Videan. London: Allen & Unwin, 1964.
Abu'l-Faraj al-Isfahani. *The Book of Strangers: Medieval Arabic Graffiti on the Theme of Nostalgia*. Trans. Patricia Crone and Shmuel Moreh. Princeton: Markus Wiener Publishers, 2000.
Ahmad, R. A., ed. *Muhammad ibn Ahmad al-Suyuti, Ithaf l-akhissa bi-fada'il al-masjid al-aqsa*. Cairo: al-Hay'ah al-Misrīyah al-'Ammah lil-Kitāb, 1982.
Alami, Mohammed Hamdouni. *Art and Architecture in the Islamic Tradition: Aesthetics, Politics and Desire in Early Islam*. London: I. B. Tauris, 2011.
Alcouffe, Daniel. "Rock-Crystal Lamp with Marine Life" and "Rock-Crystal Lamp in the Shape of a Fish," in *The Treasury of San Marco, Venice*, exh. cat. Metropolitan Museum of Art, New York. Milan: Olivetti, 1984, 82–87.
Alexander, Philip S. "The Targumim and Early Exegesis of 'Sons of God' in Genesis 6," *Journal of Jewish Studies* 23, no. 1 (1972), 60–71.

Asutay-Effenberger, Neslihan and Arne Effenberger, *Die Porphyrsarkophage der östromischen Kaiser. Versuch einer Bestandserfassung, Zeitbestimmung und Zuordnung.* Wiesbaden: Reichert, 2006.

Bal, Mieke "Heterochrony in the Act: The Migratory Politics of Time," in *Art and Visibility in Migratory Culture: Conflict, Resistance, and Agency,* eds. Mieke Bal and Miguel Á. Hernández-Navarro. Amsterdam: Rodopi, 2011, 211–38.

Barry, Fabio "Walking on Water: Cosmic Floors in Antiquity and the Middle Ages," *Art Bulletin* 89, no. 4 (2007), 627–56.

Blair, Sheila S. and Jonathan M. Bloom. "Timur's Quran: A Reappraisal," in *Sifting Sands, Reading Signs: Studies in Honour of Professor Géza Fehérvári,* eds. Patricia L. Baker and Barbara Brend. London: Furnace Publishing, 2006, 5–13.

The Book Most Comprehensive in Knowledge on Precious Stones: Al-Biruni's Book on Mineralogy (Kitāb al-Jamāhir fi Ma'rifat al Jawāhir). Trans. Hakim Muhammad Said. Islamabad: Pakistan Hijra Council, 1989.

Brock, Sebastian, Haim Goldfus, and Aryeh Kofsky, "The Syriac Inscriptions at the Entrance to Holy Sepulchre, Jerusalem," *Aram* 18–19 (2006–2007), 415–38.

Cahen, Claude. "Abdallatif al-Baghdadi, portraitiste et historien de son temps: Extraits inédits de ses mémoires," *Bulletin d'Études Orientales* 23 (1970), 101–28.

Clines, David J. A. "The Significance of the 'Sons of God' Episode (Genesis 6:1–4) in the Context of the 'Primeval History' (Genesis 1–11)," *Journal of the Study of the Old Testament* 13 (1979), 33–46.

Collins, Christiane C. and George R. Collins. "Monumentality: A Critical Matter in Modern Architecture," *Harvard Architecture Review* 4 (1984), 15–35.

Contadini, Anna. "Facets of Light: The Case of Rock Crystals," in *God is the Light of the Heavens and the Earth: Light in Islamic Art and Culture,* eds. Jonathan Bloom and Sheila Blair. New Haven: Yale University Press, 2015, 125–55.

Dawdy, Shannon Lee. *Patina: A Profane Archaeology.* Chicago: University of Chicago Press, 2016.

Deér, József. *The Dynastic Porphyry Tombs of the Norman Period in Sicily.* Trans. G. A. Gillhoff. Cambridge, MA: Harvard University Press, 1959.

Durand, Maximilien. *Parfum de sainteté.* Paris: Les Allusifs, 2007.

Erdmann, Kurt. "Islamische Bergkristallarbeiten," *Jahrbuch der königlichen Preussichen Kunstsammlungen* 61 (1940), 125–46.

Erdmann, Kurt. "Fatimid Rock Crystals," *Oriental Art* 3 (1951), 142–46.

Erdmann, Kurt. "Die fatimidischen Bergkristallkannen," in *Wandlungen christlicher Kunst im Mittelalter.* Baden Baden: Verlag für Kunst und Wissenschaft, 1953, 189–205.

Erdmann Kurt. "Neue islamische Bergkristalle," *Ars Orientalis* 3 (1959), 200–05.

Fillitz, Hermann "Das Kreuzreliquiar Heinrichs II. in der Münchener Residenz," *Münchner Jahrbuch der bildenden Kunst* 3, nos. 9–10 (1958–59), 15–31.

Fischer, Moshe L. and Tziona Grossmark, "Marble Import and *Marmorarii* in Eretz-Israel during the Roman and Byzantine Period," *Eretz-Israel: Archaeological, Historical and Geographical Studies* 25 (1996), 471–83.

Flood, Finbarr B. "Animal, Vegetal, and Mineral: Ambiguity and Efficacy in the Nishapur Wall Painting," *Representations* 133 (2016), 20–58.

Frazier, Ian. "Patina: How the Statue of Liberty Colors the City," *New Yorker,* September 19, 2016, 46–49.

Freedman, Paul. *Out of the East: Spices and the Medieval Imagination.* New Haven: Yale University Press, 2008.

"The Hanged Poems: The Poem of Imru-ul-Quais." Trans. F. E. Johnson, with revision by Sheikh Faiz-ullah-bhai. In *The Sacred Books and Early Literature of the East,* vol. 5: *Ancient Arabia,* ed. Charles F. Horne. New York: Parke, Austin, and Lipscomb, 1917.

Harmanşah, Ömür. "Monuments and Memory: Architecture and Visual Culture in Ancient Anatolian History," in *The Oxford Handbook of Ancient Anatolia, 10,000–323 B.C.E.,*

eds. Sharon R. Steadman and Gregory McMahon. Oxford: Oxford University Press, 2011, 623–51.

Herklotz, Ingo and Paolo Delogu, *"Sepulcra" e "Monumenta" del Medioevo. Studi sull'arte sepolcrale in Italia*. Rome: Rari Nantes, 1985.

Houben, Hubert. *Roger II of Sicily: A Ruler between East and West*. Trans. Graham A. Loud and Diane Milburn. New York: Cambridge University Press, 2002.

Huyssen, Andreas. "Monumental Seduction," *New German Critique* 69 (1996), 181–200.

Kahle, Paul "Bergkristall, "Glas und Glasflüsse nach dem Steinbuch von el-Berúní," *Zeitschrift der deutschen morgenländischen Gesellschaft* 15 (1936), 322–56.

Klein, Holger A. *Byzanz, der Westen und das "wahre" Kreuz: die Geschichte einer Reliquie und ihrer künstlerischen Fassung in Byzanz und im Abendland*. Wiesbaden: Reichert, 2004.

Krenkow, Fritz. ed. *Kitāb al-Jamāhir fi Ma'rifat al Jawāhir*. Hyderabad: Maṭba'at Jam'īyat Dā'irat al-Ma'ārif al-'Uthmānīyah, 1936.

Kubler, George. *The Shape of Time: Remarks on the History of Things*. New Haven: Yale University Press, 1962.

Kubler, G. "The Shape of Time Reconsidered," *Perspecta* 19 (1982), 112–21.

Lachenal, Lucilla de. *Spolia. Uso e reimpiego dell'antico dal III al XIV secolo*. Milan: Longanesi, 1995.

Lamm, Carl Johann. *Mittelalterliche Gläser und Steinschnittarbeiten aus dem Nahen Osten*, 2 vols. Berlin: D. Reimer, 1929–30

Latour, Bruno. "Reflections on Étienne Souriau's *Les différent modes d'existence*." Trans. Stephen Muecke. In *The Speculative Turn: Continental Materialism and Realism*, eds. Levi R. Bryant et al. Melbourne: re.press, 2010.

Leuschner, Eckhard and Mark R. Hesslinger, eds., *Das Bild Gottes in Judentum, Christentum und Islam: Vom Alten Testament bis zum Karikaturenstreit*. Petersberg: Michael Imhof, 2009.

Malafouris, Lambros. *How Things Shape the Mind: A Theory of Material Engagement*. Cambridge, MA: MIT Press, 2013.

Marion, Jean-Luc. *God without Being: Hors-Texte*. Trans. Thomas A. Carlson. Chicago: University of Chicago Press, 1991.

Maupeu, Sarah, Kerstin Schankweiler, and Stefanie Stallschus, eds., *Im Maschenwerk der Kunstgeschichte: eine Revision von George Kublers "The Shape of Time"*. Berlin: Kulturverlag Kadmos, 2014.

McClung Fleming, E. "Artifact Study: A Proposed Model," *Winterthur Portfolio* 9 (1974), 153–73.

Milwright, Marcus "The Balsam of Matariyya: An Exploration of a Medieval Panacea," *Bulletin of the School of Oriental and African Studies* 66, no. 2 (2003), 193–209.

Milstein, Rachel. "The Iconography of Moses in Islamic Art," *Jewish Art* 12–13 (1986–87), 199–212.

Milstein, Rachel, Karin Rührdanz, and Barbara Schmitz, *Stories of the Prophets: Illustrated Manuscripts of Qisas als-Anbiyā'*. Costa Mesa, CA: Mazda Publishers, 1999.

Nagel, Alexander. "Style-Eating Granite," *Cabinet* 53 (2014), 81–84.

Northedge, Alastair. *The Historical Topography of Samarra*. London: British School of Archaeology in Iraq, 2005.

Northedge, Alastair and Derek Kennet. *Archaeological Atlas of Samarra*. London: British Institute for the Study of Iraq, 2015.

O'Kane, Bernard. "Monumentality in Mamluk and Mongol Art and Architecture," *Art History* 19, no. 4 (1996), 499–522.

Osborne, James S. "Monuments and Monumentality," in *Approaching Monumentality in Archaeology*, ed. James S. Osborne. Albany: State University of New York, 2014.

Pentcheva, Bissera V. "Hagia Sophia and Multisensory Aesthetics," *Gesta* 50, no. 2 (2011), 93–111.

Rice, David S. "A Datable Islamic Rock Crystal," *Oriental Art* 2 (1956), 85–93.

Ritter, Markus and Nourane Ben Azzouna, *Der Goldkoran aus der Zeit der Seldschuken und Atabegs: vollständige Faksimile-Ausgabe von Cod. arab. 1112 der Bayerischen Staatsbibliothek München.* Graz: Akademische Druck- u. Verlagsanstalt, 2015.

Rogers, J. M., ed. *Empire of the Sultans: Ottoman Art from the Khalili Collection.* London: Nour Foundation, 2000.

Sanders, Paula. *Ritual, Politics, and the City in Fatimid Cairo.* Albany, NY: State University of New York Press, 1994.

Schramm, Percy Ernst and Florentine Mütherich, *Denkmale der deutschen Könige und Kaiser,* vol. 1: *Ein Beitrag zur Herrschergeschichte von Karl dem Großen bis Friedrich II. 768–1250.* Munich: Prestel, 1962.

Sert, José Luis, Fernand Léger, and Sigfried Giedion. "Nine Points on Monumentality," *Harvard Architecture Review* 4 (1984), 62–63.

Shalem, Avinoam. "Fountains of Light: The Meaning of Medieval Islamic Rock Crystal Lamps," *Muqarnas* 11 (1994), 1–11.

Shalem, Avinoam. "Bi'r al-Waraqa: Legend and Truth; A Note on Medieval Sacred Geography," *Palestine Exploration Quarterly* 27 (January–June 1995), 50–61.

Shalem, Avinoam. *Islam Christianized: Islamic Portable Objects in the Medieval Church Treasuries of the Latin West.* Frankfurt am Main: Peter Lang, 1996.

Shalem, Avinoam "Islamic Rock Crystal Vessels—Scent or *Ampullae?*," *Bamberger Symposium: Rezeption in der islamischen Kunst, Beiruter Texte und Studien* 61 (1999), 289–99.

Shalem, Avinoam. "Verbildlichung Allahs: Für eine andere Bildtheorie," in *Das Bild Gottes in Judentum, Christentum und Islam: Vom Alten Testament bis zum Karikaturenstreit,* eds. Eckhard Leuschner and Mark R. Hesslinger. Petersberg: Michael Imhof, 2009, 81–92.

Shalem, Avinoam and Eva Maria Troelenberg, "Beyond Grammar and Taxonomy: Some Thoughts on Cognitive Experiences and Responsive Islamic Ornaments," in *Beiträge zur islamischen Kunst und Archäologie,* vol. 3, ed. Ernst-Herzfeld-Gesellschaft. Wiesbaden: Reichert Publishing House, 2012, 385–410.

Schapiro, Meyer. "On the Aesthetic Attitude in Romanesque Art," in *Romanesque Art: Selected Papers.* New York: George Braziller, 1977, 1–27.

Stern, S. M. "'Abd al-Latif al-Baghdadi," in *Encyclopaedia of Islam,* 2nd ed., vol. 1. Leiden: Brill, 1986.

Thurlkill, Mary. *Sacred Scents in Early Christianity and Islam.* Lanham: Lexington Books, 2016.

Toorawa, Shawkat M. "Abd al-Latif al-Baghdadi," in *Interpreting the Self: Autobiography in the Arabic Literary Tradition,* ed. Dwight F. Reynolds. Berkeley: University of California Press, 2001, 156–64.

Toorawa, S. "The Educational Background of 'Abd al-Latif al-Baghdadi," *Muslim Education Quarterly* 13, no. 3 (1996): 35–53.

Toussaint, Gia. "Cosmopolitan Claims: Islamicate Spolia during the Reign of King Henry II, 1002–1024," *Medieval History Journal* 15, no. 2 (2012), 299–318.

WanderKam, James C. "The Enoch Literature," Guest Lectures, School of Divinity, University of Saint Andrews, 1997), available at www.st-andrews.ac.uk/divinity/rt/otp/guestlectures/vanderkam (accessed December 11, 2017).

Watson, Andrew M. "Back to Gold—and Silver," *Economic History Review* 20, no. 1 (1967), 1–34.

Winter, Irene J. "'Idols of the Kings': Royal Images as Recipients of Ritual Action in Ancient Mesopotamia," *Journal of Ritual Studies* 6, no. 1 (1992), 13–42.

Wheeler, Brannon. *Mecca and Eden: Ritual, Relics, and Territory in Islam.* Chicago: University of Chicago Press, 2006.

Young, James E. "The Counter-monument: Memory against Itself in Germany Today," *Critical Inquiry* 18 (1992), 267–96.

12 Sarah Sze's *The Last Garden* and the Temporality of Wonder

Christine Ross

> The gentle simplicity of the installation slowed me to a tiptoeing pace—moving with a sense of wonder, I revelled at each new discovery I made, and there was such an epic beauty in that.[1]

> . . . we walked into this garden and stumbled across these pieces that take you so much by surprise.[2]

This chapter sets out to examine some of the unique temporalities coming out from the ongoing dialogue between contemporary art, new materialism, speculative realism, object-oriented philosophy, and affective studies. New materialist and speculative investigations of change—especially studies that propose to explain how change occurs by examining the materiality and relationality of objects, things and events—have been rather rich in that regard. Investigations adopting a feminist new materialist perspective include: Rosi Braidotti's study of metamorphosis as a reformulation of becoming and Elizabeth Grosz's examination of the productive forces of duration, becoming and untimeliness; Jane Bennett's analysis of the vibrancy of matter; Rebecca Coleman's notion of time "as non-linear, as intensive and immanent . . . where time doesn't [only] move from the present to the future, but where the future is experienced in and as the present, as that which must be acted on now"; and Rachel Lowen Walker's "living" present (a present always stretching as opposed to a static "now").[3] Adopting a more speculative—realist—investigation of change, they also include: Manuel DeLanda's re-reading of Gilles Deleuze's Chronos (immaterial linear time; time as destiny and certainty) versus Aion (material time; time as possibility and uncertainty) to explain how virtuality emerges from the actual world; Jussi Parikka's talk of processual materiality; and Steven Shaviro's accelerationism as a way "to get beyond the current social and economic order and reach a post-capitalist future."[4]

Artistic and curatorial practices of the 2010s have been negotiating with these philosophical theories and concepts, both explicitly and obliquely. This is especially manifest in practices engaged in the aesthetic investigation of the object, the agency of things, realism, and materialism, as well as the aesthetic contemplation of reality beyond the confines of human finitude. These forms of artistic engagement probe the relationality between humans and non-humans to think time in terms of transformation, change, generation, and emergence—an impulse toward the living.[5] They often do so by overtly or implicitly mixing the new materialist promotion of relations over autonomous objects and the object-oriented ontological (OOO) defense of objects as realities that exceed their relation to humans. Hence, although new materialism has been noticeably rich in its conceptualization of temporality and although OOO has

not been particularly innovative in that area (except for its insistence on the present as a temporality that unfolds in the sensual realm of objects), artistic practices have nevertheless explored some of OOO's valued operations—withdrawal, objecthood, and vicariousness—as temporal.[6] This mixture counters the increased philosophical polarization between new materialism and OOO. As it combines them, art necessarily re-defines the concepts of both camps. These translations and distortions (concepts that OOO supports to explain the modus operandi of knowledge-making) are salutary, for it is in such operations that insightful re-formulations of temporality are in fact appearing.

Installations by American artist Sarah Sze are pivotal to this dialogue. Fully engaged in an object-driven investigation of time, they set into play a loose mobilization of new materialist and object-oriented philosophical insights to elaborate what I would like to call a *temporality of wonder*. In the following, I focus on Sze's *The Last Garden (Landscape of Events Suspended Indefinitely)*, a garden made for the 2015 56th Venice Biennale International Art Exhibition, as part of the biennale curator Okwui Enwezor's *All the World's Futures* exhibition. My main objective is to tease out the inventive temporalities elaborated in that work by following its connections with new materialism and OOO. I am not arguing here that the garden is a direct response to or engagement with new materialism and OOO. Rather, I am contending that the active dialogue between contemporary art, new materialism, and object-oriented philosophy offers a point of entry into *The Last Garden*'s temporal investigations. This chapter asks: if, as new materialists have contended, certain temporalities indeed act as productive forces (forces that generate new objects or are the dimension by which things change, evolve, differ, or transform themselves), how can materiality and historicity be conveyed to these temporalities? In other words, what type of temporalities matter in this historical moment and how does Sze's practice participate in that mattering? My main claim is that the temporal significance of Sze's mid-2010s work, of which *The Last Garden* is a critical instantiation, lies in its development of wonder—an affective form of temporality that comes about when we encounter objects "*as if* for the first time," surprising us and moving us in that surprise—as a condition of possibility of the future.[7] The work of two thinkers, object-oriented philosopher Graham Harman and new materialist philosopher Catherine Malabou, will be put into dialogue with Sze's work to help specify the materiality (and, more specifically, the affectivity) and historicity of that temporality.

From *Triple Point* to *The Last Garden*

In 2013, Sze represented the United States at the 55th Venice Biennale with a sequence of installations presented in the American Pavilion, under the title of *Triple Point*. The installations were in continuity with Sze's previous work and its preoccupation with objects—more specifically, the accumulation but also the assemblage of everyday, generic, mass-produced objects, including: office supplies, electric lights, desk lamps, string, fans, water systems, houseplants, birthday candles, napkins, batteries, packing material, colored yarn, empty plastic water bottles, and tins of paint. Sze has often spoken of her interest in the lives of objects, in the ways in which objects change value and meaning through labor, treatment, or context, and the means by which they can acquire an aesthetic value. The mutability of objects in *Triple Point*—"[t]his idea that objects, like experiences, are ultimately fleeting, ephemeral, and located in a very

specific moment"—was made manifest in the pavilion's multiple displays of objects, which gave them different meanings and functions.[8]

But mutability was not the sole temporality sustaining *Triple Point's* installations. The ordering of the objects and connecting devices, as well as the labor-intensiveness by which they were assembled showed objects to be one of the vital means by which human actors locate themselves in time and space, not only socially and physically but also psychologically and emotionally. Sze described them as orientation devices—as "tools to calculate time, measure space, understand behavior."[9] Troubling that function of orientation, *Triple Point* conveyed the sense that these tools were not endlessly effective: some objects were so interdependently connected that the break or displacement of one of these would likely cause the collapse of the structures. As one critic phrased it about similar work made in the 2000s, each installation "holds things together . . . taking no pains to hide a careful choreography of metal rods and wire that renders the work's elements neither a collection of autonomous bits nor a fully seamless unit. Each of the various components appears to depend on one another, like organs in a body performing equally necessary functions. They are assembled in a precarious, mutable chain of causes and effects."[10] In his own review of the show, art historian Benjamin Buchloh saw the assemblages both as a manifestation of and a remedy to precariousness. He more specifically maintained that the accumulation of the objects disclosed today's "ceaseless proliferations" of objects and the "sense of a definitive loss not only of the utilitarian dimensions of objects but even of their groundedness in matter, structure, and process" that have come to characterize the "monumental legitimation of the commodity regime."[11] He convincingly argued that Sze's *Triple Point* was a critical response to this intensified regime of commodification and the traumatism by which we experience objects under that regime. As a provisional response to that regime, the installations set into play the perceptual and cognitive activities of classification and typology as "operative counterforces" to the traumatism of its experience.[12]

Two years later, in the context of the 2015 56th Venice Biennale and as part of the exhibition *All the World's Futures*, Sze was invited to create a new installation. The work maintained Sze's understanding of objects as orientation devices, but the entangled assemblage effect of the *Triple Point* installations was sensibly diminished. Entitled *The Last Garden (Landscape of Events Suspended Indefinitely)* (2015), it consisted more of an environment than an installation—an open-air expanse and not a sheltered grouping of objects tightly connected together (Figure 12.1). In contrast to *Triple Point*, withdrawal became one of the environment's main operations. If objects continued to work as counterforces to trauma, as I believe they were, that effectiveness had more to do with withdrawal than with the human capacity to order the proliferation of objects.

To begin to understand that shift and the temporality it generated, let us have a close look at the five main levels of withdrawal sustained by the garden. First, *The Last Garden* was geographically withdrawn, located behind the Arsenale's Corderie and the Gaggiandre buildings, in the remote Giardino delle Vergini of a former monastery at the utter limits of the Biennale's spread, partly delimited by decaying brick walls. A minimalist intervention within a hidden and abandoned garden, it was barely announced by the few yellow strips surrounding the row of trees at the entrance; these ambiguous strips could easily be interpreted as markers installed by a gardener. Second, the few artifacts installed in the garden—hammock structures, stringed rocks,

Figure 12.1 Sarah Sze, *The Last Garden (Landscape of Events Suspended Indefinitely)*, 2015, mixed media installation. Courtesy of the artist

metallic grids, photographs, paint strips, mirrors, a Foucault pendulum (a device that makes manifest the earth's rotation through the oscillation of its pendulum), empty plastic water bottles, a sink—were dispersed here and there, sometimes next to each other, but their assemblage did not follow the logic of accumulation. The assemblages were looser and scarce. Third, interactions between objects mostly occurred between the artifacts and natural elements—plants, wind, water, earth, the sun. These interactions provided an entropic evolution to the garden, leading to the slow irreversible transformation, de-differentiation, decay, and sometimes destruction of some of the artifacts, and to nature outgrowing (increasingly camouflaging) artifacts. Fourth, the hidden enclosure was itself composed of hidden worlds that were physically out of reach, although obliquely visible (and easily missed), as was the case with the micro-garden within the well only made visible by a mirror (Figure 12.2). Finally, some of the artifacts withdrew from the centrality of human visitors, as their human destination was suspended to reinforce their usefulness for non-human elements.

That last point is key because it showed withdrawal to be a non-anthropocentric operation. This disruption of anthropocentricism can be further elucidated if we consider one of the main components of the garden—the nylon hammock-like structure strung between two trees with a piece of rock, suspended on a string, dangling just above it—and contrast it with Gabriel Orozco's *Hammock Hanging between Two Skyscrapers* (1993), a sculpture that *The Last Garden* re-enacts but also problematizes a great deal. Orozco's white cotton hammock was installed in the Museum of Modern Art's sculpture garden in the context of the *Projects 41* exhibition. Hung between two trees in front of the north wall, the hammock was hardly noticeable. Its droopy

Figure 12.2 Sarah Sze, *The Last Garden (Landscape of Events Suspended Indefinitely)*, 2015, mixed media installation. Courtesy of the artist

contour and parabolic shape, however, entered into a dialectical interchange with the standing viewers, to convey the possibility of a horizontal positioning of the viewer's body as he or she imagined using it, the possibility of sleep and the possibility of experiencing views of the sky when lying in the hammock. In *The Last Garden*, that

phenomenology significantly disappeared. The relationship between the hammock structure and the suspended rock confirmed the hammock's reluctance to receive a human body: there was simply not enough room between these two elements to allow for that reception; and that reception would have entailed disrupting the hovering dialogue between the suspended rock and the suspended hammock. Moreover, petal-like fragments were sometimes found occupying that space: *they* were the beings lying on the hammock. Human visitors were thus exposed to the temporality of non-human others. This ecological approach, but also the liminal and minimal quality of Sze's intervention discussed above, is key to the historical significance of wonder, to which I will return later.

The Withdrawal of Objects

Graham Harman's object-oriented philosophy helps to qualify and identify the pro-ductivity of withdrawal—a productivity that Sze's garden activated but also prob-lematized a great deal by temporalizing it. Again, it is not that the garden was a direct response to or engagement with OOO, but that Sze's investment in objects and in "the social life of things,"[13] as well as her privileging of relations over autonomous objects while still advocating for withdrawal, obliquely engages with new materialism and OOO. In a 2016 interview with Enwezor, she explains that her sculptural practice is "as much about the dispersal of objects as the agglomeration of objects."[14] As an object-oriented aesthetics privileging the relationality of objects, her work both solic-its and complicates OOO's notion of withdrawal.

OOO's central principle is that all objects (a category that includes humans and non-humans) withdraw from access and that it is only the sensual qualities of objects that are accessible.[15] They withdraw in the sense that they never touch, except sensu-ally. This principle goes hand in hand with the assumption "that all objects are equally objects, though not all are equally real": real objects are autonomous, whereas sensual objects depend on the entities they encounter.[16] Objects have a surplus reality—they "are sleeping giants holding their forces in reserve, and do not unleash all their ener-gies at once"—that exceeds their sensuality and especially the human consciousness of objects.[17] That surplus is what accounts for the realness of the objects: forms of knowledge (any discipline that seeks to know objects) and our practical use of objects can never exhaust the being of objects, which exist not only beyond human finitude but also beyond any relation whatsoever. This is what Harman means when he says that the surplus of rocks, for example, "is not the result of some sad limitation of human or animal consciousness. Instead, rocks themselves are not fully deployed or exhausted by *any* of their actions or relations. When a rock smashes a window, these two entities come into contact in only the most minimal fashion, never sounding one another's depths. Direct contact is actually quite impossible. Not only must knowl-edge be indirect but causal relations can only be indirect as well."[18]

Harman's main rationale for postulating withdrawal is the need to account for emergence and change in a world where stability, rather than contingency, is the norm.[19] OOO contests the undermining perspective supported by physics and, some-times, new materialism, according to which objects depend on their components—a perspective that cannot account for emergence and the relative autonomy of objects from their constituent parts. It also contests the typically new materialist insistence on objects as relations or actions to the detriment of the objects—a perspective that fails

to account for change, the surplus of reality of objects beyond what they transform. Although its view of new materialism is reductive and questionable (new materialism does in fact explain change, but does it by approaching the world as predominantly contingent), I believe that OOO's insistence on withdrawal is productive in the following sense: withdrawal means that objects are not easily changeable. Objects hold a hidden surplus in reserve, beyond their sensual phenomenal presentation. Therefore, they are not fully perceivable, explainable, mastered, controlled, exhausted, or reducible. This surplus is indicative of the object's capacity to "surprise" us, or any non-human observer, as it emerges or changes against all expectations. That specific understanding of withdrawal helps to specify its role in Sze's *The Last Garden*: the surplus any object in the garden holds in reserve is what potentially enables it to surprise us humans—to make us wonder—when it changes or emerges. That surplus cannot be directly perceived, but some objects can work as mediators, intermediaries, or vicars to make it indirectly perceivable.

However, as we observe the interactions at play in Sze's environment, the OOO principle of withdrawal starts to wobble. It gains in neo-materialism. It does so at least for two reasons. First, object-oriented philosophy has a narrow definition of temporality because it postulates that time only concerns the sensual world. Objects do not easily change; they are quasi-eternal essences or forms.[20] In contrast, though *The Last Garden* insists on the withdrawal of things, it turns it into a sensual and temporalizing operation since it is the operation by which wonder—what Harman calls surprise and what new materialist philosopher Catherine Malabou defines as "the capacity to be amazed"—is potentially experienced by the beholder.[21]

Second, *The Last Garden* integrates withdrawal as a fundamental organization principle not despite, below, or above, but amidst relationality. Relationality (let us follow new materialist philosopher Rebekah Sheldon on this point) "begins from the assumption that ideas and things do not occupy separate ontological orders but instead are co-constituents in the production of the real . . . Matter draws together what appears separate and makes the totality subject to mutation and emergence."[22] *The Last Garden* never abandons that assumption of co-constituency; it supports nature's transformation of the artifacts and the artifacts' underlining of natural elements. However, it also re-defines the experience of relations by moving away from the new materialist assumption that everything is related to everything within ecosystems that are always immanent. As will be explained further below, it makes withdrawal and relations benefit from each other to create wonder, making full use of what Harman calls "vicarious causation"—the capacity of objects to relate through a third mediating object that functions as a vicar. In *The Last Garden*, most of the artifacts work as mediators between objects; their main function is to allow invisible objects to become partly visible and to amaze us in that very process.

In short, *The Last Garden* activates these two concerns tightly together: the artifacts—when they are seen, a reality which is never guaranteed—orient viewers toward the withdrawn and the withdrawn is the reality by which art defines itself as a practice of discovery. The bright colors of the objects (red, yellow, blue) and the re-iteration of blue throughout the garden catch the approaching human visitor's vision: they have a performative stance because they help visitors orient themselves in time and space. In so doing, the artifacts signal the presence of other not-so-easily-perceived, unperceived, or unperceivable cultural or natural objects. At the same time, the withdrawn can be partly discovered even if never resolved: it creates the sensory

threshold conditions by which art re-invents itself as a wondering activity. So, why is this mutual operation about temporality? The answer, which will be developed in the remaining of this chapter, is a twofold one: I want to argue that mediation, relationality, and withdrawal act together to create wonder—an affect that continental philosophy and contemporary neurobiology recurrently consider the most fundamental of all affects; and I also want to argue that wonder is itself a temporality, a productive force of transformation and, as such, a condition of possibility of the future, what Malabou designates as "the introduction of time within identity."[23]

All the World's Futures

As stipulated above, Sze's environment was made in the context of *All the World's Futures*. Enwezor stated that the biennale exhibition was conceived as an answer to the precariousness of the world affected by the 2008 financial crisis:

> I came to this title because I was imagining what role a Biennale could play in a moment of such uncertainty. I cannot remember a time more precarious, more foreboding, than the current moment . . . We have reached a point where we cannot have one homogenized narrative, one view of the future, a singular idea of what constitutes the good life . . .[24]

Enwezor's was a curatorial attempt to establish a dialogue between art, politics, and the economy in temporal terms—as a deliberation oriented toward the enabling of future(s)—an echo to Buchloh's previous comment about how Sze's *Triple Point* worked as operative counterforces to the traumatic conditions of the present.

Arguably, Sze's environment responded to Enwezor's concerns not by providing a content or narrative as to what the future is or what it could or should be. As systems theory sociologist Niklas Luhmann has convincingly argued elsewhere, "The future never becomes present; it never begins but always moves away when we seem to approach it": in light of that fleetingness and instead of endlessly waiting for the future to materialize, the "more pressing need might well be to describe the present condition, but then we might have to acknowledge that there are many possible descriptions, so that we will have to move from first-order to second-order descriptions."[25] In response to Enwezor's concern for futurity, Sze's environment did not imagine a future, but, following a Luhmannesque perspective, attended to the present condition to potentialize the future. It did so, and this is my main claim, by materializing one particular means of futurity: the subject's capacity to wonder—the capacity to be affected and not to retreat into indifference. That capacity is itself a form of temporality.

Objects as Mediators

To begin our discussion on wonder as the primary affect of temporality, let us first look at how wonder worked in the garden. As will be shown, wonder was the affect by which the human visitor was oriented throughout the garden as some objects highlighted or revealed—without resolving—the withdrawn and as the withdrawn oriented art toward a wondering practice.

If we adopt media historian and philosopher John Durham Peters' definition of media as amphibious—as infrastructures living or able to live both on land and in

water, or connecting land and water, combining qualities of nature and culture—*The Last Garden* can be said to be an environment of objects that worked as media and whose main function was now (compared to *Triple Point*) more about disclosure than orientation, or about orientation as a mode of disclosure: they revealed objects which would have been otherwise unperceived, unobserved, unnoticed.[26] Natural and cultural objects disclosed one another, becoming land and water affordances to each other. The blue hammock-like structure revealed the plants invading it, but also the wind moving it. It underlined the rock above it (both of them moved although differently with the wind) and showed the rock to be a miniature landscape within the larger landscape. The bright blue that punctuated the whole garden helped visitors perceive the deceptively unremarkable parts of the garden: the sink, the metal grids, the trees, the plants, the nest, the walls, earth, and various sounds of water. The back wall mirror disclosed an otherwise invisible and inaccessible well, reflecting the hammock hidden inside. The other mirror disclosed any human or non-human visitor approaching the sink. As human visitors got closer to the revived sink, they could hear the water; the bottles on and in the sink were media that made the water containable and transportable, but they were empty and, because of that emptiness, emphasized the running water they did not contain, and from that view and sound one's imagining of the canal beyond the enclosure. Photographs of water and of the sky were folded and inserted into the cracks of the back wall. Notice how they were inside the wall and not simply on a wall reduced to a background; as such, they invited the viewer to observe the materiality of the bricks sheltering them and to follow a weaving vertical line leading to the sky. Sze called this "turning the volume up": "This place," she continues, "is so layered. Feel the layers of history. I wanted to sort of trace that history, to highlight it . . . to actually turn the volume up on your sense of every part of the space, even your sense of sound, sense of light, sense of nature."[27]

This continual process of discovery of the withdrawn enabled by the mediating function of the objects was intensified by the entropic quality of the garden. *The Last Garden* was abandoned to the tendency for all matter and energy in the universe to evolve toward a state of inert uniformity; the inescapable steady deterioration of a system following the second law of thermodynamics, which states that in any irreversible process, entropy always increases. Some of the artifacts were invaded by natural elements and others fell apart (notably, the black material in the sink, slowly eroded by the dripping water). As Peters has also observed about media: "Despite the interconvertibility of storage and transmission, time and space, and the time-confounding powers of recording, nothing in the end can stop the universe from degrading, and it degrades in a linear path towards chaos rather than order. Time is likely the effect of cosmic entropy, the tendency of everything to run down steadily in one direction."[28] And yet surprisingly, although some objects were decaying, some of them resisted even if inevitably slightly changed (the main hammock and the bottles, for instance), despite the six months of their exposure to the natural elements of water, wind, and sun. Some objects were shown not to be fully reducible to the laws that govern them: as a surplus, they transformed themselves and did not simply die in that timespan.

The Temporality of Wonder

Sze has often stated that the consideration of the viewer is crucial to the structuring of her work: "There's a consideration of how the viewer will see it at every point—even

what one sees peripherally when looking at other things . . . I always want to find out how you enter, what you will see first, what leads you to your experience of the work, and then what you will see last. The viewer's perspective [and how information is revealed to viewers as they move through time and space] are for me actually what the experience of the work is always about."[29] About *The Last Garden*, she wanted "discovery" and "amazement" to be the way in which the viewer entered, circulated, and experienced the environment:

> This idea of discovery in my work is something I like to put the volume up on . . . this location [works] in a very different way than the American Pavilion where you go right there; you often stand in line; it's told to you that it's important. This is exactly the opposite. This is a place where you come to the door and you don't even know if it's art or not. And you find the art. So your first impression of the art is that you've discovered it. It wasn't presented to you . . . This is a great opportunity to be in a place, which is a hidden entropic place within which you find these smaller entropic places . . . At each place there is that amazement of finding more . . .[30]

This amazement state of affairs—a discovery process made possible by the objects' mutual role of mediation and withdrawal—was fully assumed. The artist was aware that withdrawal meant that *The Last Garden* would largely be missed (Sze: "Maybe only 2% of the people who come to the Biennale will see it. But I think that for these two people it will be a very unique memory . . . and I think also the story of it . . . the telling of the story of what happened, what it was, is actually in many ways as important as the numbers.")[31] The environment orchestrated discovery at the limit of its possibility. The affective occurrence of discovery is best designated by the concept of wonder (surprise, astonishment, amazement, and awe). In the words of feminist phenomenologist Sara Ahmed, wonder is the affect that unfolds when the object that appears is encountered "*as if* for the first time"; it has a transformative impact on our perception of the world:

> Wonder is an encounter with an object that one does not recognize, or wonder works to transform the ordinary, which is already recognized, into the extraordinary. As such, wonder expands our field of vision and touch. Wonder is the pre-condition of the exposure of the subject to the world: we wonder when we are moved by that which we face . . . I would suggest that wonder allows us to see the surfaces of the world as *made*, and as such wonder opens up rather than suspends historicity.[32]

Sze's garden mobilized wonder specifically in these terms: its intersection of withdrawal and relations between withdrawn objects turned "the volume up" on our sense of the site, including the layers of history of that site; it prepared but never guaranteed the viewer's experience of wonder, by which the viewer notices the complexity of a *Umwelt* (milieu), is touched by it, and is transformed in that encounter. What we have just described as occurring when the human viewers circulate in the garden— objects acting as amphibious revelatory media to indirectly yet never fully disclose the withdrawn and the surplus they hold in reserve—can thus be complicated as we develop our dialogue between new materialism, speculative realism, affective studies,

and contemporary art. How is wondering temporal, i.e. how does it generate temporality? Why is that temporality historically important? And how can it be understood as a pivotal condition of possibility of the future?

New materialism, at least in the work of Jane Bennett and Catherine Malabou, associates the affect of wonder with vitality and the subject's capacity to be touched. Particularly relevant to the aesthetics of wonder is the dialogue that Malabou establishes between neuroscience and the continental philosophical tradition of emotions and passions. Hers is an attempt to materialize that tradition by confronting it with the biological findings of neuroscience. Malabou is particularity interested in how Derrida's reading of Descartes and Deleuze's reading of Spinoza discredit the Kantian notion of affect as an autoaffectation (autoaffectation being a concept coined by Heidegger in his own reading of Kant). Autoaffectation is the process by which the subject is in touch with itself and modified in that touch "by the impact of an encounter (with another subject or object)."[33] In Kantian metaphysics, subjectivity is self-affecting. Heidegger's, Derrida's, and Deleuze's critical reading of that definition is crucial for our understanding of wonder. I will identify three reasons why this is so.

First, the critique of affect as a mere autoaffectation shows that affects are temporalities. This is Heidegger's conclusion as he reads Kant's study of affects: an affect is the auto-affecting process by which the subject is not only in touch with itself but also modified in that touch following its encounter with another subject or object. Affect introduces a "temporal difference between the self and itself."[34] Malabou insists on that point: for continental philosophy after Heidegger, autoaffectation—affects in general and wonder in particular—is the very "introduction of time within identity."[35] Time is the productive force by which transformation occurs. Second, post-Kantian philosophy (but also neurobiology) seeks to complicate the definition of affect as autoaffectation. Derrida's deconstructive reading of Descartes's *Passions of the Soul* shows that there is no pure autoaffectation. More precisely, there is no autoaffectation without a hetero-affectation—which is to say that the other is always involved in the deployment of affects; autoaffectation takes place in "my being affected by the other in me" as well as the other outside me.[36] And Deleuze's reading of Spinoza's study of passions shows that subjectivity is constituted by affects that pre-exist it. These two philosophical readings are decisive for the evolution of the concept: they claim that subjects and affects do not coincide. For Malabou, contemporary neurobiology is even more radical in its challenge of autoaffectation. Why? Because the wounded patients of neurobiology are, from the start, deserted subjects—subjects whose capacity to feel is lost. And while that loss is still reversible for Spinoza, contemporary neuroscience postulates that it is in some cases—as it is for patients suffering from Alzheimer's—irretrievable. Third, in the continental philosophical tradition but also in contemporary neuroscience, the affect of wonder has a special place in relation to other affects: it is a primary affect. This is certainly true of Descartes's *The Passions of the Soul*, which designates wonder as the primary emotion of the six primitive passions of the soul. Spinoza also supports the primacy of wonder, although in his *Ethics* he finally affirms that joy, sorrow, and desire are the primary affects. What does that primary role entail? Basically, for Malabou, it entails that: "Without the capacity to be surprised by objects, the subject wouldn't be able to have a feeling of itself."[37] As such, "wonder is what attunes the subject both to the world and to itself."[38] Malabou emphasizes the ambivalence of that fundamental role: "What are the soul, or the mind struck by: the surprising object or its own capacity to be surprised? What does

the soul or the mind wonder at: the other or themselves?"[39] This ambivalence is what makes wonder especially interesting as an affect; its occurrence lies between autoaffectation and hetero-affectation.

What makes Malabou's take on affect especially relevant to artistic practices invested in the affect of wonder (as I claim it to be to Sarah Sze's work) is its consideration of the neurobiological study of brain plasticity—not only the brain's capacity to change "continuously throughout life, in response to everything we do and everything we have," but also how traumatic imprints can orient that plasticity destructively.[40] Malabou relies here on the work of neurobiologist António Damásio, which shows that subjects with an impaired prefrontal cortex (the zone of the brain responsible for the interpretation of emotional stimuli) are disconnected from emotional experience. Damásio's research suggests that this impairment can be expanded to include homeless people, the depressed, victims of abuse, and persons suffering from post-traumatic stress disorder. For Malabou, Damásio's conclusion is decisive: "*the loss of wonder is the emotional and libidinal disease of our time.*"[41] She names this loss a "hetero-heteroaffection," a state in which the loss of the subject's capacity to wonder is significant enough to erase the subject, leaving in its place an utterly dissimilar subject. Considering the intimate relationship between wonder and temporality, the loss of the subject's capacity to feel is also a loss of temporality; it entails a subject "whose present does not stem from any past, whose future has no future."[42] Primary and endangered by what Malabou calls a spreading politics of indifference, it is an affect that needs taking care of, insofar as the loss of wonder produces an indifferent—disaffected—subject; a subject unable to attune itself to the world and to itself.

Why is the new materialist postulation of wonder as a temporality crucial to our understanding of Sze's work? The answer to that question is twofold. By activating wonder (what Sze calls amazement and discovery), *The Last Garden* can be seen as an environment that activates a special form of temporality—temporality as a force of alteration generated when a subject is in touch with itself and touched by others through affects. In so doing, it should be seen as attending to and taking care of a threatened affective temporality whose existence or re-invention must be secured to enable open, touchable, caring, and concerned forms of subjectivity. Our discussion of the work has shown that at least two operations come together to facilitate the human experience of wonder: withdrawal and the exploration of objects as amphibious media whose main function is to disclose the withdrawn without resolving it—that is, to turn the volume up on the unperceived, the barely perceivable, the under-perceived. To this function must be added two others: entropy and the partial suspension of anthropocentricism—operations that are themselves temporal (entropy as the irreversible degradation of matter and, in this work, the growing entanglement of nature and artifacts, and the problematization of anthropomorphism as a means by which the phenomenology of time can be alluded not only as a human but also a non-human animal or plant experience). Combined in this garden, all of these aesthetic operations work together to surprise the human visitor.

Of course, *The Last Garden* facilitates but certainly never guarantees wonder and it is hard to imagine how wonder could ever be guaranteed insofar as it takes its supply from withdrawal and from the withdrawn that a vicarious object might or might not partly reveal. Wonder, *The Last Garden* declared, is a way of approaching objects as sensory thresholds and as relatively autonomous (indifferent to us but "wanting"

us through that partial indifference). It takes its affective temporal dimension—the beholder's capacity to change when in touch with the other inside or outside of the self—from that approach. It also takes its historical significance from that approach. For, indeed, what is the historical significance of wonder? *The Last Garden* gives a perceptual, ecological, and affective response to that inquiry. By favoring wonder as an affect that might not occur, it certainly disrupts the over-programming of perception increasingly regulated by the participatory ethos of the contemporary museum. It can also be seen as unsettling the increased human domestication of nature in the age of the Anthropocene as a geological period where human activities are acknowledged as being the primary cause of global climate change and the large-scale destabilization of natural ecosystems—its intervention in the garden is minimal and its deployment is not altogether human-centric. Finally, and this is what this chapter has attempted to demonstrate, it took seriously the loss of wonder as the emotional and libidinal disease of our time—not necessarily repairing it, but sustaining the subject's capacity to be touched and not to be indifferent.

Notes

1. Rhiannon Vogl, "Venice Art Biennale: Affecting the Now," *Herd Magazine* 10 (2015), 48, www.herdmag.ca/wp-content/uploads/2012/11/Herd-Issue-10-1.pdf (accessed December 11, 2017).
2. "Margot Bowman," *Gilded Birds*, June 26, 2015, https://gildedbirds.com/2015/06/26/margot-bowman (accessed December 11, 2017).
3. Rosi Braidotti, *Metamorphoses: Towards a Materialist Theory of Becoming* (London: Polity, 2002); Elizabeth Grosz, *In the Nick of Time: Politics, Evolution and the Untimely* (Durham, NC: Duke University Press, 2004) and *Time Travels: Feminism, Nature, Power* (Durham, NC: Duke University Press, 2005); Jane Bennett, *Vibrant Matter: A Political Ecology of Things* (Durham, NC: Duke University Press, 2010); Rebecca Coleman, "Inventive Feminist Theory: Representation, Materiality and Intensive Time," *Women: A Cultural Review* 25, no. 1 (2014), 27–45; and Rachel Lowen Walker, "The Living Present as a Materialist Feminist Temporality," *Women: A Cultural Review* 25, no. 1 (2014), 46–61.
4. Manuel DeLanda, *Intensive Science and Virtual Philosophy* (London: Bloomsbury Academic, 2013); Jussi Parikka, "Radical Temporality and New Materialist Cultural Analysis," 2009, https://jussiparikka.net/2009/06/09/"radical-temporality-and-new-materialist-cultural-analysis" (accessed December 11, 2017); Steven Shaviro, *No Speed Limit: Three Essays on Accelerationism* (Minneapolis: University of Minnesota Press, 2015); and Charlie Ambler, "Is Consuming Like Crazy the Best Way to End Capitalism?," *Vice*, March 19, 2015, www.vice.com/read/is-consuming-like-crazy-the-best-way-to-end-capitalism-050 (accessed December 11, 2017).
5. See, for example, Laura Mclean-Ferris, "Indifferent Objects," *Art Monthly* 368 (July–August 2013), www.artmonthly.co.uk/magazine/site/article/indifferent-objects-by-laura-mclean-ferris-july-august-2013 (accessed December 11, 2017); Michelle Kasprzak, "OOO," *Art + Life + Technology*, June 28, 2013, https://michelle.kasprzak.ca/blog/archives/tag/ooo (accessed December 11, 2017); Robert Jackson, "If Materialism is Not the Solution, Then What was the Problem?", *Nordic Journal of Aesthetics* 24, no. 47 (2014), 111–24; and Graham Harman, "Art Without Relations," *ArtReview* 66, no. 6 (September 2014), 144–47.
6. On time in object-oriented philosophy, see especially Graham Harman, "Road to Objects," *continent* 1, no. 3 (2011), 176.
7. Sara Ahmed, *The Cultural Politics of Emotions* (New York: Routledge, 2004), 179.
8. Melissa Chiu, "The Line between Drawing and Sculpture: An Interview with Sarah Sze," in *Sarah Sze: Infinite Line*, eds. Melissa Chiu and Saskia Sassen (New York: Asia Society Museum, 2011), 12–13.

9. Chiu, "The Line between Drawing and Sculpture," 12.
10. Johanna Burton, "Sarah Sze: Objects, Food, and Rooms" in *Sarah Sze: Triple Point*, eds. Johanna Burton and Jennifer Egan (New York: Bronx Museum of Arts and Gregory R. Miller, 2013), 23.
11. Benjamin Buchloh, "The Entropic Encyclopedia," *Artforum* 52, no. 1 (September 2013), 315.
12. Buchloh, "The Entropic Encyclopedia," 316.
13. Arjun Appadurai, ed., *The Social Life of Things: Commodities in Cultural Perspective* (Cambridge: Cambridge University Press, 1986).
14. Artspace Editors, "Sarah Sze on Why She Had to Invent a New Way of Making Sculpture," *Artspace*, May 4, 2016, www.artspace.com/magazine/art_101/book_report/sarah-sze-okwui-enwezor-interview-53754 (accessed December 11, 2017).
15. Graham Harman, "Materialism is Not the Solution: On Matter, Form and Mimesis," *Nordic Journal of Aesthetics* 24, no. 47 (2014), 107.
16. Graham Harman, *Immaterialism* (London: Polity, 2016), 3.
17. Harman, *Immaterialism*, 6.
18. Graham Harman, "The Four Most Typical Objections to OOO (2011)," in *Bells and Whistles: More Speculative Realism* (Alresford: Zero Books, 2013), 32–33.
19. Harman, *Immaterialism*, 15.
20. Harman, "Road to Objects," 176; and Harman, *Immaterialism*, 17.
21. Catherine Malabou, "Go Wonder: Subjectivity and Affects in Neurobiological Times," in *Self and Emotional Life: Philosophy, Psychoanalysis, and Neuroscience*, eds. Adrian Johnston and Catherine Malabou (New York: Columbia University Press, 2013), 8.
22. Rebekah Sheldon, "Form/Matter/Chora: Object-Oriented Ontology and Feminist New Materialism," in *The Nonhuman Turn*, ed. Richard Grusin (Minneapolis: University of Minnesota Press, 2015), 196.
23. Malabou, "Go Wonder: Subjectivity and Affects in Neurobiological Times," 6.
24. Michelle Kuo, "Global Entry: Okwui Enwezor talks with Michelle Kuo about the 56th Venice Biennale," *Artforum* 53, no. 9 (May 2015), 85–86.
25. Niklas Luhmann, "The Paradoxy of Observing Systems," *Cultural Critique* 31 (autumn 1995), 51.
26. John Durham Peters, *The Marvelous Clouds: Toward a Philosophy of Elemental Media* (Chicago: University of Chicago Press, 2015), 49.
27. Sarah Sze, "Biennale Arte 2015-Sarah Sze," video, https://www.youtube.com/watch?v=QPdiYD2Ida8 (accessed December 11, 2017).
28. Peters, *The Marvelous Clouds*, 312.
29. Melissa Chiu, "The Line between Drawing and Sculpture," 13.
30. Victoria Miro Gallery, "Sarah Sze/The Last Garden/Venice," video, https://www.youtube.com/watch?v=WugFEAzpxsw (accessed December 11, 2017).
31. Victoria Miro Gallery, "Sarah Sze/The Last Garden/Venice."
32. Ahmed, *The Cultural Politics of Emotions*, 179 and 180.
33. Malabou, "Go Wonder," 5.
34. Malabou, "Go Wonder," 6.
35. Malabou, "Go Wonder," 6.
36. Malabou, "Go Wonder," 63.
37. Malabou, "Go Wonder," 9.
38. Malabou, "Go Wonder," 8.
39. Malabou, "Go Wonder," 9.
40. Moheb Costandi, *Neuroplasticity* (Cambridge, MA: MIT Press, 2016); for Malabou's take on destructive plasticity, see Catherine Malabou, "Emotional Life in a Neurobiological Age: On Wonder," lecture, School of Criticism & Theory, Cornell University, Ithaca, NY (July 16, 2013), https://www.youtube.com/watch?v=H4oFump89W4 (accessed December 11, 2017).
41. Malabou, "Go Wonder," 11. Italics in original.
42. Catherine Malabou, *Ontologie de l'accident: Essai sur la plasticité destructrice* (Paris: Éditions Léo Scheer, 2009), 9. Author's translation.

Bibliography

Ahmed, Sara. *The Cultural Politics of Emotions*. New York: Routledge, 2004.

Ambler, Charlie. "Is Consuming Like Crazy the Best Way to End Capitalism?", *Vice*, March 19, 2015. www.vice.com/read/is-consuming-like-crazy-the-best-way-to-end-capitalism-050 (accessed December 11, 2017).

Appadurai, Arjun, ed. *The Social Life of Things: Commodities in Cultural Perspective*. Cambridge: Cambridge University Press, 1986.

Artspace Editors. "Sarah Sze on Why She Had to Invent a New Way of Making Sculpture," *Artspace*, May 4, 2016. www.artspace.com/magazine/art_101/book_report/sarah-sze-okwui-enwezor-interview-53754 (accessed December 11, 2017).

Bennett, Jane. *Vibrant Matter: A Political Ecology of Things*. Durham, NC: Duke University Press, 2010.

Braidotti, Rosi. *Metamorphoses: Towards a Materialist Theory of Becoming*. London: Polity, 2002.

Buchloh, Benjamin. "The Entropic Encyclopedia," *Artforum* 52, no. 1 (September 2013). https://www.artforum.com/inprint/issue=201307&id=42627 (accessed December 11, 2017).

Burton, Johanna, and Jennifer Egan, eds. *Sarah Sze: Triple Point*. New York: Bronx Museum of Arts and Gregory R. Miller, 2013.

Chiu, Melissa, and Saskia Sassen, eds. *Sarah Sze: Infinite Line*. New York: Asia Society Museum, 2011.

Coleman, Rebecca. "Inventive Feminist Theory: Representation, Materiality and Intensive Time." *Women: A Cultural Review* 25, no. 1 (2014), 27–45.

Costandi, Moheb. *Neuroplasticity*. Cambridge, MA: MIT Press, 2016.

DeLanda, Manuel. *Intensive Science and Virtual Philosophy*. London: Bloomsbury Academic, 2013.

Grosz, Elizabeth. *In the Nick of Time: Politics, Evolution and the Untimely*. Durham, NC: Duke University Press, 2004.

Grosz, Elizabeth. *Time Travels: Feminism, Nature, Power*. Durham, NC: Duke University Press, 2005.

Harman, Graham. "Road to Objects." *continent* 1, no. 3 (2011), 171–79.

Harman, Graham. *Bells and Whistles: More Speculative Realism*. Alresford: Zero Books, 2013.

Harman, Graham. "Art without Relations," *ArtReview* 66, no. 6 (September 2014), 144–47.

Harman, Graham. "Materialism is Not the Solution: On Matter, Form and Mimesis," *Nordic Journal of Aesthetics* 24, no. 47 (2014), 94–110.

Harman, Graham. *Immaterialism*. London: Polity, 2016.

Jackson, Robert. "If Materialism is Not the Solution, Then What was the Problem?", *Nordic Journal of Aesthetics* 24, no. 47 (2014), 111–24.

Johnston, Adrian, and Catherine Malabou. *Self and Emotional Life: Philosophy, Psychoanalysis, and Neuroscience*. New York: Columbia University Press, 2013.

Kasprzak, Michelle. "OOO," *Art + Life + Technology*, June 28, 2013. https://michelle.kasprzak.ca/blog/archives/tag/ooo (accessed December 11, 2017).

Kuo, Michelle. "Global Entry: Okwui Enwezor Talks with Michelle Kuo about the 56th Venice Biennale," *Artforum* 53, no. 9 (May 2015). www.artforum.com/inprint/issue=201505&id=51556 (accessed December 11, 2017).

Luhmann, Niklas. "The Paradoxy of Observing Systems," *Cultural Critique* 31 (autumn 1995), 37–55.

Malabou, Catherine. *Ontologie de l'accident: Essai sur la plasticité destructrice*. Paris: Éditions Léo Scheer, 2009.

Mclean-Ferris, Laura. "Indifferent Objects." *Art Monthly* 368 (July–August 2013). www.artmonthly.co.uk/magazine/site/article/indifferent-objects-by-laura-mclean-ferris-july-august-2013 (accessed December 11, 2017).

Parikka, Jussi. "Radical Temporality and New Materialist Cultural Analysis," 2009. https://jussiparikka.net/2009/06/09/"radical-temporality-and-new-materialist-cultural-analysis" (accessed December 11, 2017).

Peters, John Durham. *The Marvelous Clouds: Toward a Philosophy of Elemental Media.* Chicago: University of Chicago Press, 2015.

Shaviro, Steven. *No Speed Limit: Three Essays on Accelerationism.* Minneapolis: University of Minnesota Press, 2015.

Sheldon, Rebekah. "Form/Matter/Chora: Object-Oriented Ontology and Feminist New Materialism," in *The Nonhuman Turn*, ed. Richard Grusin. Minneapolis: University of Minnesota Press, 2015, 193–222.

Walker, Rachel Lowen. "The Living Present as a Materialist Feminist Temporality," *Women: A Cultural Review* 25, no. 1 (2014), 46–61.

Part VI

Photographic Time

13 Showtime and Exposure Time

The Contradictions of Social Photography and the Critical Role of Sensitive Plates for Rethinking the Temporality of Artworks

Emmanuel Alloa

Showtime in an Age of Immunity: For a Temporal Approach of Art

When is art? This question might seem odd, or a lot odder at least than to ask: *where is art?* The notion of *art spaces* immediately triggers a whole range of associations—indeed, entire libraries are filled with reflections on art institutions, museums, and conservation, and about how to display, hang, light, and arrange works of art, as well as about art sites in general. So, what about this strange question: *when is art?* Clearly, a great deal has been said about exhibition spaces; much less about exhibition times. The whole debate around what it means to exhibit (or, to borrow from Romance-language usage, "to expose") art has been characterized, as I shall argue in this chapter, by an outlandish over-emphasis on the spatial aspect at the expense of the temporal one. The problem of exhibiting art has been viewed above all as an issue of the architecture of the show itself. Under these circumstances, what might it actually mean to focus on the exhibition's *chronos* rather than on its *topos*? In point of fact, several of the problems raised by the issue of exhibition spaces have their counterpart in analogous problems relating to time. When it comes to visual artefacts, what would it mean, one might also ask, to *make space for time?*

In the first part of this chapter, a number of aesthetic strategies for introducing the time factor into the question of exhibition/exposure will be discussed. As will become clear, in time-based arts, the question of time comes into play on at least three different levels: the lapse of time documented by an artwork (*the shown time*); the lapse of time it takes for the artwork to present itself (*the time of showing*). Both of these temporalities will be subsumed as *showtime*. Showtime is intimately tied to a *will-to-show*, with a meaning that is meant to be conveyed. Beyond these two temporalities, however, there is a third, which is irreducible to the two previous ones and has long been disregarded as being pre- or non-artistic, since it appears to be a purely technical issue: *exposure time*. But before returning to focus more closely on "exposure time," the coincidence of its specific historical emergence with early photographic discourses, and also its theoretical potential for any more general rethinking of the what *ex-positio* means, it is necessary first to consider the modernist paradigm of exhibition as showcase.

As we review the issue of exhibition, its historical conditions, policies, and future, we now have at our disposal a vast literature enabling us not only to better grasp the parameters of the historical emergence of an institution such as the museum, but also the normative implications inherent in both its architecture and its modernist legacy.

The consequences of the aseptic presentation of gallery space, aptly termed a *White Cube*, are well known: by transporting the work of art into a supposedly neutral topography, the art work is shielded from the intrusion of the context, i.e. from the intrusion of its usages and their respective values. Exhibition conditions are achieved through a process that isolates the art work, banishing whatever might otherwise interfere with the construction of *l'art pour l'art*: this now classic argument posits the *White Cube* as an ideological space.[1] It goes without saying that Alfred H. Barr's famous argument about neutrality cannot be neutral itself: when in 1945, the director of the New York Museum of Modern Art (MoMA) claimed that a neutral presenta- tion of an art work is the only way of protecting it from hypothetical political med- dling,[2] he was of course already taking a stance against the instrumentalization of art by Nazi Germany. But the disentanglement of art from society has consequences too, of course. Viewed in this way, the construction of an immanent and self-referential world—the drawing together of what is conventionally called the "art world'—is undertaken through the topographical exclusion of the outside, of the context, or, in Gadamer's words, of the "world." In some respects, this "world of the work of art,"[3] with all its socio-historical rootedness, is precisely what has to be bracketed in order to permit the emergence of a wholly other "world," which Arthur C. Danto has theo- rized as "the world of art."[4] International Biennales are now as interchangeable and spatially homogeneous as "white cubes": it is as though each emerging new Biennale, as it aspires to break into the globalized art circuit, is forced to seek accreditation by presenting time and again the same prominent "world"-famous artists.

Much case has been made of the deleterious effects of this globalization of art and of the increasing uniformity of art spaces; much has also been written of the "vitri- fication" of art and of its confinement, to this process of museification which, not unfrequently, comes all too close to mummification. Indeed, the overriding effect on the spectator or gallery-goer is, as it were, to arm her in advance against any risk of being surprised by the unforeseen emergence of the art object in question. The appa- ratus of the museum, its institutional framing, serves to immunize every gaze and to render aesthetic experience largely predictable. Museum space is highly regulated, with precise stipulations regarding permitted routes and movements, what is placed on display and what is not exhibited, what there is to be seen and what is with- held from view. If one observes closely the dramaturgy of major exhibitions—which, after all, have now become the principal tourist attractions in the great European metropolises—one is forced to acknowledge that far from being spaces of exhibition (*ex-positio*), they have now turned into spaces of constraint (*im-positio*); put differ- ently, *ex-positio* has been replaced by *im-positio*. What then remains of the museum as a nonspace (M. Augé) or as a "heterotopia" (M. Foucault)? Or, rather, what becomes of the museum's "heterochronia"?

The discourse relating to the immunization of artistic experience, which is at the center of the critique of the *White Cube* device, remains paradoxically marked by a prevalence of the spatial model; indeed, it is no accident that it is often examples taken from Land Art or from new forms of public art that are used to deconstruct the self-referential homogeneity of the said device. It is similarly unsurprising that work devoted to a reconstruction of something amounting to a history of exhibiting—from the birth of the earliest national museums to the present day—focuses first and fore- most on exhibition spaces, on their rationales, and on the way they can be organized.[5] But if exposing is the result of a performative act and hence possesses a ritualistic

aspect,[6] how then can we take account of its temporal parameters? Because the issue of immunization clearly cannot be confined to the spatial dimension (even though the entire drift of contemporary philosophy that reposes on this paradigm adopts essentially spatial metaphors: inclusive exclusion, the assimilation of the foreign body, exclusive containment, etc.; therefore, one has to ask just what type of immunized gaze is produced by the new tempos and rhythms of exhibition—or rather of *exposition*, as I will say, from now on, for the sake of greater coherence. Forced to compete with the visual maelstrom enveloping our channels of communication, contemporary art not infrequently chooses the strategy of hyperbole which, instead of revealing unimagined fissures, seals and further fixes the opacity of the screens. In an era of hyper-solicitation—when no resource is scarcer than attention—even art has to compete in the overall vanity fair. Given the ubiquity of its presentation, far from inducing a more intense visibility, it is not rare for art to produce a genuine immunization of the gaze.

How can alternative exposure policies help to defuse this immunizing showcase? In view of the results of empirical studies suggesting that the average amount of time spent in front of art works has been falling steadily,[7] the most obvious corrective strategy appears to be to extend exhibition time by extending the time of the artwork. One of the most spectacular installations is the video entitled *24 Hours Psycho* by Douglas Gordon, in which the 109 minutes of Hitchcock's classic are stretched out unendurably over an entire day. Other examples include Doug Aitken's *Electric Earth* (1999), which imposes a state of bewildered strolling through an ill-defined urban territory, or Bruce Nauman's *Mapping the Studio*, a montage of chunks of forty-two nights spent filming his own study in the summer of the previous year in the attempt to capture, in this state of quasi-immobility, the buzzing of flies and the arabesques of moths.[8] Also worthy of mention is Christian Marclay's *The Clock* (2010), a collage of thousands of fragments of film where every scene contains an indication of the time, thus recreating a gigantic clock consisting of nothing but quotes; or *5 Year Drive By* (1995), again by Douglas Gordon, a showing of John Ford's *The Searchers* extended to cover seven weeks. While considerable skill and effort are demanded to slow down the pace of moving images without completely distorting their nature, this remains much easier than slowing down the sound. Yet here too there have been some interesting experiments, for example by the sound artist Leif Inge. Inge's *9 Beet Stretch* is a recording of Beethoven's Ninth Symphony stretched over an entire day so that the listener, incapable of recognizing the details, is exposed to a wholly new listening experience. Lastly, *Postman Time* by Philippe Parreno and Hans-Ulrich Obrist (presented in Manchester in 2007 and in Basel in 2009): in this instance, rather than set up a space for displaying time-based art, the two curators have designed a collective show that occupies time rather than space, making use of a theater that successively exhibits the works of approximately fifteen artists.

However, not all of these experimental works are satisfying. It is as though the attempt to dismantle the logic of immunization had approached exhibition from the wrong end. For it is entirely evident that the artwork's time does not necessarily coincide with the viewer's time: by expanding the duration of the work itself, you do not necessarily expand the exhibition. This brings us to a fundamental distinction: *that between the time of the artwork and the experiential time*. Put differently, the time that a work of art takes to unfold does not necessarily correspond to the time that viewers take to experience it. Very few spectators will have sat straight through

Douglas Gordon's *24 Hours Psycho* and you can just bet that nobody ever devoted seven weeks of their life exclusively to watching Ford's *The Searchers* in Gordon's super-slow version. The age of spectatorial involvement and compulsory participation has contributed to theories according to which the qualities or features of an art work are propagated as if by magic, being transferred to whoever attends them. Yet even if certain forms of performance art suggest the collapse of this distinction, marking the demise not only of art's autonomy but also of the spectator and inaugurating a process whereby "production and reception are thus effected in the same space and time,"[9] such statements certainly cannot be broadened to apply to all forms of contemporary art.

We shall resist the temptation to view the empowerment of the viewer as a possible response to the immunization of the gaze imposed by the *White-Cube* model of exhibition. It is by no means certain that what is presented as an emancipation of those who had previously been relegated to a position of passivity is not, on the contrary, a new and distinctly more sly form of *mancipatio*. Although, as Grotowski emphasized, there is no theater without spectators, the concept of the "activated spectator" deserves re-consideration in the light of its problematic implications.[10] The line of investigation that interests us is neither that which divides institutions and subjects nor that between exhibition spaces and experienced spaces. We shall instead seek further to clarify the concept of exposure time, a concept whose literal meaning deserves to be thought through. As we shall show, exposure time is the privilege neither of the spectator nor of the work, but represents first and foremost the medium itself; it is from this starting point that it needs to be re-examined, along with its critical and political implications.

Before confronting these issues, however, we need first to dwell on another important distinction proposed by the field of narratology. In narratology, we find a distinction which is made between *narrated time* and the *time of narration*. While narrated time refers to the time in the fictional world which is being told, the time of narration designates the time it takes for the story to be told.[11] If we transfer this distinction from narrative forms to pictorial forms, one might make a similar distinction between *shown time* and *time of showing*. Whereas the *time of showing* denotes the lapse of real time during which the work unfolds (in the case of a video or film, this would be the total running time), *shown time* denotes the temporal sequence that the work records, recounts, or re-creates. The pictorial medium that allows for a good illustration of all the various implications of depicted time is photography. But as we will see, it also yields a dimension which exceeds these two sides of showtime, since beneath the will-to-show, the materiality of the medium generates visibilities that were never intended. In the next section, the question will be addressed on a more theoretical level, while in the last section, an exemplary case study—Jacob A. Riis' early social photography—shall demonstrate the inherent tension in the *will to expose*.

Aperture Time: The Case of Photography

Photography is traditionally characterized as the art of capturing the fleeting instant, the "decisive moment" as Cartier-Bresson described this photographic *kairós*. At the click of the shutter, in an unrepeatable fraction of a second, an instant of life is frozen and delivered over to the device's memory. The *nunc stans*, by definition evanescent, thereby achieves immortality. Yet the idea that the object of photography is arrested

life rather than arrested time—a thread of argument that runs through the history of modernity and can be traced from Hippolyte Bayard to Auguste Rodin, from Anton Giulio Bragaglia to André Bazin—is clearly mistaken: even if the shutter opens for a mere fraction of a second, it is always a time lapse (and not a point-like moment) that the light-sensitive device records. This can be best grasped in extended-exposure photography. The MoMA commissioned the photographer Michel Wesely to track the museum's entire extension program from 2001 through 2004. This he did by employing a device specifically constructed to obtain a record-breaking exposure time: the thirty-four months during which the new construction took shape were caught in a single image. As Wesely has explained in interviews, such extreme exposure times are able to bring out things that otherwise would remain invisible.

Expanded shutter time, however, does not automatically make it possible to see more. Indeed, a series such as *Theatres*, on which the Japanese photographer Hiroshi Sugimoto has been working since the 1970s, appears to underscore this point. In the course of innumerable journeys across North America, Europe, and Asia, Sugimoto photographed movie theaters. At the center of these projection spaces, many of which call to mind the architecture of Baroque theaters, there is a white rectangle. This might perhaps be seen as a sort of degree zero of the image, a white picture against a black background à la Malevich. In fact, the empty space in the center is not so much the result of some avant-garde *tabula rasa*, but rather the outcome of an information overload. Throughout the entire duration of the film, the photographer kept his lens open so that, in this case, the exposure time of the negative corresponds precisely to the running time of the film in question. The resulting immaculate whiteness is a product of *white noise*, i.e. that background din familiar to us from Shannon and Weaver's theory of communication.

With Sugimoto and his *Theatres* series, we move toward a completely different dimension of temporality, a dimension that in its technical banality has generally been ruled out of reflections on the time of images. Other than the *shown time* and the *time of showing*, there is in fact a third modality that is irreducible to either of the aforementioned. This third variety is a singular temporality which might be described as the *time of the medium*. This time of the medium (or "medial time") can take different forms. In the case of the photographic medium, this time is known as *exposure time*.

The examples cited here refute the idea that photography captures always and only a single instant (given that every point is already an extension and extension is itself a duration), while also problematizing the notion of exposure. If Michael Wesely's photograph might at a stretch be regarded as a condensation in a single plane of a process that otherwise would elude the eye, the same cannot be said of Sugimoto's *Theatre* photographs. It would certainly be hard to say anything at all about the content of the films screened in the cinemas in question. If you expose a photographic plate for too long, you reach a threshold beyond which instead of seeing more you will end up seeing nothing at all. As if seeing too much might come to signify seeing too little: at the limit, over-exposure and under-exposure asymptotically tend to become one and the same.

The indissoluble link between over-exposure and under-exposure is a phenomenon first studied at the end of the nineteenth century by the chemists Vero Charles Driffield and Ferdinand Hurter. Driffield and Hurter laid the foundations of sensitometry, a technique for measuring the sensitivity of optical materials and devices.

Following their experimentation with exposure times, Driffield and Hurter identified four levels of exposure:

(a) under-exposure;
(b) correct exposure;
(c) over-exposure; and
(d) reversal.

What the two chemists defined as "correct exposure" corresponds to the "perfect negative." ("We define a technically perfect negative as one in which the opacities of its gradations are proportional to the light reflected by those parts of the original object which they represent.")[12]

According to Driffield and Hurter, photography is thus able to provide a faithful replica of objects, even of objects in movement, and also of events, provided the exposure time and diaphragm aperture can be adjusted to the object being photographed. In other terms, photography is able to capture the event, provided the event is predictable. From the scientific viewpoint, photography is truthful when, in the right place and at the right time, it re-creates a perfect congruence between shown time and time of showing, which are the two sides of what we called *showtime*.

In 1978 Thierry de Duve published his book, *Time Exposure and Snapshot: The Photograph as Paradox*, in which he defends the thesis that photography has to be approached from its defining paradox. De Duve writes: "Photography is generally regarded in two ways: either as an event, but in this case as a strange event, a frozen form that expresses little of the fluidity of the things that happen in real life; or, alternatively, as an image, an autonomous representation that can be framed and hung on the wall but which curiously ceases to refer to the particular event from which it has been derived."[13] De Duve associates the first of these two conceptions with the notion of the snapshot, while defining the second as exposure time. To conceive of photography as "exposure time" entails seeing it from the viewpoint of the final image, whereas the "snapshot" conception of photography sees it as event (which might be exemplified by press photography). According to de Duve's line of argument, these two conceptions rule each other out. De Duve's article has become canonical, as has the thesis he expounds in it. Yet it is legitimate to wonder just how pertinent this really is. What type of event is press photography capable of recording? Can a social event—the kind of thing that press photographers are often called upon to cover—really be considered an "event" in any meaningful sense? What can be the nature of such an event when its parameters are pre-determined far in advance? What margin for the unforeseen remains in a mechanism based on literal foresight (pre-vision)? There is no doubt that just as such an event is pre-packaged by the media apparatus, so too does this apparatus function to preserve the event.

In a critical comment directed at Thierry de Duve, Hilde van Gelder neatly captured this aspect: "The tragedy of the snapshot is that it always arrives too soon to see how the event presents on the surface. It arrives always too late to bear witness to its occurrence."[14] From this viewpoint, the press-photography snapshot refutes the very "event-ness" of the event—its element of surprise, its destructive and unforeseeable character—and thus from the outset attributes a normalized framework to what is depicted. Here too, though in a quite different register, it is the logic of immunization that is operative.

The feature that the albeit diverse cases considered thus far have in common is that the issue of exposing is always already framed within the various regimes of pedagogy, museum mediation, journalistic reference, or by the subjectivity of the sovereign spectator. In all these cases, the nature of the exhibition is, as it were, predictable and its temporality determined from the outset: the very opposite of *ex-positio*, of *ek-thesis*, or of the risk of aperture. Photography has not always been subjected to these external demands. The fact that photography, which by its nature is mechanical and profoundly indifferent to what it happens to record, might also be regarded as the very emblem of an alternative conception of exhibition, rather closer to the view of exposure as an ontological condition—as Jean-Luc Nancy would say[15]—i.e. of "exposure" to anything at all, to *quodlibet*, to the "any-thing-whatsoever." All of this has been the object of lengthy discussions in newer post-structuralist philosophies. Maybe one of the best explanations of what this ontological condition means is not to be found in philosophical texts, though, but in the literature provided by the photochemistry textbooks. In 1874, Hermann Vogel, Professor of Photochemistry at the Technical University of Berlin, summed up the problem that so many early pioneers had encountered: "To the plate it's all indifferent."[16] This means equally that the photographic plate registers everything *indifferently*. It registers everything to which it is exposed, irrespective of meaning. By virtue of its undifferentiated sensitivity, photography is the supreme medium of the insignificant. Or to borrow Siegfried Kracauer's observation: the most notable characteristic of photographic media is that they "tend to reveal things normally neglected."[17]

In the next section, we shall examine more closely the attempt to expose in an image this insignificance, along with everything that such an attempt may imply, not excluding the problems that it raises. Specifically, we shall be looking at the case of the Danish-American photographer Jacob Riis.

Jacob Riis: Exposure Time

Jacob August Riis (3 May 1849–26 May 1914) may rightly be regarded as a pioneer of social photography. His early life, however, provides few clues to this later destiny. Born in 1849 in Denmark, at the age of twenty-one he emigrated to the United States to seek work in New York as a carpenter. In those years, the island of Manhattan was very different from today; nor was it populated at all evenly. The highest urban density was to be found in those neighborhoods peopled by immigrants, especially from Ireland, Russia, and Eastern Europe, as well as from the southern states. There was a clear dividing line running through the city: on one side, the high-class brownstone mansions on Fifth Avenue and to the north of Central Park; on the other side, seven-story tenements hurriedly erected by unscrupulous landlords, providing deplorably unhygienic living quarters. The poorest would rent a bed in some windowless, airless backroom shared by a dozen or so strangers. In such conditions, social tensions were high, as was the crime rate. The area known as Five Points, located around present-day Columbus Park, was considered having the highest homicide rate in the world: legend has it that in the thousand-strong tenement known as the Old Brewery—demolished in 1853—there was on average one murder a night (Figure 13.1).

Forced to live in these conditions, one of the first things Riis did was to spend half his savings on purchasing a pistol—which, as we shall see later, came to play an unexpected role. After assorted laboring jobs and a variety of mishaps, Riis managed

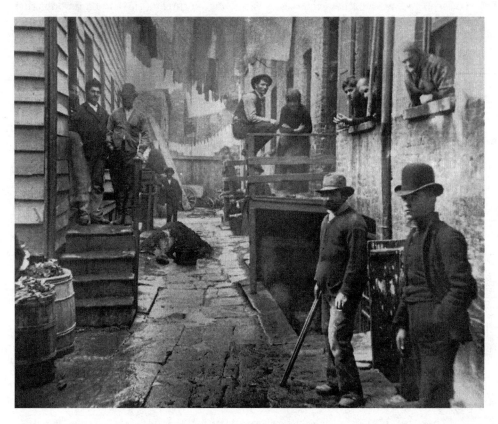

Figure 13.1 Bandit's Roost, Bandit's Roost—a Mulberry Bend Alley, 1888. From: J. Riis, *Making of an American*. New York, Grosset & Dunlap 1901, 276

to find work as a reporter for the New York News Association, working first on the *South Brooklyn News* and then on the *New York Tribune*. From his office on Mulbery Street in the Lower East Side, at the heart of New York's slum land, Riis devoted his days to investigating the conditions of neighborhoods drowning in poverty, violence, and squalor, where infant mortality stood at around ten per cent. Riis' first reports set out to describe these living conditions, striving to dispel the prejudice that indigence was the consequence of the innate nature of the poor themselves. Riis argued that rather than resulting from some kind of inherent moral weakness, it was circumstances that created criminals. However, Riis' articles, often written in a melodramatic tone, had scant impact.

A turning point arrived unexpectedly.[18] Between filing reports for the *New York Tribune*, Riis was employed by an advertising company for which he had acquired a "magic lantern" (stereopticon), enabling him to project advertising messages interlaced with photographs of places and people. The success of the stereopticon convinced Riis of the power of images in conveying a message. He began to think about how to add photographs to his reports on the life of the poor. Yet the subject of his journalistic investigations eluded visualization: given the rudimentary state of the technology, the places he wished to portray were too dark to be photographed. He found the solution to this problem while reading an article on a recent discovery

by two German scientists. In 1887, the astronomers Adolf Miethe and Johannes Gaedicke had finally succeeded in developing a magnesium powder that would allow photographers to work in poorly lit surroundings. Although Edward Sondstadt had already created the first flash lamp in 1862 using a magnesium wire, there were two major limitations that barred his discovery from wider application: on the one hand, the high cost of magnesium, which at that time was as expensive as silver; and, on the other hand, the fact that the explosion of magnesium always produced a gigantic toxic cloud. Miethe and Gaedicke obtained a much better result using a new magnesium mixture that included other inflammable substances, thus inventing the first market-able powder for use in flash photography. The patent was purchased by Agfa, who marketed the powder in cartridge form. Riis immediately procured himself a supply of Agfa cartridges and this is where his pistol came in: the flash cartridges had to be fired from a gun.

Having acquired a camera and the services of two members of New York's Soci-ety of Amateur Photography, Riis re-launched his night-time explorations into what were considered the "seediest corners' of the Lower East Side.[19] Equipped with this camera, he gained access to dwellings where the better-off would never willingly have set foot and, armed with his flash gun, he was able to document conditions that had previously always remained well out of shot[20] (Figure 13.2). As may be imagined,

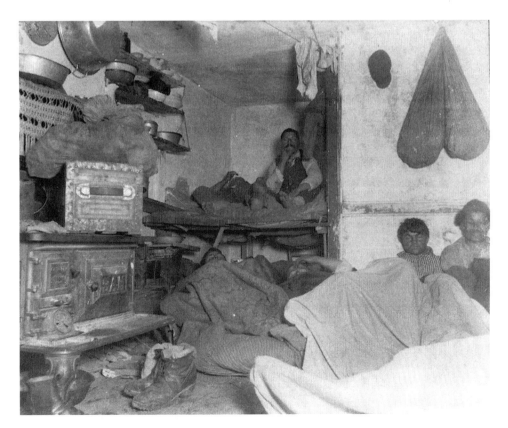

Figure 13.2 Lodgers in Bayard Street Tenement. From: J. Riis, *How the Other Half Lives: Studies among the Tenements of New York*. New York: Charles Scribner Son's, 1890, 69

the intrusion by a team of photographers, on occasion accompanied by one or more police officers, was rarely greeted with enthusiasm by the subjects to be portrayed.

> Our intervention team sowed terror wherever we went . . . The sight of strange men breaking into apartments at the dead of night, armed with pistols they proceeded carelessly to discharge, was not reassuring, even if we did speak softly. It's hardly surprising that the inhabitants fled from the windows and darted down fire escapes the moment we showed up.[21]

It wasn't long before Riis' two untrained assistants refused to go out at night, while the professional photographer whom Riis had hired to replace them attempted to sell the pictures on his own account. In January 1888, Riis himself began to operate the camera and, instead of firing Agfa cartridges, he took to burning magnesium powder in a frying pan, a method that proved not altogether risk-free: on two occasions the dwelling which he had entered caught fire and once Riis' clothes were also scorched. Wishing "to ensure he'd captured the image," the earliest of his negatives to have come down to us were all over-exposed. Little by little, however, Riis perfected his technique and thus began to make use of photographs to illustrate his articles, and also the lectures he was now giving at a variety of social clubs and public meetings. In 1890 all this material was collected in the book *How the Other Half Lives*. The title is a reference to Rabelais, whose character Pantagruel remarks: "Half of the world does not know how the other half lives" ("la moytié du monde ne sait comment l'autre vit"). Riis' book was a bestseller, one of its earliest readers being Theodore Roosevelt, shortly to be appointed head of the New York police and later to become the twenty-sixth President of the United States. Picking up on a number of Riis' recommendations, Roosevelt secured the allocation of sufficient funds to completely rebuild the affected neighborhoods, outlawing child labor and bringing electric lighting to areas where previously only hazardous gas lamps had been used.

Shortly thereafter, for a variety of reasons, Riis gave up photography. First and foremost, he thought of himself as a writer rather than a photographer and felt that his photographs lacked compositional finish and were poorly cropped or somehow unbalanced. Furthermore, he was troubled by the excessive use of artificial lighting; in his view, the explosion of magnesium flattened the backdrop and sometimes even corroded the margins, as can be seen in the photo of a cigar workshop set up in an apartment of immigrants from Bohemia (Figure 13.3).

A pioneer of exposure journalism, Riis and his photographs fell victim, in their turn, to a process of sanitization. It is precisely the precarious and ever-uncertain condition attendant upon the birth of visibility that is occluded when Riis' photographs, reproduced in photography albums, are framed and cropped in such a way as to obliterate every trace of the magnesium explosion (Figure 13.4). As early as 1893, J. McClellan had the idea of inserting a magnesium-coated wire in a glass bulb, thereby minimizing the explosion and eliminating the risk that the photographer might get burnt. As a result, if one examines Riis' photographs with the eyes of today, it is hard to account for the amount of apparent imperfections, but then almost all the photographs were re-framed in order to satisfy later criteria regarding transparent documentation. Yet perhaps the most striking example of tampering is provided by the photo representing a woman photographed by Riis in a police station (Figure 13.5).

The photo's caption signals how the image is to be read: *A Plank for a Bed*. If one takes a closer look at Riis' original negative, another element emerges: on the

right-hand side of the negative, one can clearly trace the outline of a hand (Figure 13.6). It could be the hand of an assistant, or perhaps even the hand of Riis himself holding the wire between thumb and index finger to control the shot. In any case—and the coincidence is striking—the fingers point at the head of the woman, who wears an expression of resignation, like that of a person condemned to execution awaiting the lethal shot. Except that, obviously, if the old woman's eyes are half-closed, this is not because of some attitude of resignation but rather because the "shot" has already been fired.

What we see is, as it were, the moment after the shot. In this image, Jacob Riis created the symmetrical equivalent of the famous condemned prisoner Lewis Paine as depicted by Alexander Gardner. Of this portrait, Roland Barthes (Figure 13.7) said that we are in the presence of someone awaiting a shot that for us as spectators has already taken place, a sort of "past future" captured by the photographic plate.[22] In the case of Riis, on the other hand, we are in the presence not so much of a past future as

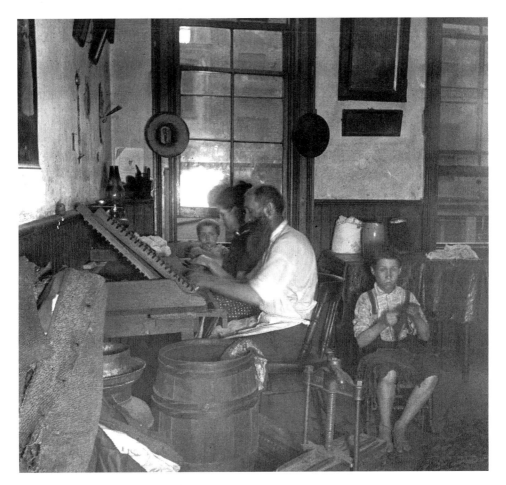

Figures 13.3 Bohemian Cigars at Work in their Tenement. 1889. From: J. Riis, *How the Other Half Lives: Studies among the Tenements of New York.* New York: Charles Scribner Son's, 1890, 143

Figures 13.4 J. Riis, *Bohemian Cigars at Work in their Tenement*. 1889. Museum of the City
of New York

of a "future pluperfect." What the photograph shows is the moment of an *après-coup*
that has always already occurred. The moment captured in this instance by the camera
sends us back to a "before" that we can only imagine, because in all the possible mean-
ings that we can attach to this phrase, it is a reality that remains in the dark. Did or
did not this woman know that she was going to be photographed? Was there perhaps
some other reason why she was standing up? Had she—like so many other subjects
Jacob Riis photographed—been caught off-guard by him? Or had she already resigned
herself to being forced to participate in the game of representation and thus was ready
to act out her part?

Riis' images raise the following question: who is (or *what is*) the object of exposure?
If exposure cannot be reduced either to what is depicted or to the act of depiction
itself, but instead obeys a quite particular logic, this is not without consequences either
for the referent or for the spectator. Re-thinking what it means to show (and to be
exposed) from the vantage point of the medium entails the creation of short-circuits
between the regimes of meaning that generally order the experience of art, whether
this involves the omnipotent figure of the curator or the less authoritative one of the
spectator. In an era when contemporary art is increasingly framed by discursive devices
designed to make apparent what it "wants to say," the paradigm of the photographic

plate offers an opportunity to form a different conception of the question of *aisthesis*. Riis had subordinated his photographs to a quite precise intention. Indeed, his "enlightened" embrace of technology overlays an almost missionary zeal for reform: "I loathe darkness and dirt everywhere, and naturally I want to bring in light."[23] Seen thus, the sole purpose of photography is to draw attention to a state of affairs which it is hoped, finally, may be abolished. Judge Louis Brandeis may have had similar considerations in mind when he said that "sunlight is the best disinfectant." However, when one sets out to expose everything to the light, over-exposure can end up disrupting the field of vision. The photographic medium that Riis employed withstood submission to the photographer's will-to-say by always bringing out aspects and dimensions that the photographer could not foresee. In a way, exposure time can never be fully transferred into showtime.

If it is true, as the photo-chemist Hermann Vogel stated, that during exposure the plate records everything, irrespective of what that is, this might incline one to favor

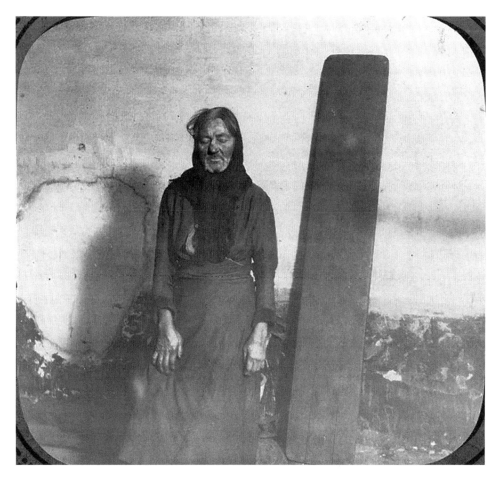

Figures 13.5 A Scrub and Her Bed, Eldridge Street Station. From: J. Riis, *The Battle with the Slums*, New York: Macmillan, 1902, 171

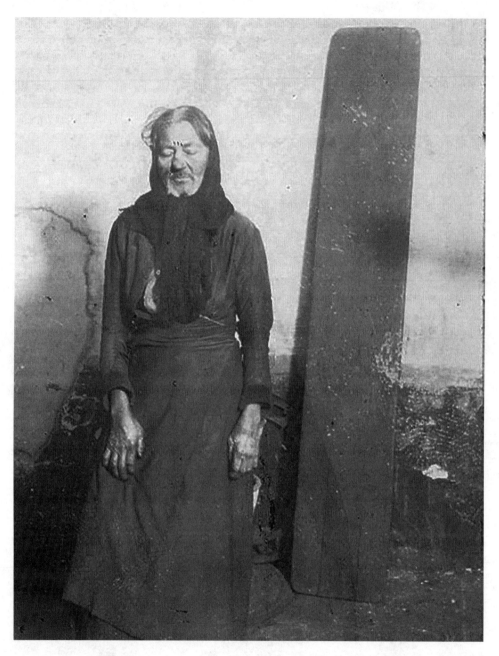

Figures 13.6 Jacob Riis, *A Scrub and Her Bed, Eldridge Street Station*, Museum of the City of New York

a process that would precede the division between meaningful and meaningless, relevant and irrelevant. Kracauer was therefore right to think that photography made it possible to "reveal things that normally remain neglected."[24] Moving beyond an art of representation confining itself to representing "significant" things, but also moving beyond an exposure journalism that believes itself capable of bringing the margins

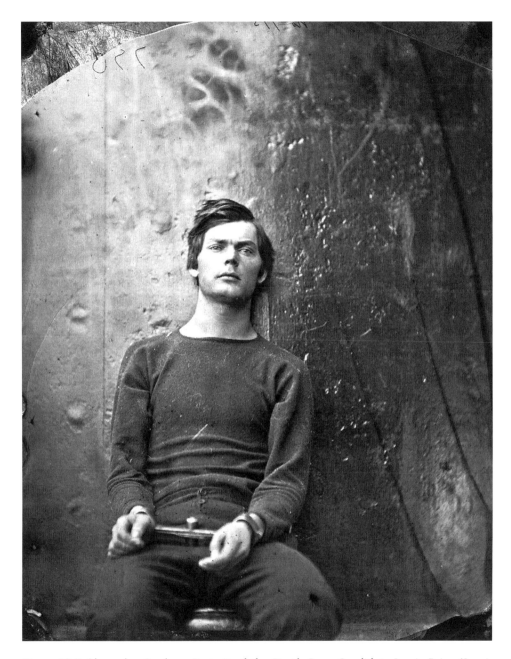

Figure 13.7 Alexander Gardner, *Portrait of the Death Row Candidate Lewis Paine [Lewis Powell]*, April 27, 1865. Albumen silver print, 22.4 × 17 cm

into focus, the exposure of the medium forces us to re-think the relationship between the conspicuous and the overlooked, the relationship between what is significant and what is insignificant. There is an "aperture value" which, from a merely technical parameter, becomes a critical one.

Notes

1. Brian O'Doherty. *Inside the White Cube: The Ideology of Gallery Space* (Berkeley: University of California Press, 1999 [1976]).
2. Alfred H. Barr. "Art in the Third Reich—Preview 1933," *Magazine of Art*, October 1945, 211–22.
3. Hans-Georg Gadamer. *Truth and Method*, trans. Joel Weinsheimer and Donald G. Marshall (New York: Bloomsbury, 2013 [1960]), 117.
4. Arthur C. Danto, "The Artworld," *Journal of Philosophy* 61 (1964), 571–84.
5. Jérôme Glicenstein, *L'art, une histoire d'expositions* (Paris: PUF, 2009).
6. Dorothea von Hantelmann and Carolin Meister, eds. *Die Ausstellung. Politik eines Rituals* (Zurich/Berlin: Diaphanes, 2010).
7. Jeffrey K. Smith and Lisa Smith, "Spending Time on Art," *Empirical Studies in the Arts* 19 (2001), 229–36.
8. Daniel Birnbaum, *Chronology* (New York: Lukas & Sternberg, 2005), Chapter 3.
9. Erika Fischer-Lichte, *The Transformative Power of Performance: A New Aesthetics*, trans. Saskya Iris Jain (New York: Routledge, 2008), 38.
10. On these paradoxes, see Jacques Rancière. *The Emancipated Spectator*, trans. Gregory Elliott (London: Verso, 2011).
11. See e.g. Günther Müller. "Erzählzeit und erzählte Zeit," in *Morphologische Poetik. Gesammelte Aufsätze*, eds. Elena Müller and Helena Egner (Tübingen: Niemeyer, 1968), 269–86.
12. Ferdinand Hurter and Vero Charles Driffield, "Photochemical Investigations and a New Method of Determination of the Sensitiveness of Photographic Plates," *Journal of the Society of Chemical Industry* XI, no. 5 (1890), 455–69, at 455.
13. Thierry de Duve, "Time Exposure and Snapshot: The Photograph as Paradox," *October* 5 (1978), 113–25.
14. Hilde Van Gelder and Helen Westgeest, "Time in Photography: The Rivalry with Time-Based Arts," in *Photography Theory in Historical Perspective* (Oxford: Wiley-Blackwell, 2011), 64–111, at 79.
15. Jean-Luc Nancy, *The Sense of the World*, trans. Jeffrey S. Librett (Minneapolis: University of Minnesota Press, 1997).
16. Hermann Vogel. *Die chemischen Wirkungen des Lichts und die Photographie in ihrer Anwendung in Kunst, Wissenschaft und Industrie* (Leipzig: Brockhaus, 1874), 125.
17. Siegfried Kracauer. *Theory of Film: The Redemption of Physical Reality* (Princeton: Princeton University Press, 1997 [1960]), 46
18. See Bonnie Yochelson, "Photographer 'After a Fashion,' " in *Rediscovering Jacob Riis: Exposure Journalism and Photography in Turn-of-the-Century New York*, eds. Bonnie Yochelson and Daniel Czitrom (New York: New Press, 2007), 121–27.
19. Jacob Riis, *The Battle with the Slums* (New York: Macmillan, 1902), 266.
20. A comprehensive catalogue of Riis' photographs is now available: *Jacob A. Riis: Revealing New York's Other Half: A Complete Catalogue of His Photographs*, ed. Bonnie Yochelson (New Haven: Yale University Press, 2015).
21. Jacob Riis, *Making of an American* (New York, Grosset & Dunlap, 1901).
22. Roland Barthes, *Camera Lucida: Reflections on Photography*, trans. Richard Howard (London: Vintage, 1993 [1980]), 96.
23. Riis, *Making of an American*, 435.
24. Kracauer, *Theory of Film*, 46.

Bibliography

Barr, Alfred H. "Art in the Third Reich—Preview 1933," *Magazine of Art*, October 1945, 211–22.
Barthes, Roland. *Camera Lucida. Reflections on Photography*. Trans. Richard Howard. London: Vintage, [1980] 1993.
Birnbaum, Daniel. *Chronology*. New York: Lukas & Sternberg, 2005.
Danto, Arthur C. "The Artworld," *Journal of Philosophy* 61 (1964), 571–84.

De Duve, Thierry "Time Exposure and Snapshot: The Photograph as Paradox," in *October* 5 (1978), 113–25.

Fischer-Lichte, Erika. *The Transformative Power of Performance: A New Aesthetics*. Trans. Saskya Iris Jain. New York: Routledge, 2008.

Gadamer, Hans Georg. *Truth and Method*. Trans. Joel Weinsheimer and Donald G. Marshall. New York: Bloomsbury, [1960] 2013.

Glicenstein, Jérôme. *L'art, une histoire d'expositions*. Paris: PUF, 2009.

Hurter, Ferdinand and Driffield, Vero Charles. "Photochemical Investigations and a New Method of Determination of the Sensitiveness of Photographic Plates," *Journal of the Society of Chemical Industry* XI, no. 5 (1890), 455–69.

Kracauer, Siegfried. *Theory of Film: The Redemption of Physical Reality*. Princeton, NJ: Princeton University Press, [1960] 1997.

Müller, Günther. "Erzählzeit und erzählte Zeit," in *Morphologische Poetik. Gesammelte Aufsätze*, eds. Elena Müller and Helena Egner. Tübingen: Niemeyer, 1968, 269–86.

Nancy, Jean-Luc. *The Sense of the World*. Trans. Jeffrey S. Librett. Minneapolis: University of Minnesota Press, 1997.

O'Doherty, Brian. *Inside the White Cube: The Ideology of Gallery Space*. Berkeley: University of California Press, [1976] 1999.

Rancière, Jacques. *The Emancipated Spectator*. Trans. Gregory Elliott. London: Verso, 2011.

Riis, Jacob. *Making of an American*. New York, Grosset & Dunlap, 1901.

Riis, Jacob. *The Battle with the Slums*. New York: Macmillan, 1902.

Riis, Jacob. *Jacob A. Riis: Revealing New York's Other Half: A Complete Catalogue of His Photographs*, ed. Bonnie Yochelson. New Haven: Yale University Press, 2015.

Smith, Jeffrey K. and Smith, Lisa. "Spending Time on Art," *Empirical Studies in the Arts* 19 (2001), 229–36.

Van Gelder, Hilde and Westgeest, Helen. "Time in Photography: The Rivalry with Time-Based Arts," in *Photography Theory in Historical Perspective*. Oxford: Wiley-Blackwell, 2011, 64–111.

Vogel, Hermann. *Die chemischen Wirkungen des Lichts und die Photographie in ihrer Anwendung in Kunst, Wissenschaft und Industrie*. Leipzig: Brockhaus, 1874.

Von Hantelmann, Dorothea and Meister, Carolin, eds. *Die Ausstellung. Politik eines Rituals*. Zurich/Berlin: Diaphanes, 2010.

Yochelson, Bonnie. "Photographer 'After a Fashion,'" in *Rediscovering Jacob Riis: Exposure Journalism and Photography in Turn-of-the-Century New York*, eds. Bonnie Yochelson and Daniel Czitrom. New York: New Press, 2007, 121–27.

14 "Objects Moving are Not Impressed"
Reading into the Blur

Amelia Groom

As something that fixes bundles of photic information onto receptive surfaces, photography is often thought of as a suspension of transience; it slices into continuity and isolates a specific moment from what was previous and what came next. But photographs also gather up and move through times, in ways that can disrupt notions of temporal steadiness and divisibility. One phenomenon of photography that invites us to grapple with its temporal complexities is *the blur*. As a site of evasion and spatial disorganization, the blur goes against commonly held assumptions about photographic fixity and certainty.

In this chapter I will look to the blur as a mark of dynamism and duration in the photographic "still." My analysis will first zoom in on an instance of blurring found in a very early photograph, Louis-Jacques-Mandé Daguerre's *View of the Boulevard du Temple*. I will argue that the sites of ambiguity and apparent illegibility in this image turn out to be surprisingly meaningful. While focusing on this one particular site of non-focus, I will also aim to zoom out on some broader questions pertaining to the temporalities of images and the ways in which we read them. I will consider how blurs and other aspects of time in images can affect how we think about representation, objectivity, and documentational transparency. Finally, I will reflect on some of the implications that an *attunement to blurring* could have for temporally sensitive modes of art historical inquiry.

The new transportation and communication technologies of the industrializing world in the early nineteenth century facilitated unprecedented speed in the flow of information, people, goods, and capital. The invention(s) of photography came out of—and helped perpetuate—this state of rapidly accelerating movement and change. But one of the medium's paradoxes is that in this historical context, the photographic plate could not capture anything in motion. The long exposures that were required at this time meant that any movement would detract severely from the precision of the impression. As such, the camera's lens was turned to things that would stay put—such as building facades, inanimate objects, and unpopulated landscapes.

Since bodies are sites of perpetual motion, the task of inscribing their forms on a photographic surface was a serious challenge for early practitioners of the technique. One way to deal with the restlessness of people for the purpose of photographing them was with the use of a popular device known as the *Brady stand* (after the photographer Mathew Brady), a heavy cast-iron stand with an adjustable height that could anchor heads and limbs into fixed positions. Another popular way for photographers of this era to ensure that their inscriptions of bodies would not blur away

Figure 14.1 Louis-Jacques-Mandé Daguerre, Triptych "Boulevard du Temple," facsimile in original passe-partout and frame, inventory no. R 6312.1–8. © Bayerisches Nationalmuseum München. Photo: Stöckmann, Mariann

into formlessness was to photograph those bodies after death. While the popularity of post-mortem portraiture in nineteenth-century photography is often touted as evidence of Victorian morbidity, it is also simply an effect of the technical limitations of a medium which demanded stasis from its subjects.

Louis-Jacques-Mandé Daguerre's iconic photographs of the Boulevard du Temple in Paris were taken in 1838 or 1839—right when the new photographic technique and the word "photography" were being introduced to the public for the first time. And the emptied city streets in these pictures remind us that during this time of increasing mobility, mobility amounted to disappearance from the picture. With early daguerreotypes like these, the emulsion's relatively low light-sensitivity meant that it would take between three and thirty minutes to inscribe an image on the iodine-sensitized silver plate. The oddly vacant city that appears in these pictures would in reality have been bustling with pedestrians and carriages; it is just that the potential subjects have been wiped out by their own movement.[1]

In the most frequently reproduced image from the *View of the Boulevard du Temple* series, there is an anonymous male figure who did in fact remain still long enough to be recognizably recorded. In the lower-left area of the picture, he can be seen standing on the street corner with one foot up on what appears to be a shoeshine box. After

seeing this picture in Daguerre's studio in 1839, the inventor Samuel Morse described it in a letter that was published in the *New York Observer*:

> Objects moving are not impressed. The Boulevard, so constantly filled with a moving throng of pedestrians and carriages, was perfectly solitary, except an individual who was having his boots brushed. His feet were compelled, of course, to be stationary for some time, one being on the box of the boot-black, and the other on the ground. Consequently, his boots and legs are well defined, but he is without body or head because these were in motion.[2]

This "individual who was having his boots brushed" has often been referred to as *the first human being to be depicted in a photograph*. But while Morse's passive grammatical construction implies that a man could just "have his boots brushed" without there being another person who does the brushing, in actuality the "individual" is not alone. Closer examination of the image shows that the man is accompanied by another body—the body of the working bootblack who is bending down at his customer's feet. While historians of photography have often neglected to mention this other figure in the scene, one notable exception is Geoffrey Batchen, who writes of the image that: "More than the first photo to show people, it is the first to illustrate both labor and class difference, and in a particularly graphic fashion (standing middle/upper-class being served by kneeling worker)."[3]

The body of the bootblack is less distinct as an image, because this body was required to move more than that of the paying customer. So while the upright bourgeois subject is recognizable as a human form, the worker who is crouching by the tree stump can only be detected in relation to the situation. It is because of what we can apprehend about the scene that we are able to read the blurry form as the body of a bootblack—in other words, without the client standing over it, the blur where the worker enters into the image might be entirely illegible.

But at what point does an ambiguous image no longer count as representational? Most of the activity that was present on the Boulevard du Temple that day has been left out of the picture, while the bootblack's activity is there, pictured somewhere in between form and formlessness. By being on the receiving end of the polishing service, the body of the standing man becomes more stable and pronounced. Meanwhile, on the other side of that relation, the polishing is also what renders its provider indistinct. And when we factor in the less distinct marks, we can see the standing man as a figure bound up with traces of the labor that supports and maintains his polished image. Far from only being a failed representation, then, the blur also pictures the tension that exists between the so-called "individual" and the (usually hidden or overlooked) support that sustains him.

Furthermore, if it is labor itself that has rendered the laborer's body indecipherable, then perhaps blurriness turns out to be a perfectly accurate portrayal of the circumstances. The blur does not show us a body as a delineated form, but it does indicate the movement which that body must carry out. So while we might not see the bootblack as a recognizable person, we can see the prescribed labor power that their body is being reduced to. In this sense, it is precisely by failing to fully depict legible forms that this fuzzy part of the image inadvertently succeeds in showing the real socio-economic conditions.

In his description of the *View of the Boulevard du Temple* in 1839, Samuel Morse mentions but does not linger on the blur. He focuses instead on what is in focus—marveling over "the exquisite minuteness of the delineation," where details are "clearly and distinctly legible." What is exciting about this new invention is what Morse sees as its "unerring fidelity," and its promise for "perfect representations."[4] The blur is there, but it is something to be looked past, so that the image's impressive clarity and semantic detail can be pursued.

Throughout his letter, Morse also compares the photographic camera to the telescope and the microscope, two other optical instruments which came out of a lust for enhanced visual reach and precision. Like the modern telescope and microscope, photography feeds into the ideals of access, identification, quantification, and immobilized representation that characterize the trajectories of capitalist-colonialist modernity. But while the camera may have perpetuated notions of reality as something that is "out there" waiting to be discovered, details like photographic blurs can help us unravel certain assumptions about objectivity and visibility.

Photojournalistic depictions of disaster zones and *National Geographic*-style nature photography are two areas where ideals of documentational purity endure with particular pertinence. Here, the world is to be pristinely depicted in all its horror and glory, and the camera is usually left as an invisible and unproblematized apparatus offering a "window" onto another time and place.

But notions of objective observation and transparent representation have been dissected and critiqued from various positions, most notably over the last several decades within the fields of feminism, post-colonial and critical race studies, and queer theory. One figure who has fought persistently—with her writing and with her camera—against the (peculiarly western) pretention of objectivity is the feminist theorist and filmmaker Trinh T. Minh-ha. In an early text called *Bold Omissions and Minute Depictions*, she calls for an understanding of images that takes into account not just what is definitively depicted, but also where omissions allow for open-ended suggestion. Recalling traditional Chinese aesthetic ideals of formlessness, she writes that there "would be no 'new,' no 'different' possible if it were not for the Formless, which is the source of all forms."

For Minh-ha, this is an innately political concern. The belief that "there can exist such a thing as an outside foreign to the inside, an objective, unmediated reality about which one can have knowledge once and for all" has, she argues, served for centuries to stabilize existing power structures and to "reduce the world to the dominant's own image." The fight against the notion of documentary realism is, then, "not a denial of reality and of meaning, but rather, a determination to keep meaning creative, hence to challenge the fixity of realism as a style and an arrested form of representation."[5]

The myth of objectivity has usually depended on a denial of temporality, and becoming more attentive to the temporal complexities of photographic images inevitably involves complicating long-held assumptions about the medium's special capacities for truth and transparency. As long as photography is assigned the role of isolating a single instant and salvaging it from the ravages of time, then the disappearances of moving bodies in pictures like the *View of the Boulevard du Temple* are taken as evidence of the medium's technical limitations, which were particularly pronounced in its first decades. But when we attune ourselves to the multiple temporalities that photographs participate in and evoke, we can find more to see—and other ways of seeing.

If time is "what prevents everything from happening all at once" (as the saying attributed or misattributed to Einstein goes), how are we to apprehend the temporality of the prolonged exposure photograph which gathers duration up into a single area of space and shows it happening all at once? Duration and simultaneity, continuity and suspension, inscription and erasure—all co-exist in the *View of the Boulevard du Temple*. The image necessitates a way of seeing that allows for its various temporal registers to exist, incommensurably, together.

On its most immediately legible level, Daguerre's picture presents a particular place that is recognizably described at a particular moment in time. It offers an elevated perspective onto the buildings and cobbled road of this boulevard in Paris's Marais area, several years before Baron Haussmann's renovations would begin in the 1850s. So it refers to a particular moment, but if we only look at the clearly delineated forms in the picture, we miss the ways in which it also spills out from the particular moment. Despite this being one of the busiest streets in the city, the crowds that were present in front of the camera are present in the image only as absence. With their speed being so far from that of the buildings and pavements—and from the chemical process of the photographic plate—their present absence reminds us that appearance and disappearance are bound up with each other.

And then there is the blur, which happens somewhere between appearance and disappearance. Being sensitive to the blur can mean being sensitive not only to the inscriptions but also to the erasures that all images, and all histories, involve. The blur signals a disruption of familiar spatial boundaries; objects and their surrounds interpenetrate, as figure spills into—and takes in—ground. The blur also marks a re-organization of sequential time, with the distinct registers of "before" and "after" opening out into each other. So the blur invites us to re-think the notion of photography as a clean slice through continuity that fully petrifies the onrush of time. And as a mark of temporal disorder in the image, it can disrupt notions of pictorial resemblance based on ideas of a pre-existing reality that can be directly accessed and transparently recorded.

The blur is not a time-stamped form that existed before the image that came along and documented it; it is something produced in and by the image, as the image came into being. The blur is a site where the apparatus and its processes are revealed as part of the pictures they bring forth. It can thus remind us that the observer and the apparatus are not outside of what they see and show—and even pictures produced with lenses are far from neutral or unmediated. As a failure of focus, the blur can bring into focus the failure of the promise of direct, untainted, and unsituated knowledge.

In the decades following the first experiments in photography—or "the art of fixing a shadow," as Daguerre's competitor William Henry Fox Talbot termed it in 1839[6]— shutters and chemical processes would speed up so that forms in motion could be inscribed with ever-increasing clarity and solidity. In the 1880s, inventions by Eadweard Muybridge in the United States and Étienne-Jules Marey in France would allow for moving forms—like a racehorse on the tracks or pelican in flight—to be visualized as a series of constituent pictures lined up or superimposed onto the same plane. With camera devices that could now shoot many frames per second, motion was broken up into strings of successive units that would remain obediently inert under the gaze of scientific study. Later, as hand-held cameras became widely available, the apparatus would get progressively quicker and lighter. When digital cameras enter the market, they are constantly updated with more and more pixels, and ever-enhancing auto-focus sensors, so that pictures keep getting sharper and more legible.

The history of photography, when considered simply in terms of technological advancement, could be told as a history of improvements in blur management. But there are also more blurry and multi-directional counternarratives to be drawn out from photography history, which go against the technocratic fetishization of ever-increasing resolution and definition. Because no matter how quick the exposure is (cameras today commonly allow shutter speeds as fast as 1/4000ths of a second), depiction never fully achieves fixity, or mastery over time's contingencies.

The idea that time could be broken up into equidistant units, and made universally measurable and accessible, is of course not naturally occurring. It is a peculiar, culturally specific construct with a traceable history and major ongoing ramifications. In basic terms, we can say that the standardization and regimentation of time that begins in early modern Europe is something that facilitates—and becomes naturalized by—the systems of capitalism. For these systems to take hold, time needed to become homogenized and quantitative; it was flattened out into a continuous line and cut up into equivalent, precisely regulated units.

In order for it to serve and perpetuate capital's principals of compartmentalization, exchangeability, and expansion, universal observance of this new sort of measurable time needed to be enforced. This is a process that has been examined at great length by many historians and theorists; the mechanical clock and the standardized twenty-four-hour day establish crucial preconditions for capitalist regulation, production, exchange, accumulation, and debt.[7] We also know that along with time, many other aspects of life were to be divided up into discrete, intelligible pieces as the early foundations of capitalism were being laid. This is also when the land and the commons begin to be cut up and privatized, and our bodies have their constitutive elements increasingly sectionalized, categorized, and managed.[8] Space, too, begins to be visualized as a predictable and divisible surface—this is perhaps most clearly evident in the aerial views of early modern European cartography and in the new regimes of perspectival space in painting.

In his study of the rationalization and secularization of time during the early phases of capitalism, medieval historian Jacques Le Goff considers concurrent innovations in pictorial representation. Perspective, he writes, broke with the traditions of previous centuries in that it "expressed a practical knowledge of space, in which men and objects are reached in successive, quantitatively measurable steps by methods within the reach of human capacities." And with the invention of the portrait in Florentine painting, under the patronage of the merchant aristocracy, it was "no longer the abstract image of a personage represented by symbols or signs materializing the place and rank assigned him by God, but rather the rendering of an individual captured in time, in a concrete spatial and temporal setting."[9]

The principles of perspectivalism (where we have a single point of view onto a space that is continuous and measured out) and portraiture (where individuals are shown immortalized in a specific time and place) might be thought to culminate centuries later in photography. Translating three-dimensional objects onto a circumscribed two-dimensional plane, the photographic image brings with it the promise of immobilizing appearances before they pass, and referring back to specific spatial and temporal coordinates. Photographs easily render the world in perspectival space-time, with vanishing lines that lead out from the camera's point of view, along which everything steadily shrinks away in proper proportion.

But, as I hope to have shown, there are also ways in which photographs can signal evasion within industrial modernity's monochronic temporal orders. With photographic blurring, the image's ostensibly rationalized and unified pictorial space is disrupted. Against the perspectival continuity, where all units are neatly lined up, the blur is a mark that allows for the image's temporal multiplicity to show through. Rather than signaling a delineated form at a specific moment, the blur gathers up and leaks out over times. And even when a stabilized aperture implies a single, static point of access from which the image is to be viewed, the blur invites us in on the inherent instabilities and spatio-temporal disunities of all images.

We can think of the blur is an irrational temporal density, where time refuses to be flattened out and instrumentalized as a series of discrete units. As a part of the image that withholds expected detail and decipherability, the blur invites a reading of time as something that is never fully tamed or manageable. So blurs allow us to see the photographic image not just as a clean incision into continuity, but also as a site of temporal convergence and overflow; within the slice, there is spillage.

In concluding, I want to briefly consider some possible implications that an *attunement to the blur* could have for art historical inquiry more generally. Because, since photographs have so often been thought about in terms of indexicality, stillness and fixity, homing in on their capacities for movement and temporal plurality can be useful for developing broader methodologies that leave the discipline of art history better equipped to deal with the multifarious temporalities of its subjects.

Images and artworks—including ones that seem to have no kinetic or durational elements—should always be granted the potential to disrupt stable meanings and proper chronological orderings. While they might be pinpointed to specific historical contexts, and while they can refer back to the initial moment of their inception, they also continue to spill out from their allotted units of time. They carry temporal densities—or blurs—where other times are gathered up in disorderly fashion. To cite Virginia Woolf's narrator in *Orlando: A Biography*, "it is a difficult business—this time-keeping; nothing more quickly disorders it than contact with any of the arts."[10]

Things like historical periodization and artist biographies—or narratives of stylistic evolution and artistic influence and legacy—might sometimes seem to conform to ordinary laws of successive time. And technological advances might be understood in terms of linear and accumulative improvement. But to apprehend images only in terms of sequential positioning is to not look at them at all. In order to really grapple with the temporal plurality and multi-directionality of their subject, art historians need to also consider the blurs—the sites where expected legible details move away from themselves, as time reveals and demands difference. These blurs can be found not just in prolonged exposure photographs where objects moving are not impressed—but also wherever the time of an image overflows from its own confines, inviting us to apprehend duration and sprawl as part of its possibility.

Notes

1. A complete overview of the extensive body of literature on Daguerre and the *View of the Boulevard du Temple* series is not possible here, but I wish to acknowledge the sources I have found particularly helpful for this research: Kaja Silverman, *The Miracle of Analogy: Or the History of Photography, Part 1* (Stanford: Stanford University Press, 2015), 44–49; Geoffrey Batchen, *Burning with Desire: The Conception of Photography* (Cambridge, MA: MIT Press, 1999), 133–37; Sylvia Ballhause, *The Munich Daguerre-Triptych: The Story of*

the *Munich Daguerre-Triptych*, published for the exhibition *Images* by Sylvia Ballhause at Les Rencontres d'Arles, France, July 2–August 19, 2012, www.sylviaballhause.de/assets/Textdateien/Daguerre-folder-safe.pdf (accessed December 11, 2017).

2. Samuel Morse, "The Daguerrotipe," *New York Observer*, April 20, 1839, 62, republished in Steffen Siegel, *First Exposures: Writings from the Beginning of Photography* (Los Angeles: Getty Publications, 2017), 85–87.
3. Batchen, *Burning with Desire*, 136.
4. Morse, "The Daguerrotipe."
5. All citations: Trinh T. Minh-ha, "Bold Omissions and Minute Depictions," in *When the Moon Waxes Red: Representation, Gender, and Cultural Politics* (New York: Routledge, 1991), 155–68, at 164.
6. "The most transitory of things, a shadow, the proverbial emblem of all that is fleeting and momentary . . . may be fixed for ever in the position which it seemed only destined for a single instant to occupy." William Henry Fox Talbot, "Some Account of the Art of Photogenic Drawing: Or the Process by Which Natural Objects May Be Made to Delineate Themselves without the Aid of the Artist's Pencil," *London and Edinburgh Philosophical Magazine and Journal of Science* XIV (March 1839), 196–208, republished in Siegel, *First Exposures*, 105–16, at 109.
7. Space does not permit a full bibliography here, but for some key references, see: Éric Alliez, *Capital Times: Tales from the Conquest of Time*, trans. Georges van den Abbeele (Minneapolis: University of Minnesota Press, 1996); Guy Debord, "Spectacular Time," in *Society of the Spectacle*, trans. Donald Nicholson-Smith (New York: Zone Books, 1995), 109–19; David Harvey, "Money, Time, Space and the City," in *The Urban Experience* (Baltimore: Johns Hopkins University Press 1989), 165–98; David Landes, *Revolution in Time: Clocks and the Making of the Modern World* (Cambridge, MA: Belknap Press of Harvard University Press, 2000); E. P. Thompson, 'Time, Work-Discipline and Industrial Capitalism," *Past and Present* 38 (1967), 56–97; and George Woodcock, "The Tyranny of the Clock" in *The Anarchist Reader* (Brighton: Harvester Press/Humanities Press in association with Fontana, 1977), 132–36.
8. See, for example, Silvia Federici, "The Great Caliban: The Struggle against the Rebel Body" in *Caliban and the Witch: Women, The Body and Primitive Accumulation* (New York: Autonomedia, 2004), 133–62.
9. Jacques Le Goff, *Time, Work and Culture in the Middle Ages*, trans. Arthur Goldhammer (Chicago: University of Chicago Press, 1982), 36–37.
10. Virginia Woolf, *Orlando: A Biography* [1928] (London: Penguin, 1993 [1928]), 211.

Bibliography

Alliez, Éric. *Capital Times: Tales from the Conquest of Time*. Trans. Georges van den Abbeele. Minneapolis: University of Minnesota Press, 1996.

Ballhause, Sylvia. *The Munich Daguerre-Triptych: The Story of the Munich Daguerre-Triptych*, published for the exhibition *Images* by Sylvia Ballhause at Les Rencontres d'Arles, France, July 2–August 19, 2012, www.sylviaballhause.de/assets/Textdateien/Daguerre-folder-safe.pdf (accessed December 11, 2017).

Batchen, Geoffrey. *Burning with Desire: The Conception of Photography*. Cambridge, MA: MIT Press, 1999.

Debord, Guy. *Society of the Spectacle*. Trans. Donald Nicholson-Smith. New York: Zone Books, 1995.

Federici, Silvia. "The Great Caliban: The Struggle against the Rebel Body," in *Caliban and the Witch: Women, The Body and Primitive Accumulation*. New York: Autonomedia, 2004, 133–62.

Fox Talbot, William Henry. "Some Account of the Art of Photogenic Drawing: Or the Process by Which Natural Objects May Be Made to Delineate Themselves without the Aid of the Artist's Pencil," *London and Edinburgh Philosophical Magazine and Journal of Science* XIV (March 1839) 196–208.

Harvey, David. *The Urban Experience*. Baltimore: Johns Hopkins University Press, 1989.

Landes, David. *Revolution in Time: Clocks and the Making of the Modern World*. Cambridge, MA: Belknap Press of Harvard University Press, 2000.

Le Goff, Jacques. *Time, Work and Culture in the Middle Ages*. Trans. Arthur Goldhammer. Chicago: University of Chicago Press, 1982.

Minh-ha, Trinh T. "Bold Omissions and Minute Depictions" in *When the Moon Waxes Red: Representation, Gender, and Cultural Politics*. New York: Routledge, 1991, 155–68.

Morse, Samuel. "The Daguerrotipe," *New York Observer*, April 20, 1839, 62.

Siegel, Steffen. *First Exposures: Writings from the Beginning of Photography*. Los Angeles: Getty Publications, 2017.

Silverman, Kaja. *The Miracle of Analogy: Or the History of Photography, Part 1*. Stanford: Stanford University Press, 2015.

Thompson, E. P. "Time, Work-Discipline and Industrial Capitalism," *Past and Present* 38 (1967), 56–97.

Woodcock, George. "The Tyranny of the Clock," in *The Anarchist Reader*. Brighton: Harvester Press/Humanities Press in association with Fontana, 1977, 132–36.

Woolf, Virginia. *Orlando: A Biography*. London: Penguin, 1993 [1928].

Index